RE-COLLECTING BLACK HAWK

Culture, Politics, and the Built Environment
DIANNE HARRIS, EDITOR

RE-COLLECTING
BLACK HAWK

LANDSCAPE, MEMORY, AND POWER
IN THE AMERICAN MIDWEST

NICHOLAS A. BROWN AND SARAH E. KANOUSE

University of Pittsburgh Press

Publication of this book is supported, in part, by the Iowa Arts Council, a division of the Iowa Department of Cultural Affairs, and the National Endowment for the Arts. Supplemental funding provided by the Office of the Vice President for Research & Economic Development and the College of Liberal Arts & Sciences at the University of Iowa.

IOWA **ARTS** COUNCIL
IOWA DEPARTMENT OF **CULTURAL AFFAIRS**

ART WORKS.

National
Endowment
for the Arts
arts.gov

Published by the
University of Pittsburgh Press,
Pittsburgh, Pa., 15260
Copyright © 2015,
University of Pittsburgh Press
All rights reserved
Manufactured in the
United States of America
Printed on acid-free paper
10 9 8 7 6 5 4 3 2 1

Supplemental material and excerpts of this book are available at www.recollectingblackhawk.net

Library of Congress
Cataloging-in-Publication Data

Brown, Nicholas A.
Re-Collecting Black Hawk: Landscape, Memory, and Power in the American Midwest / Nicholas A. Brown and Sarah E. Kanouse.
 pages cm. — (Culture, Politics, and the Built Environment)
Includes bibliographical references and index.
ISBN 978-0-8229-4437-9 (alk. paper)
1. Black Hawk War, 1832—Influence. 2. Middle West—Pictorial works. 3. Black Hawk, Sauk chief, 1767–1838—Influence. 4. Names, Geographic—Middle West. 5. Names—Middle West. 6. Cultural landscapes—Middle West. 7. Sauk Indians—Historiography. 8. Indians in popular culture—Middle West. 9. Collective memory—Middle West. 10. Whites—Middle West—Relations with Indians. I. Kanouse, Sarah E. II. Title.
E83.83.B6365 2015
973.5'6—dc23 2015004078

For

SENN RUFUS BROWN

and

GENESEE NORA BROWN

CONTENTS

ACKNOWLEDGMENTS

This book developed slowly, unfolding over a period of eight years marked by multiple anniversaries of signal events in the so-called settlement of the American Midwest. We began taking photographs in 2007, the 175th anniversary of the Black Hawk War. Indeed, the project, in its early stages, was conceived as a response to the commemorative zeal that swept through the region in the summer of 2007. We write these acknowledgments with the echoes of fireworks celebrating the 175th anniversary of the founding of Iowa City, our current home, still fresh in our minds.

We were troubled but not surprised when the local newspaper, reflecting on the anniversary, described the area that would later become Iowa City as "mostly uninhabited" and commended the founders for "carving the city out of the wilderness."[1] Given the nature of our book, it seems fitting to conclude this journey here in Iowa City, which was not an uninhabited wilderness but rather the site of three prominent Meskwaki villages at the time of the city's establishment in 1839. The precise location of Iowa City has everything to do with these villages and also the land speculation and cessions that forced the Sauk and Meskwaki out of eastern Iowa following the Black Hawk conflict.[2]

In between the Black Hawk and Iowa City anniversaries came the sesquicentennials of other, linked events described in this book: the establishment of the Meskwaki Settlement (2007), Minnesota statehood (2008), and the U.S.–Dakota War (2012). Far from impressing us with the distance separating then and now, these anniversaries reveal both the persistence of settler mythologies and the very thin skin of time separating today's possession of the land from its violent theft. If anything the slow gestation of this project has only reinforced the centrality of land and the need to unsettle possession in both a material and discursive sense. As Thomas King writes in *The Inconvenient Indian*, "The issue that came ashore with the French and the English and the Spanish, the issue that was the raison d'être for each of the colonies, the issue that has made its way from coast to coast and is with us today, the issue that has never changed, never varied, never faltered in its resolve is the issue of land. The issue has always been land. It will always be land, until there isn't a square foot of land left in North America that is controlled by Native people."[3]

Re-Collecting Black Hawk began to take shape during a two-month collaborative residency at the Institute for Quotidian Arts and Letters in Milwaukee, founded by the artist and filmmaker Steve Wetzel. Steve and members of the advisory

board, especially Marc Tasman, were unfailingly helpful in connecting us with Milwaukee residents whose knowledge of local and regional history, and interventions into the city's public memory, greatly enriched this project. In particular we would like to thank Nancy Oestreich Lurie, Nicolas Lampert, Jennifer Geigel Mikulay, and Carl Bognar for their early support of and belief in this project. An early sketch of this book was prepared for our concluding exhibition at the Walker's Point Center for the Arts, which included video interviews with other individuals whose perspectives have been instrumental in revising and clarifying this project, including the Meskwaki elder Preston Duncan (Tama, IA), Beth Carvey of the Black Hawk State Historic Site (Rock Island, IL), the anthropologist Larry Nesper (Madison, WI), and the sociologist Al Gedicks (La Crosse, WI). Many thanks are also due to members of the broad community of Native activists and non-Native allies in Milwaukee, especially Diane Amour, Ben and Dona Yahola, and Rick Whaley. Finally, we are indebted to the extraordinary example set by the Ho-Chunk photographer Tom Jones, whose images and integrity continue to inspire.

It was during an informal show-and-tell in Dianne Harris's living room that the possibility of expanding what we had considered a modest art project into a full-length book first entered our minds. Dianne has been a tireless advocate, advisor, and mentor to this project and many others, both individual and collaborative, over the last ten years. Her early invitation to submit this book to the University of Pittsburgh's Culture, Politics, and the Built Environment series helped us to see that our unconventional methods might be both welcome and useful in the academy.

We are grateful for the work of our contributors, both to this book and out in the world. Tribal officials' work is demanding and of great consequence to their communities; we thank Johnathan Buffalo, Yolanda Pushetonequa, George Thurman, and Sandra Massey for seeing value in sharing their words and experiences with us. In addition to their important contributions to this book, we are thankful for the extended conversations with Dylan Miner on Ni-aazhawa'amminis (Rabbit Island) in 2014 and Waziyatawin on the Dakota Commemorative March in 2008. Thanks also to Ray A. Young Bear for permission to reprint his poem "The Rock Island Hiking Club," which appears in its entirety on page 45.

We received substantial support, both material and intellectual, from academic institutions. At the University of Illinois, Urbana-Champaign, we thank Dianne Harris and D. Fairchild Ruggles in the Department of Landscape Architecture, Kevin Hamilton and Laurie Hogin in the School of Art & Design, Robert Warrior and Jodi Byrd in the American Indian Studies Program, Sharon Irish in the Graduate School of Library and Information Science, and the Illinois Program for Research in the Humanities. At the University of Iowa, we are grateful for the friendship of Jacki Rand, Erica Prussing, Laura Rigal, Naomi Greyser, and Eric Zimmer. Thanks to all the people at the Obermann Center for Advanced Studies, especially Teresa Mangum, whose unflagging support for and perceptive feedback about work blurring the boundaries between scholarship and creative practice

have greatly enriched this and other projects. In 2011 we participated in the NEH Summer Institute in Digital Humanities and American Studies at the University of Southern California, where John Carlos Rowe, Tara McPherson, Craig Dietrich, Wendy Cheng, and Kara Thompson provided helpful and challenging feedback on this book.

We are grateful to the University of Pittsburgh Press, particularly Peter Kracht and Abby Collier, for their enthusiasm in taking on this unconventional project and flexibility in adapting academic publishing conventions to accommodate its quirks. Alex Wolfe provided efficient and thoughtful copyediting; the book is cleaner for his clear eye. Through the University of Iowa, Katie Hargrave and Christopher Pickett made valuable contributions as research assistants in the preparation of the manuscript. We also appreciate the time and suggestions of the anonymous reviewers, who confirmed that we were onto something and helped make it better.

The Iowa Arts Council, a division of the Iowa Department of Cultural Affairs, and the National Endowment for the Arts provided financial support for *Re-Collecting Black Hawk*. Additional funding was granted by the College of Liberal Arts and Sciences and the Office of the Vice President for Research and Economic Development at the University of Iowa.

This project—its process, form, and spirit—owes much to the comradeship of Compass. Thanks to our fellow travelers in the Midwest Radical Culture Corridor: Brett Bloom, Rozalinda Borcilă, Duskin Drum, Bonnie Fortune, Ryan Griffis, Brian Holmes, Sarah Lewison, Amy Partridge, Claire Pentecost, Matthias Regan, Sarah Ross, Heath Schultz, Nick Smaligo, Fereshteh Toosi, Dan S. Wang, and Mike Wolf. For friendship, intellectual provocation, and modeling new forms of critical and experimental geography in the Midwest and beyond, we thank Jenna Loyd, Shiloh Krupar, Lize Mogel, Trevor Paglen, A. Laurie Palmer, Shiri Pasternak, Emily Eliza Scott, and Daniel Tucker.

Finally, we thank our families, particularly our parents, Kathleen and Senn Brown and Kenlyn and David Kanouse, for cultivating in us a curiosity about and openness to landscape in all its myriad dimensions (not to mention the dog sitting, baby sitting, and house sitting that enabled us to travel throughout the Midwest in search of Black Hawk). We dedicate this book to Senn Rufus Brown and Genesee Nora Brown, each of whom in their own way has taught us and continues to teach us to listen: to the land, to the people, and to the stories.

RE-COLLECTING BLACK HAWK

Introduction

NICHOLAS A. BROWN AND SARAH E. KANOUSE

Across two pages of a book, a pair of black-and-white photographs meet at the binding and fill nearly half the spread. They are wider than they are tall, "landscape orientation," as word-processing software calls it. The image on the left is taken from the middle distance, the frame nearly bisected. On one side is a van, headlights toward the photographer; on the other, a canoe, sawn in half and crookedly propped against a tree. The half-canoe is a sign, the bottom of the boat covered with painted lettering advertising the services of a business in Sauk City. "Paddle the Wisconsin River," it enjoins. The sign promises canoe rentals, shuttle services, sandbar camping, and another, presumably discontinued service, covered by duct tape. The single word "Blackhawk" arches above "River Runs" at the top of the sign.

The adjacent photograph is a detail of what appear to be canoes, stacked upside down for storage. A decal near the tip of one of the boats links this image, and the canoes it depicts, with the business shown on the other page. "Blackhawk River Runs," the decal reads, and it lists the same phone number as the sign in the facing photograph. Very close framing of the image makes the canoes fill the frame, suggesting an abundance, but the photographer focuses on the decal, where a nineteenth-century Indian perches on his scalp lock, his familiar chiseled features confirming that he is, indeed, the renowned Native American leader and the canoe-rental business's namesake. The caption below the image reads, "Sauk City, WI."

Beneath these photographs, a section header acts as an alternate caption: "'Kill the Indian, Save the Man': A Boarding School Story." The text that follows tells how six-year-old Richard Ackley came to attend the Lac du Flambeau Indian School in the late 1920s, a story that sounds for all the world like an abduction. The quotation comes from the May 2007 Lac du Flambeau tribal newspaper *Inwewin*, which ran two articles in that issue describing the boarding school from a first-person or

tribal perspective. The text makes no explicit or implicit mention of Black Hawk, canoes, or Sauk City; the photograph betrays no evidence of Richard Ackley or Lac du Flambeau. Yet their position juxtaposed on facing pages places them in dialogue—or confrontation—with one another. Reading conventions in which images illustrate texts and words contextualize photographs press the viewer to make sense of the juxtaposition. What do Richard Ackley and the Lac du Flambeau Indian School have to do with Blackhawk River Runs canoe rental? What links the experience of two men—Black Hawk and Richard Ackley—from different tribal nations, separated by more than a century and hundreds of miles? What, really, does Black Hawk have to do with Blackhawk River Runs anyway? The image-text pairing prompts these questions but does not answer them. By placing Black Hawk, a canoe rental service, the Lac du Flambeau Indian School, and Richard Ackley in proximity, it suggests that they are related. The spread—itself in dialogue with other such pairings—leaves it to the viewer to sort out what that relationship is, or rather, what it could be.

Black Hawk was really Makataimeshekiakiak, and his most famous "river run" was at Bad Axe.[1] It involved no canoes. Instead, the starving, exhausted remnants of a band of Sauk Indians that he had led through Illinois and Wisconsin in search of food and allies streamed into the Mississippi River. They were desperate to make it back to what remained of their land in Iowa after months of dodging and skirmishing with government forces. Women held children on their backs or above their heads and tried to swim across. Old people, frail from three months of foraging and marching, waded into the powerful current. U.S. soldiers and state militiamen fired on them from a steamboat patrolling the river and from the tall bluffs rising from its banks. Hundreds of men, women, and children perished in the massacre, with soldiers scalping most of the dead and cutting long strips of flesh from others as souvenirs. Makataimeshekiakiak fled the scene of the massacre and turned himself over to the army a few days later, a prisoner of war in his homeland.

For years, the slaughter at Bad Axe was described as the final "battle" of the Black Hawk War, which was in turn known as the last Indian war east of the Mississippi. However, to call Bad Axe a battle—or the conflict a war—is problematic given the military's disproportionate use of force. The events of August 1–2, 1832, are more aptly named the Bad Axe Massacre. Moreover, Makataimeshekiakiak's intention to return home with his people might be seen more accurately as an act of love than war. Framing the Black Hawk War as the "last Indian war east of the Mississippi" is equally problematic. It implies closure: the war is over, mission accomplished. This designation is another instance of the "phenomenon of lasting," which Jean O'Brien identifies as a "rhetorical strategy that asserts as a fact the claim that Indians can never be modern."[2] Although its status as the last Indian war *east* of the Mississippi is technically correct, the Black Hawk War was obviously not the last Indian war nor was it the last conflict over settlement in the Midwest. It wasn't even the last Black Hawk War. Ironically, the "longest and most destructive conflict between pioneer immigrants and Native Americans in

NICHOLAS A. BROWN AND SARAH E. KANOUSE

Utah history," which occurred thirty-three years *after* the conflict in Illinois, is also commonly referred to as the Black Hawk War (1865–1872).[3]

In light of this historical context, the decision to name a river recreation business Blackhawk seems not merely politically incorrect but also distinctly ill-advised. If the historical precedent were taken seriously, the name portends a less than happy ending for a leisurely paddle, analogous to naming your new seaside community Guantánamo Bay. So it is probably fair to assume that the business owner did not think about the Bad Axe Massacre or the bloody process of Western expansion when choosing Black Hawk's name and image, nor did she believe that vacationers and day-trippers from nearby Madison would make the connection either. And why should they? Along the route roughly traveled by Makataimeshekiakiak and his band in 1832, Black Hawk's name and image promote fitness clubs, subdivisions, churches, butcher shops, and used car dealerships—not to mention the municipal streets, parks, schools, and mascots that bear his name. In parts of Iowa, Illinois, and Wisconsin, it may seem like an easy way to name your business while expressing regional pride.

But Black Hawk is not simply plucked from thin, if collective, air. Or rather, the collective air is pretty thick. As recent work in critical toponymy has demonstrated, naming is an inherently political act.[4] Naming is claiming.[5] Because the Black Hawk conflict is popularly known as the last Indian war east of the Mississippi, the constant repetition of his name positions this sleepy sliver of the Midwest as central to the nation's foundational narrative of westward expansion, even if most people remain a little hazy about the details. Often paired with an image of a stoic, traditional Indian, the Black Hawk name evokes the same noble resistance that nineteenth-century Americans romanticized as soon as actual Indians no longer posed a threat to their territorial ambitions. The historical markers erected over the decades represent the evolution of white America's psychic investment in the conflict at least as much as they accurately describe the actual events that took place. The commercial and municipal uses of the name Black Hawk chart another kind of changing investment in the past as an admixture of myth, fact, illusion, ideology, possession, and convenience. Yet their overall impact marks an absence—the supposed pacification and removal of Native Americans, reiterated by historical markers, artisanal breweries, and credit unions alike. These practices weave an unreliable, highly ideological tapestry of collective (mis)memory through the surveyed, sectioned, and settled midwestern landscape.

RE-COLLECTING, RE-ASSEMBLING, AND RE-ASSOCIATING BLACK HAWK

The meanings of landscape, whether historical or for the future, are never simply there, inherent and voluble. Instead, they are made to speak, invited to show themselves, and that invitation is the process of practicing landscape which always places landscape in a present moment. This presentation is a crucial one and a political one, for it disrupts accounts of landscape which seek to ground certain claims and identities in a self-evident earth. Landscapes are always perceived in a

particular way at a particular time. They are mobilized, and in that mobilization may become productive: productive in relation to a past or to a future, but that relation is always drawn with regard to a present.

<div align="right">

MARK DORRIAN AND GILLIAN ROSE,
Deterritorialisations . . . Revisioning Landscapes and Politics[6]

</div>

Re-Collecting Black Hawk is an extended image-text essay exploring the cultural and political landscapes of the Midwest. It brings together roughly 170 photographs of historical markers and monuments, organizations, sports teams, consumer products, businesses, parks, subdivisions, and other places that reference the nineteenth-century Sauk leader Makataimeshekiakiak. These photographs are arranged geographically and organized into chapters by state (Iowa, Illinois, and Wisconsin). Each image is paired with an appropriated text drawn from sources as wide ranging as press releases and scholarly histories, government reports and advertisements, and poetry and recipes published in tribal newspapers. Interwoven throughout are contributions by and interviews with activists, scholars, and tribal officials, who, in some cases, reflect on the image-text strategy and, in other cases, ground it in specific, current struggles around decolonization, self-determination, and cultural revitalization.

On the most basic level, *Re-Collecting Black Hawk* is both a call and an attempt to practice landscape differently. It proceeds by staging a series of encounters between image and text, each with different implications in the realm of political imagination. The purpose of staging these encounters is to call attention to relationships or the lack thereof, as the case may be. These juxtapositions highlight disconnect—or what Elizabeth Povinelli might call "dead dialectics"[7]—but also, in a more speculative manner, propose *living* dialectics that are grounded in and accountable to collective visions of justice. The encounters operate on multiple levels, suggesting a range of possible relations within pairs and also between pairings. Together they produce a deeper map of the territory,[8] which necessarily entails the "decolonization of our spatial imaginations."[9] The encounters represent, therefore, a modest and regionally specific contribution to the larger project, described by Jodi Byrd, of "imagining an entirely different map and understanding of territory and space: a map constituted by over 565 sovereign Indigenous nations, with their own borders and boundaries, that transgress what has been naturalized as contiguous territory divided into 48 states."[10] The book's title suggests this approach and holds a double meaning. In the most literal sense, it connotes the remembering of something past. The hyphen, however, hints at another, more active meaning. To re-collect is to gather again or to collect anew in the present. Or, following Bruno Latour, to re-collect is to reassemble Black Hawk in a manner that accounts for the disconnection between past and present, absence and presence.[11] With this in mind, the small sign posted above a row of trashcans at Black Hawk State Park in Lake View, Iowa, could refer to more than just an environmentally responsible way to handle glass, plastic, and metal. "Help Black Hawk Recycle," appeals the

sign. Putting aside for a moment its more obvious meaning, the sign can also be read as an invitation—to campers, fishermen, birdwatchers, or anyone else who happens upon his eponymous park—to help Black Hawk re-collect, re-assemble, and re-associate his name, image, and legacy.

Re-Collecting Black Hawk is more about the present, less about the past. The history of the Black Hawk War is important. This book, however, is not primarily about the war, nor is it about the person for whom the war is named.[12] Rather, it is about the various and conflicting ways the history of that war and the memory of that person function in the present. It is an argument for the importance not only of remembering and forgetting—present tense practices—in shaping both history and the landscape but also recognizing the power geometries within which these contemporary mobilizations of the past are situated. In an encounter between existing and evolving political temporalities, settler practices of commemoration—depicted through photographs—allude to history and our colonial past. "That happened there," the monument declares. In contrast, the texts speak to our colonial present.[13] They refuse to be contained by the past tense.[14] "This is happening here," insist activists blockading the route of an oil pipeline through sovereign tribal lands. As opposed to confronting a monument in the landscape *or* happening upon a provocative activist news release, encountering the monument *and* the news item in close proximity encourages us to reflect on possible relationships. Or, if nothing else, it calls attention to our unwillingness or failure to do so.

If *Re-Collecting Black Hawk* is more about the present, less about the past, it is also more about presence, less about absence. Taking present presence as its baseline, and thus establishing certain horizons of possibility, this book considers the unevenness of presence, the legibility of presence, and the potential for just and sustainable co-presence. The materiality of the built environment—business signs, historical markers, and other ephemera—is contrasted with the corporeality of Indigenous sovereignty and the everyday life circumstances of Indigenous peoples living throughout the region.[15] In an encounter between existing and evolving political geographies, a settler landscape of commemoration—evoked through photographs—is juxtaposed with an Indigenous landscape of resilience or *survivance*—evoked through texts.[16] Despite the really real (and really ongoing) processes of dispossession and colonization in the region, there remain robust and evolving Indigenous political geographies that have never been extinguished. Eschewing the task of recuperating Indigenous voices, restoring aboriginal presence, or giving the gift of liberal multiculturalism,[17] *Re-Collecting Black Hawk* instead calls attention to the polyvalent voices and presences that always already constitute the midwestern landscape, as well as the traditional and emergent practices of "critical individual and collective self-recognition" that continue to reshape our understandings of the region.[18] "Black Hawk's story ultimately is not about disappearance but survival," argues Mark Rifkin, as it "draws attention to traditional (regional) social formations alternately ignored and assaulted by the United States and insists on the meaninglessness of a rhetoric of Indian assent

in the absence of a substantive reckoning with the self-understandings and lived topographies of native peoples."[19]

The act of re-collecting, re-assembling, and re-associating can be understood as a methodology of sorts—a means without ends that is aligned, conceptually and practically, with ongoing processes of decolonization. As outward manifestations of this methodology, the staged encounters found throughout this book function partly as a way of interrogating the denial of relationships and asking critical questions about the continuity of colonial logics. A particular pairing of image and text may elicit the question, How is it possible to commemorate the Battle of Stillman's Run without reflecting on the contemporary politics of repatriation in Illinois? Another pairing might provoke the reader to ask, How do present-day tensions around blood quantum and citizenship in Tama, Iowa, inflect our historical understanding of the shifting intertribal alliances at the time of the Battle of Wisconsin Heights? In contrast, other juxtapositions may prompt more general questions or meta-level reflection. What allows denial to endure? And whose interests does disconnection serve? In the words of Sandy Grande, "What is gained from the proliferation of essentialist portrayals of *whitestream* domination and Indian subjugation?"[20] Alternately, what are the consequences of remaining trapped in a "dialectics of genocide"?[21] Encountering these encounters, and the range of new relationships and horizons of possibility they suggest, readers may ultimately ask, What is to be done? This vital question reflects a growing desire to move beyond the "economy of equivalence" and to grapple in a substantive manner with the political consequences of social difference. Instead of simply asking about the function of commemoration, we begin to speculate about how we might commemorate or mobilize the past differently, in a manner that promotes justice and prefigures habitable worlds.[22]

RE-IMAGING BLACK HAWK

There is never a single approach to something remembered. The remembered is not like a terminus at the end of a line. Numerous approaches or stimuli converge upon it and lead to it. Words, comparisons, signs need to create a context for a printed photograph in a comparable way; that is to say, they must mark and leave open diverse approaches. A radial system has to be constructed around the photograph so that it may be seen in terms which are simultaneously personal, political, economic, dramatic, everyday, and historic.

JOHN BERGER, "Uses of Photography"[23]

The photo-essay that forms the core of *Re-Collecting Black Hawk* revolves around the complex relations between image and text, past and present, presence and absence, and colonialism and resistance that have long been co-implicated in the modes of photographic representation. Edward Curtis's iconic images of unsmiling nineteenth-century Indians continue to echo in contemporary stereotypes of

"authentic" Indigenous people as noble, stoic, and doomed, if not already extinct. But the ideological work of photography—and what Raymond Williams terms the "structures of feeling" it supports—operates not just at the level of image but also of medium.[24]

While its indexical relationship to reality has made the photograph a prized documentary form, photography itself is suffused with absence. What is captured photographically can be forever revisited but is understood to be gone. Roland Barthes famously claimed that the photograph always speaks of death because it eternally presents a past state of being—the image is "here now," in a material sense, but also, inescapably, a record of a "having been."[25] The eternal past of Curtis's portraits is not just a function of age, lighting, printing, subjects, and staging; the photographs reinforce in their very temporal structure cultural assumptions about the essential, if regrettable, pastness of Native Americans. In addition, photographs decontextualize as well as de-temporalize. Wrenched from context, images become scattered and fragmentary observations, deprived of the meanings that motivated them. Early portraits of Native Americans establish an aura of "authentic Indianness" because the specific significance of items of dress, dwellings, and activities depicted within them are unclear and therefore removed from the flow of history and cultural reinvention. As John Berger wrote, photographs "offer appearances—with all the credibility and gravity we normally lend to appearances—prised away from their meaning. Meaning is the result of understanding functions."[26]

The widespread practice of using Black Hawk's mystique to name parks, decorate car washes, or anoint a new subdivision effects the same abstraction. Complexity is flattened into icon. Even more responsible settler practices—like consulting with tribes before erecting historical monuments—must radically simplify, first by rendering into narrative, then by shortening that narrative to fit on a sign. Makataimeshekiakiak, a human being with all the contradictions and complexity that entails, becomes literally dimensionless—a flat image printed on a sign or invoked through Roman letters spelling the English translation of his name. Far from summoning his enduring presence, the constant citation of Black Hawk underscores his absence and, by extension, the supposed pacification and removal of Native Americans. At the level of the image, our photographs of Black Hawk's appropriated name and image perform the same conceptual violence that the original appropriations do to him. Each image is stripped of particularity and transformed into a signifier of settler colonialism. A geographically dispersed phenomenon is condensed into a book; a mom-and-pop business full of family memory and neighborhood lore is reduced to a four-by-six snapshot. A practice of appropriation that is no doubt in flux and someday may end is arrested at one moment of its development. Though this strategy could be read simply as turning the camera on the colonizer, it goes beyond mere documentation and can be seen as a hopeful gesture of decolonization. Our images operate in what Judith Butler calls the photograph's "future anterior." She writes, "The photograph relays less the present moment than the perspective, the pathos, of a time in which this will have

been."[27] The fact that we chose to take the photographs in this book thinks forward to a time when businesses like Blackhawk River Runs will be renamed, not from pressures of political correctness but rather because today's colonial relations will have been transformed.

Jodi Byrd calls for images that cause "people to acknowledge, to see, and to grapple with lived lives and the commensurable suffering" of colonial violence.[28] Channeling Butler, she describes this as a process of "grieving," as opposed to the sentimental lamentations of salvage portraiture, à la Edward Curtis. Given the structural limitation of photography to depict both the passage of time and social context (as Bertolt Brecht observed long ago), the image must be re-grounded in text.[29] Responding to Berger's charge in the epigraph to this section, this book creates a "radial system" for our loosely documentary images through texts, juxtapositions, and accumulations. If the Black Hawks represented in the photographs are floating signifiers or empty signs, as some have suggested,[30] one of our goals is to reassociate and anchor them in the dynamic and evolving Indigenous political geographies represented by the texts. In short, we aim to connect absence with presence. Or, borrowing Gerald Vizenor's language, one of our goals is to link "*indians*"—the "simulations of the tragic primitive," which insinuate the "ruse of colonial dominance" and "an overseas enactment that has no referent to real native cultures or communities"—to "postindians," "the storiers of an imagic presence."[31] Failing to make these connections, the empty signs and the "obvious simulations," which proliferate under the banner of settler commemoration, will continue not only to resuscitate dead dialectics but also to cultivate a deadening dialectic. The disconnection, in other words, extends beyond our understanding of the historical and present-day lives of Native Americans to include future lives as well. The empty signs that circulate in the landscape diminish our capacity to imagine alternative futures.[32] They inhibit the development of new forms of recognition and solidarity,[33] reduce the possibility of "sustainable self-determination,"[34] and prevent us from creating "a truly post-colonial relationship of peaceful co-existence."[35] Deeply invested in the future tense, *Re-Collecting Black Hawk* therefore scrutinizes the foreclosure of "futurity" in both the past and present.[36]

Like the work of groundbreaking visual essayists such as Victor Burgin, Martha Rosler, and Allan Sekula, who used serial imagery and original and appropriated text to both de- and reconstruct images, *Re-Collecting Black Hawk* is a true image-text. This tradition runs counter to received conventions of the framed print as art object. Images are often appropriated (as in much of Rosler's work) or are relatively unremarkable aesthetically, as in early photo-essays like Dan Graham's *Homes for America* (1965), Ed Ruscha's *Every Building on the Sunset Strip* (1966), or Allan Sekula's *Untitled Slide Sequence* (1972). The use of a relatively amateur aesthetics, rather than "wow factor" verisimilitude, understands the photograph as an aspect of the material social process of ordinary culture, to use Raymond Williams's terms.[37] In this way, the image-text shows rather than tells, channeling Walter Benjamin's literary essayism and Allan Pred's performative geography.[38] Neither illustrated essays nor captioned photographs, image-texts play up the

inherent intertextuality of photographic interpretation to build, invent, or nego-tiate an environment in which they take on new, self-reflexive, and potentially decolonial meanings.

This visual essayist approach resonates with that thread of contemporary art where we locate this project: critical art practice. If, as the influential philosopher Jacques Rancière argues, the realm of the sensible—what can be seen, felt, and experienced—delimits the space of political imagination and action, then all art is inherently political, even when it is not overtly "about" politics.[39] *Critical* art prac-tice brings an awareness of art's capacity to frame perception by asking probing questions about politicized content or by politicizing a topic by posing questions strategically. It is better understood as a method rather than a style or genre, a way of inquiring into social and political phenomena by making and assembling visual, spatial, or experiential notes about them. In contrast to what is typically described as activist artwork, a critical approach often explores "structures of feel-ing" rather than communicating a definitive position on a single issue. This is not to say that critical artists lack a position or pull their punches, though the current (relative) art world success of this work has prompted some soul searching.[40] Yet as the skeptical practitioner Martha Rosler acknowledges, "art continues to have a mapping and even critical function in regard to geopolitical realities. Artists have the capacity to condense, anatomize, and represent symbolically complex social and historical processes."[41] Concerned in equal parts with social and po-litical conditions "out there" in the world *and* with the complex ways concepts, practices, and images are dialectically bound up with them, critical artists pursue their investigations self-reflexively, recognizing that there is no outside position from which to critique or intervene. At their best, critical artworks are sites where maker and spectator both grapple with their expectations and find their sense of the world changed in the process. Critical art therefore asks much more of the viewer than passive aesthetic contemplation. It demands attention simultaneously to the ostensible content of the work, the methods by which it is presented, the shifting positions of producer and spectator, and the spaces of political and aes-thetic possibility it opens up.

Influenced by the shift from modernism's autonomous art object to Umberto Eco's open work, or from Barthes's readerly text to the writerly text, the forms of intellectual and political engagement prompted by critical art resonate with a broader struggle for cultural decolonization.[42] The Transnational Decolonial Institute, a loose group of artists, critics, and scholars, recently formed with the aim of devising a properly intercultural and decolonial aesthetics that recognizes the centrality of colonialism to modernity. Their statement of purpose explains, "Within different genealogies of re-existence 'artists' have been questioning the role and the name that has been assigned to them. They are aware of the con-finement that Euro-centered concepts of arts and aesthetics have imposed on them. . . . They are dwelling in the borders, sensing in the borders, doing in the borders, they have been the propellers of decolonial transmodern thinking and aesthetics."[43]

The methods and aesthetics of these projects may—indeed must—look different depending on the operative colonial contexts, but art can play a vital role in any case. Recognition of its unique capacities is implicit in notions such as "intellectual sovereignty," "cultural sovereignty," and "sovereign Native spatial discourse."[44] The significance of cultural production vis-à-vis sovereignty and self-determination is more explicit, for example, in the recently ratified Constitution of the White Earth Nation, coauthored by the Anishinaabe poet, novelist, and critic Gerald Vizenor. Chapter 3, article 5 of the Constitution reads: "The freedom of thought and conscience, academic, artistic irony, and literary expression, shall not be denied, violated or controverted by the government."[45] Those of us working with a Euro-American colonial heritage must consider not only how settlers can act in solidarity with Indigenous intellectual self-determination but also how settlers can decolonize our own cultural imagination. Recent examples of anticolonial aesthetics include Gaye Chan's *Waikiki: A History of Forgetting and Remembering*, Drex Brooks's *Sweet Medicine*, and Robert Adams's *Turning Back*.[46] Like *Re-Collecting Black Hawk*, these photographic books arise from the dense, fraught, and layered territory of history, memory, and cohabitation that is our colonial inheritance, implicating the reader in the labor of weaving together these fragments and conceptual disjunctions and leaving it up to us—readers, writers, image makers, Natives, and non-Natives—to make something like justice of it.

UNEQUIVALENCE AND THE POLITICS OF LISTENING

If "culture" is the matter of difference, then how is one to listen to and understand the particular "difference" of Indigenous peoples and their particular nationhoods? Both "aboriginality" and nationhood are constituted (and constitutive of) political postures, experiences and discourses and these processes are inextricably joined to culture. As they are joined they are articulated through the apparatii of history, power and experience. The very notion of an Indigenous nationhood, which demarcates identity and seizes tradition in ways that may be antagonistic to the encompassing frame of the state, may be simply unintelligible to the western and/or imperial ear. Or is it not?

AUDRA SIMPSON, "Paths toward a Mohawk Nation"[47]

Although it conveys a sense of the tremendous diversity of intellectual, political, and social life in and around "Indian Country," *Re-Collecting Black Hawk* is not principally about the contemporary lives of Indigenous peoples throughout the upper Midwest, just as it is not explicitly about the history or commemoration of Black Hawk and the Black Hawk War. Instead, its primary concern is the nature of the relationships between these things. The image-text strategy upon which this book relies attempts to counteract the denial of relationships and the perpetuation of colonial logics that denial enables. By exploring how the *cultural* landscape of settler commemoration, appropriation, and projection intersects with the *political*

landscape of Indigenous survivance, ongoing resistance, and evolving presence, this image-text essay inverts a pernicious colonial paradigm that continually relegates indigeneity to the cultural domain. Following Maureen Konkle, this strategy recognizes that "Native peoples' connection to land is not just cultural, as it is usually and often sentimentally understood; it is also political—about governments, boundaries, authority over people and territory."[48] A substantive engagement with the *politics* of indigeneity, which is emphasized throughout *Re-Collecting Black Hawk*, entails active participation in the "politics of thick life—in which the density of social representation is increased to meet the density of actual social worlds."[49] Engagement, moreover, requires a degree of receptivity to individual and collective transformation—a willingness to be unsettled, literally and figuratively, by the political implications of indigeneity. Engagement necessitates that we "reassess [our] place within an Indigenous nation," and take seriously the call to "assimilate the newcomers"[50] through "an Indigenous checkerboarding of American political space."[51]

The politics of indigeneity, as characterized by Aileen Moreton-Robinson, functions as an ontological disturbance.[52] In the most general sense, it profoundly unsettles what Bruno Latour calls the "modern constitution," "the ontological presuppositions that underwrite modern society's self-understanding."[53] It destabilizes, in other words, the meaning of foundational concepts such as landscape, space, place, environment, citizenship, sovereignty, and property. Framed by the politics of indigeneity these concepts are rendered historically, socially, and spatially contingent, and also implicated in enduring systems and structures of colonization.[54] According to Sarah Whatmore, ontological disturbance occurs at the moment when "the things on which we rely as unexamined parts of the material fabric of our everyday lives become molten and make their agential force felt."[55] *Re-Collecting Black Hawk* attempts to track this disturbance as it ripples across the molten landscape, particularly as it rubs up against and contests the logic of settler colonialism. In this sense, the politics of indigeneity (and the disturbance left in its wake) is conceived as a constructive and generative force, especially in relation to movements for justice and peaceful coexistence. It has the capacity to "undo hegemonic signifiers, affect their usual semantic chemistry to produce new valences, and thus reconfigure indigeneity itself opening it up to the acknowledgement of historical contemporaneity and radical social justice."[56] Writing about its generativity as an analytical and geopolitical category, Mary Louise Pratt suggests that we conceive of indigeneity "not as a configuration or a state, but as a force that enables, that makes things happen." It is a force, moreover, full of possibility and potential that operates across the continuum of time. "Unrealized possibilities of the past remain available to the present," Pratt argues, "and unrealized possibilities in the present remain available to the future; they are part of the fertility or potency of thinking and knowing through (i.e., by means of) the Indigenous."[57]

The serial encounters of image and text may, in the most literal reading, suggest some sort of equivalence—one based primarily on visual cues. By simply occupying the same spread a certain degree of visual equivalence is established, for example, between the photograph of Blackhawk River Runs and Richard Ackley's

written account of his experience as a student at the Lac du Flambeau Indian School. This formal equivalence is reinforced by reading conventions that shape our expectations of how images and texts are supposed to relate. Images illustrate; texts contextualize. *Re-Collecting Black Hawk*, however, frequently upends these conventions. At the very least, the staging of image and text is intended to preserve and expand dialectical tensions.[58] More poignantly, the staging frequently calls attention to *un*equivalence and also to the inherent "violence of equivalence." Even though Ackley reflects in part on a more lighthearted aspect of his boarding school experience—being perplexed by the relationship between rabbits and Easter eggs—the excerpted text nevertheless casts the image in a different light, causing the name on the side of the canoe to appear much less benign. The text—and its omissions—overwhelms the image. And, in this case, the reality of intergenerational trauma stemming from the boarding schools shrinks the distance between Baraboo and Bad Axe.

The historian Boyd Cothran writes eloquently about unequivalence in relation to the Modoc War, which, coincidentally, is often referred to as "the last Indian war in California."[59] Within the context of U.S.–Indian violence, "reconciliatory narratives," "exchange of remembrances," and "historical justice-making," Cothran argues, form an "economy of equivalence" and a "multicultural marketplace of remembering and forgetting." This economy or marketplace is problematic insofar as it obscures historical and contemporary power relations and the continuity of colonial logics that shuttle between past and present. In short, the market is "power-denying." It contributes to the production of what Paul Carter calls "imperial history," the primary object of which "is not to understand or to interpret: it is to legitimate."[60] Like other supposedly free markets, this one conceals the various ways in which it is subsidized by the state and also through our individual investments—possessive and psycho-affective—in the land and the narratives that legitimize our ownership of it. The economy of equivalence, Cothran observes, enables the authors of reconciliatory narratives to "depart with no strings attached,"[61] a simple way of describing liberal capitalist society's fantasy of "convulsive competition purged of real conflict, social difference without social consequences."[62] Ultimately, Cothran calls for "unequivalent multivocal remembering" as a means of enabling participants to "sidestep the marketplace of remembering, stop trading stories with the dead and actually listen to the stories we are offered as gifts from the living."[63] Following Cothran, *Re-Collecting Black Hawk* calls attention to the unevenness and unequalness of social memory in the colonial present—the uneven and unequal ways that landscape is practiced and mobilized in the present by settlers and Indigenous peoples alike. Furthermore, it advocates a practice and politics of listening that sidesteps the marketplace of remembering and forgetting.

The notion of a "politics of listening" developed in Euro-American feminist theory to articulate how the work done in consciousness raising groups contributed to the formation and mobilization of radical and oppositional subjectivities. In contrast to European, patriarchal standards that valorize the individual speaking subject, what have been called "women's ways of knowing" are said to

emphasize the intersubjective nature of consciousness, recognize the context and contingency of information, and attend to the affective dimension of experience.[64] Although the idea that a politics of listening serves as a necessary counterpart to the more familiar and celebrated politics of speaking has surfaced in rhetoric, media theory, art, trauma studies, and, as demonstrated by Audra Simpson's quote in the epigraph to this section, Indigenous studies, it remains underappreciated.[65] Nevertheless, the notion of listening before speaking—or being willing to suspend speech altogether—takes on particular significance in the context of colonial encounters. In North America, the settlers have done most of the speaking and precious little listening—an asymmetry of communication that remained largely constant for hundreds of years and continues to plague efforts to "include" Native voices in historical accounts that usually remain, at their core, rooted in settler priorities and temporalities.

In an era of liberal multiculturalism, in which governments issue official apologies for past genocides, the settler's voice and actions—first violent, now contrite—remain central.[66] Adding settler apologies to settler historical narratives furthers Cochran's "economy of equivalence" and sidesteps the more unsettling consequences of dealing squarely with the legacy of ongoing, if never total, dispossession. *Re-Collecting Black Hawk* takes a different tack. In re-collecting and re-assembling what is already here in the colonial landscape, we must listen to it (and look at it and read it) deeply and at length. Our image-text strategy forestalls the transmission of a single message or the formulation of a clear demand in favor of continuing to perceive and examine conditions as they are now, in all their complexity. As the activist sound art collective Ultra Red writes, "*listening is a site for the organization of politics.*"[67] This work does not just lead to a more "correct" sense of the world out there, but rather it reconfigures the position of the perceiver in relation to the perceived. This change of subjectivity is necessary if we are ever to build an anticolonial solidarity not just around issues of mutual concern—as has happened so effectively and inspirationally around certain environmental campaigns—but also in matters where justice requires non-Natives to give something up. Cautioning about the ease of making demands, Ultra Red continues, the "capacity to privilege the demand must be constrained so that it may call us to the silence that is the condition for listening. . . . We hear beyond need. This remainder is the medium of intersubjectivity."[68] It is only through working subjectively and intersubjectively—through relationships and through representation—that we will begin to understand what solidarity, and what justice, will look like.[69]

Though we are troubled by the ideological work done by settler appropriations of Black Hawk, we have chosen to listen to them, deconstruct them, and reshape them. We have not explicitly tried to present a more authentic or historically accurate picture. This important work has already been (and continues to be) done. In book form it exists, for example, in Makataimeshekiakiak's own *Life of Black Hawk*, which is a source of great pride to the present-day Sac and Fox Nation as the first published "as-told-to" autobiography of a Native leader.[70] As descendants of European settlers to this very region, we are interested in examining structures

of possession and how they are perpetuated and naturalized through the settler organization of space.[71] It may not be our role to present Native voices—which are numerous, informed, powerful, and fully capable of presenting themselves. Following Aileen Moreton-Robinson, a Native scholar sometimes questioned for her decision to focus on white possession, it is settler beliefs and practices that are the problem.[72] As non-Natives, we are uniquely situated to address that problem. Any anticolonial project requires that non-Natives examine how our territorial claims, political processes, national narratives, and even senses of self are bound up first in genocide and then in the resurrection and use of phantom Indians.[73] However, this project cannot be undertaken in isolation from contemporary, flesh-and-blood Native people without unintentionally recentering the white narrative, such that coming to grips with colonialism remains "all about us," as it were.[74] As many of the text fragments and long-form interviews that round out this book demonstrate, there are countless people working tirelessly across Indian Country to exercise tribal sovereignty, restore ecological balance, improve Native health, rebuild tribal languages and land bases, and address violence in all its forms. By juxtaposing appropriations of Black Hawk with texts pointing toward these efforts, we do more than gesture at the gulf between Native and non-Native experiences of these histories. We also offer a predominantly non-Native audience hundreds of paths to educate themselves about the tremendous diversity, energy, intellect, and dedication to be found in Indian Country—which is not just "over there" on the rez but also in our own backyards.

The contributions and interviews that round out this book detail specific Native efforts that put to lie narratives of pacification and extermination, and that make Makataimeshekiakiak's legacy available to the present. We sought these texts in recognition that before Black Hawk was a symbol, he was a man, a father, a warrior, an elder, and a leader to his people. His life has enormous consequence—principally for the Sauk and Meskwaki people, who were punished for his actions, but also for anyone who lives or owns property, as we do, in the territory seized by the U.S. government in treaties both before and after the war. What this requires at the very minimum is a politics of listening, of recognizing that, while this project may not be "merely" about Black Hawk to us, there is nothing "mere" about Makataimeshekiakiak, whose spirit continues to live within the Sac and Fox Nation as surely as his name appears on their flag. For this reason, we sought the participation of representatives of the Sac and Fox tribes in Oklahoma and Iowa.[75] We spoke with three tribal officers involved in the preservation and transmission of Sauk and Meskwaki history, culture, and language: Johnathan Buffalo, historic preservation officer for the Sac and Fox Tribe of the Mississippi in Iowa (Meskwaki); Yolanda Pushetonequa, former language preservation officer for the Sac and Fox Tribe of the Mississippi in Iowa; and Sandra Massey, historic preservation officer for the Sac and Fox Tribe of Oklahoma (Sauk). These recorded conversations were transcribed and then jointly edited, resulting in the interviews placed between the three photo-essay chapters in this book. In addition, George Thurman, a direct descendant of Makataimeshekiakiak and current

principal chief of the Sac and Fox Tribe of Oklahoma, contributed a moving statement about Black Hawk's continued significance to a living and evolving Sauk people. Rather than providing a singular "Native perspective" (as if there were such a thing), these contributions counteract the narrative of disappearance and pacification suggested by the phrase "the last Indian war east of the Mississippi" and provide varied perspectives on the continued cultural genocide and historical erasure that proceed much less visibly than the Bad Axe Massacre but which appropriations of Black Hawk might be one part.

If the contributions by Sauk and Meskwaki officers contextualize the photo-essays in light of tribal perspectives and programs, the chapters by activist scholars place the image-text in another context. The Michif (Métis) artist and art historian Dylan Miner's contribution places the Black Hawk conflict in legal, political, and colonial history and contextualizes the image-text—and critical art in general—as part of decolonial praxis. Finally, in a coda suggesting links between Black Hawk and other colonial conflicts in the Midwest, the Dakota scholar and activist Waziyatawin describes and reflects on her involvement in contesting Minnesota's official sesquicentennial commemorations of statehood (2008) and the U.S.–Dakota War (2012). Her account demonstrates how deeply non-Native culture continues to use historical commemorations to shore up its legitimacy—which includes the adoption of a rhetoric of inclusivity, tolerance, and, in some cases, contrition. In contrast to both the settler appropriations documented in this book and our own image-text intervention, Waziyatawin discusses the "Take Down the Fort" campaign as a counter-memorial practice that bridges representational, discursive, and material strategies. She also speaks to the ugly response that often awaits those who challenge the casual racism that cuts through landscapes and practices of commemoration. She reminds us that, "in the context of justice, not all accounts of history are equal" and that the settlement and pacification of the Midwest can never be total and will never be complete.

BLACK HAWK IN UNEXPECTED PLACES

The figure of "impossibility" indexes something more than the limits of either practicality or constitutionality, pointing less toward a concern over native sovereignty per se than the articulation of a version of it not directly managed by the federal government. This "doctrine" seems to mark an anxious denial, a kind of primary repression not of a particular kind of governance so much as the possibility of an eruption of an autonomous political order within what the United States maintains is its own boundaries. In asserting a de facto right to superintend Indigenous territories and populations in perpetuity, though, the decision repeatedly describes . . . dispossession . . . as an "ancient" act, displacing and safely sealing it into a long distant past and thereby casting current conflict over the contours of U.S. legal geography as instead merely anachronistic Indian longing for what has vanished.

MARK RIFKIN, *Manifesting America*[76]

The critical questions generated through the juxtaposition of image and text can be read as a provisional response to Irene Watson's call for a "meditation on discomfort."[77] *Re-Collecting Black Hawk* is fueled by a desire to facilitate such a meditation to traverse the affective geographies of settler anxiety and move toward a more just landscape. A key aspect of this meditation concerns the efficacy of dispossession. If the photographs in this book reveal how narratives of dispossession, which reproduce old ideologies of extermination, pacification, and assimilation, are inscribed in the landscape, the accompanying texts do not describe the images so much as they refute their ideological certainty. The pairings of image and text—the crux of this project—speak of a failure to dispossess. They testify to the durability of Indigenous possession, the inalienability of land, and the refusal of settler recognition.[78] Collectively they challenge us to reconcile this failure with a commemorative landscape that exudes an "evasive melancholy of dominance."[79] By unsettling the "quietness of possession,"[80] the pairings destabilize normative settler cartographies that embody not only this evasive melancholy but also a palpable "anxiety of dispossession."[81] More importantly, however, the pairings demand recognition of the dynamic and evolving Indigenous political geographies that have long refused containment by narratives of dominance and dispossession. And they compel us to move beyond the property paradigm in order to see, perhaps for the first time, land not simply as a resource but as "the nonfungible matrix of the community" and "the inalienable ground of the communal."[82]

Refusing the rhetoric of pacification and contesting the efficacy of narratives of dispossession allow us to better appreciate the continuity of struggles that persist to this day. Arguably, the same sentiment that compelled Makataimeshekiakiak to return to Saukenuk in 1832 fueled the slow and deliberate efforts of the Meskwaki Nation to expand its land base in central Iowa by purchasing and collectivizing private property. It emboldened a group of Omaha Indians who occupied Blackbird Bend along the Missouri River in western Iowa in 1973 and again in 1975. It motivated Ojibwe tribes in northern Wisconsin to defend their treaty rights during the Walleye War in the late 1980s. And it was channeled by four women in Saskatchewan who in December 2012 launched the ongoing Idle No More movement in defense of Native sovereignty and ecological sustainability. The spirit of Black Hawk, in other words, is alive and well. It animates current campaigns by organizations such as Honor the Earth and the Indigenous Environmental Network to resist the expansion of pipelines carrying oil from the Alberta tar sands to distant markets, traversing reservations, reserves, and traditional aboriginal territories in the process. Makataimeshekiakiak's spirit energizes the anti-mining movement in northern Wisconsin and Michigan as it mobilizes once again to oppose new plans by multinational corporations to mine low-grade iron ore (taconite) in the Penokee-Gogebic Range, directly upstream from the Bad River Band of the Lake Superior Tribe of Chippewa Indians, and to conduct metallic sulfide mining in the Upper Peninsula's Yellow Dog Plains, which includes Eagle Rock, a sacred site for the Keweenaw Bay Indian Community and other Anishinaabeg peoples.

About a month after Navy SEALs killed Osama bin Laden in Pakistan in May 2011, the 1491s released a video poem, "Geronimo E-KIA,"[83] which challenged the military's conflation of a contemporary terrorist with the renowned Apache warrior. The 1491s, "a sketch comedy group, based in the wooded ghettos of Minnesota and buffalo grass of Oklahoma," insisted that Geronimo—code name for bin Laden—had not been killed in Pakistan.[84] Nor did he die in February 1909.

> Geronimo was not killed in Pakistan. . . . He is alive in the single mother from Tahlequah . . . who talks to her kids in Indian because she won't give up . . . one . . . more . . . inch. . . .
> Geronimo did not die in Abbottabad. . . . He is alive in Sisseton . . . living in the elder who refuses to die . . . that fluent speaker that shows up every day . . . saving the language one story at a time. . . . He lives in the lawyer from Black River Falls . . . who beats them at their own game. . . . He is alive in the domestic violence victim in White Cloud . . . who decided to fight back.

Although they describe themselves as "a gaggle of Indians chock full of cynicism and splashed with a good dose of Indigenous satire," the 1491s had a serious message. Geronimo is "a college student in Lawrence," "a civil servant from Gila River," "a grant writer from Shiprock," "a language immersion teacher from Browning," and "the history teacher from Akwesasne . . . who knows that truth does not come in versions." Geronimo, in other words, is everywhere. He is a part of every Indigenous person who resists colonization. "We chase his legacy, not his truth," the poem concludes. "Neither will be caught, but one of them can be made up."

The message of "Geronimo E-KIA" resonates on many levels with that of *Re-Collecting Black Hawk*. Indeed, it is easy to imagine the military using Black Hawk as an enemy code name had it not already been assigned to a helicopter. Ironically, the Navy SEALs used two modified Black Hawk helicopters in their raid on bin Laden's compound in Abbottabad.[85] Similarly, it is not a stretch to imagine the 1491s producing another viral video featuring Black Hawk in place of Geronimo. Geronimo is Black Hawk. And vice versa. The 1491s poem "isn't about Geronimo" in the same way this book isn't about Black Hawk. Like Geronimo, Black Hawk is alive in Lawrence, Gila River, Shiprock, Browning, and Akwesasne. There are many Black Hawks and many Black Hawk Wars. The relevance of these particular histories reverberates far beyond the upper Midwest.

1.

We Are Still Here to Tell Their Stories and to Add Our Own

GEORGE THURMAN

Black Hawk is the name of a man whose life has achieved legendary, almost mythical, proportions in the 177 years since he last walked this earth. His name has come to stand for more than one person's identification—the mention of his name even now evokes a profusion of impression and emotion. Black Hawk was a fierce warrior who fought the American government and whose name has been given to the conflict described as a war in American history. Black Hawk was a leader who led women, children, and old people back to their cornfields at Saukenuk because they were starving. Black Hawk was a man who loved his people.

Black Hawk believed in the sovereign rights of his people and fought to defend them. He understood that the treaty ceding our homeland in Illinois was invalid because the signatories had no authority to make such agreements. He agreed to move to Iowa if the American government provided food to replace the crops that would be lost in our fields in Illinois. When the American government failed to honor its side of the agreement, he believed that rendered the agreement null and void and that he had every right to return home. His arguments would be compelling evidence in a modern courtroom.

Black Hawk was not the first to lead his people against the Americans but few others have so captured the enduring attention of not only his own people but also of the general population. He was the first Native American to tell his story to a young America, and through his published autobiography, *Life of Black Hawk*, he is still telling his story today.

A visitor to Sauk homelands in Illinois and Wisconsin finds the names of Black Hawk and his people on everything from golf courses to auto repair shops. Initially the nominal tie might have included knowledge of our history, an acknowledgment that we once lived in the area, but with so many entities bearing those names the reality of Black Hawk and the Sauk blurs and fades from history into mythology, where very real people become historical and now commercial icons.

The seed of the myth is truth. Black Hawk lived, and his people still live, maintaining our traditions and culture, our language and customs, the unique characteristics that make us a people. We are the Sac and Fox Nation in Oklahoma, the descendants of the people who followed Black Hawk and shared his convictions, instilling in the ensuing generations the beliefs that are still a part of our living identity. No one in our nation stands alone—we have our ancestors to guide us. We look to those who came before us, those who died for what they believed in or, if they survived the conflict, witnessed the loss of our homelands and the limitations of reservations or allotted lands.

Yet in the wake of such loss, we were never defeated as a people. Black Hawk never came to Indian Territory, now Oklahoma, but his fighting spirit survived with his people and arrived here with them. We are a nation within a nation. The elected leaders of the tribe more than thirty-five years ago selected an emblem for our tribal flag that pays homage to Black Hawk with the symbol of a hawk and his name above it. This honor indicates he is still a leader, and that we, as he did, will fight for our people. We have fought our battles not out in the fields or on waterways but in courtrooms to defend our right of governance and to protect our history, not only in the story of our people but also in the people themselves, the graves of our grandparents who were the very people Black Hawk also protected.

To say that Black Hawk still has relevance to the Sac and Fox implies a hold to the past, and that's true because we are all connected, a part of those who came before and holding on to what they taught us for those yet to come. However, our past is not a fixed point that grows further away with each new generation; instead, our past is like a bloodline, living, breathing, and growing as we grow.

Black Hawk's bloodline still lives in the tribe today. I make this statement as the principal chief of the Sac and Fox Nation, but I am also proud to say I am a descendant of Black Hawk, whose blood continues to flow into new generations in several families.

As principal chief, I am elected by the tribal membership who have entrusted me and anyone else who holds this and other elected positions to act in the best interests of the tribe. Our existence as a people is our inheritance and legacy from our ancestors, so to hold such positions is a sacred trust. We are here for the people because we are here by the people who have given us the privilege to serve them.

As a descendant, my perspective about Black Hawk is more personal. He is a very real part of what I bring to the Sac and Fox Nation as its chief and who I am as Sac and Fox. I have visited the places where he walked and could place my own footsteps where his had been. I stood on the banks of the Mississippi River at Bad Axe where 183 years ago I would have been a target for the guns and cannons just for being Sauk.

So many of our people died there. The massacre still echoes within us. It was a tragic ending.

But *I*, a member of that same tribe, stood there at the place of "ending" and saw my people of today make offerings at the riverside. Black Hawk fought so his

people could live, and there, where one might think it all ended for us, we stood, remembering our people in the way they left to us and that is uniquely ours.

Only a chapter closed in 1832. We are still here to tell their stories, our history, and to add our own, and we do so as Sac and Fox people.

2.
Iowa

CHIEF BLACKHAWK PORTER

In 1767, a great Sauk leader was born. His name meant "the black sparrow hawk."
He came to be known as Black Hawk.

Strong beliefs, independent thinking and an unwavering commitment to his
family and his people earned him a reputation as a man of integrity and courage.
In 1832, along with 1,200 of his people, Black Hawk was driven from his ancestral
home during a war that bears his name. We celebrate this Sauk leader and his
courage with our Chief BlackHawk Porter, the kind of beer that makes you say
Ma-ka-tai-she-kia-kiak [*sic*]!

TYRANENA BREWING CO., Lake Mills, Wisconsin, 2015

Lake View, IA

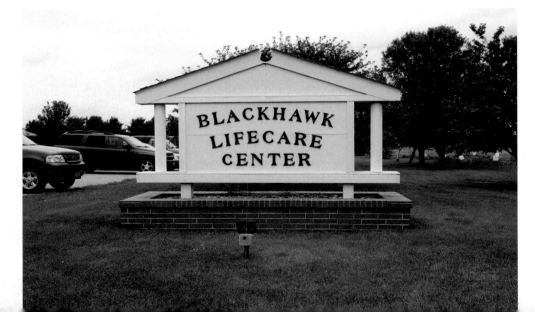

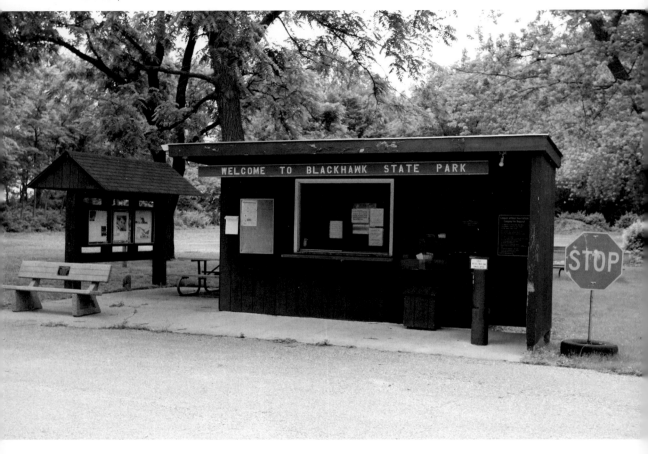

SPEAK YOUR PIECE: FIXING OURSELVES

Today I awoke to find that another white journalist has figured out that the United States was built on the death of its indigenous peoples and the theft of their lands.

He is sorry.

He cries and he wants to help the Indians.

He has beautiful poignant photos of many folks on Pine Ridge.

He, of course, chose to photograph the poorest, the intoxicated, the gang members and (God help me if I see another Hollywood picture of an angry, young Lakota guy looking attractive on horseback I may gag while ripping my hair out) many Indians on horses. How they love, love to put us, especially Plains Indians, on horses.

This young white journalist . . . comes cloaked in the righteous DIY nation of social media. But he still comes like all the others.

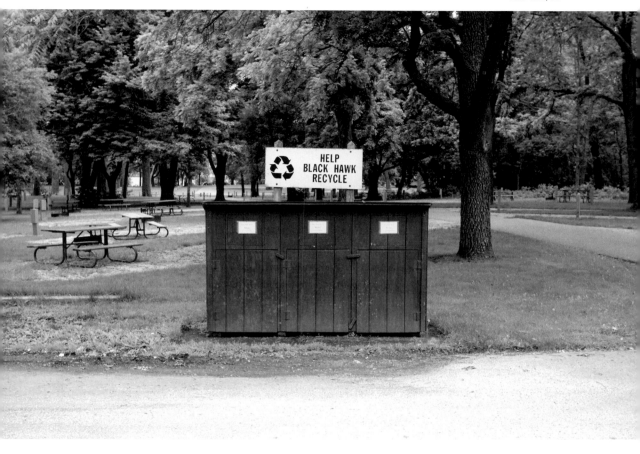

He comes with the assumption that he and other white folks have the tools that we want to help ourselves. He shows white America the plight of the American Indian and asks them to join him in helping us.

I really want to tell [him] that American Indians have had just about all the help that we can stand from white America.

Maybe the tenor of this new wave of white guilt and recognition of our "plight" will motivate people to at least seek a basic understanding of the history and current status of American Indians. . . .

The bottom line, though, is that Indians need to fix ourselves on our own terms.

They are the only terms anybody knows.

MARY ANNETTE PEMBER, *Daily Yonder*, 2011

THE BLACK HAWK WAR IN RETROSPECT

There are no heroes who deserve our thanks or honor for the parts they played in that campaign of 1832. At best, the Black Hawk War was a sorry combination of mistakes, bungling, and bad luck. At its worst, it illustrated many of the darker strains in the story of frontier settlement which most twentieth-century Americans neither remember nor care to understand. But the factors that brought about the war should not be forgotten. One was a lack of concern about or outright rejection of fair treatment for minority peoples. An abiding ethnocentrism showed itself in the whites' self-righteous certainty that the Indians had to move aside for "civilization." Political opportunism displayed by frontier officials made matters worse rather than easing tensions or seeking peaceful solutions. Finally, the Black Hawk War is a compelling, and by no means unique, lesson in America's historic willingness to fasten upon military solutions to difficult political and diplomatic questions. It is sobering to reflect that Americans had had two hundred years of frontier experience in which to develop attitudes and courses of action by the time Black Hawk and his band of followers "invaded" Illinois. We might well ask ourselves if, in the ensuing one hundred and fifty years, we have learned anything that might improve our capacity to respond to similar emergencies in other, less warlike ways.

ROGER L. NICHOLS, *Wisconsin Magazine of History*, 1982

THE BIOPOLITICS OF SETTLER SEXUALITY

The late nineteenth and early twentieth centuries saw institutions and discourses of modern sexuality proliferate along with the "closure" of the frontier as a central feature of national consciousness in a white settler society. . . . Thus, far from reflecting the finality of conquest, this period was one of tense negotiations of active and contested settlement. Any iteration of modern sexuality in this time that placed Native people in the past knew itself to be a contingent claim that remained open to challenge. Given these conditions, modern sexuality was not a product of settler colonialism, as if it came into being in the United States after settlement. Rather, modern sexuality became a method to produce settler colonialism, and settler subjects, by facilitating ongoing conquest and naturalizing its effects.

SCOTT LAURIA MORGENSEN, *Spaces Between Us*, 2011

CHIEF BLACK HAWK STATUE

A statue of the great Sac Indian, Chief Black Hawk was sculpted in 1934 by Harry Stinson, a participant in the CWA [Civil Works Administration] Arts program under the direction of Grant Wood. This eleven foot tall statue sits on the north edge of Camp Crescent where he looks over the lake that bears his name. . . . A university student was used as a model for the body of Black Hawk and Moses Slick, a Tama Indian, was used as the model for the face. . . .

As in the days when the Indians inhabited parts of this area, the chief originally overlooked the lake at its edge. But as a result of a 1930s dredging project, the chief currently overlooks the 1st spoil site now known as Camp Crescent.

LAKE VIEW, IOWA, "Home of Beautiful Black Hawk Lake," 2012

A SALUTE TO THE RED, WHITE & BLUE

Sunday, July 18th
9:30 a.m.—Ecumenical Church Service—West Stone Pier
*Noon—Beer Garden & Local Stands Open, Art in the Park
*Noon—Mud Volleyball
3:00 p.m.—T. Texas Terry—Cowboy Hypnotist (On Stage)
4:30 p.m.—Little Miss Black Hawk Pageant
7:00 p.m.—T. Texas Terry—Cowboy Hypnotist (On Stage)
10:00 p.m.—Fireworks over the Lake
*After Fireworks Cash Drawing

LAKE VIEW CARNIVAL COMMITTEE,
"57th Annual Black Hawk Lake Summer
Water Carnival Program," 2010

WATER FINALLY FLOWS THROUGH SAC AND FOX RESERVATION

A precedent-setting settlement between a major corporation and an American Indian tribe ended in a win-win situation.

The result is an abundance of quality drinking water for the Sac and Fox Reservation in Oklahoma after it has suffered through four decades of polluted groundwater.

"This is truly an historic event for the Nation," said Dora Young, principal chief of the Sac and Fox Nation, in a prepared statement. "Having our own water supply for the first time in 40 years opens the door to our moving forward with plans to develop the Reservation."

DAVID MELMER, *Indian Country Today*, 1997

INDIAN TRIBE WORRIES PIPELINE WILL DISTURB GRAVES

As President Barack Obama pushes to fast-track an oil pipeline from Oklahoma south to the Gulf Coast, an American Indian tribe that calls the oil hub home worries the route might disrupt sacred sites holding the unmarked graves of their ancestors.

Sac and Fox Nation Chief George Thurman plans to voice his concerns this week in Washington. He said he fears workers placing the 485-mile Keystone XL pipeline that would run from Cushing to refineries on Texas' Gulf Coast could disturb holy ground without consideration of the tribe. He and another tribe member say the pipeline's route travels through areas where unmarked graves are likely buried.

"We've been here 171 years," said Sandra Massey, the Sac and Fox Nation's historic preservation officer. "We've been living and dying here. We are all over."

Obama announced last week in Oklahoma that he was directing federal agencies to expedite the southern segment of the Keystone XL line, removing a critical bottleneck in the country's oil transportation system. The full, 1,700-mile Keystone pipeline, which would run from Canada to the Gulf Coast, became a political flashpoint late last year when congressional Republicans wrote a provision forcing Obama to make a decision, and environmental groups waged a campaign to kill the project.

KATIE FRETLAND, Associated Press, 2012

THE TERRITORIALITY OF TRADITION

In a telling statement very near the end of the narrative [of *The Life of Black Hawk, or Ma-ka-tai-me-she-kia-kiak*], Black Hawk notes, "my people have started to their hunting grounds, and I am anxious to follow them," suggesting that the practices and forms of collective self-identification targeted by federal Indian law and the civilization program have not disappeared in the wake of removal. Given the importance of the hunting grounds in both the narrative and U.S. policy, the reference to hunting here signals the continuance of native networks despite imperial efforts to break them up into modular geopolitical units to suit U.S. jurisdictional mappings and territorial claims. Rather than a "middle ground," what emerges in the *Life* is an antagonism in which existing shared modes of trade, subsistence, diplomacy, leadership, land tenure, and warfare need to be displaced in order to accommodate white settlement and associated assertions of the insulated coherence of U.S. domestic space. If the texts of Cherokee nationalism serve as one kind of response to the U.S. effort to produce forms of native political subjectivity that validate its policy, Black Hawk's narrative offers another. Less occupying an imposed identity to oppositional ends, it refuses the structural premises of such identity, deconstructing or negating it in ways that, in Dale Turner's terms, seek to "open up the physical and intellectual space for Aboriginal voices to participate in the legal and political practices of the state."

The text documents the limits and lacunae of the archive of imperial governance, testifying to the persistence of a countervailing conception of native collectivity and occupancy despite its being rendered subaltern in U.S. law and policy. As Gerald Vizenor observes, "the stories that turn tribes tragic are not their own stories." Black Hawk's story ultimately is not about disappearance but survival. It draws attention to traditional (regional) social formations alternately ignored and assaulted by the United States and insists on the meaninglessness of a rhetoric of Indian assent in the absence of a substantive reckoning with the self-understandings and lived topographies of native peoples.

MARK RIFKIN, *Manifesting America*, 2009

PAINT THE TOWN

The city allowed [the University of Iowa professor Donna] Friedman and her students to move forward with some murals downtown and one of the walls chosen was the West-facing wall of the still-standing Paul-Helen building. . . . The design chosen was of the Sac war chief, Black Hawk. . . .

In the mural Black Hawk stood, larger than life, in a formal, three quarters stance, looking out over downtown Iowa City, wearing his regalia and holding his symbols of authority. In the style of M. C. Escher, the atmospheric background composed of his outlined shape morphed into hawks soaring up to the top of the building as though riding thermals into the sky. It was a dignified and proud portrait.

Free Environment, a citizens' group formed at this time to advocate for public space, said of the Black Hawk mural that it "reminds us that the guardians of this land who came before us treated it with more respect then we do." . . .

Sometime in the '80s the mural was removed and the building remodeled. Nothing remains of the Black Hawk mural.

DEANNE WORTMAN, *Little Village*, 2010

In the days when prairies stretched from river to river across the expanse of what we now call Iowa, bison disturbance was essential to the health of the ecosystem. As the herds thundered across the grasslands and created wallows—depressions in the ground in which the animals rolled to cover themselves in mud and dirt— like a plow, they brought buried soil to the surface, leading to greater plant species diversity and ecosystem health. Recently, construction work on Iowa City's Pedestrian Mall unearthed three long-forgotten bison, and from their re-appearance lots of conversation has sprouted about our community, its history and its future.

Construction fences went up around the Black Hawk Mini-Park area of the downtown Ped Mall several weeks ago . . . As the nondescript Wells Fargo building came down, the wall of an adjacent building was revealed. And on that wall was a long-forgotten mural panel of three bison, part of one of Iowa City's great historical efforts in public art. This was a remnant of the large Chief Black Hawk mural entitled "Black Hawk's Dream," . . . [which] disappeared in the 1980s when a new entrance and new windows were installed on that side of the building. This "bison disturbance" has dredged up a lot of welcome interest in local history and public art.

THOMAS DEAN, *Little Village*, 2012

(OPPOSITE + ABOVE) Iowa City, IA

MESKWAKI TELL THEIR OWN STORY WITH MUSEUM

No one can quite tell the story of the Meskwaki tribe like the people themselves.

And their story unfolds at the museum at the settlement.

The museum opened last year and has been a popular place for those who want to learn more about the history of the Meskwaki people and the Sac & Fox Tribe.

Johnathan Buffalo, historical preservation director with Meskwaki, said the museum has been well-received and he finds great joy in sharing the history of the tribe with the public.

The museum features artifacts, photographs, maps and enough historical items that Buffalo said most people leave with their brain full of information.

"There's a whole bunch of information packed into that little room," Buffalo said.

There are tribal drums, headdresses, clothing and other artifacts, but the beaded work appears to get the most attention at the museum.

"I think people see the beauty in the work," Buffalo said.

ANDREW POTTER, *Times-Republican*, 2012

Iowa City, IA

HOBBY HITCHING POST

If on a Saturday afternoon you're ever in the vicinity of the Quad Cities . . . and you see 20 or more automobiles traveling in convoy fashion, it's likely to be members of the Black Hawk Hiking Club starting out on one of their regular bi-weekly outings. And even if it's raining or snowing, it might still be our auto caravan of hikers, for never during the 29 years that the Black Hawk Hiking Club has been organized have we cancelled a planned hike because of bad weather. . . .

Our hikes have taken us to many of the beautiful forest preserves in our territory, the lovely wooded areas in the Rock River valley, the Indian trails in our state parks, and several places of national historic interest, such as the birthplace of "Buffalo Bill" Cody.

JOHN H. HAUBERG, *Rotarian*, 1950

FEW ARTIFACTS, LETTERS REMAIN FROM DARK PART OF QUAD-CITY HISTORY

Someday when you're traveling along Davenport's East River Drive in the area of McClellan Heights, turn up McClellan Boulevard and imagine how the area might have looked 150 years ago . . .

That is when a steamboat came down the Mississippi River from Minnesota and docked nearby, unloading about 265 male Dakota Sioux prisoners, 16 Dakota women and two children.

There was no River Drive and no homes. The hilly, woodsy area of McClellan was a Civil War training camp, and the Dakota, chained together in pairs, were marched up the hill, guarded on each side by Union soldiers, to begin what for many would be three years of imprisonment.

By one estimate, about 120 prisoners would die here, victims of cold, hunger and diseases such as smallpox.

Today, there is virtually no public memory of the prison in the Quad-City area.
. . .

Memories are different, however, among the Dakota.

ALMA GAUL, *Quad-City Times*, 2013

PROM—BRIGHT LIGHTS, BIG CITY

The Meskwaki High School Prom will be held on Friday, May 10th. This year the Prom will be held in Marshalltown at the Best Western across from McDonalds. Due to time constraints, there will be no promenade.

The schedule is as follows:

6:30 p.m.—Meet at the school to load bus to Marshalltown. ALL students attending the Prom must ride the bus to and from the dance.

6:40 p.m.—Bus leaves school to Marshalltown.

7:00 p.m.—Dinner served. Menu includes: Chicken, potato, and vegetable.

8:00 p.m.—Prom begins

12:30 a.m.—Prom ends. Load busses to return to school.

1:00 a.m.—Arrive at school. Please make sure your student has a ride home from the school.

MESKWAKI SETTLEMENT SCHOOL, *Meskwaki Settlement School Newsletter*, 2013

NARRATIVES ON POSTINDIAN SURVIVANCE

Manifest Destiny would cause the death of millions of tribal people from massacres, diseases and the loneliness of reservations. Entire cultures have been terminated in the course of nationalism. These histories are now the simulations of dominance, the causes of the conditions that have become manifest manners in literature. The postindian simulations are the core of survivance, the new sources of tribal courage. The simulations of manifest manners are the continuance of the surveillance and domination of the tribes in literature.

Gerald Vizenor, *Manifest Manners*, 1994

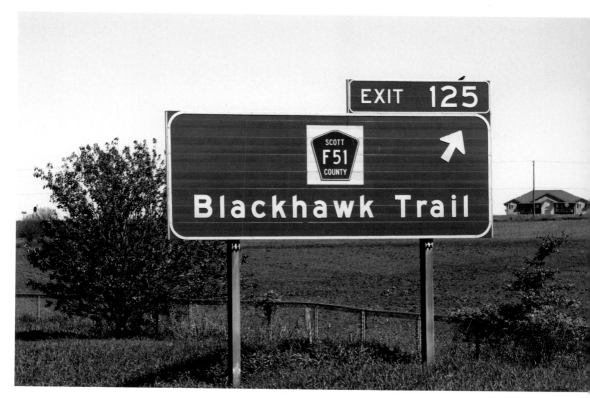

Davenport, IA

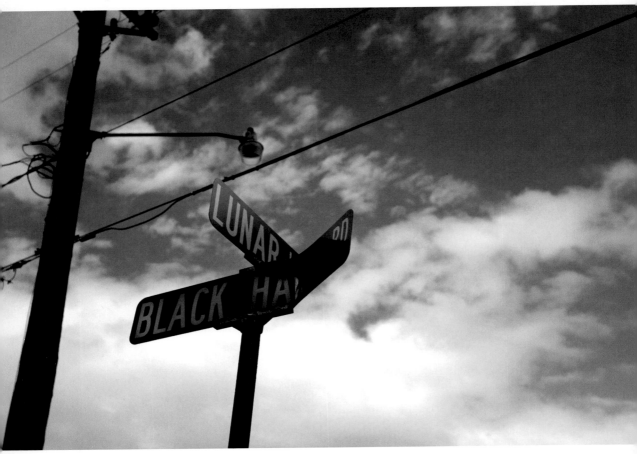

MAKING THE MODERN MESKWAKI NATION

Many Meskwaki never left Iowa for Kansas. They camped in woods along river-banks, hunted, and sometimes even begged for food to get by. Of those who did move west, many drifted back for a variety of reasons, especially dislike of an effort by the federal government to divide their reservation land into individual home-steads for families to farm. Each spring federal troops would try to round up all the Indians they could find in Iowa and force them back to Kansas. The spectacle aroused the sympathy of white settlers in the area, who petitioned the governor of Iowa to allow them to stay. Gov. James W. Grimes agreed, and on July 13, 1856, the Iowa Legislature approved a measure permitting the Meskwaki to stay in Iowa and asking the War Department to pay them their share of the Sac and Fox annuities.

Waterloo, IA

Using money saved from the annuities they received in Kansas, Meskwaki representatives on July 13, 1857, purchased 80 acres of land along the Iowa River for $1,000 and took up residence there. The governor of Iowa, not the federal government, held the land in trust for them. The bureau, in fact, refused to recognize the Meskwaki as a distinct tribe and paid their share of annuities to the Sac in Kansas. Finally, in 1866, the federal government agreed to begin paying annuities to the Meskwaki but recognized them only as a band of the Sac and Fox, rather than as the Meskwaki. The Indian service assigned agents to the Meskwaki, but they usually were local people who did little but pay out the annuities. In 1873 the government appointed a man to teach the Meskwaki how to farm, and in 1876 it opened a school. Few Meskwaki showed interest in such innovations. Gradually, the tribe bought more land until the settlement reached 3,253 acres in 1915. The community celebrates the initial land purchase each July 13 as a holiday, often holding Proclamation Day ceremonies, to which heirs of the white family who sold them the first 80 acres of land are invited. The Meskwaki and their land remained under state jurisdiction until the end of the nineteenth century, when Indian rights groups successfully pushed for the transfer of jurisdiction to the federal government. That was completed in 1908.

JUDITH M. DAUBENMIER, *The Meskwaki and Anthropologists*, 2008

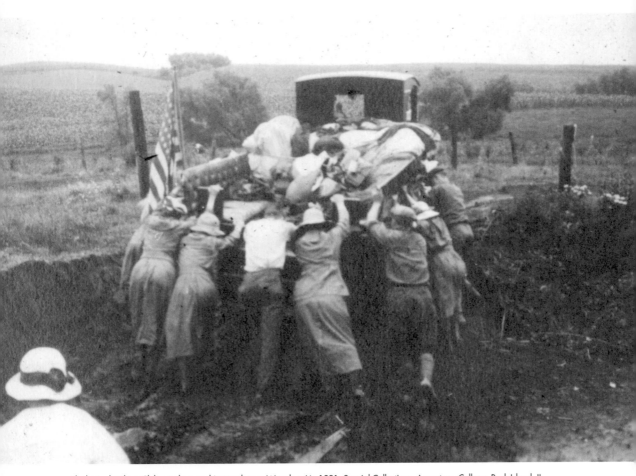

Black Hawk Hiking Club members pushing truck near Waterloo, IA, 1921. Special Collections, Augustana College, Rock Island, IL

Symbolically, they stand close together
as they have done throughout their lives
on Black Eagle Child Reserve. They peer nervously
into the shaded bigtop tent where the tribal
celebration is about to take place:
Mary Two Red Foot in her brilliant
cotton-white skirt has her one year old,
big-boned son, Robert No Body, slung
on her back in a green yarn-fringed shawl.

In the choking humidity, the serrated trim
of the tent vibrates as a concert bass drum
is being tuned. Mary squints in the harsh
daylight and begins talking: "Agwi ma ka ski
bi da bi ya nin ni sha na ki sha bi wa ke.
I can't see in there, but they're already
seated." All she can make out are silhouettes
of singers on bales of hay.

Her younger half-sister, Doreen Half Elk,
with unseen hands on her hips leans over
and listens intently. In the heat all Doreen
wishes to show is her face. A black and gray-
striped shawl covers her body and head.
Even her feet and shoes are in the dark
shade of her ruffled skirt. She's a statue
whose base is the earth.

Beside them, sitting in a semi-circle
on the ground, four white men in neckties,
suspenders and strawhats are having lunch.
The baby, No Body, looks down at the men
who are nearly transparent in the hot,
July 15, 1932 sun.

RAY A. YOUNG BEAR, *Virginia Quarterly Review*, 1988

Histories of conquest are stories of disjuncture, and the great curse of Euro-American history is its shallowness, its failure to take root in a place so different from its place of origin. There are other countries which have absorbed their conquerors, but the States can't absorb an immigrant population which can't remember where it is or who preceded it to the place. It is the conquerors and invaders, not the conquered or invaded, who have lost their roots, their ties, their sense of place. Amnesia is one potent means of overcoming the traumatic dislocation of the conqueror: Rather than lacking a personal past in a particular place, the amnesiac lacks the past. Invention is the other means, the means by which a place is covered up with decorative motifs and fantasies; and for the U.S. the Bible has provided many of the principle embroideries scattered across the continent that was so blank to its invaders. Pretending that the place is somewhere else, whether it means naming it Zion or "making the desert bloom" by redistributing fabulous quantities of water, has been one way of coping. But the inability to remember the past becomes the inability to imagine the future, and it is not surprising that a country with a ten- or hundred-year past can't make wise decisions about the long-term future. There are other maps.

REBECCA SOLNIT, *Savage Dreams*, 1994

Waterloo, IA

MESKWAKI (SAC AND FOX TRIBE OF THE MISSISSIPPI), IOWA

Waterloo recreation officials aren't sure they want to take the Meskwaki up on an offer of free scorecards because of worries golfers might get the wrong idea. The tribe offered to give the city scorecards for municipal golf courses if the tribe's logo is printed on them. "I have a concern that with the Meskwaki logo on there, people will think that they have something to do with the upkeep of the courses," said commission member Kim Lozier. Commission member Esther McGuire is concerned that it may appear the city is endorsing gambling because the tribe operates a casino near Tama. Voters in Black Hawk County twice rejected referenda in 1994 to allow slot machines at Waterloo Greyhound Park. Leisure Services director Paul Huting said the city takes bids for printing scorecards for the three city-owned courses, which cost about $4,000 annually. The Meskwakis own their own print shop. Commission member Bob Molinaro supported the idea, as long as it's done "tastefully." Commissioners voted to have the tribe print up a sample card. The proposal will be weighed against bids received by the next meeting in August.

"SAC AND FOX TRIBE OF THE MISSISSIPPI IN IOWA,"
Indian Country Today, 2000

RETURNING LIFEWAYS OF NATIVE AMERICA

Returning to the belief systems upon which our lifeways are based forms the essence of a powerful movement which can bring about healing and empowerment of Native individuals, communities, and nations. Native people are revitalizing traditional governmental, educational, economic, spiritual, and socio-cultural systems; protecting existing ways of life, homelands, environment, and rights; reinstating traditional land management and use practices; reintroducing indigenous species of plants and animals and traditional agriculture and foods; developing language and cultural immersion projects; instituting community healing projects which have significantly reduced alcohol and drug use and suicides; adapting Native principles to tribal judicial, environmental, and ethical laws; and exploring and developing solutions for Native challenges through collaborative efforts among the diversity of Native peoples.

Despite the overwhelming obstacles of environmental degradation, depriva-
tion of land and resource rights, seizure of tribal homelands, and internalized
oppression, many still stand firm in their lifeways and continue to speak their
languages, practice their ceremonies, and apply traditional knowledge in daily life.
By the tens, hundreds and thousands, Native traditionalists have stood in the way
of bulldozers, cattle chutes, and nuclear waste dumps to preserve and protect a
way of life that for too many has become nothing but a nostalgia-laden memory.
For those who live the ways of their people, traditions are part of living reality.
Practicing and teaching these traditions is vital to the survival of the Native na-
tions, for in them are found the collective memory and knowledge of our ances-
tors which form the essence of our identities and strength.

DAGMAR THORPE, *People of the Seventh Fire*, 1996

THE RISE OF A WOMEN'S MOVEMENT FOR EQUAL RIGHTS

In 1998, in response to the tribal enrollment and housing policies, approximately 30 Mesquaki women formed a group called the Lost Nation. Most of these women were enrolled, full-blood Mesquakis with unenrolled mixed-blood children. In addition, a number of older enrolled women, who are married to enrolled Mesquaki males, supported the group. The Lost Nation group has been urging the tribal council to find a way around the patrilineal descent rule. They contend that the tribe cannot promote cultural survival by disenfranchising women, the primary bearers of Mesquaki language and culture. They point out that the tribal council is actually rewarding males for marrying White women who do not bring up their children in the Indian way. In sharp contrast, many Mesquaki women with mixed-blood children bring them to the traditional ceremonies and enroll them in the tribal school. . . .

Many Mesquaki brothers, fathers, and uncles are searching for ways to help these women without abandoning the principle of patrilineal enrollment. But most traditionalists still say, "These women know the rule. It is very clear. If you have children with outsiders, these children can never be enrolled because their father is not Mesquaki." Ironically, traditionalists now find themselves defending patrilineal descent at the cost of eroding a tribal tradition of generosity and communalism. Consequently, they are left with the anguished realization that "we are becoming like the Whiteman, denying our sisters and daughters what we keep for ourselves."

DOUGLAS FOLEY, *"The Heartland Chronicles*, Revisited," 2005

A series of staccato whistles pierce the air, followed by the crash of pad against plastic-covered pad. Coaches' orders narrate the scene.

"Ball! Ball! Ball! Ball!"

These sounds weren't heard a year ago on the practice fields by the Meskwaki Settlement School. But now they're commonplace. Football season has begun in earnest for the Warriors.

The school had a sharing agreement for sports with the South Tama School District prior to this year. It has lapsed, and the school has formed its first football team.

"I was happy they were starting the program," said Vernon Lasley, a senior who plays nose tackle and center for the team.

In August, school officials celebrated the grand opening of the Meskwaki High School. Students must derive a quarter of their heritage from the Sac and Fox Tribe of the Mississippi in Iowa. The high school has 105 students enrolled this year, more than double the population the year before, said Superintendent Jerry Stephens.

A team on the settlement has added meaning for the players, said head coach Todd Dale, who also coached football for 12 years at South Tama.

"They're doing this not for just themselves," Dale said. "They're doing it for their community."

JOSH NELSON, *Waterloo-Cedar Falls Courier,* 2009

Waterloo, IA

As a boy, [Lew] Wallace had been disappointed that the Black Hawk War had ended before his father's militia could fight. As an adult, Wallace had felt frustrated that his infantry's company hadn't participated in any significant action in the Mexican War. In the Civil War, General Ulysses S. Grant had scapegoated and martyred Wallace's troops, blaming them for arriving at Shiloh too late to help the Union side win. Later, during the range war and Indian wars in Lincoln County, New Mexico, Wallace had pleaded in vain for more assistance from the U.S. cavalry, believing that military action would have helped restore rule. Wallace's military career, in other words, had been marked by disappointment, postponement, and failure. But his excursion into literature yielded him an escape from the frustration that he had encountered in life. . . .

Ben-Hur is a western in toga, in drag. Wallace used the conflict that motivated many formula westerns not only to work out issues that concerned the West as a region but to explicate matters that affected the U.S. as a whole. The Mexican War and the Civil War—which dealt with issues of national priority, such as sovereignty, conquest, and race—were as influential for Wallace in the process of writing *Ben-Hur* as were matters of local priority: the Black Hawk War, the removal of the southwest Apaches and Navajo, and the resolution of range wars in Lincoln County, New Mexico. . . . *Ben-Hur* contemplates imperialistic U.S. acts of aggression by narrating the historically and geographically distanced encounters between Rome and Jerusalem during the dawning of a new Christian age.

BLAKE ALLMENDINGER, in *Over the Edge*, 1999

(ABOVE + OPPOSITE) Waterloo, IA

NATIVE LANGUAGE REVITALIZATION CAMPAIGN

Cultural Survival and the Sauk Language Department, based at the Sac and Fox Nation of Oklahoma, sent our master-apprentice team on a week-long language immersion field trip to their sister language community, the Meskwaki Nation, based in Tama, Iowa. Team members return from Iowa today, and have spent over 8 hours each day during the past week communicating exclusively in the Sauk/ Meskwaki language. They also participated in a language conference designed for local Meskwaki community members to set priorities for long-term language revitalization efforts.

The Meskwaki Nation (also known as the Sac and Fox of the Mississippi in Iowa) and the Sac and Fox Nation of Oklahoma, are politically distinct communities today but share close ancestral and linguistic ties, and this marked the second language immersion visit by the Sauk master-apprentice team to the Meskwaki community. While the Sauk language community in Oklahoma has dwindled to a handful of elderly first-language speakers who are working with dedicated corps of language apprentices over a three-year period, the Meskwaki community has hundreds of first- and second-language speakers throughout its adult population; however, a recent language survey conducted by their Language Preservation Office found very few speakers among those in their 40s and younger. The Sauk Language Department in Oklahoma is on-track to open a preschool immersion program in 2012 (to be staffed by the current language apprentices) and shared their language revitalization planning approaches with the Meskwaki community during their visit in Tama.

"FALL NATIVE LANGUAGE SUMMITS," *Cultural Survival*, 2010

(ABOVE + OPPOSITE) Waterloo, IA

NEW SCHOOL FOR MESKWAKI

The grand opening of the new Meskwaki High School marked "one of the biggest days in our history—bigger than the opening of the casino," said Jon Papakee, vice chairman of the Meskwaki Nation Tribal Council.

"It ranks at the top. It will last longer and do more good" than the Meskwaki Bingo Casino/Hotel, whose proceeds paid most of the facility's $23 million cost, said Tribal Council member Don Wanatee.

Former Tribal Council Chairman Homer Bear Jr., who spoke his invocation in the Meskwaki language, said the school fulfills the dreams of tribal elders, who have long sought "to have a hand in" the cultural and academic education of Meskwaki youth.

Classes in the 108,000-square-foot facility began Aug. 19 with enrollment continuing to mount. "We don't know how many students we have. We're still entering them into the computer" as more transfer from the South Tama public schools, said Superintendent Jerry Stephens.

He said enrollment in the school has more than doubled since last year to about 325 students, with about 125 in grades 7 through 12. The school could easily accommodate all 450 eligible students, and "more of them will come when they see the facility and the education it provides." . . .

Papakee said the school will teach students their Meskwaki culture and language and reinforce their identity as members of the Meskwaki Nation.

"It symbolizes our achievement as a nation, our endurance and our destiny."

ORLAN LOVE, *Gazette*, 2009

Blackbird Bend is a thumb of land along the Missouri River. Only God knows who owns it; then again, maybe not. If the land could speak, what would it say? That once it was inhabited by the Omaha Indians. Then the Missouri changed course and land that had been west of the river ended up on the eastern bank, several thousand acres gone from the Indians' Nebraska reservation. Sometime early in the twentieth century it came into the hands of white owners in Iowa. Tiring of white ownership, however, the Indians decided to reclaim the land in 1973. About twenty of them trudged to Blackbird Bend in sneakers and blue jeans at about the time the Lakota, not too far away, were winding up their occupation of Wounded Knee. But no one remembers Blackbird Bend, except the Omaha Indians, of course. In 1975, the Indians occupied the land for a second time. Then the lawsuits began, a decade and a half of court appearances, motions, briefs, trial, and appeal. And still the most difficult question you can ask anyone along this brief stretch of Missouri Valley is only four words long: Who owns Blackbird Bend?

THEODORE STEINBERG, *Slide Mountain, or the Folly of Owning Nature*, 1995

Cedar Falls, IA

Many people wonder about the names of the Meskwaki Casino's new Convention Center meeting rooms: Meskwaki, Outagami, Fox, Renard, and Red Earth. The easy answer is that they are all names this tribe has been known by throughout history. If you do any historical research on the Tribe, make sure you remember those five rooms because chances are good you'll happen to come across all of the terms in multiple translations and variable spellings. . . . Every single tribe had/has its own name in its own language that it calls itself. In our tribe's case, the root words in our own language is Mesk (red) and aki (earth), which becomes Meskwaki, literally translating in the English language to Red Earth. This name was given to us by our Creator. Then there are all the other names that other Indian tribes and European civilizations have called us in their own language over thousands of years that simply reflected how they saw us or felt about us at the time of initial meeting.

Examples of other names we've been called by other American Indian tribes include:

- Outagami—The Ojibwa tribe's term that they called us, meaning "People of the Other Shore." At one time the Ojibwa lived on the northern shore of Lake Superior and the Meskwaki lived on the southern shore. Come to think of it, no matter which shore we occupied, the Ojibwas always seemed to prefer being on the opposite shore from us.

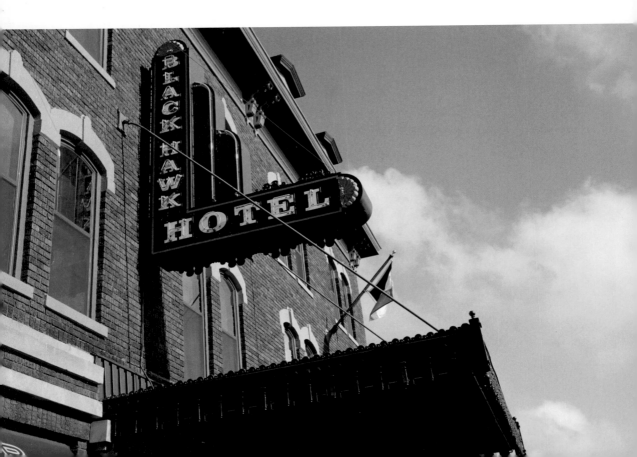

- Ca ge wa—The Osage tribe's term that they called us, meaning "Hard to Kill People." It's actually kind of cool.
- To che wah coo—The Arikara tribe's name for us. We have no idea what it means.
- Beshde'ke—The Dakota tribe's name for us. We're pretty sure we don't want to know what it means.
- Skenchioronon—The Neutral/Huron tribe called us this in 1640 when we lived in the Michigan area.

The first Europeans our tribe came in contact with were the French, not the English, who decided to identify us in the French language as Les Renards, which means "The Foxes" in the French language. Much of our early history was written by the French in French, so historical documents of that era record us as the Renards, not the Meskwakis. Later the British came along and just borrowed the same French description except they said it in their own language, referring to us simply as the Fox Tribe. The Spanish eventually showed up and called us the Rencor, which is either a corruption of the French word "renard" or it means what it really means in the Spanish language: "resentment" . . . a curious and somewhat amusing description that makes us wonder how our first meeting with the Spanish went those many centuries ago.

JOHNATHAN BUFFALO, *Meskwaki Nation Times*, 2007

SEXUAL VIOLENCE AND AMERICAN INDIAN GENOCIDE

On reservations, American Indians have a life expectancy of 47 years. The tuberculosis rate for Natives is 533 percent higher than the national average; the accident mortality rate 425 percent higher; the infant mortality rate 81 percent higher; the sudden infant death syndrome rate 310 percent higher; the alcoholism rate 579 percent higher; the diabetes rate 249 percent higher; and the suicide rate 190 percent higher than the national average.

American Indian women are twice as likely to be victimized by violent crime as women or men of any other ethnic group. In addition, 60 percent of the perpetrators of violence against American Indian women are white.

Indian women suffer death rates twice as high as any other women in this country from domestic violence. Native people are per capita the most arrested, most incarcerated, and most victimized by police brutality of any ethnic group in the country.

ANDREA SMITH, *Conquest*, 2005

OCTOBER 2006—ERIKA LENI PAYTON

Erika Payton is Meskwaki—Sac & Fox of the Mississippi in Iowa (Bear Clan). She graduated from Oklahoma State University with a Bachelors Degree in Apparel Design and Production and a minor in Apparel Merchandising. Erika enjoys traveling, powwows, water sports, volleyball and spending time with her husband and new baby son. Her future plans include opening her own boutique that will feature her own designs and creations.

REZ DOG CLOTHING COMPANY,
American Indian Beauties, 2006

Sports legend Jim Thorpe, Sac and Fox, won gold medals in the ten-event Olympic decathlon and five-event pentathlon at the 1912 Olympics in Sweden, a feat that has never been duplicated.

A year later he was stripped of his medals. Ugly politics played a big part in the Amateur Athlete Union's (AAU) decision to do this, according to his family. Thorpe had played semi-professional baseball in the summers of 1909 and 1910, earning about $2 a day, while a student at Carlisle Indian School. . . .

After strenuous efforts to restore Thorpe's honor, the family accepted the re-turn of the two Olympic gold medals at a ceremony during the 1984 Olympics in Los Angeles. Overlooked by the family were the gold medals that Thorpe won at the 1912 Amateur Athletic Union national championships in Boston, which at the time served as a qualifying meet for the Olympics.

On Saturday, March 1, 1997, Thorpe's national championship track and field medals were returned to Thorpe's children in a ceremony at the Lac Courte Oreilles Casino Convention Center, in Hayward, Wisconsin.

Jim Thorpe was just under 6 foot and weighed 179 pounds when he went to the Olympics. His sons share a striking resemblance to their father and inherited his physique. Hiram Thorpe, Jim's father, a direct descendent of the famous warrior Chief Black Hawk, was a great athlete. Jim once told a reporter, "My father was the undisputed champion in sprinting, wrestling, swimming, high jumping and horseback riding."

TRACE A. DEMEYER, *News from Indian Country*, 1997

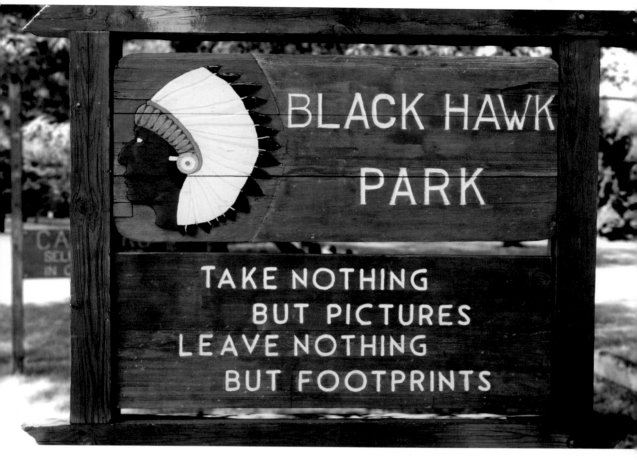

EULOGY FROM INDIAN COUNTRY

Thus conflict with stereotyped Indians could—indeed had to—become central to the American story, but flesh-and-blood Indian people and the histories they made for themselves could not. So, as White Americans wrote their nation's past, their greatest erasure of all was of memories of Indians who neither uncompromisingly resisted like the King Philip of their imagination nor wholeheartedly assimilated like the Pocahontas of their fantasies.

DANIEL K. RICHTER, *Facing East from Indian Country*, 2001

3.

They Don't Even Want Our Bones
An Interview with Johnathan Buffalo
Historic Preservation Officer
Meskwaki Nation

NICHOLAS A. BROWN

Items: 1
Date: 21-Aug-2016

Order # 113-0063007-9858654
Title # 000003541724

Qty **Re Collecting Black Hawk Landscape**

1 Brown, Nicholas A

9780822944379 002200
(Used, Hardcover, Burnside)
Received Date : 17-Jan-2016
Condition: Standard 002200
Aisle: 846EndCap Shelf Under:
Dept Cat: NATAM-NORTHEAST

Ship to: Shelby Christensen
 100 Daum Rm 5425.
 Iowa City, IA 52242.
 United States

Powell's
CITY OF BOOKS
2720 NW 29th Ave☐
Portland, OR 97210☐
United States☐
800-291-9676
100% SATISFACTION IS OUR GOAL
If you've received defective, damaged, or incorrectly shipped merchandise,
please contact customer service, and we'll make arrangements for its return. If
you're unhappy with your purchase for any reason, simply return the item in its
original condition within two weeks of receipt, and we'll credit your account for the
full amount of the item.

Nicholas A. Brown (NB): Could you situate the Black Hawk War, which is often described as the last Indian War east of the Mississippi River, in the larger context of the conquest of the United States?

Johnathan Buffalo (JB): Well, you have to remember: Europeans invaded. It was not a discovery. It was an invasion. And the problem was, there were already people here. Every time you invade a new land, you have to get rid of the Indigenous people—either push them out or kill them. And that starts war.

The first recognized Indian War in American history is King Phillip's War, which was in the 1680s. And then, from the 1680s to 1732, there's a whole series of Indian Wars to conquer the eastern half of the United States, with the Mississippi being the boundary: King Phillip's War, Little Turtle's War, Tecumseh's War, Pontiac's War, then the Black Hawk War. And all of those men had the same idea. They all wanted to form confederacies and said: "If we don't get together, we're going to be defeated piecemeal, so we have to be together." But by the time Black Hawk's war came, it was basically every tribe for themselves. That's why Black Hawk couldn't form a confederacy. After the Black Hawk War, basically, the eastern half is considered pacified and safe, except maybe a little uprising here and there in Wisconsin and Minnesota, but they weren't considered wars. They were considered nuisances.

After the Revolutionary War, the Americans claimed all land east of the Mississippi, and they were fighting all these tribes that less than a hundred years earlier were allied with the French against us. So when these tribes were fighting the Americans, we didn't feel an urge to run over there and help them. Individuals went, but tribally, we didn't join any confederacy. We stayed on the Mississippi, and each war brought the Americans closer, until they crossed the Illinois River and they came to our lands, and the result was the Treaty of 1804, which was signed by a Sauk band and one Meskwaki. It signed away Illinois and influenced

the Black Hawk War, because according to the treaty the Indians were supposed to remove by 1829. But that is also where the Meskwaki began a treaty relationship with the government. So as much as we hate the Treaty of 1804, we have to kind of accept it today because it gives us that federal status.

The treaty also made us know that these Americans weren't going away. The English, the French, even the Spanish all left. But we knew these Americans weren't going anywhere, and we knew they were very harsh. Our chiefs would go to Washington. They would be shown shipyards. They would be shown West Point. They were shown the might of the nation. So they came home and tried to explain what they saw, and they said: "We can't fight these people."

The only one who didn't go was Black Hawk. So in a way the only Americans he saw were these settlers. So when he crossed over the Mississippi he thought he was only dealing with a certain type. He didn't know the whole weight that was coming down. And that is why I think he should have been a little bit more cautious.

NB: *How did the Meskwaki come to be involved in the Black Hawk War, and what were the outcomes of it?*

JB: Well, it wasn't a traditional war, and we never considered it "our" war, even though individual Meskwakis might have joined Black Hawk. As a tribe, we were neutral. So technically it wasn't a war in the sense that the whole tribe was going. But if someone is shooting at you, then at some level it's a war. We understood there was a battle going on—they were trying to kill these people, trying really hard. And after the war, we lost land—we were punished, too, along with the neutral Sauk.

When Black Hawk crossed the Mississippi, he was not going to war. But the United States considered it an act of aggression. They had to portray Black Hawk as dangerous and threatening to Chicago. Chicago! [*Laughs*] Like we're going to threaten Chicago? It's like the old idea of the wagon train: the invader actually makes themselves into victims. The invader is always more dangerous than the invaded. But the invader has to feel like they're the victim. But nobody, no town got wiped out. Even though they might have been scared of this invasion in Chicago, Milwaukee, Madison, there's no way Black Hawk could threaten Chicago. But there's still this perception that there was real danger, but to us, the Black Hawk War was a massacre.

They had to raise the threat of Black Hawk to a high level to justify future treaties. The Americans wanted it to be a war because that way they could make the Black Hawk Purchase legal as a kind of reparations. Even today, the Americans still need it to be a war to justify the Treaty of 1832, the Second Black Hawk Purchase, and the Treaty of 1842, because they all are connected. After the Black Hawk War, the United States treated us as conquered people. And we were never conquered. We don't feel conquered. We were overwhelmed by events and people, but never conquered.

In many ways the Meskwaki Settlement is proof that the tribe was never conquered. Since the Black Hawk War resulted in the loss of all lands in Illinois and Iowa, how did the Meskwaki reclaim territory in Iowa?

JB: Well, even in the 1850s, there would have been no way. Hell could have even frozen over—there would have been no way to go back to Illinois. But Iowa—Iowa has always been special. And it's why we say that we're the luckiest people in the world because if you look at our history, we should have been extinct a hundred times. We're the luckiest people because we kept surviving.

When the Meskwaki left for Kansas, they just dissipated. Only a small group made it to Kansas. The rest were hiding out in Iowa. So actually, we were always in Iowa from the day we left. The phrase "coming back" from Kansas is kind of misleading because some people came back and some people never left. And some kept going back and forth. But we always had a presence in Iowa, from the very beginning.

So what does it mean to "come back"? By 1854, the tribe said: we want land. That's the difference. And that's what we mean when we say we came back. We had a purpose—which was to get land.

By the 1850s, Iowa, Minnesota, and Wisconsin were filling up with European Americans—these were mostly Germanic people, Danes, Norwegians, and Germans. Their instinct wasn't to shoot first, their instinct was, "Hey, Indians! I'll go talk to them!" We don't know his name but some white friend overheard our leaders talking about wanting land. And he said, "I know what you guys need." And the chief said, "What do we need?" And he said, "You guys need a deed." And the chief said: "Deed? Explain a deed." And he said: "Well, a deed is a piece of paper that says you own the land. And according to American tradition and American ideals, once you have a deed, nobody can take it away from you because you're a landowner. Even the government can't take it away from you, in theory." And the chief said: "That's what we need! We need a deed. And that way nobody can take it away."

So between 1854 and 1856, we became friendlier. Our chief said, "Okay, men, for God's sake don't kill any white people. Don't steal their horses or kill their cows or anything. Be nice." It was a PR campaign. We got friendlier. We courted the mayors. We went to towns and performed. That's when we got our reputation as "The Peaceful Meskwakis," and the petitions to let the Indians stay in the state started.

We looked all over central Iowa—Tama County, Johnson County, and Linn County, an area traditionally occupied by the Meskwaki. But we were looking for a particular spot. A little bit isolated. We just wanted to be left alone in some corner where somebody wouldn't always bump into us and get curious. Not a major roadway, no large population centers. It was important to be on the Iowa River, which had been our river since we came here. And Tama County offered us that spot.

In 1856, Iowa passed a law allowing us to remain there, and then the following year we purchased the first 80 acres. The governor was in favor of our buying land,

but Indians couldn't buy land, legally, so he agreed to hold it in trust. He wouldn't order a settler to sell the land, so we had to find someone willing to sell to us, and Isaac Butler was that man.

July 13 is the day the deed got recorded in the courthouse. In 1992 the tribal council made it an official tribal holiday: Proclamation Day. It's just like any state holiday or federal holiday where workers don't work.

NB: Could you describe the historic and contemporary relationship between the Meskwaki and the Sauk? They are distinct tribes but have been confederated for a long time, and, as you say, the Meskwaki were punished for the war right along with Black Hawk's band, even though they were officially neutral.

JB: The Sauk and Meskwaki have the same creation place. We're a little bit north, and they're a little bit south. When we were created, our creator gave us the name "Meskwaki"—"Red Earth People." And the same creator gave them their name "Asakiwaki," which means "Yellow Earth People."[1] So, we've been together for a long, long time, and we migrated at the same time. First, to Rhode Island, Massachusetts, then the New York area, then Ohio . . . Michigan, Wisconsin, then to Iowa, because we fought a war with the French in Wisconsin. So we've always been close. Every time you would find one, you would find the other.

But the social lifestyles are totally different between the Sauk and Meskwaki. The Sauk people have always been city Indians. They lived in huge towns. Thousands of people in a town, like Saginaw Bay in Michigan. And Rock Island is called Saginaw. What you call Oklahoma, we call Saginaw. Anywhere they lived is Sag-i-naw: Sauk Land. They've always lived in huge villages, while the Meskwaki lived in a cluster of smaller villages. And the basic thing you need to run a city is a strong central government. Sauk chiefs were very strong. Because the Meskwaki lived in semiautonomous villages, our government was kind of loose. Our chiefs were great orators because they had to convince, but if I was a Sauk chief, I could tell you what to do, and you'd go do it.

The official name for the tribes is Sac and Fox, which we got because the French met someone from the Fox clan and called us Renard, or Fox. When the English came in, they also called us Fox. When the Americans came, they were mostly interested in land treaties. With two tribes occupying the same land, they couldn't buy it from one tribe and not the other and they didn't want to pay double. So to solve that problem, the U.S. government made the Sac and Fox Tribe so they could make one treaty for the same lands—the Treaty of 1804. Some of the Sauk removed to Missouri in 1815 and are now in Kansas and Nebraska. Then, after the Black Hawk War, the rest of the Sauk and Meskwaki went on to Oklahoma. When we came back to Iowa in the 1850s, we became known as the Sac and Fox of the Mississippi in Iowa. When it has nothing to do with the government, we tend to use "Meskwaki," but if you have to deal with the government, then it is the Sac and Fox of the Mississippi in Iowa. The group in Oklahoma dropped the Mississippi part and is just the Sac and Fox Nation.

Presently, the relationship between the three tribes is more social, but we are still connected by our treaties as Sac and Fox people. If anything major happens with one tribe, there's political unity. And the biggest thing, recently, that causes political unity is NAGPRA—the Native American Graves Protection and Repatriation Act. In 1994, the three tribes made a NAGPRA confederacy to work with the federal law as a united Sac and Fox issue. We each have our own office, but the confederacy helps us coordinate so we can deal with the issue with a united front. Socially, we go to each other's powwows. We visit. We adopt each other ceremonially. And there's still that connection, even though it's a long-distance relationship. But there is still a relationship among the three groups.

NB: *The Meskwaki are one of the few tribes with a land base that is not a reservation. Most people aren't familiar with the difference between a settlement and a reservation or even that there is something other than a reservation. Could you explain what it means to call your land a settlement?*

JB: Well, we call our land a settlement because the federal government did not reserve it for our use, which is the definition of a reservation. Indians don't own the land; it's just reserved for their use. The difference for our lands is that we purchased them from the landowner who purchased the deed from the United States. We have the title, so that's why we call it a settlement, not a reservation. And we're proud we're not a reservation, but when we say we're not a reservation, people assume that we don't have federal rights. But since 1867 we have had federal reservation status, and it's still considered Indian Country.

Our relationship with Iowa has changed somewhat over the past 100 years. When they want to tax us, Iowa says, "You're not federal Indians! You don't live on a reservation." But whenever it's to their advantage, like in the 1940s and '50s when they didn't want to give us aid for children, they also say, "You're federal Indians! It's the federal government who should be responsible for you." But when the casinos started, that's when they started saying "No, you're not federal Indians! We can tax you, you don't live on a reservation." It's never to our advantage. It's always to the advantage of the state.

We paid taxes on our lands from 1875 to 1976. According to oral history—I've never seen a legal document, but it must be in the archives—the federal government told the state of Iowa, "They don't need to be paying taxes because they have reservation status." The state said: "No, we're gonna tax those Indians." And the federal government said: "If you do—if you take one cent out of those Indians, we're going to stop all the federal funding that comes to this state." That got them to stop collecting taxes. So, no matter what Iowa says today, in 1976, the state did not fight to make us pay taxes. And they can't change their mind years later because at the time they didn't want to give up the millions and millions of federal dollars to get a couple hundred dollars from the Meskwakis. So that's been the relationship with the state. It's still a good state. But when our old friends started dying off, things changed. When Iowa started to forget that early history . . . that's

when things start to change. And Iowa today doesn't know us, except for the casino. And they see dollar signs.

NB: *So how has the casino changed life on the settlement?*

JB: Well, the casino has been very beneficial to us because we've built infrastructure, with a little help from the federal government. Water lines. Electricity. We have a new health clinic. We have a new high school. So it's been very helpful for things like that. It hasn't really changed life, it's just changed things physically.

We have running water in the house, now. That's a big change. You know, we actually have a faucet. But I grew up drinking water in a can. We had to haul water, the drinking water came in a pail, and there'd be a cloth on top so bugs don't fall into it. To drink water, you'd lift the cloth and use a dipper. Even today, by habit, I don't carry around water, you know. I drink water when I'm thirsty. I learned to be careful of water, of not being too wasteful because if you wasted your water you'd have to go down a couple miles just to get more.

When most people talk about that lifestyle they're talking as if it's ancient history—the Depression in the 1930s, their grandma, maybe their parents—that's what they're talking about. When we talk about that lifestyle, we're talking about the '80s—the 1980s. So anytime somebody threatens our casino, that's what they're threatening us with: to go back to the 1980s. The casino opened in 1993. People born in '93, '94, who are now young adults, they don't remember. The settlement to them always looked the way it is now.

NB: *And a lot of people don't recognize the way in which that money is reinvested in all the things you mentioned in terms of infrastructure.*

JB: They think we're multimillionaires, individually. Before the casino, our non-Native neighbors would say, "Poor Indians!" They would give us scraps. They would pity us. And maybe somewhat hate us, too. It was pity-hate. But today they're envious, but they still hate us. Today it's envy-hate. And that's basically how Iowa has changed, too. Most Iowans think we're undeserving of what we have. Every time we have political turmoil, it's in the papers. And the average American sitting at home reading the paper, listening to the news, they're thinking, "Oh, those Indians . . . they're undeserving. They don't deserve what they got." People think we have special rights. But they should try being an Indian. It's no *Dances with Wolves*, you know . . .

Back in the Black Hawk War, it was thought we were undeserving of the land. We didn't know how to use it, we didn't know how to develop it, so [the settlers] might as well take it. And same way with the casino, some people see us as undeserving. Before it was land and now it's casino patrons. They say, "I want those casino patrons in my casino because I know how to do it better than those Indians. They're undeserving of the business." And that's how I can connect it to the Black Hawk War. From that time to today . . . we're still undeserving.

JB: The only thing we really associate with Black Hawk is going to the powwow at Black Hawk State Park [along the Mississippi River in Rock Island, Illinois]. But even then, it is an excuse for most Meskwaki to go back to the Mississippi River and camp there. The Mississippi is very important; we've always considered it our river. And at least we can go there for a day. Go smell it. Go listen to it, you know. Just look at it. It brings back old memories; it brings back our connection to our past. But when we look across that river and see Illinois, there's still danger across that river.

Even today, with NAGPRA, Illinois will not allow us to rebury repatriated people on the east side of the river. Back in Black Hawk's time, the governor said "dead or alive" when he removed the Sac and Fox. When they killed people, they canoed their bodies to the west side of the river to dump them. So when it comes to repatriations, we couldn't find a place to bury them. The state wouldn't work with us. But Iowa—thank God for Iowa—said we could use their cemeteries. So we have been reburying Sac and Fox people in Iowa that have been dug up in Illinois. We like to rebury people in the places they were dug up, but we came to consider our old boundaries for repatriation. Iowa, Illinois—those are state boundaries. But our old boundaries are huge. So we decided, instead of using state boundaries, we use our traditional boundaries, and we can bury them anyplace in our old boundaries and still consider them home. "Illinois" wasn't their home. And Illinois doesn't even consider it their home because they refuse to let us bury them in the state. And so the Black Hawk War is very much alive with us; the attitude "I want you out!"—that caused the Black Hawk War. So every time we bury someone in Iowa who should have been buried in Illinois, that sting returns. They wanted us out, and they don't want us to come back, not even our bones. And that's the legacy of our Black Hawk War. They don't even want our bones.

4.
Wisconsin

WHO IS THE INDIAN?

The Indian in Wisconsin is not easy to understand. The popular image, formed
by history and generalization, lingers on as a stereotype without basis in reality.
Casual observation of the Indian and his community provides half truths which
are more misleading than enlightening. The Indian does not explain himself read-
ily, and when he does, the non-Indian has difficulty in understanding his values
and in ascribing worth to his ways. This is an especially tangled problem, for on
the surface the Indians are a part of our culture; they watch our television, they
drive our cars, they work in our jobs. But they are separate, and they want to main-
tain their separateness. It is a state and community responsibility to attempt to
discover who the Indian is, what he wants, where he lives and—how he can regain
the proud dignity he once had.

JOYCE M. ERDMAN, *Handbook on Wisconsin Indians*, 1966

Prairie du Chien, WI

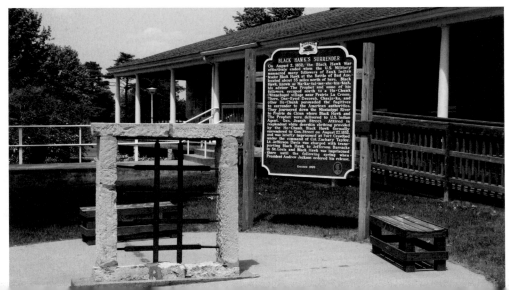

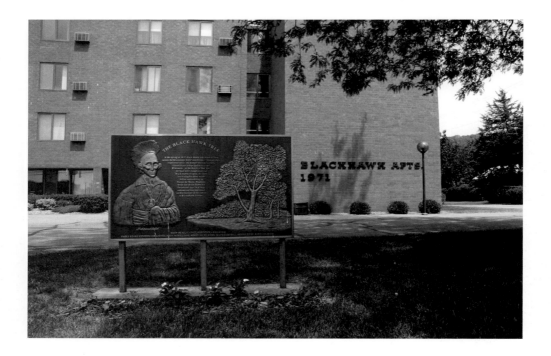

PROTOCOLS ON WORKING WITH TRIBES

The following is a list of suggestions when working with Tribes.

- Tribal leaders are governmental officials and business professionals. Treat them accordingly.
- No tribal leader speaks for all the Tribes in Wisconsin. Each elected tribal official represents his/her own nation and is responsible to those citizens.
- Tribal members are not racial minorities. They are citizens of sovereign nations. To speak to citizens of tribal governments as a minority is insulting and inappropriate.
- Prepare for your meetings. It is not the responsibility of the Tribe to educate you on their history.
- Tribal leaders should meet directly with cabinet secretaries, deputy secretaries, executive assistants or division administrators. Other meetings with tribal council officials and tribal staff should be conducted at the same level of officials within state government.
- Learn the appropriate title for the tribal representatives. In Wisconsin, there are tribal chairpersons, tribal presidents, vice presidents, legislators and board members. Also, there are tribal councils and legislatures.
- Be prepared to follow through on your discussions. Consultation is only the first step in communication.

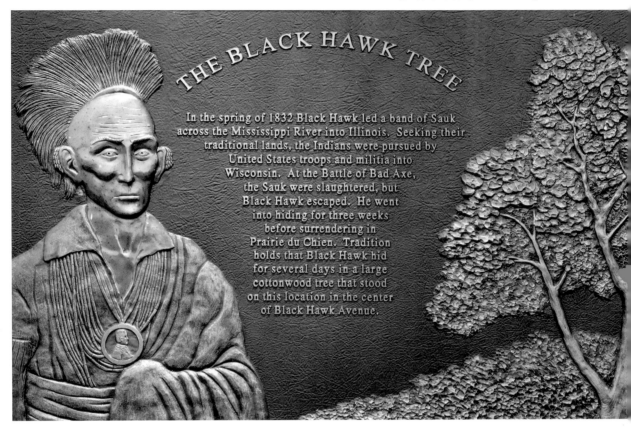

THE BLACK HAWK TREE

In the spring of 1832 Black Hawk led a band of Sauk across the Mississippi River into Illinois. Seeking their traditional lands, the Indians were pursued by United States troops and militia into Wisconsin. At the Battle of Bad Axe, the Sauk were slaughtered, but Black Hawk escaped. He went into hiding for three weeks before surrendering in Prairie du Chien. Tradition holds that Black Hawk hid for several days in a large cottonwood tree that stood on this location in the center of Black Hawk Avenue.

- ◆ Native Americans have had strained relationships with governments due to lack of follow through, appropriate respect and broken promises. Be mindful of this fact when working with the tribal governments.
- ◆ Not all Tribes are wealthy. While Indian gaming has helped the economic base of all Tribes, there is a disparity in revenues generated. Be mindful of this fact when working with the tribal governments and in discussion with others.
- ◆ Do not rely on e-mails or letters as a form of communication. Follow up written correspondence with a phone call or visit.

WISCONSIN DEPARTMENT OF ADMINISTRATION, *Tribes of Wisconsin*, 2011

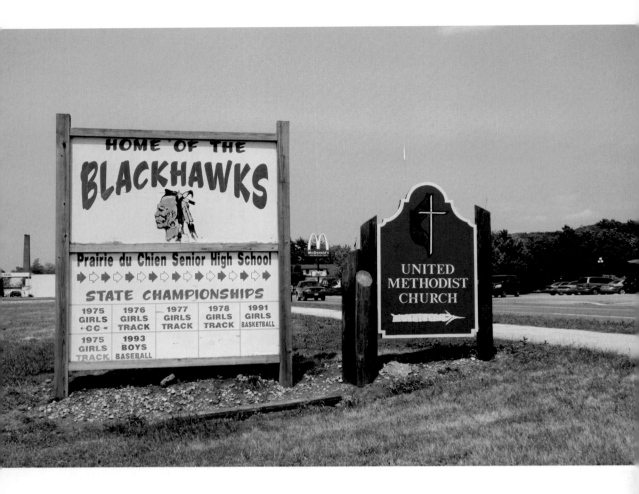

COSTS OF POLITICAL CORRECTNESS MOUNT FOR WISCONSIN SCHOOLS

It's all fun and games until somebody gets offended—at least in Wisconsin, the first state in the country to ban politically incorrect public school mascots, specifically those considered offensive to Native Americans.

The ban, signed into law by then-Gov. Jim Doyle in May 2010, does not take full effect until 2013, but schools are already beginning to change their nicknames if they are deemed to be offensive—due to the law's provision that provides residents an outlet to lodge a formal complaint with the state superintendent. If a mascot is determined to be race-based, the offending school must cease to use it.

. . .

The cost of the change will not be inexpensive. The Mukwonago School District, one of the five districts that already has had to adopt a new symbol, expects their mascot switch will cost about $50,000.

CAROLINE MAY, *Daily Caller*, 2011

THE SEVENTH GENERATION

Walt Bresette, an Anishinaabe man from the Red Cliff reservation in northern Wisconsin, passed to the next world in early 1999. His passing was a huge loss to the Native environmental movement. But his groundbreaking work on re-envisioning the Constitution and Native treaty rights for the benefit of all people and the earth continues. . . . The rights of the people to use and enjoy air, water, and sunlight are essential to life, liberty, and the pursuit of happiness. These basic human rights have been impaired by those who discharge toxic substances into the air, water, and land. Contaminating the commons must be recognized as a fundamental wrong in our system of laws, just as defacing private property is wrong.

We must follow Bresette's example and charge ourselves with curbing the rights of corporations and special interests, transforming the legal institutions of the United States back toward the preservation of the commons, and preserving everyone's rights, not just those of the economically privileged. On a community level, we must support local self-reliance and the recovery of Indigenous systems of knowledge, jurisdiction, practice, and governance.

WINONA LADUKE, *All Our Relations*, 1999

(OPPOSITE + BELOW) Prairie du Chien, WI

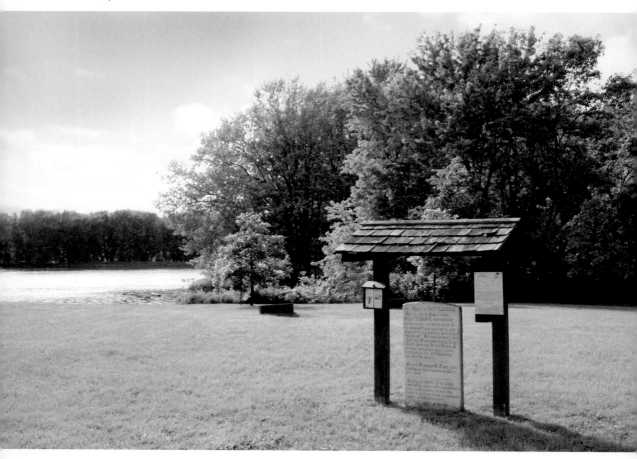

RADIOACTIVE RACISM? NATIVE AMERICANS AND THE NUCLEAR WASTE LEGACY

It seems the nuclear industry wants an easy way out of their dilemma of what to do with their wastes (that no one seems to want) presumably, so they can continue generating more.

As a mother and a grandmother, I am concerned about the survival of our people.

Indian people have been deeply divided between those tempted by short-term money and those who fear the long-term health consequences of taking the U.S. high-level radioactive waste.

So far, those who take the long view have prevailed. Of the 17 tribes who considered establishing a "temporary" nuclear waste storage site, only three remain.

But the debate has done serious damage to harmonious relationships among our people. We appeal to the U.S. government and those who use nuclear energy: take responsibility for your own wastes and leave us alone!

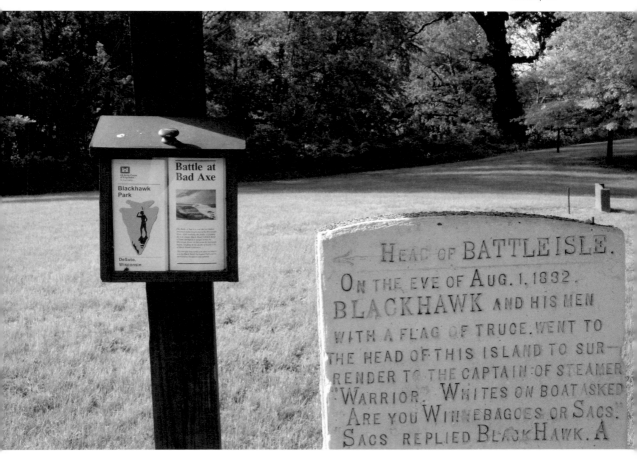

The U.S. government targeted American Indians for several reasons: their lands are some of the most isolated in North America, they are some of the most impoverished and, consequently, most politically vulnerable and, perhaps most important, tribal sovereignty can be used to bypass state environmental laws.

How ironic that, after centuries attempting to destroy it, the U.S. government is suddenly interested in promoting American Indian sovereignty—just so it can dump its lethal garbage!

All Indian treaties and agreements with the U.S. government have been broken. . . . The Indians cannot trust the federal government and certainly cannot trust the nuclear industry whose driving force is monetary profit.

GRACE THORPE, *Indian Country Today*, 1995

BATTLE BLUFF ↑ ELV 1139 FT

BATTLE HOLLOW →
SEVERE FIGHTING 1 MILE EAST
BETWEEN GEN. HENRY'S 300 ILL.
MILITIA AND 300 SAC INDIANS
AUG. 2. 1832.

← BATTLE ISLAND
HARD FIGHTING OPPOSITE. 1200
WHITE SOLDIERS ENGAGED. 17 KIL—
LED. 12 WOUNDED. OF INDIANS.
150 SHOT. 150 DROWNED, 50
TAKEN PRISONERS. 300 CROSSED.
RIVER OF WHOM 150 WERE KILLED
BY SIOUX INSTIGATED BY GEN.
ATKINSON. OF THE 1000 SACS
WHO CROSSED THE RIVER FROM
IOWA IN APRIL 1832. "NOT MORE
THAN 150 SURVIVED TO TELL
THE TRAGIC STORY OF THE
BLACKHAWK WAR"
R.G. THWAITES.
NO 8 CVP 1930S

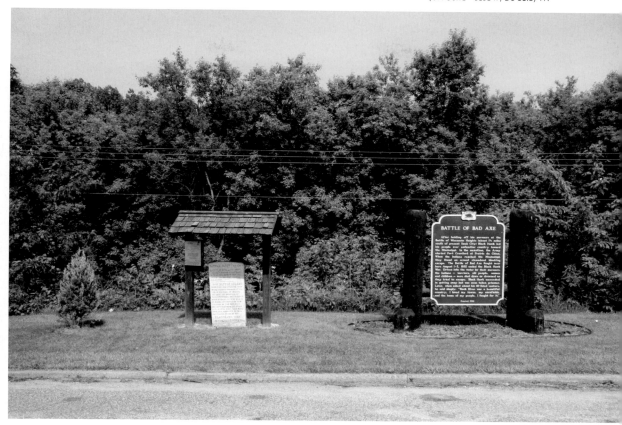

ABOUT WALT

At a meeting in Tampa, Florida during the 1980s, Walt [Bresette] received a special gift. The gift came from an alert and agile old woman. It was the war club belonging to the Sauk leader Black Hawk who, more than a hundred and fifty years ago, fought the US Army trying to move him and his people from their homeland. Walt Bresette carried Blawk Hawk's war club to the ceremonies, to the boat landings, to the mining protests, to the schools and the community.

PROTECT THE EARTH, protecttheearth.org

Phrenological Journal and Life Illustrated, 1838. Special Collections, Milner Library, Illinois State University

OF THE NATURE AND STATE OF MAN, WITH RESPECT TO THE UNIVERSE

Lo, the poor Indian! whose untutor'd mind
Sees God in clouds, or hears him in the wind;
His soul proud Science never taught to stray
Far as the solar walk or milky way;
Yet simple Nature to his hope has giv'n,
Behind the cloud-topp'd hill, a humbler heav'n;
Some safer world in depth of woods embrac'd,
Some happier island in the wat'ry waste,
Where slaves once more their native land behold,
No fiends torment, no Christians thirst for gold!
To be, contents his natural desire;
He asks no angel's wing, no seraph's fire:
But thinks, admitted to that equal sky,
His faithful dog shall bear him company.

ALEXANDER POPE, *An Essay on Man*, 1734

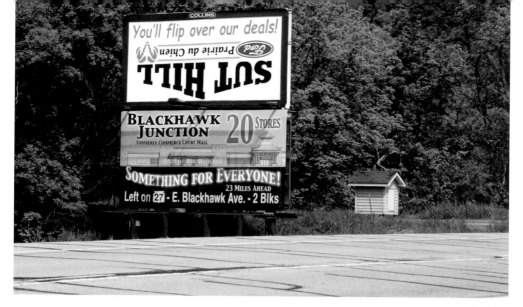

PRELUDE TO DISASTER

Phrenology, a pseudo-science of the eighteenth and nineteenth centuries by which mental faculties and character traits were deduced by carefully measuring all aspects of the human skull, was applied to the defeated Black Hawk following his eastern trip of 1833. Using a plaster cast of the living chief's head and face, the American Phrenological Journal for November, 1838, published an eleven-page article which analyzed in some detail various indices to the Sauk warrior's Amativeness (large), Combativeness (very large), Constructiveness (small), and thirty-four other personality traits. Black Hawk was much admired by his captors, who somewhat condescendingly viewed him as the ideal of the "noble savage" . . . "His head is large," wrote the editors, "giving much more than an ordinary amount of intellect and feeling, and indicative also of weight of character and extent of influence. His temperament is bilious-nervous, combining great strength with great mental and physical activity, and power of endurance. . . ." But Black Hawk's index of Causality was only moderate, and thus, "too feeble to originate very comprehensive plans, and successfully adapt means to ends." (To this last, the editors primly appended a footnote: "The deficiency of this organ [Causality] in the Indian head, generally, is one of the principle causes why they have not been able to cope more successfully in battle with the whites, or destroy their enemies by other means.") Despite its ludicrous origins, however, this likeness of the aging Black Hawk is probably quite accurate.

ANTHONY F. C. WALLACE, *Wisconsin Magazine of History*, 1982

AMERICAN INDIANS, AMERICAN IDENTITIES

Playing Indian offered Americans a national fantasy—identities built not around synthesis and transformation, but around unresolved dualities themselves. Temporary, costumed play refused to synthesize the contradictions between European and Indian. Rather, it held them in near-perfect suspension, allowing Americans to have their cake and eat it too. . . . As it did so, playing Indian gave white Americans . . . a jolt of self-creative power.

Playing Indian, then, reflects one final paradox. The self-defining pairing of American truth with American freedom rests on the ability to wield power against Indians—social, military, economic, and political—while simultaneously drawing power from them. Indianness may have existed primarily as a cultural artifact in American society, but it has helped create these other forms of power, which

have been turned back on native people. The dispossessing of Indians exists in equal tension with being aboriginally true. The embracing of Indians exists in equal tension with the freedom to become new. And the terms are interchangeable. Intricate relations between destruction and creativity—for both Indian and non-Indian Americans—are themselves suspended in an uneasy alliance.

And so while Indian people have lived out a collection of historical nightmares in the material world, they have also haunted a long night of American dreams. As many native people have observed, to be American is to be unfinished. And although that state is powerful and creative, it carries with it nightmares all its own.

PHILIP DELORIA, *Playing Indian*, 1998

REPLACING

The sometimes decades-long campaigns to erect monuments attest to the commodification of memory, as Indian ways of memory making tied to place and shared storytelling gave way to static objects produced in market economies whose meaning frequently faded over time. Absent the regular recitation of history embedded in oral cultures that fueled history tied to place, the meaning of monuments threatened to become unmoored from memory. Commodified memory making divorced from storytelling threatened to produce landscapes punctuated with statues, plaques, and markers whose meaning dissipated across the years absent tangible connections made to them through storytelling.

JEAN M. O'BRIEN, *Firsting and Lasting*, 2010

BLACKHAWK TRAIL.

At shallow pond 115 rods due south Blackhawk's 700 Sac Indians encamped July 31 1832. Soldiers found six decrepit Indians there and "left them behind".

Lee Sterling in 1846 found a handfull of silver brooches there. Hence concluded those killed were squaws.

No. 3 CVP 1930 S

HISTORIC
TRAIL MARKERS

BLACK HAWK

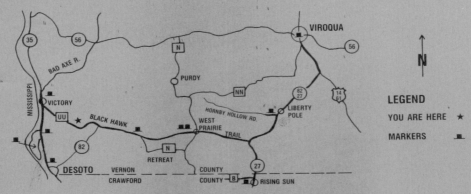

LEGEND

YOU ARE HERE ★

MARKERS ■

THIS IS THE SITE WHERE GENERAL
ATKINSON'S REGULAR ARMY TROOPS
ENCOUNTERED THE 20 WARRIORS WHICH
BLACK HAWK HAD SENT AS A DECOY
HOPING TO GIVE THE REST OF HIS PEOPLE
TIME TO CROSS THE RIVER. MEANWHILE THE
MILITIA ENCOUNTERED THE REAR GUARD
OF THE INDIAN BAND IN BATTLE HOLLOW.

GRATEFUL APPRECIATION IS GIVEN
TO DR. C.V. PORTER WHOSE HARD
WORK AND DEDICATION PRESERVED
THIS SEGMENT OF HISTORY FOR ALL.

VERNON COUNTY HISTORICAL SOCIETY
WISCONSIN HUMANITIES COMMITTEE
WISCONSIN STATE DEPT. OF TRANSPORTATION
VERNON COUNTY HIGHWAY DEPARTMENT

THE STATE OF WISCONSIN RECOGNIZES DR. PORTER'S
MARKERS AS PART OF VERNON COUNTY HISTORY BUT DOES
NOT CONDONE THE LANGUAGE OR PREJUDICIAL INFERENCES
USED ON SOME OF THE MARKERS. DR. PORTER USED
DESCRIPTIVE, INTERPRETATIVE LANGUAGE WHICH HE
RESEARCHED AND FELT WAS ACCEPTABLE FOR HIS TIME.

EXCHANGING GIFTS WITH THE DEAD

Despite the wishes of many to control and tame our faculty for remembrance and foist forgiveness upon the living, the complexities and variety of functions which society asks remembering to perform obscure the fact that atoning for the violence of the past is itself often an act of violence—in this case, the terrible violence of equality. The deconstruction of the silence and violence produced by attempts at atonement, then, requires a multitude of narratives. For it is only through multivocality that we can sidestep the marketplace of remembering, stop trading stories with the dead and actually listen to the stories we are offered as gifts from the living.

BOYD COTHRAN, *International Journal of Critical Indigenous Studies*, 2011

(OPPOSITE) Vernon County, WI | (BELOW) Soldiers Grove, WI

Black Hawk's justified struggle to regain his people's homeland failed because his own nation was divided on whether to back his cause and because only a few individual allies stepped forward to help. Our vigil at Bad Axe on the Thanksgiving after our first year's witness was a reminder of the importance of finding allies in our struggle, too.

As the Americas, north and south, near the twenty-first century, it is obvious that the wars against Indian peoples are not over. Indigenous people in the United States were killed in the struggles of the 1960s and 1970s and are risking their lives again in the 1980s and 1990s, just to exercise rights they have long held. Nonviolence is not merely a strategy for the boat landings. It is a philosophy for living together today. It is also a way of reconciling with a heritage of violence, whether as victim or oppressor, by remembering together the tragedies, the real losses of life and culture for many peoples. The Bad Axe Vigil on Thanksgiving Day, 1988, was an opportunity for today's Black Hawk sojourners and the witnesses to remind ourselves where we came from—our political as well as ethnic heritages. It was a day to be inspired and recommit ourselves to the healing we still need to do in Wisconsin in our lifetimes.

RICK WHALEY, *Ojibwe Akiing*, 2004

(BELOW) Gays Mills, WI | (OPPOSITE) Blackhawk Island, Wisconsin Dells, WI

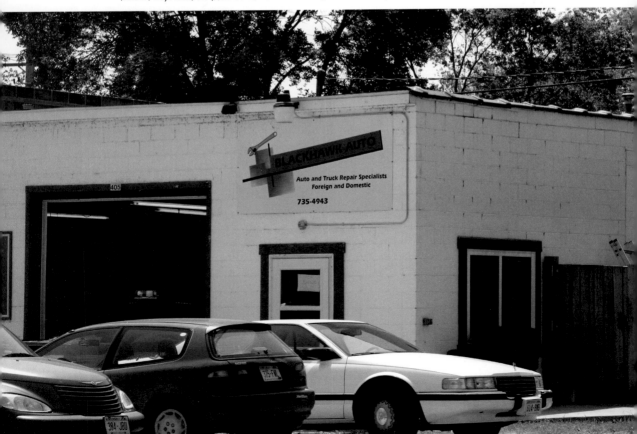

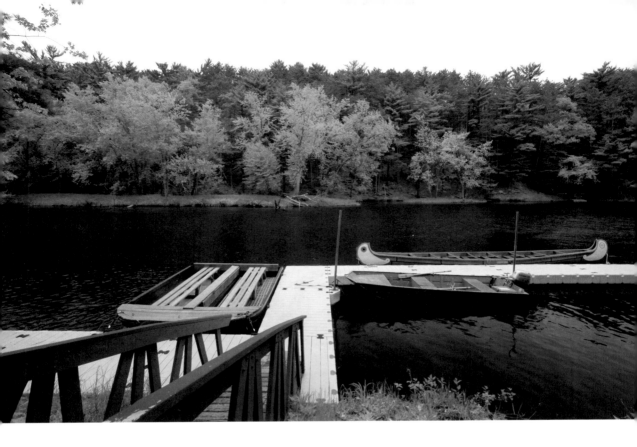

FROM ENEMIES TO ALLIES

The late 1980s and early 1990s was a time of intense conflict between Ojibwe (Chippewa) Indians and white sportfishers over Native treaty rights in the forested northern third of Wisconsin. For months, the normal peace and quiet of this ceded area outside of the state's six Ojibwe reservations was shattered by whites chanting racist taunts such as "timber n_____," assaulting tribal elders, and ramming Ojibwe vehicles to protest the ancient practice of Native spearfishing.

Less than a decade later, Native American nations and white sportfishing groups are cooperating to protect the same fish they had fought over, and building a powerful alliance that has chased several mining companies out of the state. International mining industry journals now express worry about the contagious spread of Wisconsin anti-mining strategies, and identify Wisconsin as one of four global battlegrounds for the industry's future.

ZOLTAN GROSSMAN AND DEBRA MCNUTT, *ColorLines*, 2001

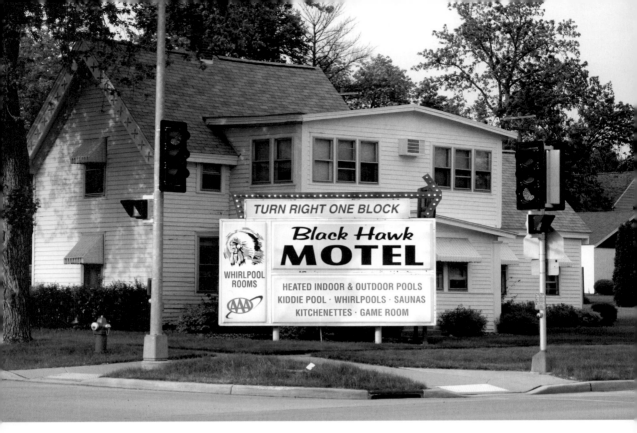

INDIANS OF WISCONSIN

Many Indians have only contempt for AIM members, but equal numbers argue that they would ask AIM for help in specific situations if all other means to re-dress specific grievances failed. Local AIM chapters can be found in Wisconsin. National AIM leaders are asked by Indians from Wisconsin to speak in this state. While the largely Indian audience may disagree with some or all of the remarks made, speakers are given a respectful and courteous reception. AIM is most cer-tainly one facet of contemporary Indian life which deserves careful attention by all those concerned with Indian affairs. And it should be noted that violence is only one possible ploy advocated by AIM members, since it must of necessity have unfortunate consequences for all those connected with it. . . .

On August 14, 1971, a political action by AIM involving the threat of violence occurred in Milwaukee. About thirty Indians occupied an abandoned McKinley Beach Coast Guard Station, located on Milwaukee's lake front. At dawn, Indians moved into two vacant buildings which had been unused for two years. City po-lice investigated almost immediately, but promised not to interfere with AIM ac-tivities "as long as things stayed peaceful and no one filed a complaint." Power and water service was maintained knowingly by local utility offices.

News coverage by radio, television, and newspapers was prompt and sympathetic. Effective white support resulted. AIM leaders announced that their intentions were peaceful and that "violence will not occur unless attempts are made to remove us forceably. Then we will resist." The intention of AIM to use the buildings for a school for Indian children and as a center for Indian alcoholics was announced by the news media and further helped to ensure the overt and tacit public cooperation. The only "weapons" displayed by Indians were a few sawed-off pool cues. Some Indians wore bead work and moccasins. Signs were displayed stating that the building now belonged to Indians. The Coast Guard half-heartedly told AIM to leave. They refused. More than three years have passed, and the former Coast Guard station remains "Indian Country." The buildings have been used as announced and federal grants plus a variety of continuing support from local whites have been given. An indefinite period of use by Indians seems likely. . . .

In the light of these and other similar incidents, it cannot be said that the state's Indians are given to violent revolutionary activity. Indian political behavior of this type seems to consist of classically understated protest appealing to the majority's assumed inherent sense of justice. Indeed, Wisconsin's Indians have been models of restraint with a mature sense of public responsibility.

WILLIAM H. HODGE, in *The State of Wisconsin 1975 Blue Book*, 1975

(OPPOSITE + BELOW) Wisconsin Dells, WI

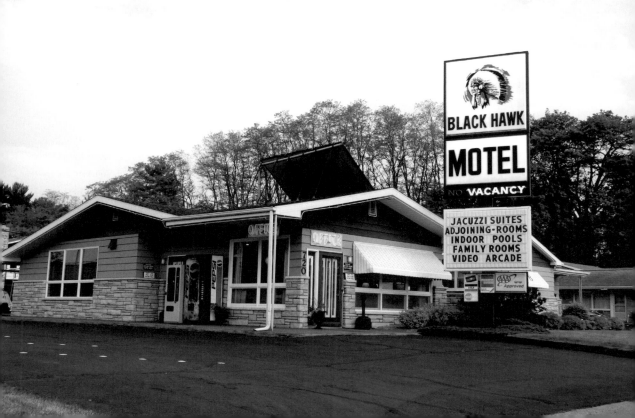

RELATING TO AN AFFIRMATION OF THE GOVERNMENT-TO-GOVERNMENT RELATIONSHIP BETWEEN THE STATE OF WISCONSIN AND INDIAN TRIBAL GOVERNMENTS LOCATED WITHIN THE STATE OF WISCONSIN

WHEREAS, the State of Wisconsin has a unique legal relationship with Indian Tribes, as affirmed and set forth in state and federal law; and

WHEREAS, within Wisconsin there are 11 federally recognized Tribes with elected or appointed Tribal governments; and

WHEREAS, the State of Wisconsin, a sovereign state within the United States, recognizes the unique status of Indian Tribes and their right to existence, self-government, and self-determination; and

WHEREAS, state regulations and other policy statements or actions have an impact on Indian Tribes; and

WHEREAS, State and Tribal governments play key roles in serving all of the citizens of the State of Wisconsin and collaboration between Tribes and State agencies will ensure that services are efficiently provided to all citizens, minimize service overlap, preserve natural resources and encourage sustainable economic development;

NOW THEREFORE, I, JIM DOYLE, Governor of the State of Wisconsin, by the authority vested in me by the Constitution and the laws of this State, do hereby:

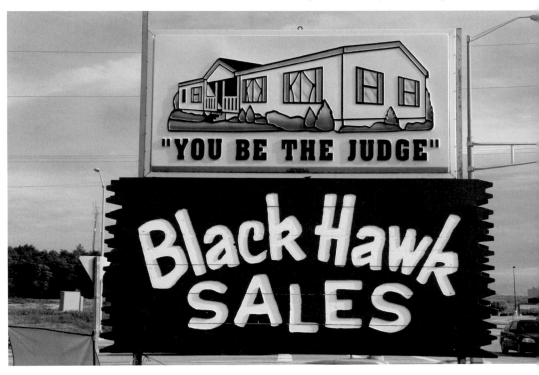

1. Direct cabinet agencies to recognize the unique legal relationship between the State of Wisconsin and Indian Tribes, respect fundamental principles that establish and maintain this relationship and accord Tribal governments the same respect accorded other governments;

2. Direct cabinet agencies to recognize the unique government-to-government relationship between the State of Wisconsin and Indian Tribes when formulating and implementing policies or programs that directly affect Indian Tribes and their members, and whenever feasible and appropriate, consult the governments of the affected Tribe or Tribes regarding state action or proposed action that is anticipated to directly affect an Indian Tribe or its members;

3. In instances where the State of Wisconsin assumes control over formerly federal programs that directly affect Indian Tribes or their members, direct cabinet agencies, when feasible and appropriate, to consider Tribal needs and endeavor to ensure that Tribal interests are taken into account by the cabinet agency administering the formerly federal program; and

4. Direct cabinet agencies to work cooperatively to accomplish the goals of this order.

JIM DOYLE, "Executive Order #39," 2004

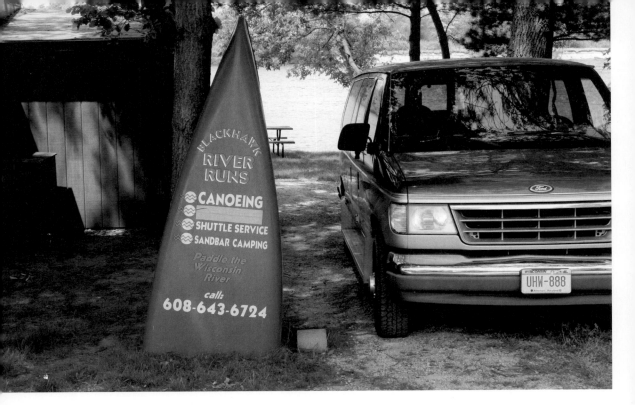

"KILL THE INDIAN, SAVE THE MAN," A BOARDING SCHOOL STORY

Starting in the late eighteen hundreds more than a million Native American children were taken from their homes and sent to government or missionary boarding schools. The point was to "civilize" natives into mainstream society. The motto at the Carlisle Indian School in Pennsylvania was, "Kill the Indian, Save the Man." Students learned farming and vocational skills. But languages were lost and several generations grew up without parents. . . .

It was nineteen twenty-seven or twenty-eight, when an imposing black car pulled into Mole Lake, south of Crandon in Forest County.

Richard Ackley was six years old, playing on a dirt road. The driver and his assistant loaded him up and took him to a Christian missionary boarding school at Lac du Flambeau. Ackley remembers, "You're scared and crying and everything like that. You don't have that thinking [about] what to do, how to do it . . . All you knew about it you're scared and crying."

On the way to the Flambeau boarding school, going down the road feeling bad, Ackley stared out the window. "I remember looking one time seeing some of these here pink flowers on the side of the road. When I see these pink flowers today that reminds me it would have to be July and August, somewhere along in there that year they took me to that school."

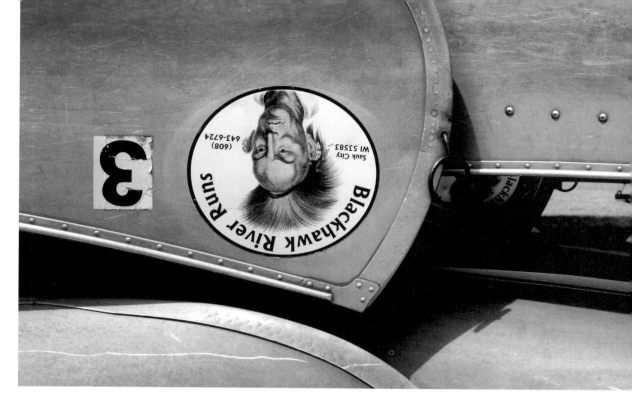

(OPPOSITE + ABOVE) Sauk City, WI

Life had been deteriorating for a long time at Mole Lake. The tribe never received a reservation in the 1854 Treaty with the federal government. The tribe was in effect squatting on its ancestral land . . . while the logging industry cut the last white pine timber.

Ackley's parents worked in a lumber camp, he recalls. "They more or less worked through the week. Then on the weekends they'd drink with their friends cuz everybody else was doing about the same thing. Then the kids were left to and fro, you know what I mean, you go here and go there."

According to Ackley the authorities from the boarding school warned the Indian parents about looking after their children or they'd be removed. "Maybe they was asking about their father and mother when the kids didn't know. And I think that's how the children got picked up and taken away then."

When Ackley arrived at Flambeau his hair was cut, he was issued a uniform, and expected to sleep on a top bunk bed. But he wasn't used to sleeping this way. At home he slept in a tar paper shack on the ground. . . . Dominant society holidays puzzled him. For instance, he never quite got the relationship between rabbits and Easter eggs. "Cuz I was raised my mother and father always said a rabbit was a rabbit. I knew where eggs came from. It was birds like that. But I didn't know anything about the eggs coming from rabbits."

NICK VANDER PUY, *Lac du Flambeau News,* 2007

The Indian Child Welfare Act was signed into federal law in 1978 to stem the placement of Indian children into foster care and adoption away from Indian families. Now, 30 years later, the rate of out-of-home placements continues at a rate that is still much greater than for other groups. Where other children may go into foster care for an average of two years, Indian children are in non-Indian foster care from seven to ten years, which amounts to a de facto adoption. This codification into state law will underline the protections afforded by the federal law. It will put social workers, agencies, and their attorneys on notice of their obligation to involve the tribes, and assure that Indian children who are in need of temporary home placement, whether for foster care or adoption, are assured of opportunity and advocacy for placement within the Indian community. To deprive a tribe of its children is to deprive it of its future. It is vital for our children to grow up in, and know the ways of our communities, so that they can be effective citizens of the tribes as well as the State. As tribes, we see this as a high priority and a matter of great importance. Its time has come. The tribes and the state departments have worked long and hard to hammer out this legislation, and we, as tribal leaders, call upon you to complete this process.

ARLYN ACKLEY, "State of the Tribes Address from [the] Sokaogon Chippewa Chairman," Wisconsin State Legislature, 2009

(OPPOSITE + BELOW) Sauk City, WI

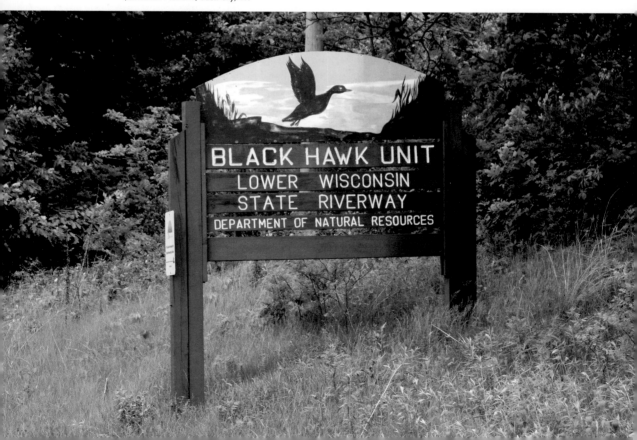

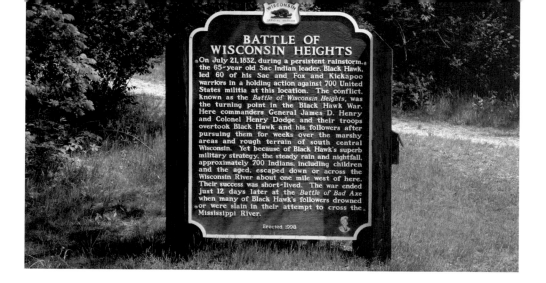

The sign reads:

BATTLE OF WISCONSIN HEIGHTS

On July 21, 1832, during a persistent rainstorm, the 65-year old Sac Indian leader, Black Hawk, led 60 of his Sac and Fox and Kickapoo warriors in a holding action against 700 United States militia at this location. The conflict, known as the *Battle of Wisconsin Heights*, was the turning point in the Black Hawk War. Here commanders General James D. Henry and Colonel Henry Dodge and their troops overtook Black Hawk and his followers after pursuing them for weeks over the marshy areas and rough terrain of south central Wisconsin. Yet because of Black Hawk's superb military strategy, the steady rain and nightfall, approximately 700 Indians, including children and the aged, escaped down or across the Wisconsin River about one mile west of here. Their success was short-lived. The war ended just 12 days later at the *Battle of Bad Axe* when many of Black Hawk's followers drowned or were slain in their attempt to cross the Mississippi River.

Erected 1998

ADOPTIVE COUPLE V. BABY GIRL

The majority opinion turns §1912 upside down, reading it from bottom to top in order to reach a conclusion that is manifestly contrary to Congress' express purpose in enacting [the Indian Child Welfare Act]: preserving the familial bonds between Indian parents and their children and, more broadly, Indian tribes' relationships with the future citizens who are "vital to [their] continued existence and integrity." . . .

The majority casts Birth Father as responsible for the painful circumstances in this case, suggesting that he intervened "at the eleventh hour to override the mother's decision and the child's best interests." . . . It bears remembering, however, that Birth Father took action to assert his parental rights when Baby Girl was four months old, as soon as he learned of the impending adoption. As the South Carolina Supreme Court recognized, "[h]ad the mandate of . . . ICWA been followed [in 2010], . . . much potential anguish might have been avoided[;] and in any case the law cannot be applied so as automatically to 'reward those who obtain custody, whether lawfully or otherwise, and maintain it during any ensuing (and protracted) litigation.'" . . .

The majority's hollow literalism distorts the statute and ignores Congress' purpose in order to rectify a perceived wrong that, while heartbreaking at the time, was a correct application of federal law and that in any case cannot be undone. Baby Girl has now resided with her father for 18 months. However difficult it must have been for her to leave Adoptive Couple's home when she was just over 2 years old, it will be equally devastating now if, at the age of 3 1/2, she is again removed from her home and sent to live halfway across the country. Such a fate is not foreordained, of course. But it can be said with certainty that the anguish this case has caused will only be compounded by today's decision.

> SONIA SOTOMAYOR, dissenting opinion,
> *Adoptive Couple v. Baby Girl, 570 U.S. _____, 2013*

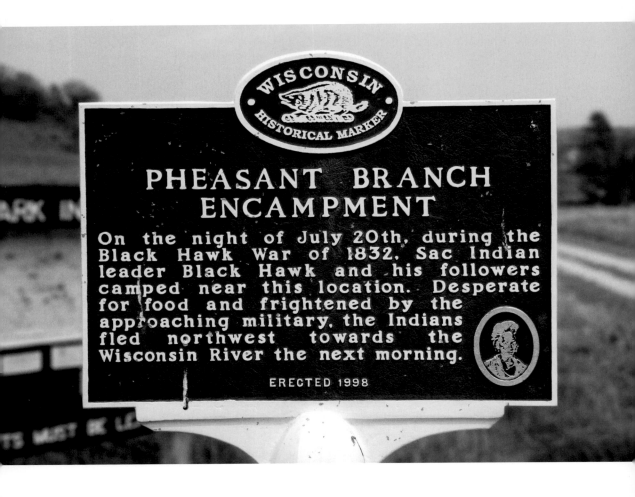

WISCONSIN HISTORICAL MARKER

PHEASANT BRANCH ENCAMPMENT

On the night of July 20th, during the Black Hawk War of 1832, Sac Indian leader Black Hawk and his followers camped near this location. Desperate for food and frightened by the approaching military, the Indians fled northwest towards the Wisconsin River the next morning.

ERECTED 1998

AN INDIGENOUS MANIFESTO

I am advocating a self-conscious traditionalism, an intellectual, social, and political movement that will reinvigorate those values, principles, and other cultural elements that are best suited to the larger contemporary political and economic reality. . . . As a movement to gain respect for indigenous people, this form of traditionalism is not predicated on racially constructed conflict. It is a matter not of red versus white, but of right versus wrong, considered within the broad framework of values we all share: freedom, justice, and peace.

TAIAIAKE ALFRED, *Peace, Power, Righteousness*, 1999

Not long after that, [Jules Anderson] said, "I was walking down the street in the French Quarter and this big Indian guy just came to me, in the spirit. It wasn't a real man. He was an Indian but he was dressed in ordinary American clothes, and he walked to me and folded his hands, like we see the statue of Black Hawk in Illinois. And he just walked right into me, and it was like a possession type thing I went into. And it was from that day on that I began to have this personal relationship with the spirit of Black Hawk, and I started to go around to different churches and other leaders told me I had the spirit strong." . . .

"Black Hawk is a spirit guide," Anderson continued, "and he is a warrior. He don't stand for any foolishness. . . . I felt like I could fight for what I wanted and win. And I did that because I was totally into Black Hawk and it was good to an extent. But then I found it wasn't beneficial to me as a minister because of the basic fight: some churches do not invoke the spirit of Black Hawk. I had a reputation of being known only as Black Hawk."

JASON BERRY, *The Spirit of Black Hawk*, 1995

(OPPOSITE + BELOW) Middleton, WI

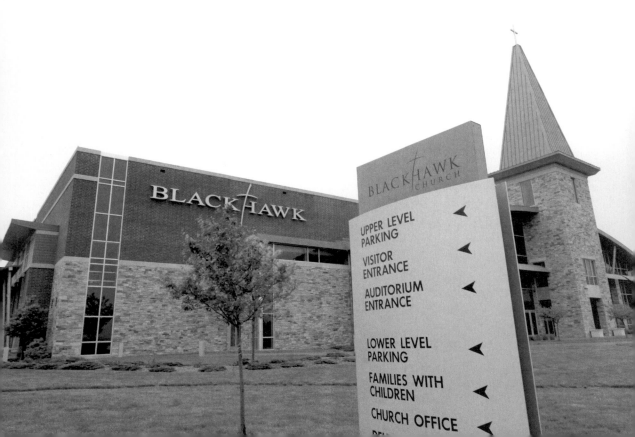

ACTIVIST SOCIOLOGY: PERSONAL REFLECTIONS

Even some of my friends in the Madison chapter of the Union of Radical Political Economists told me not to waste my time on a hopeless cause. To such naysayers, native struggles to defend their lands and resources appeared to be throwbacks to struggles already waged and lost during the nineteenth century. I took great exception to this view on both ethical and political grounds. I felt there was a moral imperative to support native struggles because it was not just a matter of preserving this piece of land or that particular resource; it was a matter of preserving an entire way of life. Beyond the morality of the situation, I also found compelling political reasons to support native struggles. I challenged my fellow radical colleagues to consider the possibility that Native American struggles over land and resources might prove to be the "Achilles heel" of U.S. imperialism. The successful assertion of Native American sovereignty would not only deprive American imperialism of a much needed source of cheap raw materials for expansion but would also provide concrete examples of how economic development could take place on a basis other than the self-expansion of multinational corporate capital.

AL GEDICKS, *Sociological Imagination*, 1996

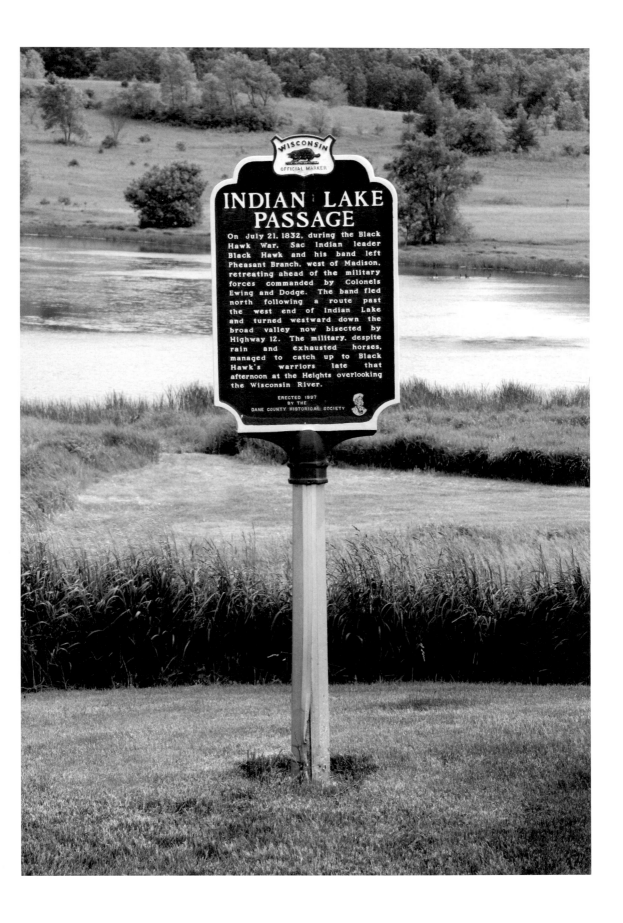

WISCONSIN
OFFICIAL MARKER

INDIAN LAKE PASSAGE

On July 21, 1832, during the Black Hawk War, Sac Indian leader Black Hawk and his band left Pheasant Branch, west of Madison, retreating ahead of the military forces commanded by Colonels Ewing and Dodge. The band fled north following a route past the west end of Indian Lake and turned westward down the broad valley now bisected by Highway 12. The military, despite rain and exhausted horses, managed to catch up to Black Hawk's warriors late that afternoon at the Heights overlooking the Wisconsin River.

ERECTED 1997
BY THE
DANE COUNTY HISTORICAL SOCIETY

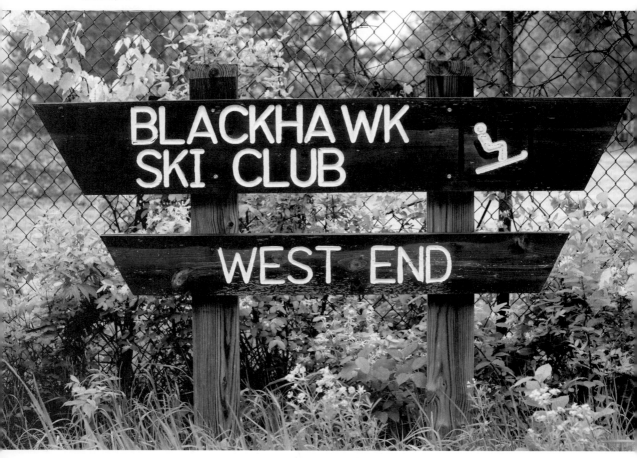

RECASTING THE NARRATIVE OF AMERICA

First, I attempt to destabilize assumptions about the uniformity of American Indian experience; the tremendous diversity of the continent's indigenous populations may partially explain the nation's historic reluctance to engage the history of the Native Americans.

Second, while introducing the diversity of Indian experiences can fragment a survey effort, common themes can unify it, particularly the centrality of Indian peoples to the making of America.

[Third], the first three centuries of colonial intrusion into the Americas form a necessary introduction to indigenous history, particularly when investigating both the influence of native peoples on the continent's development and the devastating impacts of European influence on the Americas. That third and latter

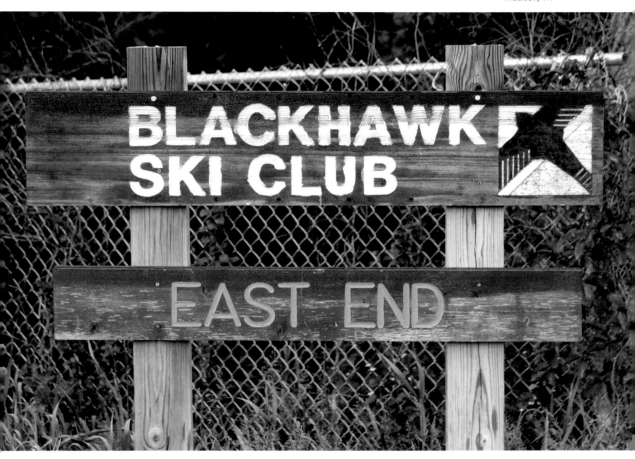

theme, I believe, is one of the hardest to integrate into a survey course, and I have encountered similar difficulties when teaching the first half of the U.S. survey course. That the largest loss of human life in world history followed the arrival of Europeans in the Americas remains so incongruent with prevailing assumptions about America and its history that many are unprepared, reluctant, or simply too overwhelmed to engage this foundational aspect of our nation's past.

Lastly, while such comparative attention can generate greater linkages and awareness, sustained focus on the uniqueness of Indian-white relations in the United States, particularly from a legal and constitutional perspective, must invariably characterize significant portions of any Indian survey.

NED BLACKHAWK, *Journal of American History*, 2007

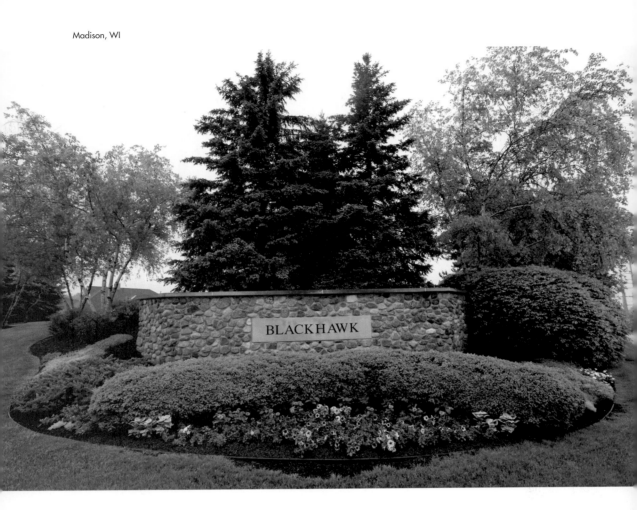

MOURNING FOR WHAT ONE HAS DESTROYED

Imperialist nostalgia revolves around a paradox: A person kills somebody, and then mourns the victim. In more attenuated form, somebody deliberately alters a form of life, and then regrets that things have not remained as they were prior to the intervention. At one more remove, people destroy their environment, and then they worship nature. In all of its versions, imperialist nostalgia uses a pose of "innocent yearning" both to capture people's imaginations and to conceal its complicity with often brutal domination.

RENATO ROSALDO, *Culture and Truth*, 1989

ALONG THE BLACK HAWK TRAIL

The route of the Black Hawk War scribes a ragged, looping arc through western and northern Illinois and southern and western Wisconsin. . . . Most of the historic sites are easily accessible, while finding some will require a bit of looking. Local sources may or may not be of help in finding the more remote markers. The vast majority of people living along the Black Hawk Trail are well schooled in the history of Washington, Jefferson, and Lincoln, but are woefully unaware of the events that took place in their own backyards 150 years ago.

WILLIAM F. STARK AND DON DAVENPORT, *Along the Black Hawk Trail*, 1984

Madison, WI

THE NATION IN THE CITY

Observers of Native American movement to cities like Chicago once believed that urbanization would mean the end of tribal identity, as "pan-Indianism" paved the way for total assimilation. That view is changing. Based on their extended observation and participation in Chicago's Native American community, Terry Straus and Debra Valentino (Oneida/Menominee) have recently suggested (1996) that the "detribalized" sense of Indian identity fostered by intertribal urban organizations is being countered by a trend towards "retribalization." To explain this new and unanticipated development, they cite changing demographic profiles that now place the majority of enrolled Native Americans in urban areas, combined with a recent surge in economic and political development among a number of Native American tribes. Such trends have led Native Americans living in cities to assert their connection to their tribal communities, and tribal communities and governments to reach out to their urban members.

The Ho-Chunk people of Wisconsin are at the forefront of the retribalization of Native American life in Chicago. In October of 1993, the Ho-Chunk Nation (known as the Wisconsin Winnebago Tribe) opened an office in Chicago. In doing so, the Ho-Chunk people became one of the few American Indian tribes in the country to create an official governmental presence in a city. . . .

The connection of Chicago's Ho-Chunk residents to their national community in Wisconsin has taken on a new form with the creation of the Ho-Chunk Nation Urban Branch Office, but the underlying connection itself has existed ever since Ho-Chunk people first moved to Chicago. Ho-Chunk people living in Chicago have traveled home to Wisconsin and Nebraska on an annual basis ever since first moving to the city. By making urban Ho-Chunk people part of their national government, the Ho-Chunk Nation exemplifies the increasing importance of tribal governments and communities in urban Native American life. This "retribalization" of urban life not only reinforces tribal identities among Native Americans living in cities, but also underscores the foundational importance of tribal identities and communities to Native American peoples, wherever they live.

GRANT P. ARNDT, in *Native Chicago*, 2002

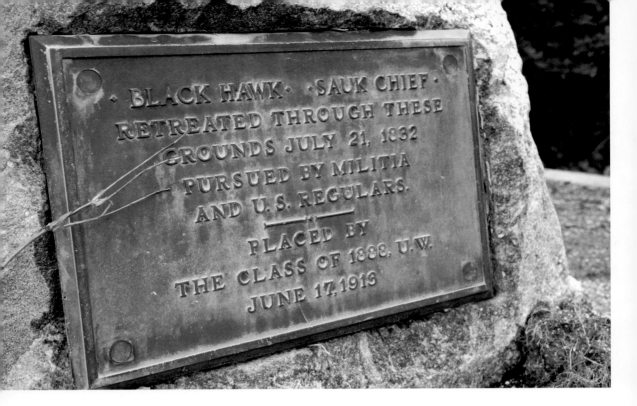

TRAIL MARKER TREES

The Trail Marker Trees . . . were part of an extensive land and water navigation system in our country that already was in place long before the arrival of the first European settlers. . . . Some of these trees would have brought them to fresh water springs, the preferred source of water used by the Native Americans and settlers alike. Other Trail Marker Trees would have guided them to areas with exposed stone and copper deposits needed for their adornments, hunting implements, and everyday tools. Yet, others would lead them to the areas where they could gather medicinal plants as well as plants used to make their dyes and paints. The Trail Marker Trees would have taken them to ceremonial sites and occasionally the burial sites of their ancestors. . . .

As Mr. [Dennis] Downes's research continues he is able to find out more about this little known phenomenon in our own back yards. He has devoted a large part of his life to the study of the Trail Marker Tree System and hopes that these quickly disappearing culturally altered living landmarks will never be forgotten. Over the years, Downes's artwork has helped to fund his continued study of the Trail Marker Trees, as well as giving him the opportunity to create both paintings and sculptures to commemorate these historic landmarks. These Trail Marker Trees are all too quickly becoming an endangered species.

DENNIS DOWNES,
"Great Lakes Trail Marker Tree Society: Our Society," greatlakestrailtreesociety.org

VALEDICTORIAN CALLS HIGH SCHOOL OUT ON NATIVE AMERICAN DISCRIMINATION

Bayfield High School valedictorian Victoria Gokee-Rindal dropped more than a few jaws last Saturday during her commencement speech. She said Native American students are made to feel inferior because of their culture, even though they make up the vast majority of the student body: "Even though we're 80 percent Native American, we have to almost check our 'Indian-ness' at the door."

A member of the nearby Red Cliff Band of Ojibwe, Gokee-Rindal says a tipping point was when students who practiced smudging—cleansing themselves with the smoke of burning sage—were told they couldn't come to class. On Monday, 15 students walked out of school in protest.

Bayfield School Administrator David Aslyn says the smell upset people with allergies, but they're working on putting together the first-ever "smudging" policy in the state.

MIKE SIMONSON, *Wisconsin Public Radio News*, 2013

(OPPOSITE + BELOW) Madison, WI

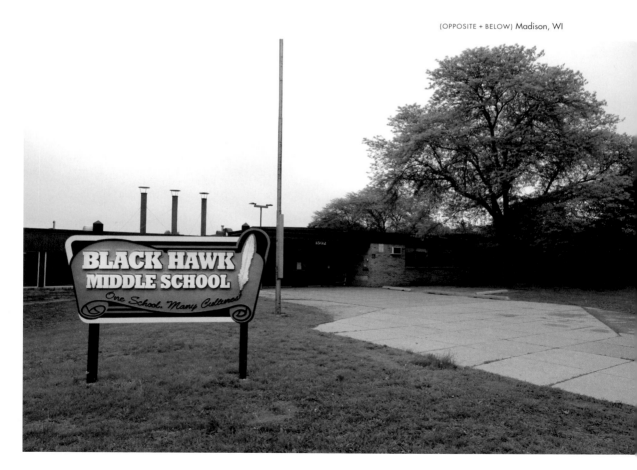

CONFIRMATION STATEMENT BEFORE THE SENATE COMMITTEE ON INDIAN AFFAIRS

I was born on the Menominee Indian Reservation in Wisconsin, a land of dense forests, a winding wild river, and streams and lakes that nourish the land, animals, and the people. I am an extension of this environment that has fostered my growth and enriched my vision. An appreciation and reverence for the land is fundamental to being Indian. . . .

The leaders of my tribe had signed the Wolf River Treaty of 1854 guaranteeing the Menominees 250,000 acres of land—*and sovereignty over that land—forever.* This was not a gift. Under decisions from Chief Justice John Marshall through the current Supreme Court, the Menominees, like other tribes, owned their land and much more before the treaty era. We ceded most of our aboriginal land held by us for thousands of years, and in the treaties reserved—thus the term "reservation"—a small part of it. Our tribal leaders were sophisticated people. They insisted upon land, sovereignty, and federal trust protection from the onrushing settlers. In that time of crisis, one of the greatest collisions of cultures in the history of the world, our leaders relied upon those promises. By the end of the treaty making, in 1871, tribes held 140 million acres. But the non-Indians marching West wanted more, and so the General Allotment Act of 1887 was passed. Indian land was opened for homesteading on a wholesale basis, and by the 1930s the tribal land base had dwindled to 50 million acres.

The next assault on our land and sovereignty was the termination policy of the 1950s. . . . This policy completely abrogated the federal trust relationship. State jurisdiction was imposed on tribal members and land. My tribe literally went from being prosperous to being Wisconsin's newest, smallest, and poorest county. Many terminated tribes saw their land sold off. My tribe's land was held by a state-chartered tribal corporation. The Termination Act stripped us of our treaty-guaranteed exemption from taxation, and our tribal leaders were forced to begin to sell off ancestral tribal land to pay the taxes.

By the 1960s, my people were in despair. Poverty had sunk to new depths and we faced the loss of our land, tribal identity, and culture. My own personal choice was clear. I had to leave law school, return to the reservation, and create a coalition of tribal leaders to reverse termination. . . .

At Menominee, we collectively discovered the kind of determination that human beings only find in times of impending destruction. Against all odds, we invented a new policy—restoration. Finally, after grueling work by more people than I could ever possibly thank, our coalition pushed the Menominee Restoration Act through Congress. This legislation is a vivid reminder of how great a government can be when it is large enough to admit and rectify its mistakes. It is also indicative of my tribe's spirit, tenacity, and ability to hold other sovereign entities accountable.

ADA E. DEER, nominee for Assistant Secretary for Indian Affairs, 1993

Shorewood Hills, WI

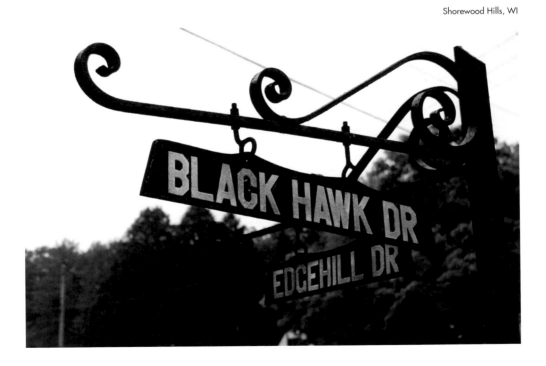

The Menominee Forest stands as a monument to the foresight of our ancestors who recognized the bounty they inherited. Today, because they acted as responsible stewards of these resources for future generations, we enjoy, cherish, and are sustained by the resources so wisely planned for and managed by them. Knowing that short term sacrifices must be endured at times to ensure the long term sustainability and quality of life, we strive to emulate our ancestors' discipline. . . .

To many, our forest may seem pristine and untouched. In reality, it is one of the most intensely managed tracts of forest in the lake states. During the past 140 years, we have harvested more than two and one-half billion board-feet of lumber from our land. That is the equivalent of cutting all the standing timber on the reservation almost twice over. Yet, the saw timber volume now standing is greater than that which was here in 1854 when the Wolf River Treaty defined the reservation.

MENOMINEE TRIBAL ENTERPRISES, *The Forest Keepers*, 1997

Shorewood Hills, WI

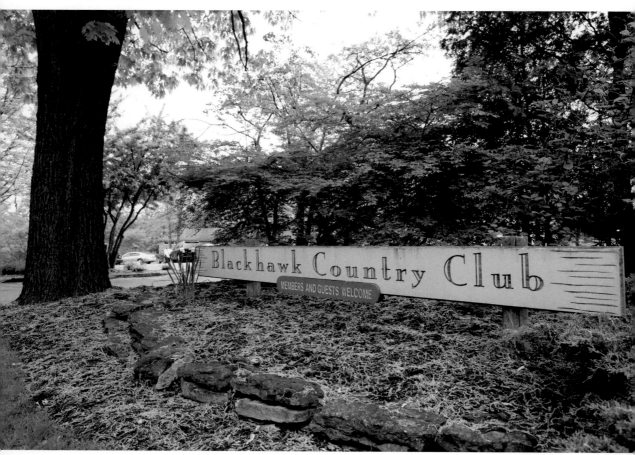

Verona, WI

TRADITIONAL FOODS

A movement is emerging in Native America. A revival of sorts, and it's deeply rooted in our food system. If you are in search of a trendy diet or carefully-portioned 200 calorie meal packaged neatly in cellophane and cardboard, you won't find it here.

This is a revival of traditional foods, the foods our ancestors cultivated, gathered, hunted, and preserved. A revival of tribal gardens flourishing with the sweet smell of blue and white corn, brightly colored chiles and ripe berries, and varieties of squash you have never seen. A restoration of fishing and gathering techniques, interwoven with traditional knowledge, stories, and language; the rebirth of buffalo herds and whole foods, honoring the generations that came before us.

When it comes to the revival of traditional foods in Native American communities, the Oneida Nation is among the leaders in this movement. . . .

The Oneida Community Integrated Food Systems entities are here as a team to help families by housing a community food system that will include traditional food products and help create a local economy that will provide jobs, and promote and encourage long range solutions to farm and nutrition issues on the Oneida Reservation. . . .

The Tsyunhehkwa program is the cultural food arm of OCIFS. They provide most of the traditional Oneida foods like the Oneida white corn, beans, squash and medicinal herbs. They also have a "Pick Your Own Berry" patch. In addition they have free range poultry, eggs, and grass fed beef. They also provide a vast array of garden produce. The Oneida Nation Farm produces black angus beef and grass fed bison. The Apple Orchard grows strawberries, raspberries, blackberries, squash, pumpkins and 26 varieties of apples.

CHELSEA WESNER, *Wellness in Native America*, 2012

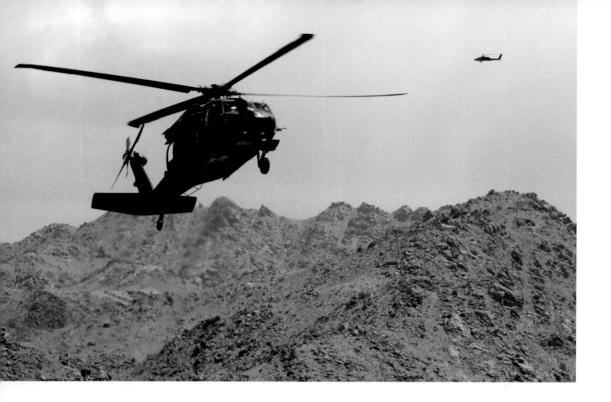

A WARRIOR CELEBRATION

American Indian warriors serve two nations, their own native nation and the United States. American Indians from many tribes have fought for the US in every war since the American Revolution, enlisting at rates higher than those of any other ethnic group. They continued to serve through World War I, even though they were not citizens at the time, and most did not receive US citizenship until 1924. Following the granting of citizenship, Native men could be drafted, but most still chose to enlist.

Many Ho-Chunks have distinguished themselves in US military service. The local American Legion Post 129 is named in honor of Andrew Blackhawk, a veteran of World War I who was gassed in that war. Mitchell Red Cloud Jr. received the Congressional Medal of Honor, posthumously, for service in the Korean War. Ho-Chunk people have continued to serve, fighting in conflicts ranging from Vietnam to Bosnia, and continuing that tradition of service today in the most recent conflict in Iraq.

The Ho-Chunks recognize the connection between contemporary military service and their warrior traditions. The Ho-Chunk Nation Veterans Affairs Committee has recently been pushing for a Veterans Service Office to be part of the tribe's Department of Heritage Preservation. Members of the Veterans Affairs Committee commented that placement of the office within this department "would be meaningful in that Ho-Chunk heritage is based on the 'warrior' culture."

SUSAN APPLEGATE KROUSE, *Visual Anthropology*, 2006

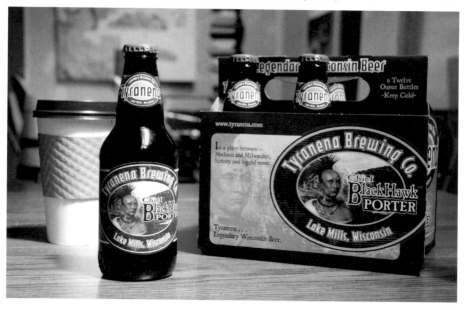

MAPLE SUGARED DEER AND LEEK STEW RECIPE

Ingredients:
1 tablespoon butter
2 pounds boneless deer shoulder meat, in chunks
1/4 medium cabbage, in thin wedges
1/4 small rutabaga, sliced
1 large carrot, in chunks
5 leeks, in small chunks
Salt
2 teaspoons grated fresh ginger
1 teaspoon ground black pepper
3/4 cup water
2–1/2 tablespoon butter
1/3 cup flour
Real maple syrup
Maple sugar

BISKAKONE,
"Editors Favorite Recipe," *Lac du Flambeau News*, 2007

THE CASINO COMPROMISE

Indian gaming, whose advent coincided in large part with Reagan-era cuts in Indian subsidies and the federal government's encouragement of tribal economic self-sufficiency and entrepreneurial activity, presented an ongoing opportunity to solve the "Indian problem"—essentially the same problem addressed by federal Indian policy since its inception—but without the perceived need to commit as many federal resources to the tribes. As some scholars have noted, this era of federal Indian policy "might be seen as either a period of the strengthening of the respect for tribal self-determination or as a period of termination by cessation of funding."

STEVEN LIGHT AND KATHRYN RAND, *Indian Gaming and Tribal Sovereignty*, 2005

(BELOW + OPPOSITE) Milton, WI

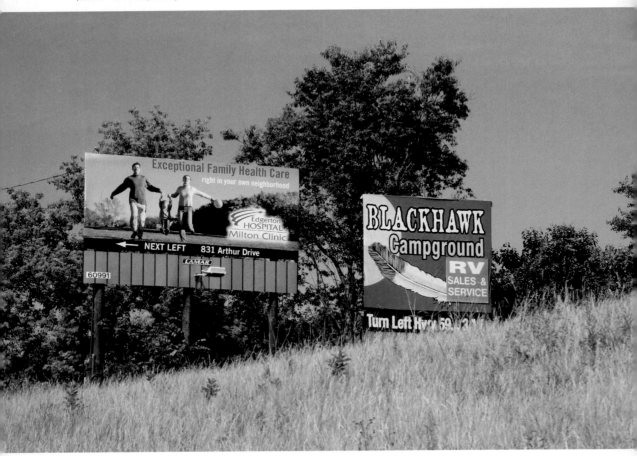

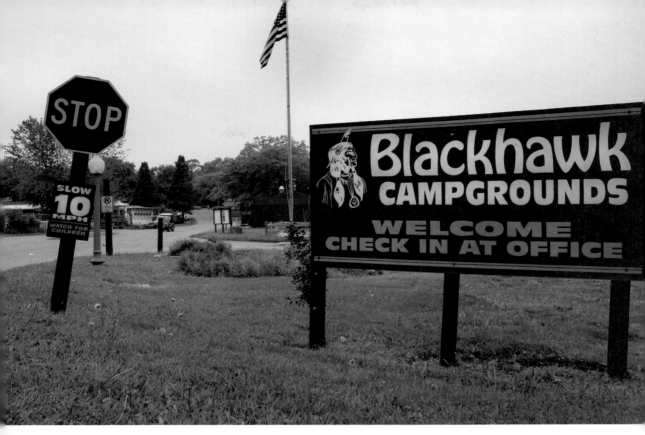

NATIVE AMERICANS AND THE CRIMINAL JUSTICE SYSTEM

The American native crime victimization rate is twice that of non-Indians. National crime victimization surveys reveal that whites perpetrate 57% of the violent crimes committed against American Indians. 80% of sexual assaults against Native Americans are perpetrated by whites.

The incarceration rate of Native Americans is 38% higher than the national rate. The U.S. Commission on Civil Rights attributes this higher rate to differential treatment by the criminal justice system, lack of access to adequate counsel and racial profiling. Law enforcement agents arrest American Indians and Alaskan Natives at twice the rate of the greater U.S. population for violent and property crimes. On average, American Indians receive longer sentences than non-Indians for crimes. They also tend to serve longer time in prison for their sentences than non-Native Americans. The suicide rate is higher among American native inmates incarcerated in jails than non-Indians. Within the prison system, Native Americans are often subject to abuse when attempting to identify with native cultures through the wearing of head-bands, using native languages, maintaining long-braided hair, listening to native music, and securing culturally-related educational material.

DEATH PENALTY INFORMATION CENTER,
"Native Americans and the Death Penalty," 2010

WE HOLD OUR HANDS UP: ON INDIGENOUS WOMEN'S LOVE AND RESISTANCE

Over the past few months, the world has witnessed the boundless love that Indigenous women have for their families, their lands, their nations, and themselves as Indigenous people. These profound forms of love motivate Indigenous women everywhere to resist and protest, to teach and inspire, and to hold accountable both Indigenous and non-Indigenous allies to their responsibilities to protect the values and traditions that serve as the foundation for the survival of the land and Indigenous peoples. These ways of being also provide a framework that ensures Indigenous women's relationship to the land and their human right to bodily sovereignty remain intact and free from violation. Specifically, women in the #IdleNoMore movement seek to protect the waters, the environment and the land from the threat of further destruction. Indeed, they seek protection not only for themselves but for those values, practices and traditions that are at the core of Indigenous women's power and sovereignty—concepts that have been, and remain under attack, and which strike at the core of a settler-colonial misogyny that refuses to acknowledge the ways it targets Indigenous women for destruction. . . .

Indeed, popular backlash against women in the #IdleNoMore movement demonstrates how Indigenous women's love is countered in patriarchal settler colonialist societies—with epidemic levels of violence, sexual assault, imprisonment and cultural and political disempowerment.

Because the colonizer has always known that to counter the power of Indigenous womanhood, you need to make acceptable the practice of hating Indian women.

DORY NASON, *Decolonization*, 2013

(ABOVE) Milton, WI | (OPPOSITE) Fort Atkinson, WI

BLACKHAWK
1225 HWY 12
BUSINESS CENTER

SJ- INDEPENDENT AUTO CARE
920-568-8800

CUPID'S CAR RENTAL INC.
920-568-8891

Major Wisconsin AUCTIONS
ESTATE SERVICES

"NOW BUYING"
"Gold - Silver - Antiques - Collectibles"
www.WisAuction.com
920-723-4309

Jake Leiser PAINTING
920-723-5611

SPEED LIMIT 30

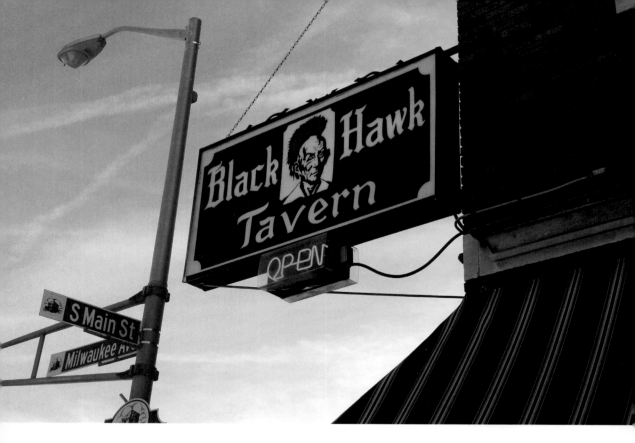

VAWA'S LOUDEST ADVOCATES FURTHER SILENCE NATIVE WOMEN

Many federally recognized tribes are celebrating the reauthorization of VAWA [Violence Against Women Act], which contains key provisions that authorize tribal courts to prosecute non-Indians in sexual assault and domestic violence cases on reservation. For too long, tribal courts in the Lower 48 have lacked the ability to prosecute non-Indians, and this is a promising step in the right direction.

Some tribes will undoubtedly benefit from expanded jurisdiction in this area, yet the nature of sexual assault and domestic violence in reservation communities has been distorted by many of VAWA's fiercest advocates. These advocates, who include Indian legal scholars, novelists and artists, have framed the issue as one in which non-Natives—acting with impunity in a jurisdictional vacuum—are almost solely responsible for violence against Indian women.

Yet those of us who are from or have spent significant time in Alaska Native or reservation communities know that the opposite is true: all too often, Native men are responsible for the bulk of violence against Native women in our communities.

In the run up to and since the passage of VAWA, countless news articles report a disturbing yet sloppily cited statistic: that in more than 86 percent of reported sexual assault and domestic violence cases on reservation, non-Indian men are the perpetrators. . . . The statistic gained widespread attention and began to be sweepingly applied to all reservation communities after it was cited in Amnesty International's high-profile 2007 report *Maze of Injustice*, even though both reports make it explicitly clear that there is very little reservation specific data on sexual assault and domestic violence.

This distortion of who perpetrates sexual assault and domestic violence in Native communities needs to end because it downplays the varied stories of survivors by placing responsibility almost solely on non-Natives. This is especially harmful in a society in which survivors already experience shame, victim blaming, and bullying. . . .

Instead of perpetuating the more than 80% statistic, we need to have an honest conversation in our community about how violence against Native women too often begins and ends with Native men. This includes identifying the action steps needed to change the way we think about and treat women, in addition to the systemic legal, jurisdictional and societal challenges that contribute to a flourishing rape culture on reservation and in the wider American society.

TIMOTHY AQUKKASUK ARGETSINGER, *Indian Country Today*, 2013

(OPPOSITE + BELOW) Fort Atkinson, WI

LOWER ELIGIBILITY AGE FOR AGING AND MEDICAID PROGRAMS

Life expectancy for Native Americans (65 years) is shorter than that of all other U.S. Non-Natives (73.3 years). The highest mortality rate is for people between the ages of 50–65. This means that the average Native American barely lives long enough to reach the age of eligibility for most age-related programs. In addition, evidence indicates that Native Americans experience the same limitations in their daily living at age 45 as do non-Native American people at age 65. Because of this, many Native elders would benefit from receiving earlier preventative care, screenings and early intervention treatment. Native American tradition generally considers a person an elder at age 55.

WISCONSIN DEPARTMENT OF HEALTH SERVICES,
"Department of Health Services and WI Indian Tribes
Consultation Implementation Plan, 2009"

THE BLACK HAWK WAR OF 1832

In 1990, the Wisconsin Legislature offered a formal apology to the Sac and Fox
Nation for Wisconsin's participation in the Black Hawk War. The principle chief
and members of Black Hawk's family accepted the apology gratefully.

ROBERT O. DODSWORTH,
The Battle of Wisconsin Heights and the Black Hawk War of 1832, 1996

REVISIONING LANDSCAPES AND POLITICS

Landscapes can often hold together a past and present, a present and a future, or all three together. They are often understood as repositories of the past, holding history in their contours and textures. W.G. Hoskins likened landscapes to palimpsests, traces upon layers of lines and marks, each left at a particular moment and still resonant, awaiting decoding. Indeed, looking at landscapes as evidence of past processes and events seems a strong temptation, much stronger than seeing landscapes as offering possibilities for the future. But the meanings of landscape, whether historical or for the future, are never simply there, inherent and voluble. Instead, they are made to speak, invited to show themselves, and that invitation is the process of practising landscape which always places landscape in a present moment. This presentation is a crucial one and a political one, for it disrupts accounts of landscape which seek to ground certain claims and identities in a self-evident earth. Landscapes are always perceived in a particular way at a particular time. They are mobilised, and in that mobilisation may become productive: productive in relation to a past or to a future, but that relation is always drawn with regard to a present.

MARK DORRIAN AND GILLIAN ROSE,
Deterritorialisations . . . Revisioning Landscapes and Politics, 2003

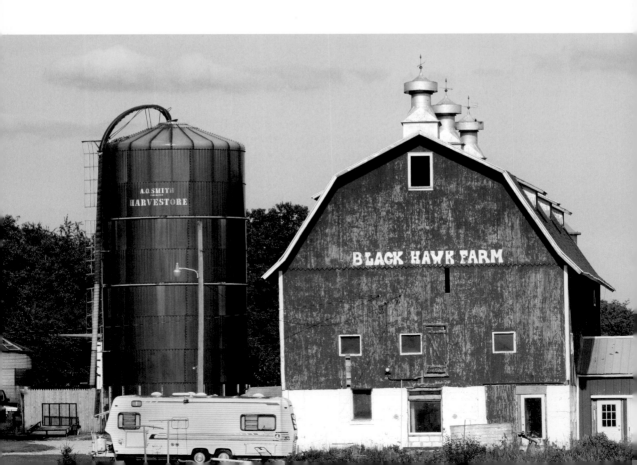

THE BATTLE FOR THE HEART OF AMERICA

It was a quarrelsome time [1829] and later, when looking back on that season of discontent, [Thomas] Forsyth wrote, "The squatters tried every method to annoy and trouble the Indians, by shooting their dogs, claiming horses not their own, complaining that the Indian horses broke into their cornfields, selling Indians whiskey for the most trifling articles against the wishes and requests of the Indian Chiefs and particularly the Black Hawk who solicited and threatened the Squatters not to sell any whiskey to Indians, but all to no purpose." . . .

After the war Black Hawk retreated more and more deeply into private life. . . . Black Hawk continued to live a somewhat ascetic existence, abstaining completely from the consumption of alcohol in any form, and before 1833, said John Spencer, he never "knew him to wear any part of a white man's garb." Like a good "puritan," he abhorred the contaminating influence American culture was having upon the traditional Sauk way of life and lamented the growing moral depravity of his own people caused mostly by the whiskey trade, and criticized them for becoming hypocrites, liars, and adulterers just like the whites.

KERRY A. TRASK, *Black Hawk*, 2007

HISTORIES OF ENDURANCE AND RENEWAL

All the Ojibwe bands have put a portion of their gaming profits into environmental programs, administered locally or through the Great Lakes Indian Fish and Wildlife Commission. Each band, for example, runs its own tribal fish hatchery and restocks not only lakes within its borders but also lakes throughout the ceded territory. Other programs include habitat enhancement, sea lamprey control, and shoreline improvement. Given the cultural importance of wild rice, it is not surprising that the Ojibwe annually reseed more than six tons of wild rice into dozens of existing rice beds and are working with state and federal officials to reestablish historical rice stands.

PATTY LOEW, *Indian Nations of Wisconsin*, 2001

SUBJECTS OF EMPIRE?

Stated bluntly, the theory and practice of Indigenous anti-colonialism, including Indigenous anti-capitalism, is best understood as a struggle primarily inspired by and oriented around *the question of land*—a struggle not only *for* land in the material sense, but also deeply *informed* by what the land *as system of reciprocal relations and obligations* can teach us about living our lives in relation to one another and the natural world in non-dominating and non-exploitative terms.

GLEN S. COULTHARD, "Subjects of Empire? Indigenous Peoples and the 'Politics of Recognition' in Canada," 2009

The Milwaukee Public Museum has thrown its hat into the arena with "A Tribute to Survival." It is the culmination of a 4-year collaboration between museum professionals and the urban and reservation Indian communities of Wisconsin. That partnership involved the planning and development of the major themes of the exhibition; the creation of the texts; the design of the powwow installation; and contributions of time, materials, expertise, and money from local Native American communities. . . .

The 6,500-square-foot gallery houses a chronological survey from precontact North America to modern-day "Indian Country" in Wisconsin. In an effort to emphasize the vitality of contemporary Native American communities, the design gives prominent focus to the powwow installation that greets the visitor at the entrance of the exhibition. There, 37 life-size nonmechanical dancers made from full body casts of local community members are posed on an enormous turntable. . . .

The constant presence of Native American voices is this exhibition's strength because they assert an active Native American perspective that until recently was not commonly found in the museum world.

JACKI THOMPSON RAND, *American Anthropologist*, 1994

(OPPOSITE + BELOW) Janesville, WI

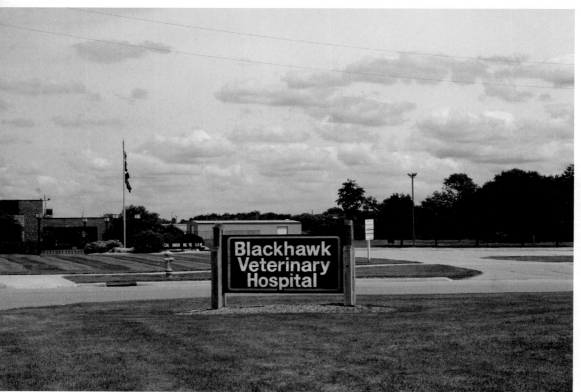

Blackhawk

VILLAGE SHOPPING CENTER

FAMILY DOLLAR

TREMORS
Bar & Grill

FRI SAT
AUTOMATIC
HAPPY B DAY
KENDRA

CONDE ST

Walgreens

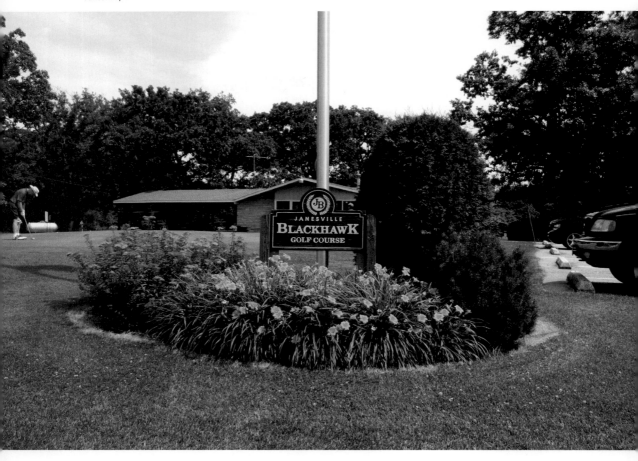

HAUNTINGS, MEMORY, PLACE

When people feel personally and culturally haunted by the past, they may evoke ghosts by making places that commemorate, question, remember, mourn, and forget. According to Avery Gordon, the ghost is a social figure through which something lost can be made to appear before our eyes, a way of coming to know the traumas that accompany modern life, even though those traumas may be socially repressed. One way people make ghosts appear is by selectively remembering particular understandings of the past through place . . . Although places are understood to be materially real and temporally stable . . . their meanings are made and remade in the present. Places are not only continuously interpreted; they are haunted by past structures of meaning and material presences from other times and lives.

Places of memory are created by individuals and social groups to give a shape to felt absences, fears, and desires that haunt contemporary society. Traditionally

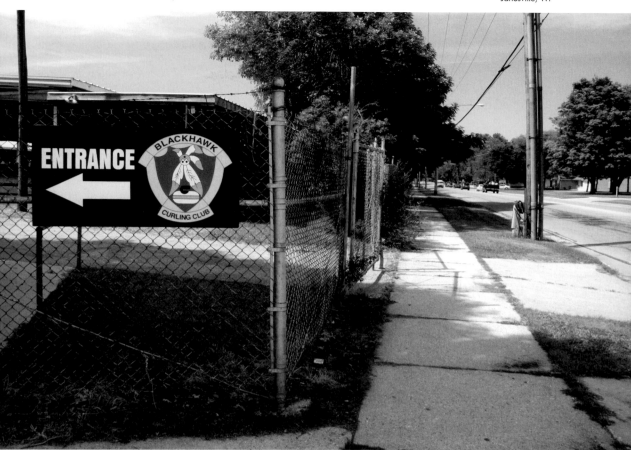

national places of memory were created and understood as glorifying the pasts of "a people." But such places are also made today to forget: they contain and house disturbing absences and ruptures, tales of violence. Places of memory both remember pasts and encrypt unnamed, yet powerfully felt absences—absences that might be considered modernity's ghosts of the nation. People speak of historic sites as eyewitnesses to the past or describe landscapes as original artifacts and traces from another time; they believe that by visiting these places they can experience, and perhaps work through, their contradictory emotions associated with feeling haunted by the past, including fear, anger, guilt, shame, sadness, longing, and unease. By representing places in these ways, people create social spaces defined by contemporary needs and desires; they emplace their social dreams and hopes for the future.

KAREN E. TILL, *The New Berlin*, 2005

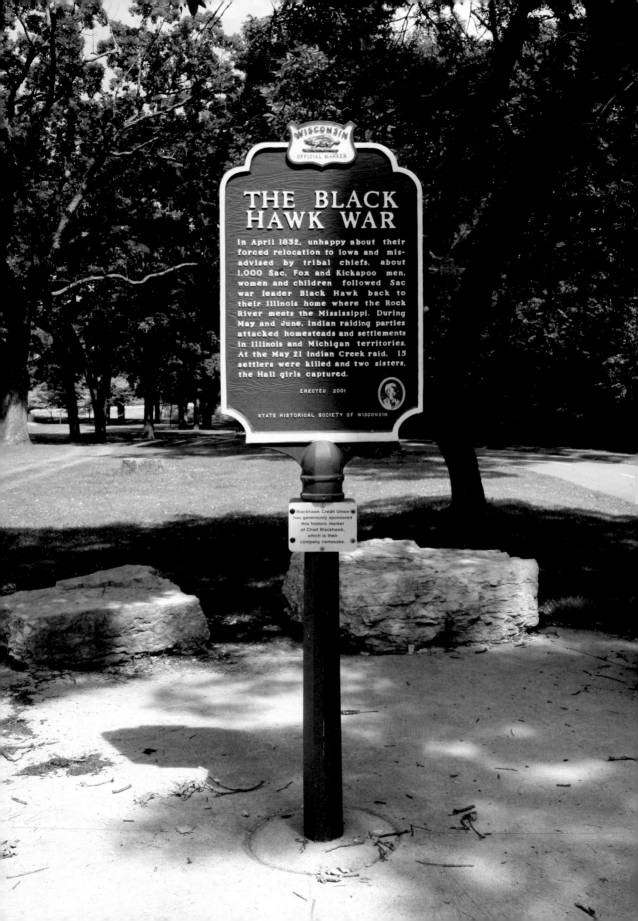

WISCONSIN
OFFICIAL MARKER

THE BLACK HAWK WAR

In April 1832, unhappy about their forced relocation to Iowa and mis-advised by tribal chiefs, about 1,000 Sac, Fox and Kickapoo men, women and children followed Sac war leader Black Hawk back to their Illinois home where the Rock River meets the Mississippi. During May and June, Indian raiding parties attacked homesteads and settlements in Illinois and Michigan territories. At the May 21 Indian Creek raid, 15 settlers were killed and two sisters, the Hall girls captured.

ERECTED 2001

STATE HISTORICAL SOCIETY OF WISCONSIN

Blackhawk Credit Union
has generously sponsored
this historic marker
of Chief Blackhawk,
which is their
company namesake.

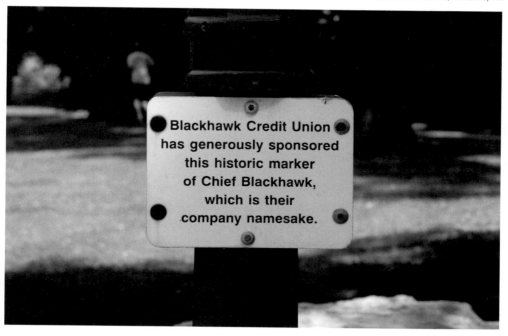

LET'S PLAY LEWIS AND CLARK!

Nothing better illustrates the problems endemic to this kind of approach to history as re-creation, or recreation, than the current passion for Civil War reenactments. The real war was certainly about slavery, race, and fear. But Civil War reenactors convert this into a story about heritage, courage, and valor. With its intense focus on the historical accuracy of costumes, weaponry, and troop movements, this recreational form of history gives its participants and audiences a powerful sense of authenticity. The result is a pleasant, even exciting excursion to "the past, a more authentic time," to quote a Union soldier I recently met. But this only ignores the unseemly legacies of slavery, race, and fear and, by actively ignoring them, only encourages their perpetuation into the future. In short, "living history" does not lead to deeper understandings of the past, nor does it let us see how the past shapes our world—it too often leads to shallow escapes from the deep historical problems of the present.

MARK SPENCE, in *Lewis and Clark*, 2004

INDIANS' REACTION VARIES OVER PROPERTY TAKEOVER

Indians who captured Milwaukee's old US Coast Guard station three years ago still stubbornly hold their enclave in a fashionable neighborhood on the Lake Michigan shoreline. . . .

They based their claim on 100-year-old treaty provisions that abandoned federal property would revert to the native inhabitants. The Coast Guard had moved to new quarters and the federal government had not yet sold the land or shifted control of it to another agency.

Law enforcement officers never seriously pressured the Indians to leave, and the Bureau of Indian Affairs said it is attempting to gain control of the land.

The Indians established on the base the Indian Community School, which had an enrollment of 76—from preschoolers to children of high school age—during the last academic year. Most are bused to the school from northwest Milwaukee, where many of the city's Indians live.

JAMES A. CARLSON, *Nashua Telegraph*, 1974

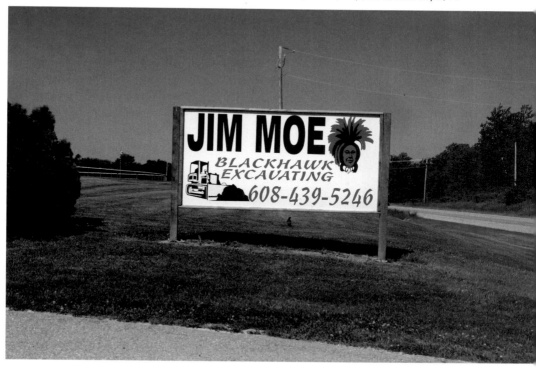

NATIVE AMERICAN SOCIAL AND POLITICAL THOUGHT

While acknowledgment of the relationship between education and culture is important, unless the relationship between culture and the socioeconomic conditions within which it is produced is recognized, the so-called at-risk conditions common to peoples living under siege will persist. With regard to American Indians, this means understanding that "the Indian problem" is not a problem of children and families but rather, first and foremost, a problem that has been consciously and historically produced by and through the system of colonization: a multidimensional force underwritten by Western Christianity, defined by white supremacy, and fueled by global capitalism.

Indian education was never simply about the desire to "civilize" or even de-culturalize a people, but rather, from its very inception, it was a project designed to colonize Indian minds as a means of gaining access to Indian labor, land, and resources.

SANDY GRANDE, *Red Pedagogy*, 2004

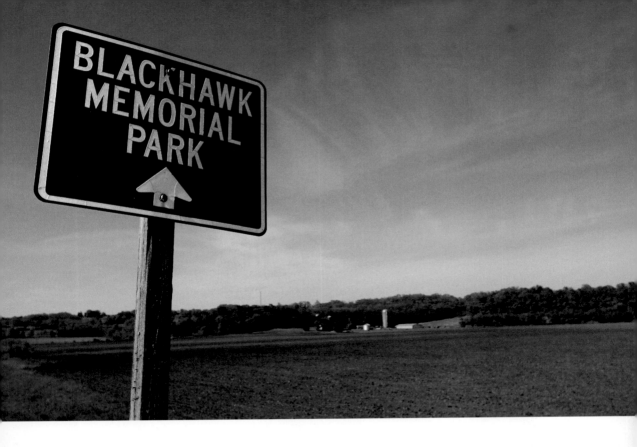

MEMORIES OF SURVIVAL: LDF BOARDING SCHOOL RESTORATION PROJECT

A government boarding school was constructed in Lac du Flambeau on the peninsula between Long Interlaken, Pokegama, and Flambeau Lake in 1895. What happened there during the time it operated (1895–1932) was not only a reflection of a systematic attack on tribal children, culture and language across the U.S., it had profound effects on local families and the community that are still visible today.

Throughout history, conquerors learned the best way to create a new culture in their own image is to start with the assimilation of young children. The U.S. Government used this method in the late 1800s when it still struggled with its mission to end Native tribes' control of their own lands. Beginning in the late 1800s, U.S. and Canadian authorities took Native children from their homes and attempted to educate, and sometimes beat, their identity out of them as part of a new plan to solve the "Indian problem."

Some tribal communities have begun attempts to heal. . . . Although there is disagreement in Native communities about how to approach the past, most agree that the first step is documentation. It is crucial that this history be exposed. The LDF Tribal Historic Preservation Office began the Restoration Project in 2002. It is planned in phases and includes grounds adjacent to the building. While this project is broad in its scope, its success could be critical to the healing of the community.

The Restoration Project could set into motion a chain of events starting with viewing the past abuse and forced hardships as the products of human rights violations from outside forces, instead of being an issue of individual failures and community dysfunction. For descendants of former students, overcoming the stigma of abuse can lead to personal breakthroughs. Lac du Flambeau would be an outstanding example of one of the tribes who are—at last—fighting back against the consequences of the government Indian Boarding Schools; the theft of their language, culture, and of childhood itself.

ABBEY THOMPSON, *Lac du Flambeau News*, 2007

(OPPOSITE + BELOW) South Wayne, WI

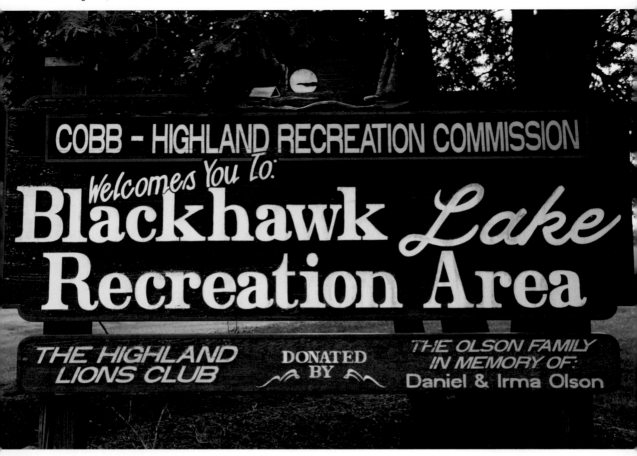

WHAT IS SETTLER COLONIALISM?

Settler colonialism is an inherited silence where you know memories are supposed to be. It is knowing that these memories have been purposely excised due to pain and the hope for a better future, if only the next generation could just forget. It is a man aging into regret for having shut out his children and grandchildren from his life and the lives of his loved ones. It is his granddaughter wanting to go back in time to hurt whoever hurt him decades ago. It is the proliferation of documents and of bureaucracy. It is opening a locked suitcase and finding papers, land allotments, and photos of relatives you have never seen. It is exploring these photos, wondering about the names of the people in them, knowing that even if you knew those names you would not know how to pronounce them or understand their meaning. It is understanding that these family documents and photos could be in a museum; there they would be made to tell a story outside the twinned nature of nation building and genocide. . . .

Settler colonialism is the history of a family welded together by natives and settlers. It is the logic of superiority, of primacy, of genocide. It is the colonization of memory and of events that come to be known as "History." It is visiting a reservation or a refugee camp and wondering how this could have been your life. It is being thankful that this is not your life and that this is only a visit or a passion, an act of activism, a choice to be here. It is realizing that this confidence in one's place has been bought with the logic and practice of settler colonialism. It is wanting answers to inquiries you cannot, and probably will never, articulate. It is seeking epiphany through writing and finding only the proliferation of questions, of doubts, and of buried histories. Like these questions, and more than anything, settler colonialism is ongoing.

MAYA MIKDASHI, *American Indian Culture and Research Journal*, 2013

**Even Though He Had a Native
Person Standing in Front of Him,
He Just Did Not See Me:**
*An Interview with Sandra Massey
Historic Preservation Officer
Sac and Fox Nation*

SARAH E. KANOUSE

Sarah E. Kanouse (sk): The story that typically gets told of the Black Hawk War is the main-stream, white American point of view. What would the Sac and Fox Nation history be?

Sandra Massey (sm): First of all, I always tell people that there was no war. Black Hawk never intended war when he went back to Illinois. We know this because women, children, and old people were with him. It wasn't a military offensive. They were just going back to their homelands where their crops were because they were starving. When the soldiers were firing on us at Bad Axe, that's who they were killing: women, children, and old people. The word "war" gives the impression that there are two adversaries who are more or less on equal ground, at least in fighting. But there's nothing noble about killing a woman carrying her baby across a flooded river.

So "war" has been a popular concept. But, I also have to expect that—the concept of "war" perpetuates the myth of us being savage warriors, and so of course you need American soldiers to keep order against people like that. Instead, I use the word "conflict." I'm not really sure that that's the best word either because it still gives the idea that we were antagonists. Going back to Illinois was never meant to be that way. So, I say "conflict" for now to point out it's not a war. There may be a better word that we might use in the future.

sk: What do we stand to gain or lose by speaking more truthfully about events like the Black Hawk conflict?

sm: If our side of the story was told more accurately and more fully, I think there would be a better understanding of not only the time we were living in but also of us as a people. Black Hawk talked about many things that we are still dealing with today. Even our belief system and our cultural practices are largely the same.

What would be lost isn't so much on our side. A lot of people never heard that there were women and children and old people. If you knew the truth about the

soldiers at Bad Axe and who they were really firing on, they're no longer these great soldiers of America. They are basically murderers.

I gave a speech in Wisconsin Heights a couple of years ago, and when the audience heard that, a lot of them cried. I think they focused on the women and the children and the old people and thought about them being chased down. I think they could see themselves in that situation. A lot of the people who reached out to me were women. I think they can relate to that and wonder how they would feel if they were being chased and had their little ones or their older relatives like their parents with them. They can put themselves in that position. Once you know more details, you know this wasn't a war party. When you hear the term "war party" it justifies war as a response, because their job was to go out and make war. But if you find out, well, no, there were other people there who would not have been there if it was a war—that changes everything.

SK: Could you describe the enduring significance of Black Hawk to the Sac and Fox Nation today?

SM: We all think highly of him because he put his people first, he believed in justice, and he was really ahead of his time. [With his autobiography] he put his life on record—the first Native American to ever do that. He explained his side of the Black Hawk conflict, but he also preserved the time he came from. He described our ceremonies, some of which we still do today while others have been lost. He basically saved a slice of life.

I think he was such a far-thinking man. He knew that tribes were sovereign. He knew the Treaty of 1804 was invalid. He had great respect for the gravesites of his ancestors. He gave his last, great stand and got pushed away anyway. Even if it didn't work, he did try to stand up for his people and our right not to leave our land. He fought for what was right. He knew what was right. We can all relate to that, the idea of being a fighter for what is right.

SK: Black Hawk's vision of justice included respect for the ancestors' graves as well as your history as a people and cultural and religious traditions more generally. What does your office—the Historic Preservation Office—do to protect the legacy of the past and work toward the future?

SM: This office implements not only the Native American Graves Protection and Repatriation Act (NAGPRA) but also the National Historic Preservation Act (NHPA), the American Indian Religious Freedom Act (AIRFA), and to a lesser degree the National Environmental Policy Act, which also has to follow section 106 [of the National Historic Preservation Act, which requires federal agencies to evaluate and mitigate the effects of their activities on historic, cultural, or religious sites]. Other agencies that have to implement these laws have to contact us and consult with us. In that way we are helping agencies to enforce the law. Nobody sees a lot of that—it's kind of behind the scenes. In a way, we're law enforcement.

The Historic Preservation Office has evolved into doing more than strictly NAGPRA and enforcement. We have been able to do a lot more outreach. A few

years ago was president Abraham Lincoln's 200th birthday. The State of Wisconsin mandated that every historic site commemorate the event with activities related to Lincoln. Site Director Michael Douglass of Villa Louis in Prairie du Chien, Wisconsin, invited us to participate in an encampment because the Sac and Fox were the only connection they had to Lincoln [who served in the Illinois militia in the Black Hawk conflict]. We were able to reach out to people who may not want to read history books or aren't too familiar with the history of the land. We also have a traveling exhibit through the Missouri Humanities Council that talks about our connection to the land there. Sac and Fox Nation Principal Chief George Thurman is a descendant of Black Hawk and took part in the reopening of the Apple River Fort [in Illinois], which ties the history of the Black Hawk conflict with the present time.

It's really good to do these events and meet people face to face. They can know us as people and maybe become a little more interested in what we do. They see the living reminder of a people who may otherwise seem like ghosts because we no longer live in an area where we were a big part of its history. We have a few tribal members living in the Midwest, but we're not there as a people anymore. But the Sac and Fox Nation is alive and well. We haven't disappeared, and we're not just part of a history. We're not dusty relics. We are still alive here with a thriving and working government, and we are a people who still retain our ancient practices.

sk: *What is the nation's relationship to its traditional homeland in Wisconsin, Illinois, and Iowa? How do you work to reconnect with this land and to protect it?*

sm: Well, on a personal level, there are so many people here in Oklahoma who have relatives in Iowa. The tribe in Iowa and the tribe in Oklahoma have never lost contact and the feeling of family. All my life we've been going to the Meskwaki Settlement in Tama to visit relatives. My grandfather came from up there. We have had constant movement between the two states. We have always been connected and always had this relationship with each other. Going to Iowa is almost like going home because we have the Sac and Fox there.

The State of Iowa has always been pretty good about contacting us with any projects [that impact the tribe]. Of course, we have a resident tribe there so that makes it a lot easier. The agencies have been really good about doing reburials and trying to protect sites. Even before NAGPRA, Iowa was great. Wisconsin already gave us a formal apology for the Bad Axe massacre years ago, and there are people working to preserve [the Black Hawk conflict site at] Wisconsin Heights. Places like Villa Louis, where there are so many layers of history, have been really eager to have us there to present our part in it. Wisconsin has also been pretty good. The people in those two states understand that we have a connection to those places even before we say anything. They want us to keep that connection, so they work very well with us.

Illinois is just now starting to reach out and communicate with us. I see a lot of things named after Black Hawk or the Sauk all over but yet we don't really hear much from the state. It's kind of sad because so much of the history that

people know us through, like Black Hawk, was centered in Illinois, and for a lot of people here in Oklahoma their memories stop at Illinois. They don't really think about the fact that we actually came from a lot farther back to the north and east. Everyone still recognizes Illinois as the homeland, and yet Illinois still doesn't deal with us on a governmental level. It's one of the states that hasn't stepped up to the plate as it should have.

SK: *In 2006, the Sac and Fox Nation passed a resolution asking Black Hawk College in Moline, Illinois, to stop using the "Braves" and "Warriors" and "Chieftains" as the name and mascots for sports teams. I was wondering if the tribe has made any similar requests? What do you think of the use of Black Hawk's name more generally?*

SM: A number of years ago, we were part of a group of tribes who passed a resolution opposing any Indian references in mascots. Since then, individual groups have called us to ask, "We would like to use this name, and is this okay?" Sometimes it doesn't have anything to do with Black Hawk the man—it's about the bird. But if they plan to use an Indian image, that changes everything because it implies a connection to Black Hawk, and we say no because we do not want to reduce him to a mascot. It perpetuates the savage warrior myth. People don't ever do the research into the whole history of a name to understand its origin. They pick up an idea and carry that through instead.

In New Orleans there is a church that picked up on the idea of Black Hawk as a spirit of justice. They have taken him as an idea but have gone way, way far from who he really was by what they use in their rituals. I read a book about it that describes the use of Indian images in full headdress. The Sac and Fox didn't wear headdresses. It mentioned how people dance and "channel" him. The book quoted one person who claimed to be channeling Black Hawk as saying, "Me Black Hawk, me help you." And I thought, "Me not like that," because, you know, that's just an idea of what your stereotypical Indian would say. This sort of thing just skims the top and grabs an idea or part of an idea. Without knowing anything about Black Hawk or the Sauk, such practices just bastardize our history and essentially say that the truth is irrelevant.

SK: *From the news reports that I read, it seemed that in this case the tribe was making a distinction between using Black Hawk's name for the college versus the "Braves," "Warriors," "Chieftains," and the associated imagery. And I was interested in how you make that distinction. Are there examples of respectful and appropriate uses of Black Hawk's name and image?*

SM: Whatever the status of the mascot issue, Black Hawk College has named some of their streets after Black Hawk's family. I thought that was okay because they actually did research on his family. The college published a book about the street names and included some of our history in the area. Even though the college may have been asked to remove the mascot, I think it tried to show respect through the street names and book. It didn't just say, "Well, we're going to name these streets after this guy and his family"; the college actually tells you why he is important.

SK: *Could you talk a little about some of the most pressing challenges that the tribe is facing today? I'm thinking particularly in the areas of protecting sovereignty, language, culture, land and water rights, but also any others you feel you would like to share with me.*

SM: I can speak best about language and culture. People don't always recognize that there is a real problem in saving our language and history. Even within the tribe in the very beginning, people didn't really know why this department would be important, especially if they're not part of the traditional culture. We have tribal members who don't go to ceremonies, who don't know the history that well, who don't know our customs. They don't know why this is important because they can't hold it or see it as something tangible. When we first started, we didn't really have funding. We had to be a constant presence to reach the point where we are now—we do have funding, we do have the support of our government, and we do have the support of the people.

Johnathan Buffalo, Meskwaki historic preservation officer, said, "If they fix the roads, you can ride on the road and say, 'This is a really smooth road!' Or if they build houses, you can say, 'Yeah, I see it over there! That's a pretty house!' All we can do is hold up a bunch of papers and say, 'Here are the letters we wrote.'" Most of what we do is out of state, and if we do our jobs well, you never have to know about it. That's what hurts us in showing our accomplishments on behalf of the tribe.

Thinking outside the tribe—people are questioning the value of the humanities everywhere. It's a big umbrella, but what is it, exactly? The humanities are the preservation of human stories and history and their impact on the larger histories of place or time. Archaeology tells the scientific stories through the physical remnants people left behind, and anthropology tells the stories of a people but as more of a scientific or recordkeeping venture. The humanities tell the story in a more human way, a more personal way, from the perspectives of the people themselves, or so it seems in my experience. The humanities projects I've worked on have focused on providing a means for my tribal history to be told through our tribal members and our tribal activities, skills, or practices, and that's how they work in local and state projects, too. State humanities councils have also brought exhibits such as those from the Smithsonian to the people in their states and help in the understanding of history on a national level and as it relates to them in their town or even personally. These stories are part of the making of our national heritage.

SK: *So, what do you say when someone says, "Oh, language and culture preservation? Why do you need that?" How do you explain why that's an important thing for the tribe to be investing in?*

SM: Well, for one, language is part of our identity. If you don't have the language, then you lose part of your identity. Our language is truly ours, unique unto us. We believe our Creator gave us our language. My mother Henrietta is one of our language speakers working to preserve our language. She agrees with a speaker from another tribe who said, "Language keeps us sovereign." Other tribes may be

able to communicate with us through our similar languages but we will each have something different, a different word or pronunciation of a word. Even among the Sac and Fox tribes are such differences, and someone familiar with our languages who hears a speaker will be able to tell if that person is Thakiwa [Sauk] or Meskwaki. Word choice also gives the listener an idea about the time period in which the speaker grew up, because even a ten-year difference in age can mean that speakers, although speaking the same language, will use different words to say the same thing. Fluent speakers also know the genders use different words. In Iowa there are also about three different accents from the same settlement.

Historic preservation is important not just for the Sac and Fox but for everyone. When your history is gone, how are you going to know where you came from or who you are? For instance, the Black Hawk conflict is part of the reason we're in Oklahoma right now. We got pushed out of Illinois and out of Kansas. I was born in Oklahoma because my people were forced away from our homelands. But Black Hawk's burial site is still on undisturbed ground. Maybe somebody wouldn't think that saving a piece of ground would matter, but what do you do if everything is all plowed over with parking lots? Where do you go? It makes it more real to have something you can see and touch and be part of.

As for our burial and sacred sites, preservation is important because those sites tie into who we are as Sac and Fox people. We came from these places, and we are still connected because the people who were there are a part of who we are now. We have our own identity as a tribe, and our ceremonies and language make us that way. Maybe we've had to adjust because we're displaced, but we still have the heart of it. We still have the spirit of something our ancestors would recognize. So that's one other reason that we take it personally when anything happens to our former homelands because we are still connected to those people. We don't think in a straight line. Our thinking is more circular. Everybody who came before is in everybody who is here now, and everybody who is here now is going to be a part of whoever's coming after. They're not just some distant memory. They are as close to us as, well, the grandparents we grew up with.

sk: *Among non-Natives in the Midwest, there is a disconnect between the image of Black Hawk or the knowledge that Black Hawk existed, on the one hand, and the awareness of any kind of present day reality of Native American people in the region, on the other. Do you have any ideas or suggestions for how non-Native people who are curious about that history might channel their interest in ways that are useful in the present.*

sm: It's hard to answer that question because my first thought is about the non-Natives who have wanted to help us, but then they tell me my spirits are talking to them . . .

sk: *Sort of a New Age type of thing?*

sm: Yeah, we do get some of that. We also get people who say they want to help us get back our homelands, but it's actually more of an economic venture for them.

Then you have others who want us there because they seem to worship the idea of bringing to life this ghostly tribe, I guess.

A few years back I did a Chautauqua with the Missouri and Illinois Humanities Councils. At a store in Illinois was a man who said if we ever had an uprising, he wanted to join us. He just thought it was terrible how we were treated. Even though he's saying all these things totally in support of Native people, he's still not seeing me as a real person because he's plugging into the idea of these poor, mistreated people who are all going to rise up one day and he wants to be with us. That's not seeing who we really are. We don't have to rise up in that way. We have other avenues that we can try. Even though he had a Native person standing in front of him, he just did not see me.

But I know there are positive ways non-Natives recognize our part in their local history. For instance, a local historical society in Illinois wanted to put up a statue of Abraham Lincoln at Stillman's Run. They felt that if they put Lincoln there, they should put Black Hawk there, too. Instead of just commissioning a statue of Black Hawk, they asked us if we had any images to use or how he dressed, because they wanted to be accurate. They didn't feel forced to include us nor were they caught up by apologizing, "Oh, we're all such evil people for what happened to you and yours." They just said, "We know he's as much a part of the history as Lincoln, and we wanted to have him there and do it right." There are more people now who don't need a federal law to compel them to do the right thing, and that's a big step forward for all of us.

6.
Illinois

THE LAST OF THE ILLINOIS AND A SKETCH OF THE POTTAWATOMIES

Their name, even, now must be blotted out from among the names of the aboriginal tribes. Henceforth they must cease to be of the present, and could only be remembered as a part of the past. This is the last we know of the last of the Illinois. They were once a great and a prosperous people, as advanced and as humane as any of the aborigines around them; we do not know that a drop of their blood now animates a human being, but their name is perpetuated in this great State, of whose record of the past all of us feel so proud, and of whose future the hopes of us all are so sanguine.

JOHN DEAN CANTON, *The Last of the Illinois and a Sketch of the Pottawatomies*, 1870

Chicago, IL

South Beloit, IL

DANCING THE WORLD INTO BEING

Over the past 400 years, there has never been a time when indigenous peoples were not resisting colonialism. Idle No More is the latest—visible to the mainstream—resistance and it is part of an ongoing historical and contemporary push to protect our lands, our cultures, our nationhoods, and our languages. To me, it feels like there has been an intensification of colonial pillage, or that's what the Harper government is preparing for—the hyper-extraction of natural resources on indigenous lands. But really, every single Canadian government has placed that kind of thinking at its core when it comes to indigenous peoples. . . .

Our elders have been warning us about this for generations now—they saw the unsustainability of settler society immediately. Societies based on conquest cannot be sustained, so yes, I do think we're getting closer to that breaking point for sure. We're running out of time. We're losing the opportunity to turn this thing around. We don't have time for this massive slow transformation into something that's sustainable and alternative. I do feel like I'm getting pushed up against the wall. Maybe my ancestors felt that 200 years ago or 400 years ago. But I don't think it matters. I think that the impetus to act and to change and to transform, for me, exists whether or not this is the end of the world. If a river is threatened, it's the end of the world for those fish. It's been the end of the world for somebody all along. And I think the sadness and the trauma of that is reason enough for me to act. . . .

Extraction and assimilation go together. Colonialism and capitalism are based on extracting and assimilating. My land is seen as a resource. My relatives in the plant and animal worlds are seen as resources. My culture and knowledge is a resource. My body is a resource and my children are a resource because they are the potential to grow, maintain, and uphold the extraction-assimilation system. The act of extraction removes all of the relationships that give whatever is being extracted meaning. Extracting is taking. Actually, extracting is stealing—it is taking without consent, without thought, care or even knowledge of the impacts that extraction has on the other living things in that environment. That's always been a part of colonialism and conquest. Colonialism has always extracted the indigenous—extraction of indigenous knowledge, indigenous women, indigenous peoples.

NAOMI KLEIN, in conversation with Leanne Simpson,
YES! Magazine, 2013

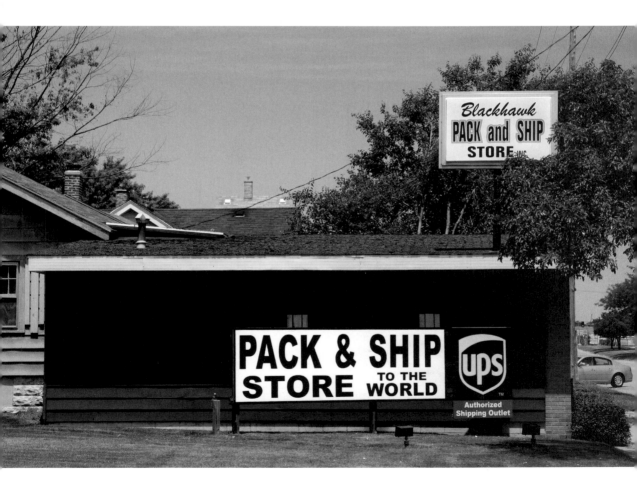

South Beloit, IL

AT HOME IN ILLINOIS: PRESENCE OF CHIEF ILLINIWEK, ABSENCE OF NATIVE AMERICANS

History is, however, not simply what happened, but the representation of what happened. Dominant representations of Native-settler historical encounters in places like Champaign-Urbana have tended until recently to play up white settlers and downplay, even erase, Native Americans in subtle and not so subtle ways. . . .

Key in this regard is that in the heart of the heart of Chief Illiniwek country, there is literally nothing, a historical absence, a nonperson. Chief Illiniwek is a sign without a historical referent, a free-floating signifier in a prairie-flat land wiped clean, erased of Native Americans. This makes the literalness with which pro-Chief supporters invoke and refer to Chief Illiniwek—as if it were a part of them—all the more a conundrum.

DAVID PROCHASKA, in *Team Spirits*, 2001

South Beloit, IL

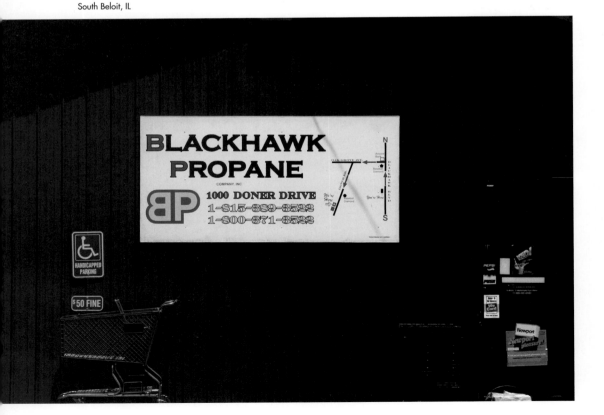

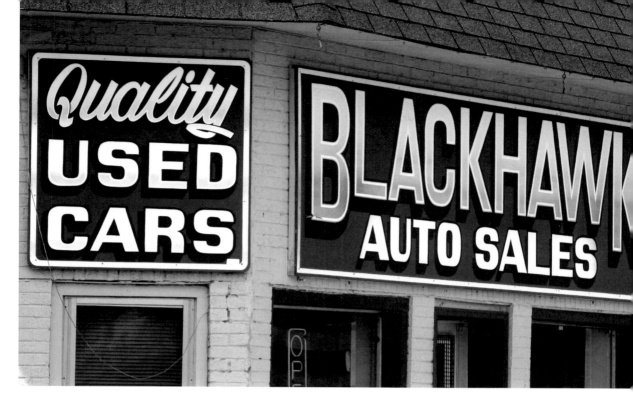

COMING HOME: THE RETURN OF THE ANCESTORS

According to the spiritual ways of North American Native peoples in general, death is the passage from life in one world to life in the next—a journey that must not be interrupted. Burial sites took many forms depending on the individual Nation's practices, but one code was universal: the ancestors must not be disturbed in their final resting place . . . In Illinois, there was no legal protection for unmarked burials until 1989, and Indian burials were either removed or swept aside to make way for the burgeoning population. . . .

An era of nearly seven decades of desecration in Illinois ended with the closing of the burial exhibit at Dickson Mounds Museum on April 3, 1992. Its legacy of abuse began in 1927 when chiropractor and land owner, Don F. Dickson, began the systematic uncovering of 248 Native American remains, which he left intact and exposed to view. This became a highly-publicized "tourist attraction" that brought, at its peak, 80,000 visitors a year. Native Americans began to challenge the right of museums to display human remains for public viewing, and Dickson Mounds became a symbol of the widespread disregard for Native rights. After repeated demonstrations and negative press coverage beginning in 1990, the museum finally agreed to place cedar planks over the burial chamber as a form of reburial, found acceptable to some and incomplete to others. The ancestors' remains were, however, successfully removed from public view.

CLARE FARRELL, in *Native Chicago*, 1998

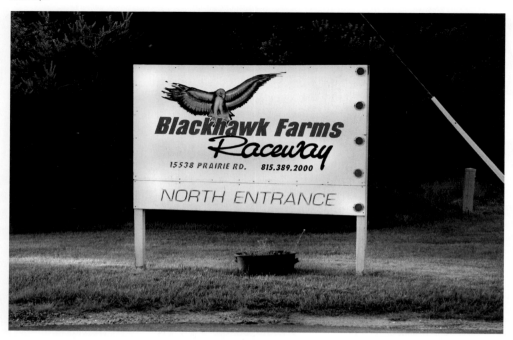

ENBRIDGE AND ENBRIDGE ENERGY PARTNERS L.P. PROJECT EXPANSIONS

Enbridge has secured commercial support to proceed with several projects designed to increase capacity on the Enbridge crude oil mainline system in Canada and the U.S. and to increase capacity on pipelines that serve eastern U.S. and Canadian refineries. . . .

The expansion of the Lakehead System includes $0.4 billion of projects to expand capacity of the Lakehead System mainline between its origin near Neche, North Dakota, to its growing terminal hub in Flanagan, Illinois, southwest of Chicago. The projects include an expansion of the Alberta Clipper line (Line 67) between the border and Superior, Wisconsin from 450,000 bpd to 570,000 bpd; and expansion of the 42-inch Southern Access pipeline (Line 61) between Superior and Flanagan Terminal near Pontiac, Illinois from 400,000 bpd to 560,000 bpd. Both projects require only the addition of pumping horsepower, with no pipeline construction.

The expansions are expected to be available for service in mid-2014 subject to finalization of scope and shipper approval. The scope of the expansions remains under discussion with and subject to approval by shippers, which could lead to an upward revision to capacity and cost.

ENBRIDGE, 2012

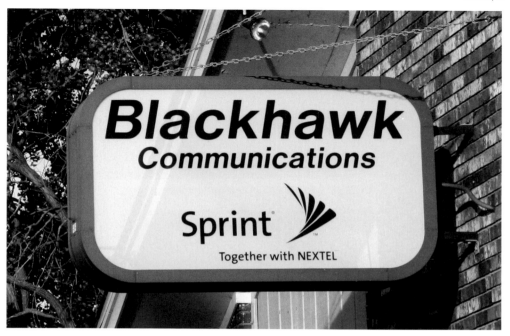

RED LAKE CHIPPEWA DISCOVER ENBRIDGE TAR SANDS PIPELINES THROUGH NATION-OWNED LAND HAVE NO EASEMENT CONTRACTS

For over two weeks now, Nizhawendaamin Inaakiminaan (We Love Our Land) has been occupying land directly above four pipelines across an easement that Enbridge has claimed since 1949 when the company, then called Lakehead Pipe Line Company, installed the first of four pipelines across land owned by the Red Lake Band of Chippewa despite not having an easement from the Red Lake Chippewa Nation. These pipes carry toxic tar sands, Bakken oil, as well as Canadian crude. By threatening the local lakes, these pipes endanger the lives and economic livelihood of Red Lake Band members.

The grassroots group of Red Lake Chippewa and Anishinaabe Indians is joined by blockaders and solidarity activists determined to shut down the pipelines, hold Enbridge to account for stealing land, and protest Enbridge's proposed expansion of the nearby Alberta Clipper toxic tar sands pipeline. . . .

Similar encampments, like the Unist'ot'en Camp, have been springing up across the continent to fight the fossil fuel industry and stop the destruction of sacred lands in the pursuit of ever-more dangerous and destructive fossil fuel resources. Indeed, the pipeline industry would be hard pressed to imagine a tougher time in which to be doing business.

TAR SANDS BLOCKADE, 2013

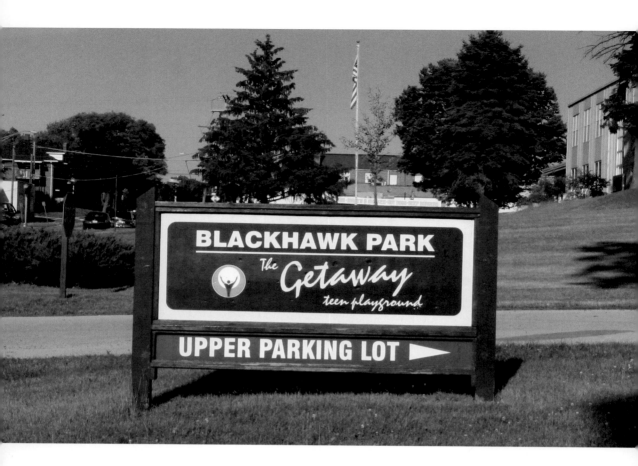

TRIBAL LAND CLAIM MEETS RESISTANCE IN ILLINOIS

A century and a half ago, U.S. Army troops herded the Miami Indians of the upper Midwest at gunpoint onto canal barges and deported them to Kansas, leaving Illinois—a state with an Algonquian name meaning "tribe of superior men"— without a single Native American tribe.

Now the Algonquian-speaking Miamis, who eventually were moved to a reservation in northeastern Oklahoma, are in federal court claiming 2.6 million acres of their ancestral home. The lawsuit contends the U.S. government violated treaties made with the tribe in 1795 and 1805 by selling the Illinois land to white settlers during the western expansion.

If successful, the lawsuit could lead to the eviction of thousands of private landowners from property the Indians estimate is now worth $30 billion and which, in some cases, has been owned by the same white families for generations. If the state intervenes to seek a dismissal of the case, as it has asked the court's permission to do, the tribe could seek title to state land containing the University of Illinois at Champaign-Urbana, tribal leaders contend.

As in similar Indian property claims that have been growing in number across the country, the historic roles of white men and Indians have been reversed. White

landowners are complaining that they are the victims of a ruthless land grab by greedy Indians backed by a complicit federal government. . . .

Tim Yow, one of 15 property owners who were symbolically named in the lawsuit—one for each county in dispute—said the sovereignty issue inherent in the land claim already has clouded the title to his house in the event he tries to sell it. But Yow said he doesn't want the state to settle with the Indians "just to get my neck out of the noose."

"As soon as you concede on this, then they have their reservation and they're not under any of our laws. Then they can do anything they want," Yow said. "I do feel sorry for everything that happened to the Indians, but to the victor goes the spoils. What do we do, give Texas back to the Mexicans?"

WILLIAM CLAIBORNE, *Washington Post*, 2001

(OPPOSITE + BELOW) Rockford, IL

HAWKS' LOGO MAY BE NO-GO

Blackhawks forward Blair Atcheynum, a Native American, doesn't have a problem with his team's logo. He feels the depiction of Chief Blackhawk represents honor and tradition.

But Atcheynum also understands the argument against using Native American caricatures as emblems for sports teams.

"Usually when a major team uses a logo, it's met with a lot of pride," Atcheynum said. "It's not a joke. But it'd be interesting to see a team called the Houston Blackmen use the head of a black man as their logo, and see how society views that."

Vernon Bellecourt, president of the National Coalition on Racism in Sports and Media, has used the same argument in battles with professional franchises such as the Washington Redskins, Atlanta Braves, Cleveland Indians and Kansas City Chiefs. Bellecourt also has tried to change the logos used by universities such as Florida State, Utah and North Dakota. And he is involved in the dispute over Chief Illiniwek, the controversial mascot used by the University of Illinois.

"The Chicago Blackhawks are on our list," Bellecourt said. "We haven't filed a lawsuit because we have our plate full at the present time. But they ought to read the handwriting on the wall. At some point, we will urge the owners to begin a dialogue with us, with the result being that they also change their name."

JENNIFER JONES, *Chicago Sun-Times*, 2000

OJIBWE GEORGE MARTIN CARRIES IN EAGLE STAFF BEFORE SOLD OUT STANLEY CUP PLAYOFF CROWD

Respected Ojibwe elder George Martin carried the Eagle Staff in front of a sold-out crowd prior to Game One of the NHL Stanley Cup Playoff Western Conference Final on Saturday afternoon between the Chicago Blackhawks and the Los Angeles Kings.

Martin was there as part of the color guard that represented different branches of the US military in front a national television audience during the singing of the national anthem. Martin served in the US Air Force during the Korean Conflict.

Having American Indians represented during the singing of the national anthem is the result of work done by the American Indian Center of Chicago that has worked with the Chicago Blackhawks organization to promote goodwill within the American Indian Chicago community.

The Chicago Blackhawks defeated the Los Angeles Kings 2 to 1 in Game One.

LEVI RICKERT, *Native News Network*, 2013

(OPPOSITE + BELOW) Rockford, IL

OUR LAST BEST HOPE TO SAVE OUR WATER, AIR AND EARTH

We are faced with tremendous odds, the end of the era of cheap energy, the loss of ecosystems to sustain unfettered economic growth and, of course, the global climate crisis. We must understand that these are all symptoms of a much larger problem called capitalism. This economic system was born from notions of manifest destiny, the papal bull, the doctrines of discovery and built up with the free labour of slaves, on stolen Indian lands. . . . There is a powerful metaphor between the economic policies of . . . Canada and the USA and their treatment of our Indigenous women and girls. When you look at the extreme violence taking place against the sacredness of Mother Earth in the tar sands for example and the fact that this represents the greatest driver of both Canadian and US economies, then you look at the lack of action being taken on the thousands of First Nations women and girls who have been murdered or just disappeared, it all begins to all make sense. It's also why our women have been rising up and taking power back from the smothering forces of patriarchy dominating our economic, political and social and I would say spiritual institutions.

When we turn things around as a people, it will be the women who lead us, and it will be the creative feminine principal they carry that will give us the tools we need to build another world. Indigenous peoples have been keeping a tab on what has been stolen from our lands, which the creator put us on to protect, and there is a day coming soon where we will collect. Until then, we will keep our eyes on the prize, organize and live our lives in a good way and we welcome you to join us on this journey.

CLAYTON THOMAS-MULLER, *Canadian Dimension*, 2013

(OPPOSITE + BELOW) Rockford, IL

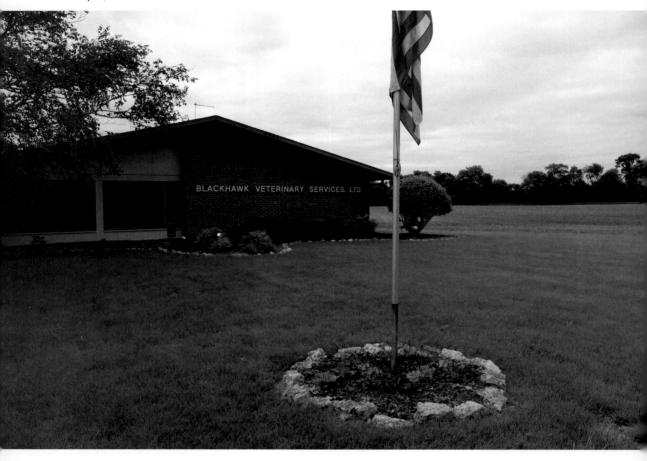

INDIAN WARS, MEMORY AND MIDWESTERN IDENTITY

If local tradition and place names are any indication, Black Hawk spent the bulk of his time sitting on large rocks and gazing out over the Rock River. From Black Hawk's Watch Tower at Rock Island to Indian Rock and Indian Head Rock thirty or forty miles upriver, to the bluff at Eagle's Nest and Squaw Rock still further up the river, if there is a place to stand along the Rock River and a scenic view to admire, some guidebook, website, or area resident will assure you that Black Hawk is said to have enjoyed it.

MICHAEL SHERFY, "Narrating Black Hawk," 2005

SO WE COMMEMORATE A GOOD AND DEAD INDIAN

In Illinois 120 years and more ago, you couldn't have made a soul believe that there would someday be a forty-three-foot-high statue on Rock River in Ogle County in honor of Black Hawk. Not, that is, unless they gave the country back to the Indians. Black Hawk, a Sauk Indian chief, sided with the British against the Americans in the War of 1812. Not satisfied with that, he started his own war against the white settlers twenty years later and massacred many. . . .

Thousands of paleface readers felt duly contrite, and Black Hawk came to be highly esteemed before his death at the age of seventy-one in 1838. . . . In 1911, a substantial year, the solid citizens of Illinois decided to memorialize the vanishing American Indian with the largest concrete statue in North America. . . . At the time, the Indian was nameless. But so many descendants of unscalped Illinois settlers thought it was Black Hawk that it gradually came to be known—by a sort of popular acclaim—as the Black Hawk statue.

IVOR MACIVOR, *Saturday Evening Post*, 1954

SAC AND FOX TO DEVELOP COMPUTERIZED LANGUAGE PROGRAM

The descendents of Blackhawk, Keokuk, and other great leaders of the Sac and Fox Nation have an opportunity to relearn the language of their ancestors after more than a century of assimilation efforts designed to blend them into the white majority population. Efforts have begun among the Sac and Fox near Stroud to develop the resources that will enable the tribe to develop a program of instruction in the ancient language.

A Sauk dictionary should be completed this summer, as well as tapes and materials that will facilitate teaching the language to those on the northern reserve. The tribe expects to use a new $400,000 Multipurpose Building for language instruction when it is completed.

ELAINE SCHROETER, *News from Indian Country*, 1995

THE HUB: A GEOGRAPHICAL AND VIRTUAL CONCEPT

The hub offers a mechanism to support Native notions of culture, community, identity and belonging away from tribal land bases. . . .

The hub is a geographical concept. Hubs can represent actual places. Gathering sites or hubs include cultural events, such as powwows and sweat lodge ceremonies, as well as social and political activities, such as meetings and family gatherings. In fact, urban hubs are often portable. . . . The hub as a geographical concept also incorporates activities on the reservation.

Indeed, the hub suggests how landless Native Americans maintain a sense of connection to their tribal homelands and urban spaces through participation in cultural circuits and maintenance of social networks, as well as shared activity with other Native Americans in the city and on the reservation. Urban Indians create hubs through signs and behavior, such as phone calling, e-mailing, memory sharing, storytelling, ritual, music, style, Native banners, and other symbols. Some of these hubs are, therefore, not based in space but include virtual activities, such as reading tribal newspapers on the Internet and e-mailing. Moreover, the hub as a cultural, social, and political concept ultimately has the potential to strengthen Native identity and provide a sense of belonging, as well as to increase the political power of Native peoples.

RENYA K. RAMIREZ, *Native Hubs*, 2007

(OPPOSITE + BELOW) Freeport, IL

MONUMENTS

Aside from the fact that you never know whether to refer to them as monuments or memorials, monuments do have all kinds of other characteristics. The most salient of these is a bit contradictory; namely, that monuments are so conspicuously inconspicuous. There is nothing in this world as invisible as a monument. They are no doubt erected to be seen—indeed, to attract attention. But at the same time they are impregnated with something that repels attention, causing the glance to roll right off, like water droplets off an oilcloth, without even pausing for a moment.

ROBERT MUSIL, *Posthumous Papers of a Living Author*, 1927

Blackhawk Battlefield Park, Pearl City, IL

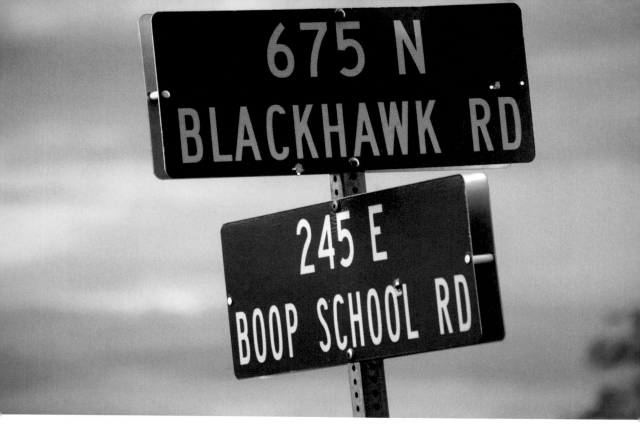

CULTURAL MEMORY AS PRACTICE

Cultural memory is, among other things, a practice, an act of imagination and interconnection. . . . Memory is embodied and sensual, that is, conjured through the senses; it links the deeply private with social, even official, practices. Sometimes memory is difficulty to evoke, yet it's highly efficient; it's always operating in conjunction with other memories . . . Memory, like the heart, beats beyond our capacity to control it, a lifeline between past and future.

DIANA TAYLOR, *The Archive and the Repertoire*, 2003

Elizabeth, IL

BLACK HAWK DESCENDANT TO SPEAK AT APPLE RIVER FORT, INTERVIEW WITH CHIEF GEORGE THURMAN

Q: What stories should be told [about] the Sac and Fox Nation in regard to the Apple River Fort?

A: One of the most important things to remember is that there was no Black Hawk War. Black Hawk did oppose the forced eviction of his Sauk people from their homelands that included 700 miles in Illinois, Missouri, and Wisconsin from Ouisconsin to Portage des Sioux, and he did rally the Sauk and their allies to take a stand against the Americans in 1832. The events of 1832 are the result of invalid or broken treaties. Black Hawk protested the validity of the Treaty of 1804, pointing out that the signatories of the Treaty of 1804 did not have the authority to sign treaties and he gave no credence to the terms of that treaty. He later agreed to move from Rock Island, Illinois to what is now Iowa with the promise from the American government that it would provide food for the Sauk since we left our crops and fields in Rock Island. The American government failed to comply, so Black Hawk, followed by women, children, and elders, returned to Rock Island for the food. This was not an act of war although Black Hawk and his warriors had to employ military tactics to divert the attention of the pursuing army and militia away from his people. A captain in the Illinois militia was a man named Abraham Lincoln.

Galena Gazette, 2009

WAS BLACK HAWK AN EARLY ILLINOIS TERRORIST, AND WHAT WAS HOMELAND SECURITY LIKE IN 1832?

Was Black Hawk a frontier terrorist, and how did settlers in the area prepare to defend themselves against him? A new exhibit that opens May 4 and a Black Hawk War militia muster May 5 will bring the 175-year-old conflict to life like never before at Apple River Fort State Historic Site in Elizabeth, Illinois.

"The Transformation of Black Hawk: Frontier Terrorist to Advertising Icon, Sainthood and Beyond," an exclusive new exhibit will explain through text and artifacts how Black Hawk, leader of the dissident Sauk and Fox Indians, after his crushing defeat by the combined forces of the United States government, Illinois State and the Michigan Territorial militia, was transformed from a tragic survivor to a lodestone for commercial enterprise, the focal point of romantic musings, and the spiritual guide for a pseudo-Christian-Voodoo sect in New Orleans.

The exhibit opens with a wine and cheese reception Friday, May 4 at 5:30 p.m. at the Apple River Fort Interpretive Center. Admission is $10 per person, and each ticket holder will receive a premier bottle of Black Hawk or Elizabeth wine from Mossbach Ridge Winery. Then, a special dinner and Meet the Exhibit Designer program will be held at 6:30 p.m. at the Welcome Inn in Elizabeth. Tickets are $25 per person.

ILLINOIS HISTORIC PRESERVATION AGENCY, Press Release, 2007

Elizabeth, IL

THE UNBROKEN PAST OF THE AMERICAN WEST

[Andrew] Jackson himself compared Indian removal favorably to white westward migration. White settlers, he said, "remove hundreds and almost thousands of miles at their own expense, purchase new lands they occupy, and support themselves at their new homes from the moment of their arrival. Can it be cruel in this Government, when, by events which it cannot control, the Indian is made discontented in his ancient home—to purchase his lands, to give him a new and extensive territory, to pay the expense of his removal, and support him a year in his new abode? How many thousands of our own people would gladly embrace the opportunity of removing to the West on such conditions."

PATRICIA NELSON LIMERICK, *The Legacy of Conquest*, 1987

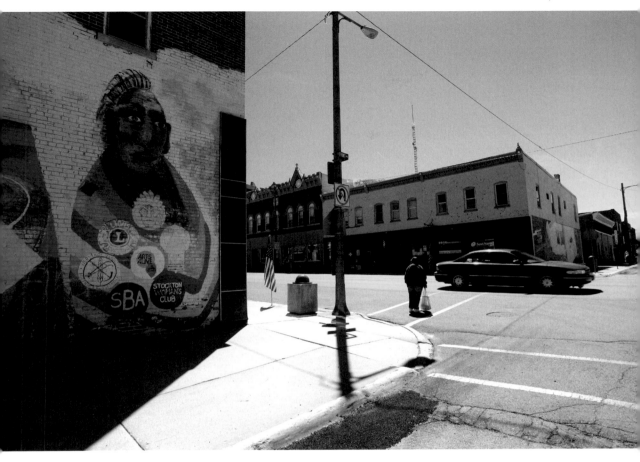

MOHAWK INTERRUPTUS

Under the conditions of settler colonialism in North America, which is an ongoing and structural project to acquire land, to maintain that land, and to eliminate who is on it, there has been a great violence, a dispossession, and, thankfully, there has been failure. It did not completely work. There are still Indians. Some still know this. Some will defend what they have left and will persist, robustly. In this failure there has been and we can infer will continue to be pushback on these logics of elimination. This failure to kill, to disappear entirely, is Indigenous life, in the face of what was to be bodily and structural death.

AUDRA SIMPSON, lecture for Indigenous Governance
Speakers Series, University of Victoria, 2012

Black Hawk's trail, a 400-mile-long semicircle that starts in Davenport, Iowa, can be retraced with the help of disparate historical sources, a good road atlas, and a little imagination (the ubiquitous appropriation of the chief's name and likeness by banks, appliance repair shops, and shopping malls does not provide reliable trail markers). Black Hawk followed mostly rivers, until the final desperate days when the group struck out overland toward the Mississippi, and most of their trail can be followed by car. What took Black Hawk 15 tortuous weeks can take you two days at a relatively demanding pace, but just imagine an ever-growing army of bloodthirsty militiamen on your heels. And bear in mind that following the chief is richer in historical thrills than in tourist-oriented stuff like fancy restaurants and quaint B and Bs.

FREDERICK MOSHER, *Chicago Reader*, 1994

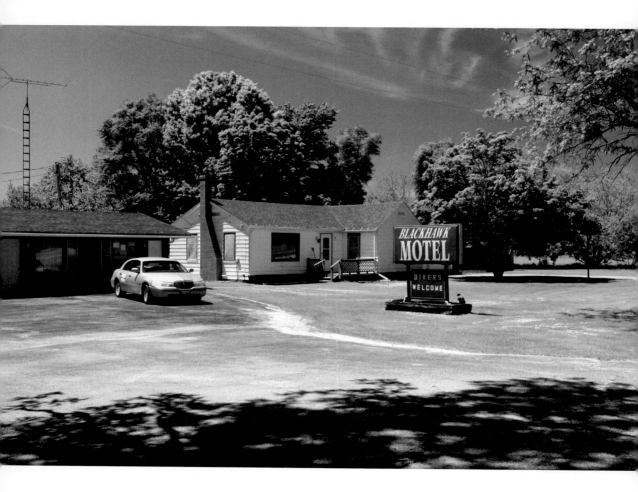

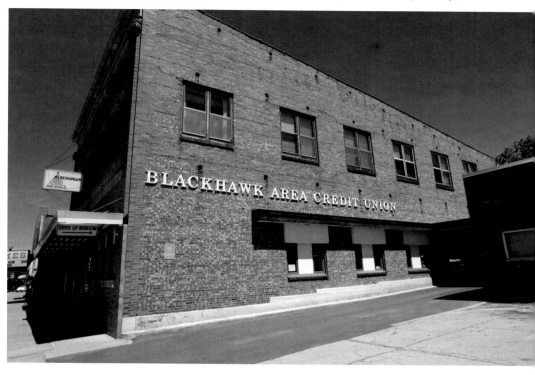

WA A O, WA BA SKI NA ME SKA TA! "INDIAN" MASCOTS AND THE PATHOLOGY OF ANTI-INDIGENOUS RACISM

The continued use of "Indian" mascots rests on the ability to wield racialized and racializing power—social, economic, and political—against actual Native peoples, while also drawing power from us. "Indian" mascots inevitably require "real Indians," . . . some of whom question the legitimacy of their continued use. (. . .) As criticism moves outward from its Indigenous critics, the debate about meaning strengthens existing webs of power in which we all presently are situated. An ingrained, racist common sense that is one of the foundations (along with gender relations) for imagining and performing domination and power in the United States reaches millions in communities and homes where actual Natives have virtually no intellectual influence.

DAVID ANTHONY TYEEME CLARK, in *In the Game*, 2005

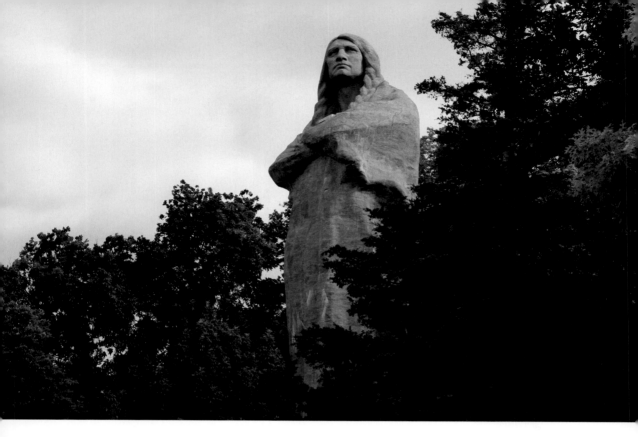

HAWKS DEVELOPING TIES TO NATIVE AMERICANS

The nearly 50-foot statue stands high on a bluff overlooking the Rock River and the city of Oregon, Ill.

At first glance, the connection between the concrete monolith named "The Eternal Indian" and a hockey team is difficult to imagine. But there is a thread that links them, one that recently drew Blackhawks executives Jay Blunk and Pete Hassen to make the 100-mile drive to view the statue and tour the surrounding facilities. Joining them on the journey was Scott Sypolt, Executive Counsel for the American Indian Center on the North Side of Chicago, the oldest Native American center in the country.

"We are planning on helping Scott and other governmental agencies in the restoration and preservation of this giant statue," Blunk said of the 1908 statue that was inspired by Black Hawk, the leader and warrior of the Sauk American Indian tribe in the early 1800's. "It's one of the iconic statues across America that honor Native Americans."

Restoring the statue and helping to renovate sections of the American Indian Center and to build a sports complex there are some of the steps the franchise is taking to foster a bond with the Native American community.

CHRIS KUC, *Chicago Tribune*, 2011

(ABOVE) Oregon, IL | (OPPOSITE) National Hockey League Twitter feed, April 30, 2013

NHL @NHL · 16h
These @NHLBlackhawks fans aren't joking around...they came ready to Game 1. #CHIvsMIN pic.twitter.com/Sw9WKSnAkN

🖼 Hide photo ← Reply ⇄ Retweet ★ Favorite ••• More

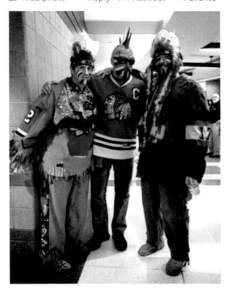

246
RETWEETS

241
FAVORITES

5:51 PM - 30 Apr 13 · Details Flag media

... @AdumbBarkowitz · 16h
"@NHL: These @NHLBlackhawks fans aren't joking around...they came ready to Game 1. #CHIvsMIN pic.twitter.com/pgxVGR3nuG" TOO BAD THEY LOSING
🖼 View photo

Travis Kirkman @FTW2423 · 16h
@AdumbBarkowitz @nhl @nhlblackhawks OMG, down by 1 with a backup goalie in and only 2 periods to go!!! We are doomed!!!
Expand

Kris S. @GwitchinKris · 16h
Oh, but they're honouring us! #racism "@NHL: These @NHLBlackhawks fans aren't joking around...they came ready. pic.twitter.com/DPkBq4Wu7Y"
🖼 View photo

nic @nicoiaci · 16h
@GwitchinKris More reasons to hate on the Chicago Blackhawks! #hockeyfan
Expand

Khelsilem @Khelsilem · 16h
.@NHL @NHLBlackhawks Racist douchbags. Dressing "like an Indian" is eff'd up.
📍 from Greater Vancouver, British Columbia

View more in conversation →

LORADO TAFT'S INDIAN STATUE "BLACK HAWK"

We loved our homes, our valleys and our prairies—but we had no business here. We had no civilization. You had plenty of it, my brothers, and the more you have the more you're afraid of your brother, and the more strong doors you have, the more strong locks, the more policemen to protect you. It is one of the most wonderful things to the Indian: the more civilized you are, the more you cannot trust your brother.

OHIYESA (CHARLES EASTMAN),
"Comments at the Unveiling of Lorado Taft's Sculpture, 'Black Hawk,'" 1911

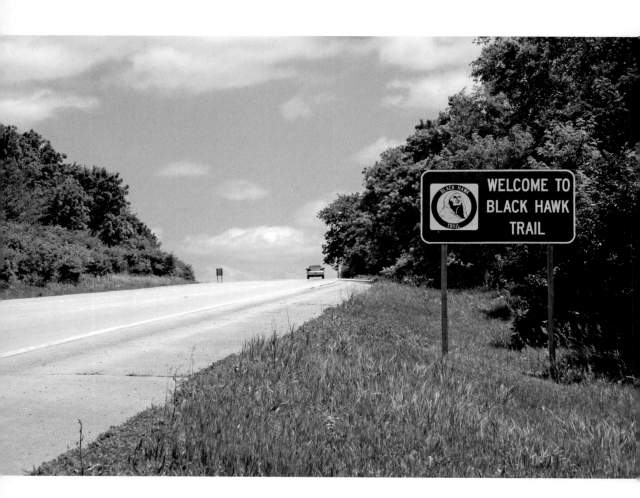

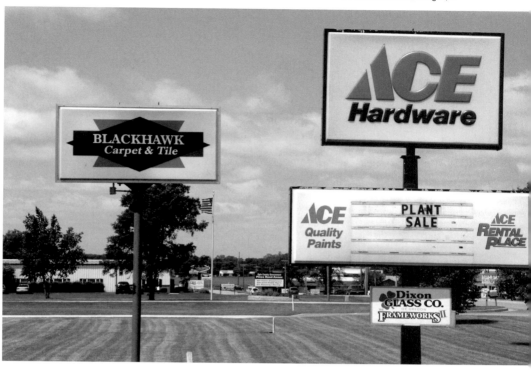

ARTIST QUESTIONS VALUE PLACED ON STOLEN SIGNS

Cheyenne-Arapaho artist Edgar Heap of Birds says Crimestoppers has never been part of his career.

"I guess it is now," he said.

A tip to the local Crimestoppers led to the arrest of Mark Nepermann, who faces a misdemeanor charge for the theft of two of the artist's signs, part of his "Native Hosts" series, from in front of the Native American House on the UI [University of Illinois] campus.

The state put a value of less than $300 on the pieces, making the charge a misdemeanor rather than felony.

Heap of Birds, as well as many other American Indians and artists in the community, believe the signs are fine art and should be judged according to their appraised value, which would lift the theft charge to a felony.

"We see it as [a] pattern of behavior of treating American Indians as second-class citizens, both on this campus and in the community," said John McKinn, assistant director of American Indian Studies at the UI. "It's just another attempt to devalue American Indians and their experience. It also speaks to the lack of education we all have for what constitutes art."

MELISSA MERLI, *News-Gazette*, 2009

INDIAN WORK AND INDIAN NEIGHBORHOODS

Beginning in the late 19th century, American Indian people seemed to become invisible to many Americans. Those who had been resisting the confines of the reservation had been subdued. Disease continued to take a tremendous toll on tribes, contributing to infant mortality rates that reached fifty percent on some reservations. Artists popularized the image of the "vanishing Indian" and suggested that Indians would slowly disappear from the national stage.

Instead, the American Indian population increased steadily throughout the first half of the twentieth century, then swelled after 1950. Beyond this demographic explosion, another remarkable transformation occurred: large numbers of previously rural Indians became city dwellers. Starting in the 1940s and 1950s, a migration began that by 1980 would find over half of Indian people living in urban areas . . .

[The] Uptown [neighborhood] achieved a special status in the minds of Indians in Chicago. It was the place to be with other Indians. Although some bureaucrats viewed the concentration of Indians in Uptown in negative terms, in retrospect the neighborhood should be envisioned as a venue for adjustment, just as immigrant neighborhoods in late nineteenth- and early twentieth-century Chicago helped Europeans adapt to a new environment.

Because large numbers of Indians resided in Uptown by the late 1950s, various organizations and community centers moved there as well. The most significant was the American Indian Center, which in 1953 had been established in two floors of an office building in the Loop. In 1963, however, the center moved to a building in Uptown, where it became an important community institution and gathering place. The center fostered contact and solidarity among Indians of various tribes, provided for social and cultural activities, helped to develop Indian leaders, and served as a forum for the discussion of (and often opposition to) BIA [Bureau of Indian Affairs] policy. For those who relied on the center for social and cultural benefits, it played a large role in making Uptown an Indian neighborhood.

Indeed, the development of Chicago's American Indian Center demonstrates the ways in which Indians used jobs and housing to adjust to life in mid-twentieth century Chicago; they connected work, neighborhood, and community life. Although most Indians did not see a lucrative job or a spacious apartment as their primary goal, they were often able to use a job or apartment—in some small way—to help themselves and their fellow tribespeople "get by" in the increased pace of "city life." By the late twentieth century, Indians had emerged as a viable part of Chicago's multiethnic, urban society, an ethnic group well adapted to urban life.

JAMES B. LAGRAND, in *Enduring Nations*, 2008

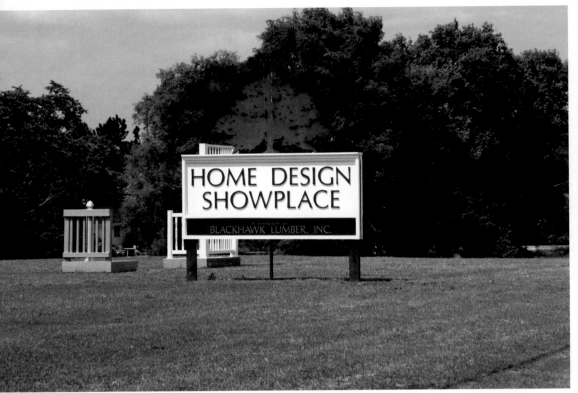

BLACK HAWK, THE GREAT SAC NATION LEADER, FACES YET ANOTHER INDIGNITY

Illinois history goes on the chopping block today, the victim not so much of the economy, but of a rudderless, captainless state adrift in political confusion.

The John Hauberg Indian Museum at the Black Hawk State Historic Site in Rock Island is one of 13 Illinois historic attractions to close today. . . .

Black Hawk and the Sac would have been accustomed to such treatment.

EDITORIAL, *Quad-City Times*, 2008

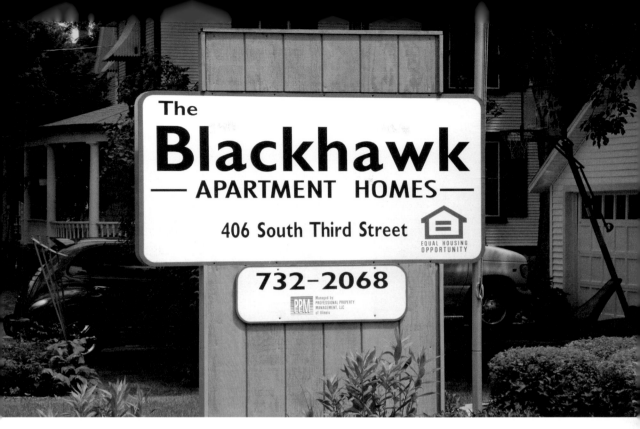

SAUKENUK LIVES AGAIN

There was a big hole in the story. People who live in and around the Quad-Cities usually know the Sauk and Mesquakie people lived in the area where the Mississippi and Rock rivers join. They know the warrior Black Hawk fought here. And through the Black Hawk State Historic Site's Hauberg Museum, they know how the tribes hunted, traded and lived.

But little was known about the tribes' origins. Or how they came to the area—and left it. Or what Saukenuk—the Native American community which, at one time, was the largest community in Illinois—looked like.

"There was nothing in the museum that explains who the Sauk and Mesquakie are," says Beth Carvey, site historian, who worked with archaeologist Ferrel Anderson to design the new, three-dimensional model of Saukenuk.

The Saukenuk exhibit, which features the to-scale model and three large back-lit maps, answers those questions. Furthermore, the Hauberg Museum is the only place in the world with an exhibit that tells the story of the Sauk and Mesquakie in such a complete manner. And that, for the descendants of these tribal peoples, is reason for celebration.

ANTHONY WATT, *Radish*, 2010

BLACK(HAWKED) OUT BARCRAWL

Tuesday, April 19 at 6:30 pm to Wednesday, April 20 at 2:00 am
 Location: Murphy's, Firehaus, Joe's, Kam's
 248 attending
 GET READY FOR THE PLAYOFFS!
 EARN YOUR FEATHERS AND GET BLACK(HAWK)ED OUT!
 The Blackhawks season is slowly coming to an end, and they have made a strong push for the playoffs, so let's raise a glass to the defending Stanley Cup champions aka get as drunk as possible.

NIKKI ALLEN AND RACHAEL NOWICKI,
"Black(Hawk)ed Out Barcrawl," user-generated Facebook event page, 2011

INDIAN COUNTRY

For the last two decades, the "clash of cultures" has been the dominant paradigm for the public interpretation of the Battle of Little Bighorn and other U.S.-Indian military conflicts. By no means do I wish to shortchange the usefulness of that model, particularly its insistence that we understand this violence within a wider historical context. But this rubric also risks repeating the nineteenth-century reasoning that this violence could not be stopped, that it was governed by an impersonal, unrelenting force that would crush Native peoples under the wheels of History. The clash of cultures replaces the struggle of civilization and savagery with a clash of putatively equal cultures, even as the rubric retains the sense of an inevitable outcome in which the decisions of individuals and institutions could have done little to change the course of the events.

MICHAEL A. ELLIOT, *Custerology*, 2008

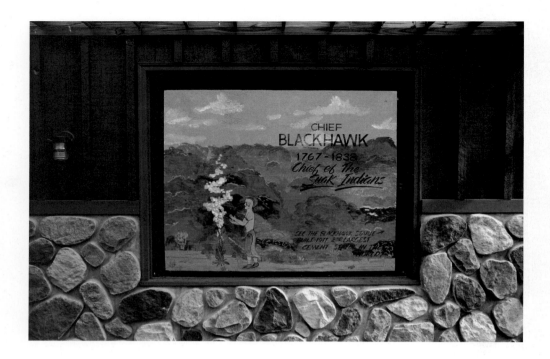

WHAT THE WHITE "SQUAWS" WANT FROM BLACK HAWK

Americans in the East were great fans of Black Hawk, whose popularity on tour overtook that of Andrew Jackson's parallel tour of the Northeast. The *Emancipator* on June 15, 1833, reports briefly, significantly identifying Black Hawk as "the celebrated Indian chief" and indicating that "he will be 'the lion' of the day, and the President, of course, must 'stand back a little.' But the 'monarch multitude' will have their way." Undoubtedly, then, Black Hawk was a celebrity. He remained popular even in 1837, when he attended Catlin's gallery opening in New York, which included his 1832 painting of Black Hawk. Black Hawk may also have been a conduit through which white women could imagine escape from the confining and "polite" parlors of eastern cities that Black Hawk toured. To these female fans Black Hawk may not have been just Jackson's official symbol to show that savagery could no longer threaten the civilization of America and its right to internally colonize the North American continent. But no matter how his female fans actually felt, their identities were used to further a political, nationalist agenda that actively denied miscegenation as a method for becoming a unified American culture. As part of that agenda, Black Hawk's identity was also constructed, commodified, circulated, and consumed through the culture via newspaper editors and his own autobiographical response. The relationship between celebrity and fans is, at least in Black Hawk's case, culturally important as a public manifestation circulated through the media.

TENA L. HELTON, *American Indian Quarterly*, 2010

(ABOVE + OPPOSITE) Oregon, IL

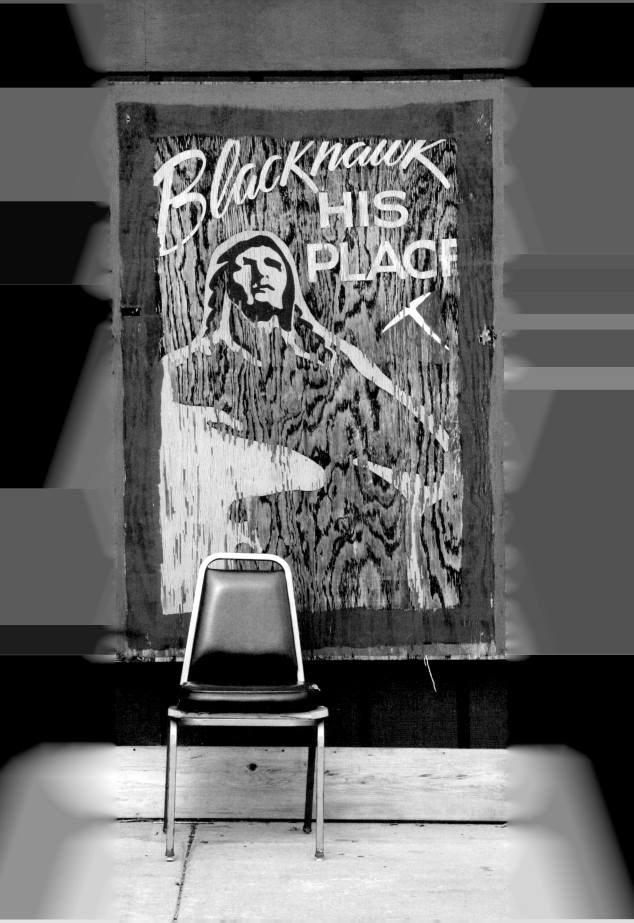

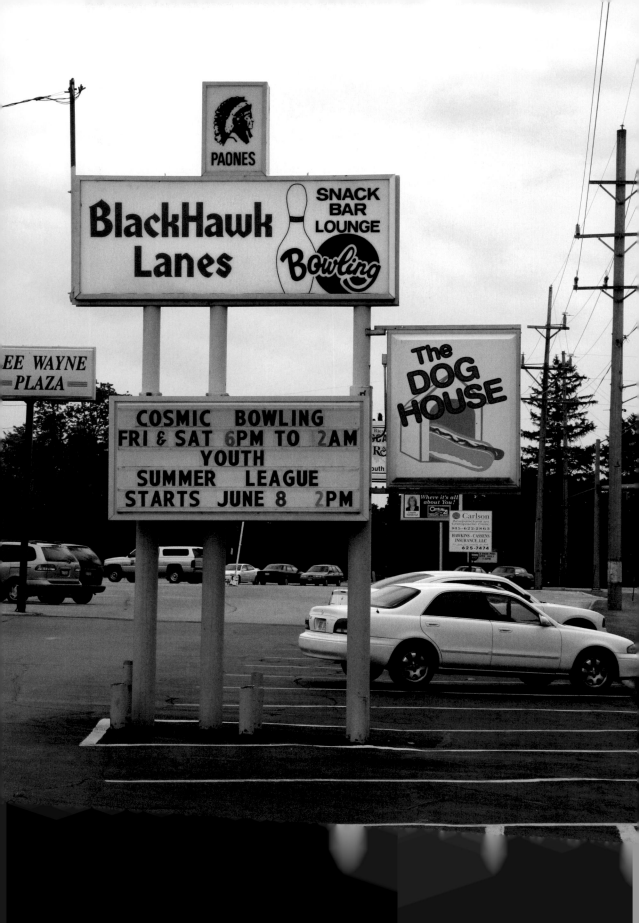

(OPPOSITE) Sterling, IL | (ABOVE) Prophetstown, IL

GYM SHOES, MAPS, AND PASSPORTS, OH MY!

Reading NMAI [National Museum of the American Indian] exhibits is similar to the practice of reading and interpreting texts; readers are free to construct meaning out of the various stories the museum tells. Storytelling is integral to Indigenous culture and a method used to educate one's children and one's community. In her multigenre text titled *Storyteller*, [Leslie Marmon] Silko claims that all of the stories need to be told before one can create a sense of self or community because stories tell individuals who they are. Therefore, she includes in her book the letters, photographs, family stories, oral traditions, anecdotes, gossip, jokes, poems, and legends that make up the patchwork collection of her family's life and their connections to land and community. Resembling this Pueblo web of stories is the NMAI's larger web of Indigenous narratives created from a patchwork or combinations of texts, including totem poles, T-shirts, woven baskets, and, yes, even gym shoes.

For political reasons, many Indigenous artists encode their work with additional meaning through the stories inherent in their art, leaving the task of interpretation to the viewer. Before viewers can unravel an object's political significance, however, they must first understand that Indigenous stories sometimes contain an absence that is always present, inviting the "listener" in. . . . Kimberly Blaeser advises listeners or readers of Indigenous stories that they have both a response-ability and a responsibility to the telling, because the story is made by storyteller and audience together. The result of creating a story together, of taking responsibility for meaning making, is that there is no "truth" or ending to the story, because listeners constantly re-create and remake the stories in order to add their own truths based on their own experiences and perspectives

ELIZABETH ARCHULETA, in *The National Museum of the American Indian*, 2008

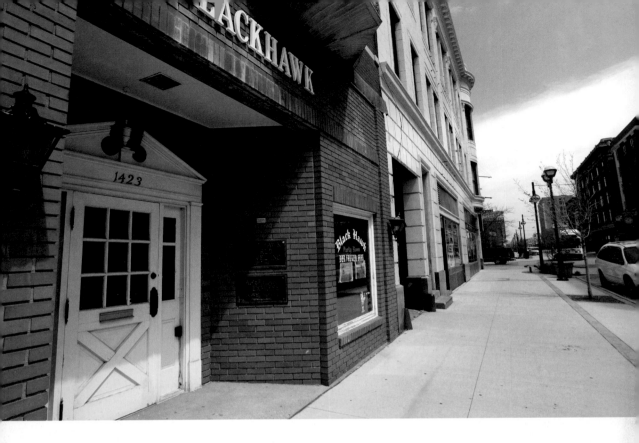

A TRAIL OF TEARS ACROSS SOUTHERN ILLINOIS

From the Ohio River to the Mississippi, straggling lines of suffering humanity plodded west. It was the winter of 1838–39, and thousands of Cherokee Indians, uprooted from the ancestral homes, were being forcibly removed to the Oklahoma territory. As they crossed southern Illinois they were weary, sick, starving, freezing, and dying. . . .

Usual progress was from ten to fourteen miles a day. At night campsites were spread out along the trail. Wild game was soon depleted, and rations promised by the government proved insufficient. From its beginning and across southern Illinois the trail was dotted with hurriedly dug graves. . . .

Many white southern Illinois inhabitants resented the Indians' passage, which led to incidents of cruelty. Wood for campfires became impossible to obtain. Often the Cherokee were denied permission to camp and were forced to move on. However, many whites sympathized with the Indians and provided what aid they could.

STU FLIEGE, *Tales and Trails of Illinois*, 2002

(ABOVE + OPPOSITE) Moline, IL

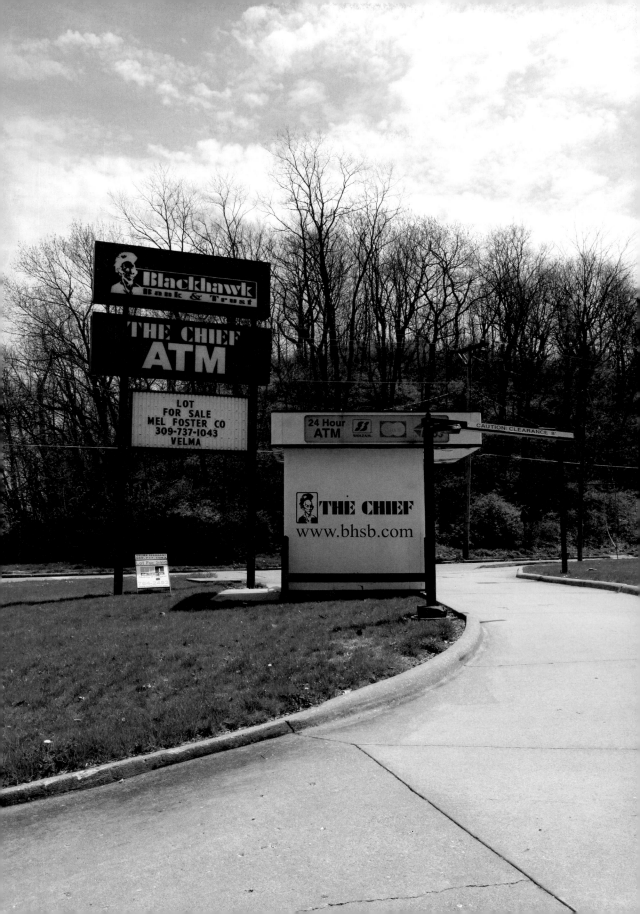

Descendants of Black Hawk's native tribe are asking his namesake college to drop its Indian-inspired team and newspaper names they believe are offensive.

About 30 people attended a discussion Thursday on the Black Hawk College campus in Moline about the name of the athletic teams, the Braves, as well as the name of the school newspaper, *The Chieftain*. The nickname of the sports teams at the college's East Campus in Kewanee, Ill., the Warriors, also is being called into question.

Sean Turnipseed, the president of the Student Government Association, said the issue was raised by the Black Hawk College Social Action Committee and plans were made the week before the Christmas break to have American Indians visit the campus and speak on the matter.

George Thurman, the secretary of the Sac and Fox Nation in Stroud, Okla., wrote a resolution passed Jan. 9 by the leadership of that 3,400-member group and received by the student association this week.

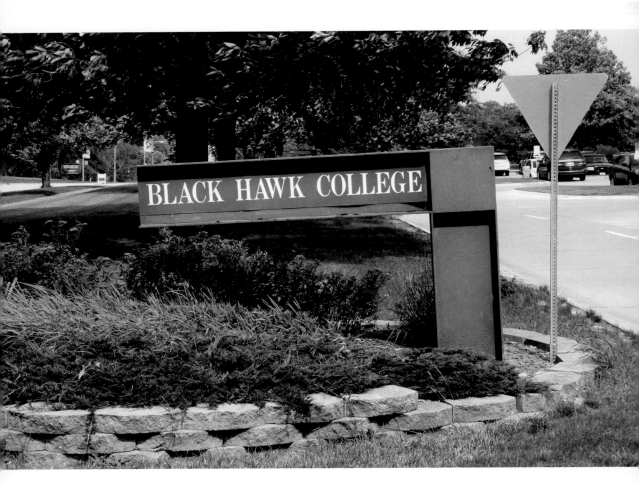

Thurman said in a telephone interview with the *Quad-City Times* that he is a descendant of Black Hawk, the Sac and Fox leader who lived in what is now the Quad-City region during the early part of the 19th century.

"I feel it is derogatory and demeaning to Native Americans" to use nicknames such as Braves and Warriors, he said.

The resolution states in part that the Sac and Fox Nation believes such names are "hostile, offensive, insulting, demeaning."

THOMAS GEYER AND ANN MCGLYNN, *Quad-City Times*, 2006

CHIEF IS GONE, BUT IS ANYBODY MOVING ON?

When Chief Illiniwek was officially retired in 2007, only the uninitiated thought the argument was over.

The UI has since tussled with Chief supporters and opponents over the use of the name "Chief Illiniwek," the official Chief logo, the costume and the "Three-in-One" music.

Chief portrayer Ivan Dozier and his predecessors have attempted to keep the tradition alive, staging events like "The Next Dance" and appearing in the crowd at UI football and basketball games and high school dances. Fans still stand and clap during the nonexistent Chief's music at halftime.

Chief opponents, meanwhile, complain that the UI hasn't done enough to up-hold its own policy or stop unauthorized use of the Chief's likeness outside the university.

UI students are preparing to take yet another advisory vote on the issue this week—specifically, whether they support the Chief as the official symbol for the

campus—in response to a contest for a new mascot by a student group called Campus Spirit Revival. . . .

UI alumnus Steve Raquel of the Council of Chiefs—former students who served as Chief Illiniwek—finds the recent student interest in the issue encouraging. He likens it to a "revival" after a waning of Chief support on campus for several years after its retirement. He was surprised the Chief question found enough signatures to get on the ballot. . . .

"I think there's an opportunity to bring the tradition back in a way that's a win-win for the university and the alumni," Raquel said.

[Chancellor Phyllis] Wise said she hasn't heard any proposals from the group. The chancellor said she would listen to ideas about "ways to remember" the Chief but stressed that the campus can't return to the past.

JULIE WURTH, *News-Gazette*, 2013

On May 5, 1970, Carol Warrington (Menominee) and her six children were evicted from their second-floor apartment at 3717 Seminary Avenue for withholding rent for seven months in protest of the poor condition of her apartment. A tipi provided by Chicago's American Indian Center was set up on a tract of land across the street from Carol Warrington's former apartment, behind Wrigley Field. Soon additional pup tents were set up, and other Indians moved in. Originally the newspapers called it the "little Alcatraz movement," referring to the Indian occupation of Alcatraz which began the previous November, but soon the Chicago occupation would be known by another name, the Chicago Indian Village.

The Village was started in support of Ms. Warrington, but it came to symbolize something bigger: the need for adequate housing for all American Indians in the city, of which Carol Warrington was but one of the many in need. Under the leadership of Mike Chosa (Ojibway), the Chicago Indian Village would remain behind Wrigley Field for the next three months before beginning a journey around Chicago and the suburbs for the next two years to publicize demands for better housing, education, training, and jobs for Chicago's Indian community.

NATALIA WILSON, in *Native Chicago*, 2002

Rock Island, IL

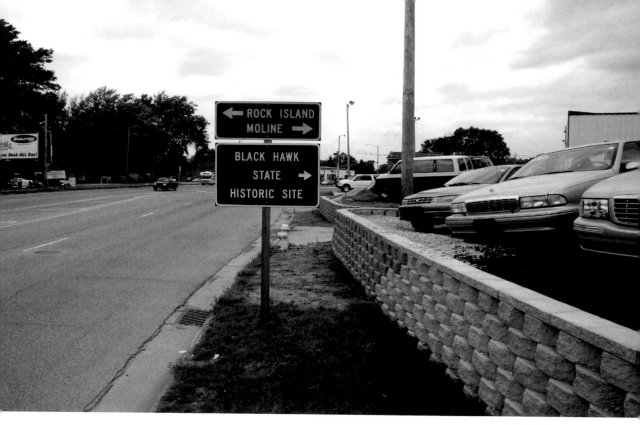

Rock Island, IL

HOW RACE SURVIVED CAPITALISM AND FREE LABOR

There were differences in scale between [Andrew] Jackson's extended and far-flung assaults on Southern Indians, and the Black Hawk War of 1832 in Illinois and present-day Wisconsin between a group of Native Americans and the US army. But North and South, Democratic and Whig, the consensus for Indian removal was broad. Indeed in the Black Hawk War a young Abraham Lincoln soldiered with Jackson as his commander-in-chief. Quickening attention as to whether farmers or slave owners would occupy the "free land" being opened to settlement sparked policy debates and occupied the attention of white working-class land reform movements . . . as the Civil War approached. Such divisions and debates mattered, but sectional division did not lead to any significant break from settler colonialism.

DAVID R. ROEDIGER, *How Race Survived U.S. History*, 2008

The following text appears on the sign in the image:

BLACK HAWK PRAIRIE

In 1800, when settlers first arrived here, the Illinois country was covered with 22 million acres of native prairie. Illinois was home of the Tallgrass Prairie, dominated by grasses such as Big Bluestem and Indian Grass. The prairie was filled with many species of forbs (wildflowers) which lent dazzling color to the rolling prairie land. Bison, elk, and deer roamed these huge grasslands. Many species of birds, insects, and amphibians thrived in the prairie ecosystem.

The settlers soon learned that the prairie soil was very rich and the invention of the self-scouring plow made its cultivation relatively easy. Within a hundred years most of the prairie, which had evolved over thousands of years, was gone. Today, less than 3000 acres of native prairie remain in Illinois.

Recently, many people have become interested in preserving and restoring true Illinois prairie. Black Hawk Prairie, established in 1983, is just such a restoration. Through careful management, this one acre site well illustrates the prairie which once covered this state.

Illinois is known as "The Prairie State." We are proud of our natural heritage. Please enjoy your tour through this small portion of that heritage.

Prairie guide available at office or museum

HOW OUR JOURNEY BEGAN

In 1992, a local historian named Ralph Duvick told us a story of the Grand Village of the Kickapoo. Until we heard the story, we were unaware of the historical significance of the farm we owned, which is on the southwest quarter of the Grand Village site. After learning some of the history, we began researching the Village.

Of the many Native Nations that lived in early Illinois, the Kickapoo was among the most populous, occupying a large central area of the state. From the mid-1700's to the early 1800's, between 2,000 and 3,000 Kickapoo lived on approximately 10 million acres, with the main village—the Grand Village—located in the center of the state between Bloomington and Champaign. Many burial sites lie hidden around the Village and a nearby Indian fort. During this era, the district hosted a timber stand that covered over 14,000 acres, with deer, buffalo and other abundant food sources. There the Kickapoo lived in pole-frame houses covered with elm bark, tapping maple trees for sap, sugar, and cultivating garden plots for corn, beans, squash, pumpkins, and watermelon. In a treaty signed at Edwardsville in 1819, the Kickapoo were made to give up all rights to their land in Illinois. The nation fought removal for many years, then was forced across the Mississippi River into Missouri and Kansas in 1838. From there, the tribe was later pushed into Oklahoma and Texas, with some eventually settling across the border in Mexico. Today's Kickapoo maintain a great reverence for the Grand Village as a religious site, in respect for the ancestors buried there.

(OPPOSITE + ABOVE) Rock Island, IL

One Sunday we learned Heartland Hogs was planning a large hog factory on the north end of the Village, which would have placed a lagoon over the burial site. We felt it was morally wrong to allow this to happen so we formed a local citizens' group, "The Kickapoo 4 Association," dedicated to stopping this facility from locating on the Grand Village. After many meetings with the people planning the facility, they decided not to build there. The Kickapoo tried to purchase the land, but the owners changed the price and terms, creating problems the Kickapoo were unable to overcome.

In 1998 we heard the owners were once again going to sell the land. The Kickapoo were not in a position to purchase it, so we thought about the need to preserve the burial site. Purchasing the site placed a great burden on our family finances, however, we were convinced this was meant to be. Everything surrounding our being on this land convinced us we were being guided by a Greater Power; therefore, we took possession of the northwestern 160 acres of the Grand Village in January of 1997, making us caretakers of the west half of the Village.

In honor of the Kickapoo, we have dedicated 2 and 1/3 acres of the land as a permanent memorial to the Grand Village in the form of a park.

BILL EMMETT AND DORIS EMMETT, grandvillage.org

RACES OF LIVING THINGS

In 1833, just as the Indians were being forcibly relocated, the poet William Cullen Bryant came to Illinois to visit his settler brother and published his famous poem "The Prairies." In his romantic view, it was the ordained will of God that the Indians must perish.

> Thus change the forms of being. Thus arise
> Races of living things, glorious in strength,
> And perish, as the quickening breath of God
> Fills them, or is withdrawn.

And now that the land is empty, the new "civilized" era can begin:

> The sound of that advancing multitude
> Which soon shall fill these deserts.
> From the ground
> Comes up the laugh of children, the soft voice
> Of maidens, and the sweet and solemn hymn
> Of Sabbath worshippers.

CAROL SPINDEL, *Dancing at Halftime*, 2002

(OPPOSITE + ABOVE) Rock Island, IL

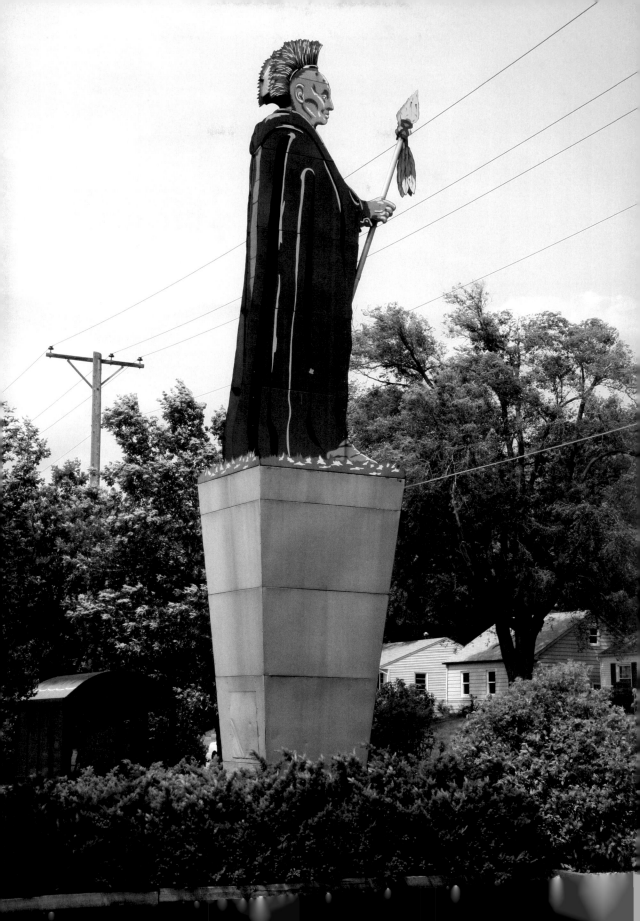

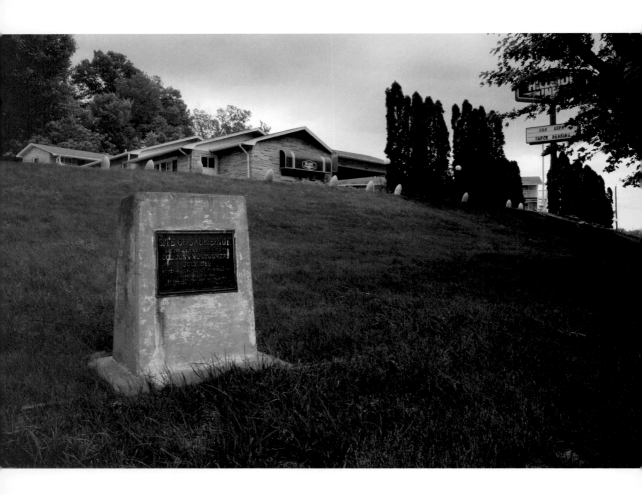

EPILOGUE TO THE BLACK HAWK WAR

The most visible legacy of the Black Hawk War is the present city of Rock Island, a grubby monument to the white man's almost mythical belief in quantity as the best index of a civilization. The cornfields of Black Hawk lie beneath the concrete and asphalt of shopping centers and shabby blocks of houses. Black Hawk now works for the local chamber of commerce, as does any other local American celebrity of the past. Among the enterprises capitalizing on his name are an archery shop, a window pane company, a frozen food locker, an antique shop, a state bank, a world travel agency, a golf range, a motel, and a pest exterminator. Bumper decals bear the inscription "Support Black Hawk," which refers to the local college. Asked about Black Hawk, a white gas pump attendant may explain that the old war chief fought with Lincoln in the Civil War. The brochure published by the Black Hawk State Park, a 207-acre preserve on a wooded bluff overlooking the Rock River, highlights the war: "On one side was a native race fighting for its ancestral lands; on the other, settlers, and soldiers, our own forebears, determined to banish fear of the scalping knife from their cabins and clearings." The text concludes sweetly, "Now a spirit of peace seems to brood over the valley."

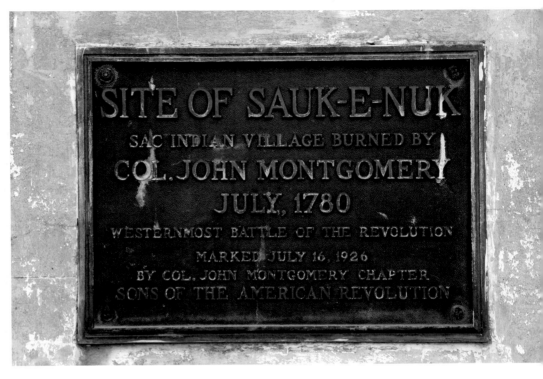

SITE OF SAUK-E-NUK
SAC INDIAN VILLAGE BURNED BY
COL. JOHN MONTGOMERY
JULY, 1780
WESTERNMOST BATTLE OF THE REVOLUTION
MARKED JULY 16, 1926
BY COL. JOHN MONTGOMERY CHAPTER
SONS OF THE AMERICAN REVOLUTION

This peace is interrupted every Labor Day weekend when Sauk and Fox stage an Indian Powwow at a stockade within the park. On this occasion warriors and squaws, outfitted in unauthentic garb that must surely come from a Hollywood warehouse, shuffle and jump to the rhythm of beaten tomtoms and rattled chains allowing hundreds of Chemokemons, armed with American flags and Japanese cameras, to participate vicariously in a segment of their heritage. Though billed as "descendants of Black Hawk," it is most likely that the dancers trace their line back to Keokuk. Most of them are middle-aged, for younger, more militant, members of the tribe regard the Powwow as a degrading circus.

Although the local white traders continue to make money from the Indians, nowadays the Chemokemons are the ones to snap up the gewgaws and trinkets. The reservoir of racial hatred is now focused between black and white; no Rock Islander hates Indians any more, there are too few left to hate.

CECIL EBY, *"That Disgraceful Affair," the Black Hawk War*, 1973

THAT A HEALING BEGINS

In the early spring, May 3, 1997, members of the boards of Midwest SOARRING, the American Indian Council of Illinois (AICI), and the Quad-Cities Native American League, met with members of the Mesquakie Nation and representatives of the John Deere Corporation in the oldest building in Rock Island County, Illinois, circa 1830's.

The concern of SOARRING began in late April when we learned that the horse farm owned for many years by members of the John Deere family was to be sold for a Professional Golf Association (PGA) tournament golf course. Many sacred sites were long known to exist on a total of approximately 365 acres, with its many bluffs overlooking the scenic Rock River, and we wanted to assure that they were respected and protected. David Keene, of Archeological Research, Inc., had done the surface survey work there, with the results showing nearly fifty sites ranging from simple campsites to burial mounds.

Rock Island, IL

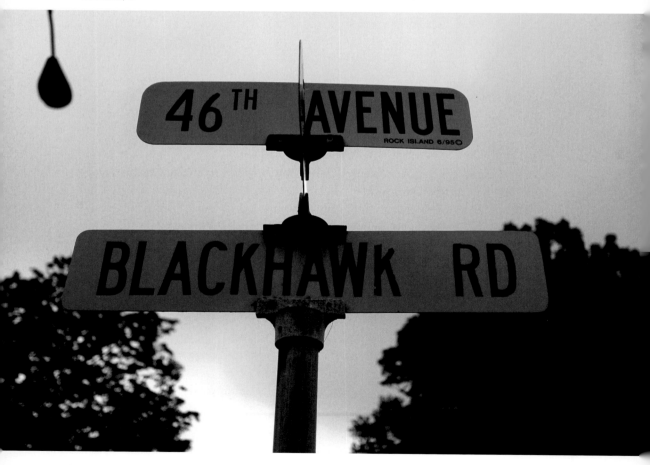

In an historic cooperative effort among land holder, archaeologist, the nation whose ancestors had occupied the land area, and Native organizations, a workable plan with respect for our sacred areas needed to be found. . . . It was agreed that no pathway, roadway or other unnatural disturbances would occur on the sacred sites, therefore this PGA course would be a model of how to design around Native American sites, extending respect by leaving them in their natural condition. No publicity would advertise the ancient history of the sites in order to preserve the anonymity of the burial areas. The decisions were made in consensus, and the spirit of good will and cooperative effort prevailed throughout the meeting, hailing the long-awaited blossoming of healing for our people.

MIDWEST SOARRING, *Wings*, 1997

Rock Island, IL

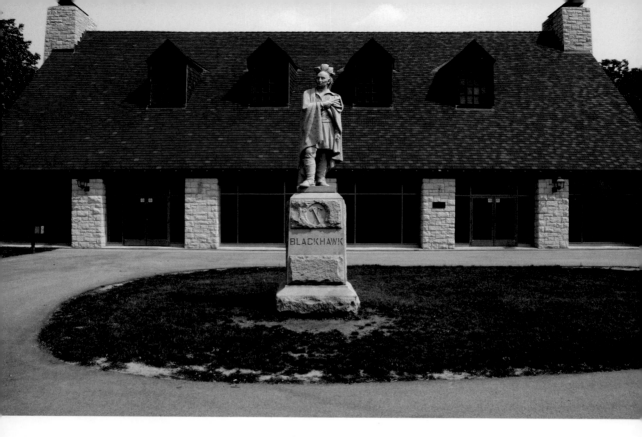

RECONCILIATION, INDIGENEITY, AND POSTCOLONIAL NATIONHOOD IN SETTLER STATES

Reconciliation frames the difference between indigenous and non-indigenous settlers in marked cultural and historical terms. Indigenous people are framed as noble savages primordially attached to their traditional lands and as less or barely capable of transitioning to settled farming and a market economy, drawing on long-standing and now . . . revivified characterizations. This framing makes indigenous people appear, retrospectively, as peculiarly vulnerable to white settlement: not just because they were swamped by white settlers but because of an inherent cultural lack. So, the destruction of their ways of life has come to seem almost inevitable in the wake of settlement and capitalist development. . . .

If indigenous people are cast as authentically primordial and therefore as inherently vulnerable to European colonial settlement, non-indigenous white settlers are presented not so much as perpetrators of violence against indigenous people as they are the winners of history.

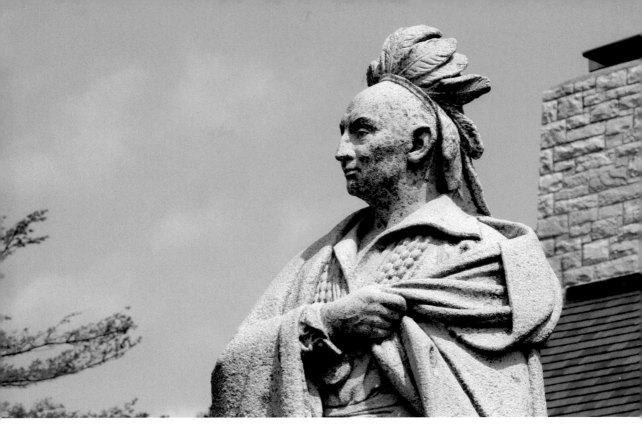

This is an old story, of frontiersmen and women conquering natives and nature in the process of creating a new civilization. Rather than being portrayed as wrong-doers, in the moment of the apology, the descendants of those early settlers bear a special burden to right the wrongs of the past. . . .

"Reconciliation" is, then, more a political frame rather than a project that identifies a specific goal. The term organizes and orients social and historical experiences to the affirmation of a relationship between indigenous and non-indigenous (primarily settler) peoples. That relationship—the interdependency of indigenous and settler peoples—is one that actually constitutes the settler state.

MIRANDA JOHNSON, *Postcolonial Studies*, 2011

7.

We Have More Important Work
to Do within Ourselves First

An Interview with Yolanda Pushetonequa
Former Language Preservation Officer
Meskwaki Nation

SARAH E. KANOUSE

Sarah E. Kanouse (sK): Why is language preservation important to the Meskwaki Nation?

Yolanda Pushetonequa (YP): Language is what carries the culture of any people, any group. Language is really central to culture. It's more than a method of transferring knowledge and information. For Native people, or Aboriginal or Indigenous people, the spiritual self is of utmost importance. It's really your first identity. For example, you're a man or woman. You're a student or a professional, a son or a daughter. But before you're anything else, you're a Meskwaki person. That always comes first. And the language was one of the many things that the Creator gave to the Meskwaki people. It wasn't just the language, but also the ways, the beliefs, the religion. But the language is a part of all of that. It is a piece of the spiritual, ceremonial, religious things.

We also can't communicate the same information—our feelings, thoughts, and ideas cannot just be translated into any language other than Meskwaki. It can be translated, but it's approximate. We need our language to keep the traditional Meskwaki perspective. You can't possibly share Meskwaki concepts using a different language and have it come out the exact same way.

sK: So what are some of the challenges and opportunities that face you right now in your job, doing language preservation?

YP: Some of the challenges are not so specific to Meskwaki—a lot of tribes are probably in the same situation. Because our language is sacred, a lot of things were never documented. They were protected from anybody from outside. But the lack of documentation, books in general—we don't have a lot of those things. Well, actually there are thousands of pages of documentation held at the Smithsonian. Unfortunately they are handwritten, sometimes using older versions of our writing. The pages are faded, and due to natural language change, some of the text may not be familiar to modern speakers. Much of this has been transcribed and

translated; however, only a small percentage of these transcriptions are available to us right now. Also, many of the grammar patterns that are available to us are not intelligible for anyone who is not an advanced linguist. We have many documents reflecting scholarly research on the language, which could be helpful in creating learning tools, but some of the best material requires a linguist to assist with interpreting the concepts.

While we have been using a writing system for about 150 years and many documents are written in Meskwaki, I can say with certainty that the majority of tribal members are not as confident in their Meskwaki literacy as they are in English. A large portion of speakers haven't learned reading and writing enough to put it to use. As a result, we don't have much modern literature. The older literature we do see often uses inconsistent characters, making it more difficult for the new reader.

The writing system we use now is somewhat inefficient because, for example, long and short vowel sound differences aren't differentiated, and there are words that can be written the same way in the current writing but, depending on vowel length, would take on a different pronunciation and meaning. I plan to have my current word lists and resources rewritten with the assistance of a fluent speaker so that vowels are marked. This will be tedious but well worth the effort. Currently, to read, you have to be a fluent speaker to look at a text and the speaker must determine the particular word from context within a sentence. It's impossible for a second-language learner trying to learn the language while at the same time not being able to read the words correctly.

SK: *It's surprising to me, as an outsider, to hear you say that because Meskwaki is said to be one of the better-documented Native languages. Could you speak a bit about the origin of the syllabary and also the Truman Michelson Collection at the Smithsonian?*

YP: The origin of the syllabary? Your guess is as good as mine [*laughs*]. I'm guessing that linguists, anthropologists, ethnographers . . . somebody showed us. It is thought we started writing in the 1880s, and it may have originated from a variation of a neighboring tribe's syllabary, the Ho-Chunk. The current syllabary is the result of a simplification project from the 1980s, but it may have been oversimplified because the different sounds are not differentiated enough for a new speaker to use the written word to support their learning. More differentiation will help new learners who wish to learn based on notes, which is common due to many learners having not yet developed daily access to a teaching-learning relationship with a fluent speaker.

In terms of the Michelson Collection, I am really thankful for it. I'm really thankful for all those Meskwaki people from a century ago who participated in his project. They wrote in their own handwriting so many stories, customs, and beliefs. I believe they were paid a nickel a page, and they wrote and wrote. Some things they wrote were routine everyday events. Most of it is more serious and culturally significant. They put things on paper that I probably should have learned as a young person. Some of it you have to take with a grain of salt because maybe

they didn't explain everything, they may have protected some information, and we can only make assumptions about what their intentions were. But linguistically, it's all very useful because it can be transcribed into English. Dr. Ives Goddard and Dr. Lucy Thomason at the Smithsonian have done a lot of translations into English for much of the material. The downside about the Michelson Collection is that the majority of it is in Washington, DC, at the archives. I think a lot of community members now aren't even aware it exists. So it's not something in wide use here. The literature we have that is currently in daily use is a lot more limited.

The other downside about the early collections, including the William Jones Collection, is that some local community members do have some disappointments in what was presented and reflected in the material. I think some of my elders question the validity of some of the explanations or stories, the cultural nuances that were provided. So I know that it's always going to be important to take some of the information with a grain of salt.

I've been to the archives on two occasions. I've physically seen some of the old papers—pencil on old notebook paper. It's pretty great to see it, and it's sad to see how it's disintegrating. I spent two full days there in the reading room and I literally read so fast I could barely understand it. There were so many documents, I'd put it away and get the next box and I'd look at it really fast. It's amazing and exciting to look at, but eight hours is not enough to see anything but a sliver of it. Some of it's available online, but not enough yet. It will be very useful for language work, as long as we can access the documentation. It is so costly to gain complete copies of all these documents.

SK: *Aside from improving the documentation, what are some other challenges for language preservation?*

YP: Unfortunately one of the struggles we will face is the individual daily choice between language learning and any other activity. Many of our youth are involved in such things as after school programs or extracurricular activities. Many of our adults are employed, raise children, and have other developed interests. It's going to be a difficult decision to shift more energy away from those things that have become important to us and toward language learning instead. Learning a new language to the point of fluency is a task that never ends, and the difficulties in achieving fluency are greater as a person ages. Those of us who are young adults and older adults will need to dedicate countless hours to the task each month and year if we want to be conversational. Now, with an Indigenous language for which there aren't official textbooks, tools, lesson plans, teachers trained in foreign language instruction, there will always be these additional barriers on top of the time commitment. Finding your way through what you need to learn without any idea about where to start is like facing a mountain. That's why I'm choosing to study linguistics, so my inquiries will be more efficient.

Any person in a society learns their language not just by speaking but also by talking to their peers, going to school, seeing things on the Internet, TV, and

anything in print. But we don't hear enough Meskwaki from our peers, at school, on the Internet or TV. Meskwaki is indeed in all of those places, but unfortunately not enough to make a person fluent.

The quickest way to learn would be to spend time with our fluent speakers. As second-language learners, we need to be with our elders. But, the elders and the youth don't spend time together or communicate as much as they should, and that's been going on for at least fifty years. Starting in the 1960s our children stopped becoming fully fluent. And it was so gradual. It didn't happen over the course of a few years, but rather decades; we can definitely say that it started around the '60s. Those born in the '60s are less fluent. Those born in the '70s, like myself, aren't fully fluent, and for us Meskwaki was our first language for only a very limited time. Those in the '80s, they understand even less. Those born in the '90s, they picked up even less. That's the pattern for almost everyone in our tribe. Today, there are many students who use very few Meskwaki words if any at all.

SK: *And what do you attribute that to?*

YP: Those who were born in the '40s and '50s, they grew up spending much of their days on the settlement except for school. They rarely went to town in comparison to today, even though it was just four or five miles away. They played outside, many had no car, phone, or TV. By the time we get to the people who were born in the '50s and '60s, we start to get vehicles, electricity, radio. They also began going to the settlement school where part of the mission was to keep the students from speaking Meskwaki and forcing them to learn and use only English, so all those students became fluent English speakers around that time. People my parents' age grew up listening to radio and then they eventually got TV, started to watch cartoons and whatever else was on TV in the '50s. So those who were born in the '70s like myself, we had electricity, TV, radio, and when VCRs came out, we had a VCR, too. We went to different towns weekly, attended school in town, knew many white people, and my parents used a lot of English with us. So we spoke English. My parents, when they were kids, they spoke Meskwaki to each other most of the time. They were very fluent. My group, we were speaking English to each other.

SK: *So the more infrastructure the settlement got, the less language . . .*

YP: Yep. Infrastructure's exactly it. And I heard the exact same story in a lecture by a Pueblo man. His lecture was all about infrastructure and how it changed the traditional, physical setup of their families. Their homes were very close to each other in traditional ways, then when HUD built for them, the homes were a little further apart and he said it changed something in how they related to each other. We've experienced the same thing with our bigger, nicer homes that we have. Our homes used to be small, even for large families. And I've had people tell me, "You know, it's kind of sad. Now that we have this big, nice home, we don't know if the others are home sometimes. I don't know if they're in the house."

SK: *Technology may have hastened language loss, but can't it also be part of language preservation?*

YP: Yes, it certainly can. There are so many examples of language learning technology in the form of CDs, DVDs, computer games, computer modules, software. They're exciting to consider, but their greatest purpose is probably getting people excited about something, and the advertising and pride that a game would create.

The setback is the staffing, the time, and the skill required in creating these. We don't have the capacity to do much beyond amateur CDs and DVDs.

Due to the constraints I just listed, I preferred to dedicate my limited department staff hours to the things that will certainly have long-term effects.

I've learned how much dedication it takes to become a second-language speaker, and now I'm certain that technology will never be what truly saves the vitality of any language on Earth in its purest form. My current beliefs are that something like a Rosetta Stone can promote the language, get people excited, build pride, and help foster confidence for those who are so under-confident that they refuse to practice words out loud in front of another person, but it won't create a true speaker.

The language exists in the subconscious mind and the voices of fluent speakers, and that is the only source that will actually increase the number of fluent speakers.

Since I know that, it's very hard to justify spending my already limited amount of hours on technology. We have more important work to do within ourselves first.

SK: *You've talked a lot about the challenges of language preservation, but what is going well? What's been successful? Or what are some of the things that make your job easier?*

YP: The thing that makes it easier is the fact that our community is small, and close-knit. Sometimes it just feels like a big extended family. Everyone knows each other, or at least everyone knows most of the families. A good thing about it, and the reason everyone stays or keeps coming back is because it is home and we all, no matter what side we are on, politically, socially, culturally, or whatever, love our community. We love our people. The pride that we have is still there, even though sometimes we might disagree, we're very proud of who we are as a people. Even though many don't know the language fluently, we were still told many things in Meskwaki that we do know and we are still taught how to live this way that we do. Being a part of a tribe is a societal element that Westerners don't have, but I'll explain it like this: You have duty to, love for, pride in, and belonging to this group that identifies your spirit, and your roots from your past, while giving meaning to the present and the future.

The ultimate goal for all of us is probably that not just our family, our closest relatives, and friends are well but also that our whole community is healthy and happy. And the most important piece of that is keeping our traditions and our

Meskwaki Language Tables, fall 2012. Photograph by Yolanda Pushetonequa

culture strong. That is probably one of the most important goals for many of us still, because being a part of a tribe means thinking of the people first. So I get a lot of support from community members in the form of ideas, learning, and insight.

SK: *What have been your major language preservation projects?*

YP: We have a limited time frame to accomplish the things I want to accomplish because the fluent speakers are older. The highly fluent ones are fifty and older, with a really good-sized handful who are forty and older. But do they have the fluency of somebody who is seventy? Most of them do not. Since we're on a time-line, I've spent a lot of time doing research, trying to separate the merely "good" ideas from the sensible and realistic things. Trying to find what models might fit here, identifying our own internal obstacles, and learning about what will work and what will not. Language preservation includes a number of subareas and processes that together work to improve the status of a language: language assessment, documenting the language, deciding together upon approaches for community-based and school-based efforts, community building, training

fluent speakers to "teach" learners, and building curricula for use in school and community programs. It's an unending work in progress that is greater than any single project.

At the time of our initial interview I was the director of the Meskwaki Language Department. As of fall 2013, I started graduate school to pursue my masters in linguistics. By understanding how language works from a structural standpoint, it's like being able to understand how to create and see a blueprint for the language. For adult learners especially, seeing the structure is very helpful. There are a few tribal linguists out there and they've all made enormous strides and impacts on their languages. So I guess you could say I found my focus in all of this language work. One of my goals is to help make stronger teaching and learning materials to support both the teachers and learners. A great challenge that first-language speakers have in teaching to new learners is that the speakers did not learn the language by being "taught" in any way; instead they just absorbed it naturally. Any of our learners who aren't babies aren't absorbing it as naturally as a baby would, and we need that extra care in the design, plan, and presentation of the language because as we grow older it becomes a little bit more challenging to take in that language. So I've seen how linguistics can play an important role in understanding the structure. Otherwise it's like looking at a mountain, or better yet, an iceberg. You don't know what's all in there and you don't know where to start. Using linguistic analysis we can break it down into digestible chunks.

While I was director of the Meskwaki Language Department, I developed a relationship with the culture staff at the school and tried to share this information with the other decision makers of the tribe; we assist each other when we are able to and support each other's ideas. A lot of interpersonal communication has to build over time to align our ideas.

In the community outreach area, we would have language tables twice a week. It's an informal gathering of language speakers and language learners. It is also a form of community outreach and facilitating community learning.

I'd wanted to start a language newsletter and begin doing fun promotional events, but with the time constraints we could always do just so much at a time. My goal was to gain support for adding new team members to the department and by my second year we had four team members.

SK: *Please describe any collaborations around language preservation between the Meskwaki and Sac and Fox in Oklahoma, as well as with other tribal language preservation groups.*

YP: Jacob Manatowa-Bailey, the director of the Sauk Language Department, summed up the differences between the Sauk and Meskwaki like this. "We're opposites," he said. "We got started a while ago and we know what we need to do, but we don't have as many resources as you. You on the other hand, are just starting out. You have the resources like money and a fluent speaker population, but you have to figure out what you need to do."

And it isn't as simple as replicating what they are doing. The Meskwaki have a significantly larger number of speakers. So the approach will be different. With a

larger portion of speakers, it'll be a different range of activities that optimize our opportunities with the resources that we have.

Cultural Survival, a leading human rights and cultural protection organization, applied for a National Science Foundation grant on behalf of both the Sauk and Meskwaki tribes to digitize the Truman Michelson Collection. We at the Meskwaki tribe wrote letters of support for the grant application process, while Cultural Survival did the application. Partnerships will always be really important for both the Meskwaki and Sauk, as they were in the past.

More fun things come about between the tribes. People make visits both ways. We exchange words back and forth. Sometimes either tribe may have forgotten a word or may not have a word that the other one does and we like to compare what we have. Lately, I've chatted on Facebook with a couple of the Sauk apprentices.

We have fun talking about our experiences and we look forward to when we're elders speaking to each other in Sauk and Meskwaki because there's still that strong bond between us being that we share a language.

SK: *Compared to some other Native languages, there are actually quite a high proportion of first-language Meskwaki speakers. I was wondering if you could talk about some of the reasons for that. I can surmise some of them: the resistance to the boarding school back at the turn of the century, that written languages developed quite early on, and the fluent code talkers during World War II. Those all seem to be ways that the language was clearly very important and remained very relevant until the advent of TV. What else accounts for the strength of the language?*

YP: I really believe that our family system, our kinship, our sense of community and staying close to each other . . . I think that's really strong. I also understand that our people were particularly more defiant of the missionaries. We remained committed to what we believed, and we defied for generations what the missionaries were trying to tell us. That same spirit was there long before the missionaries and it's still here today. That's just an example. Our community is known for being "conservative." We did a pretty good job at staying insular in a lot of ways and longer than other tribes did. You can see it at the tribal level, but from living as a member of the community, I can tell you our social connections are definitely different here all the way down to the family and individual level. We just have a strong root, a set of steadfast beliefs that couldn't be eradicated even when outsiders tried aggressively.

As for boarding school experiences, the Meskwaki maybe were traumatized, too, but not in the way that they came home and refused to speak their language. Other tribes had language loss due to the sheer torment they experienced. In our community, yes, I heard a story of an elder who recently passed at age ninety-three. He said that when he was little they had to take turns hiding to go cry because of the trauma. They would steal raw potatoes just to eat because they weren't fed. But our people came home still Meskwaki and still speaking, still proud. In other tribes, people came home and didn't speak their own language ever again; they would very purposefully teach English to their children because they did

not want the children to go through what they did. In my community, they spoke Meskwaki to the children. Even though they went to boarding school, they still came back home and told their kids the things that were really important: religious aspects, cultural aspects, the spiritual things. Like my Grandma, she passed recently at age ninety-six. She went to a boarding school and said they were made to speak English. Maybe she was not abused as bad as others, but our people carry on the old tradition regardless of boarding school: the old stories, the teachings, those important spiritual things that we're supposed to know as Meskwaki people. And we have people living who know so much. They probably have three PhDs in Meskwaki [*laughs*].

I read an excerpt of a book or article from an anthropologist who said that the Meskwaki Settlement is a "cultural island" among the rest of the cornfields of Iowa. And when I read that I thought that was exactly right. When I was growing up, the majority of our people didn't associate too much with people in the neighboring towns. It's like we didn't want anything to do with the outside world in many ways. We don't have that much in common with the neighboring farmers. Corn, I guess, but our uses of corn are so different. But our people just didn't associate with the whites surrounding us beyond buying products and services. The lack of interaction, I think, has helped insulate us for so long.

8.

Makataimeshekiakiak, Settler Colonialism, and the Specter of Indigenous Liberation

DYLAN A. T. MINER (MICHIF)

See, we only became Indians once the armed struggle was over in 1890. Before then we were Shoshone or Mohawk or Crow. For centuries North America was a complicated, dangerous place full of shifting alliances between the United States and Indian nations, among the Indian nations themselves, and between the Indians and Canada, Mexico, and half of Europe.

<div style="text-align: right;">PAUL CHAAT SMITH, Everything You Know about Indians Is Wrong</div>

For the Comanche curator and historian Paul Chaat Smith, to be Indian is to allow oneself to be defined by Eurocentric and colonial nomenclature. Prior to colonization, there were no Indians. Instead, the continent was home to dozens of autonomous Indigenous nations and the alliances and rivalries between them. Although colonial discourse remains significant within Indigenous struggles for decolonization, Smith is clear that to allow oneself to be defined as Indian is part of the ongoing and slippery process of settler dominance. The complex landscape of shifting Native alliances of the nineteenth century was overwritten by the binarisms of settler colonial hierarchies. The unique struggles and alliances of the Nemme sosoni'ihnee'e (Shoshone), Kanien'kehá:ka (Mohawk), and Apsáalooke (Crow), for instance, were subsumed in the 1890s into a single Indian polity. Settler colonialism made "Indians" from the linguistically and politically distinct Sauk, Meskwaki, and Anishinaabeg, among other national identities. The national distinctions between multiple indigeneities became a legal entity defined by a settler colonial government.

While the precise contours of this process varied from one Indigenous nation to another, the broad outlines described by Smith are clear: Indian identities and body politics only exist in response to colonial definitions of distinct Indigenous nations. Within a political framework dominated by federal Indian policy, no

Native struggle was merely local. The sovereign demands of the Cherokee Nation, for instance, had real-world impacts on the political condition of the Sauk and Meskwaki peoples. Inversely, Algonkian political and juridical battles likewise effected what was happening to the Tsalagi (Cherokee) and other Indigenous nations in the context of U.S. settler colonialism. In the context of *Re-Collecting Black Hawk*, it is imperative to concurrently understand the interconnectedness of Indigenous struggles against U.S. hegemony while we decipher the ways that settler colonialism, as a system of dispossession, negates Indigenous self-governance and appropriates its images and narratives of resistance.

As a way of countering these colonial discourses, this essay discusses Makataimeshekiakiak's stand against U.S. colonial expansion in the context of many centuries of Indigenous resistance and non-Native solidarity, of which this book is a part.[1] Employing my own knowledge of place, I invoke the four cardinal directions to spatially ground the collision of colonial and anticolonial forces. As such, imagine yourself in the western Great Lakes, the very topography this book encounters. Look around and acknowledge the specificity of your surroundings. To your east, the barbarism of settler colonialism emerges at an uncontrollable speed. To the west, the specter of Indigenous anticolonialism develops, with Makataimeshekiakiak's armed confrontation but a single encounter within a matrix of countless anticolonial insurrections. To the north, art's critical capacity flashes like the northern lights, while southern winds bring renewal and strength to renounce settler privilege—an intensely difficult task. By orienting yourself *within* the text rather than outside it, your journey through this book as a reader will confront and begin dismantling settler colonialism, beginning from the very place you inhabit.

What is now known as the Midwest was at one time the Northwest. Of course, each of these geographic designations evokes the movement of Manifest Destiny from the imperial center of Washington, DC. By contrast, situating ourselves within the geographic terrain of the Great Lakes, what could be called Anishinaabewaki (Anishinaabemowin for Indigenous lands), both reader and author may begin to move beyond colonial ways of privileging Washington, DC, as the seat of power and reinscribing the inevitable westward movement of settlement. Grounding itself in the Great Lakes region, this essay contests the westward course of empire by being about *this place* in relation to itself. By looking outward in all directions, we center this land and its stories, as well as embrace those others to whom we must listen. This approach mirrors a Native relationship with the land that, according to the Dené political theorist Glen Coulthard, "not only anchors many Indigenous peoples' critique of colonial relations of force and command but also our [Indigenous peoples'] visions of what a truly postcolonial relationship of peaceful coexistence might look like."[2] *Re-Collecting Black Hawk* invites the reader to similarly imagine and work toward that "truly postcolonial relationship," one which demands the participation of both Native and settler populations.

In *Colonialism: A Theoretical Overview*, Jürgen Osterhammel defines colonialism as "a relationship of domination between an indigenous (or forcibly imported) majority and minority foreign invaders." He continues, "Rejecting cultural compromises with the colonized population, the colonizers are convinced of their own superiority and of their ordained mandate to rule."[3] Colonialism irreparably ruptures the evolution of colonized societies while transforming the consciousness of all who live under it. As the Caribbean intellectual Aimé Césaire noted in the early 1950s, colonization "dehumanizes even the most civilized man; that colonial activity, colonial enterprise, colonial conquest, which is based on contempt for the native and justified by that contempt, inevitably tends to change him who undertakes it."[4] While independence movements of the twentieth century offered self-determination for many former colonies in Africa and the Caribbean, the United States and Canada remain colonial powers in which Indigenous nations are legally constructed as dependent entities within the settler state. North America is very much still a colonial society.

The historian Patrick Wolfe distinguishes between *colonialism* and the particularities of *settler colonialism*. For Wolfe, "The primary object of settler-colonization is the land itself rather than the surplus value to be derived from mixing native labour with it. Though, in practice, Indigenous labour was indispensible to Europeans, settler-colonization is at base a winner-takes-all project whose dominant feature is not exploitation but replacement."[5] In the so-called New World, both colonial and settler colonial projects commenced in the sixteenth century and remain ongoing to this day. Historically, French and Spanish regimes were more actively engaged in classical colonialism, while the British employed a strategy of direct land and resource appropriation that continued and often accelerated after their colonies gained political independence. The American Revolution was won by settlers, not colonized peoples, and the new government pursued an aggressive project of Euro-American expansionism known as Manifest Destiny. This required the creation of legal and economic systems that permitted European colonists and their descendants to become legal titleholders of the land. Manifest Destiny is, at its core, settler colonialism.

The nineteenth century saw Euro-American settlers move westward en masse. The U.S. government encouraged white migration into Indian Country by distributing free or inexpensive land, while cultural mythologies to justify this process were reinforced through art and literature. Emanuel Leutze's popular 1861 painting *Westward the Course of Empire Takes Its Way*, which visually illustrates the "American pioneering spirit," presently hangs in the capitol in Washington, DC. As a work of art, this painting facilitated a folkloric retelling of the peopling of the West. In the image, musket-carrying mountain men, followed by women in horse-drawn wagons, traverse high mountain passes to arrive at the barren and "uninhabited" lands to the West. The painting's continued presence in the U.S. capitol demonstrates the continued prominence of Manifest Destiny in North American historiography.

Westward the Course of Empire Takes Its Way is absent of any Native figures, as Indigenous cohabitation with Euro-American settlers was not how the narrative of settler colonialism was to be written. Yet despite the legal and cultural disavowal of Indigenous land claims, the specter of "Indian" insurrection loomed large in settler colonial North America. It was therefore vital that Native peoples be defined and managed by settler governments.

In the United States, Indigenous sovereignty, a permeable and semiautonomous governability outside federated state jurisdiction, was cemented in 1831 with the Supreme Court ruling *Cherokee Nation v. Georgia*. This decision, one of the most significant in American Indian law, limited Indigenous sovereignty by defining Indigenous nations inside the geopolitical borders of the United States as "domestically dependent." As Chief Justice John Marshall paternalistically wrote in the opinion: "they are in a state of pupilage. Their relation to the United States resembles that of a ward to his guardian. They look to our government for protection; rely upon its kindness and its power; appeal to it for relief to their wants; and address the President as their Great Father."[6]

This denial of Native coeval sovereignty (the notion that Indigenous peoples had existing governance structures already in place) facilitated the "reserving" of Indians to allotted reservation lands, which, in turn, was required for the establishment of modern-day territories and nation-state formation in North America. This is to say that the United States, and its citizenry in general, did not recognize that Indigenous nations could democratically govern themselves. Part and parcel to this dispossession was the denial that Indigenous peoples were (and are), in fact, contemporary. Distinct Indigenous nations were grouped into a single Indian polity.

Following the War of 1812 (which began in skirmishes with Native peoples around the southern Great Lakes), the Treaty of Ghent solidified European geopolitical borders in North America. In response, it dispersed many Indigenous refugees, including my ancestors, northward to escape the potential violence of the United States. Some would enter into treaty, while others would be defined as "Halfbreeds" (and not "Indians") and unable to sign treaties. However some of the legal distinction between "Indians" and "Halfbreeds" was reversed with the 2013 Daniels decision in the Canadian federal court, which ruled that the Métis Nation be recognized as Indians under the Indian Act.

To the south, the 1848 Treaty of Guadalupe Hidalgo appropriated nearly half of Mexico's land base from its primarily Indigenous and mestizo citizenry. These newly acquired territories in the mid-nineteenth century became easily obtainable for white settlement with the Homestead Act in 1862. This act, signed by president Abraham Lincoln, gave legal title of 160-acre plots to those settlers who "improved" the land. Indigenous peoples needed to be removed or relocated so that European and Euro-American settlers could repopulate their territories. But resistance was not futile.

The Indian Removal Act, the legal definition of Indigenous peoples as "domestic dependent nations," and the genocidal relocation of the Choctaw, Chikashsha

(Chickasaw), and Mvskoke (Creek) from their homelands in the southeast all chronologically coincide with Sauk resistance to U.S. violence in the early 1830s. While proving a direct connection between events in the southeast and the Sauk and Meskwaki confrontation may be complicated, the density of these events suggests the gravity of the political climate for Native people. As nations, the Sauk and Meskwaki would have been aware of the struggles of other Indigenous nations throughout the continent. To deny this would assume Indian naïveté and the political ignorance of Native peoples. Moreover, it overlooks the undeniable and robust networks of political (and cultural) alliances that existed prior to, and continued throughout, the imposition of settler colonialism. Such alliances existed within linguistic and cultural groups, such as the Haudenosaunee (an alliance of five and then six Indigenous nations) and the Anishinaabeg (an alliance of at least three Indigenous nations), as well as via expansive and continental trade networks. Tecumseh's uprising, discussed below, called for banding together all Indigenous people against setter colonialism.

WEST: MAKATAIMESHEKIAKIAK, INSURGENCE, AND THE SPECTER OF LIBERATION

If coloniality and the violence of settler colonialism came primarily from the east, the specter of Indigenous insurgence and liberation loomed large in the west. The early nineteenth-century Indigenous resistance east of the Mississippi, such as the struggles fought by Tecumseh and Makataimeshekiakiak, extended westward as the Homestead Act and transcontinental railroads violently divided Native territory. As white Americans and European immigrant settlers migrated west to squat on lands traditionally inhabited by their Native neighbors, the colonial situation between Indigenous nations and non-Native settlers became progressively more tense. In fact, the Sauk and Meskwaki's current locations in present-day Kansas, Oklahoma, and Iowa are a product of centuries of encroachment.

In the early 1600s, the Sauk lived around Michigan's Saginaw Bay, a place whose name means, literally, place of the Sauk. Driven from this territory in the 1640s, the Sauk and Meskwaki migrated across the Straits of Mackinac, resettling around present-day Green Bay, Wisconsin. In the eighteenth century, French military forces pushed them toward the northern Mississippi River, resettling in what is now Iowa. The Sauk populated the region north of the Meskwaki, in the Mississippi watershed. The U.S. militarily encroached on their territory around the beginning of the nineteenth century. The U.S. government began signing treaties with Native nations, at which point internal divisions arose within Indigenous communities.

The Sauk and Meskwaki nations, known to the U.S. government collectively as the Sac and Fox, initially entered into a treaty in 1804. Makataimeshekiakiak and many of his affiliates denied the validity of the treaty signed between William Henry Harrison, then governor of Indiana Territory, and Sauk leader Quashquame, which ceded Wisconsin, south of the Wisconsin River, and nearly

all of Illinois to the United States. While Makataimeshekiakiak was against ceding lands in principle, he also felt that this treaty, in particular, violated protocol because the tribal council was not consulted in full. The U.S. government's lack of regard for Indigenous modes of governance indicates their disregard for Indigenous sovereignty, in general.

This early nineteenth-century treaty process, one directly tied to the winner-takes-all settlement program of the U.S. government, initiated the nation-to-nation diplomacy between the United States and Sauk and Meskwaki nations. At this time (as well as today), Indigenous ontologies posed a threat to the westward expansion of capitalist ideals, while Indigenous bodies occupied territories needed for their expansion. In his discussion of Indigenous dispossession in western Canada, a place where treaties were never even signed, Cole Harris writes that "the interests of capital and settlers converged. For both, land was the opportunity at hand, an opportunity that gave settler colonialism its energy. Measured in relation to this opportunity, native people were superfluous. Worse, they were in the way, and, by one means or another, had to be removed."[7] For both capitalism and settlement to function, Indigenous nations needed to be physically, culturally, genetically, or structurally removed.

Although Indigenous nations have generally upheld their ends of the reciprocal treaty relationship, the United States and Canada have not. The Homestead Act, as a significant denial of treaty obligations, solidified the triumph of settler society over the land's Indigenous citizenry by redistributing Native lands to European-descended newcomers. That Makataimeshekiakiak's image is now synonymous with settler rule is a result of the barbarous colonial process and the failure of public history to adequately recollect our shared memories. Not only were Indigenous societies violently removed from their traditional territories, settler societies appropriated their imagery as a way to legitimate their own illegitimate claims.

Makataimeshekiakiak was certainly neither the first nor the last to forcefully resist colonial oppression. The U.S. military considers the "war against Black Hawk" as the fifth of fourteen campaigns collectively called the Indian Wars.[8] According to the U.S. Army, the Black Hawk campaign began when "a faction of Sauk and Fox Indians, living in eastern Iowa and led by Black Hawk, threatened to go on the warpath in 1832 when squatters began to preempt Illinois lands formerly occupied by the two tribes."[9]

To the east of Sauk and Meskwaki territories, the Shawnee leader Tecumseh organized tribes throughout the Ohio Valley and the Great Lakes. Prefiguring contemporary pan-indigenism by two centuries, Tecumseh believed in Indigenous sovereignty and adamantly defended Native political rights until his death at the hands of the settler-colonists. Tecumseh's Rebellion, as these events are commonly known, was the precipitating event leading up to the War of 1812. However, unlike the more widely known war, Tecumseh's struggle was one of anticolonial proportions. As a proponent of pan-Indigenous collaboration, Tecumseh worked to bring together many Indigenous nations to fight against the U.S. military. This included traveling to present-day Oklahoma to recruit Tsalagi (Cherokee),

Chikashsha (Chickasaw), Choctaw, Mvskoke (Creek), Yat'siminoli (Seminole), and Ni-U-Ko'n-Ska (Osage) warriors. For the U.S. military, this is considered the second of the Indian Wars and the first in the nineteenth century. However, it was definitely not the last time the U.S. or Canadian military assaulted Indigenous communities.

Indigenous anticolonial struggles persist today in countless forms. Chief among these is the pursuit of decolonization, the process of dismantling settler colonialism's social, political, intellectual, and spiritual hegemony. The Idle No More events of 2012 and 2013 are among the most visible of these. Noting that "colonization is an all-encompassing presence in our lives," Waziyatawin (Dakota) and Michael Yellow Bird (Arikara-Hidatsa) define it as "both the formal and informal methods (behaviors, ideologies, institutions, policies, and economies) that maintain the subjugation or exploitation of Indigenous Peoples, lands, and resources."[10] Paradoxically, the political dominance of settler colonialism means that resistance can begin anywhere and can take many forms; many of these decolonial efforts appear in image pairings on the pages of this book. Campaigns against "Indian" sports mascots; exercising the right to hunt and fish on unceded territories; activism targeting the storage of radioactive and hazardous wastes on tribal lands; environmental struggles against mining on sacred sites; and Indigenous language preservation efforts can all be seen as part of a broader effort toward decolonization.

Brown and Kanouse note that the Black Hawk War is commonly written into history as the last Indian war east of the Mississippi. By framing this nineteenth-century confrontation as the ultimate moment of Indigenous insurrection, hegemonic history masks the ongoing battles that are currently being waged against colonialism. Makataimeshekiakiak's image, once reclaimed from its myriad settler appropriations, is part and parcel of the old spirit on which to draw. To reclaim Black Hawk is to begin to reconcile history. However, Makataimeshekiakiak's reclamation does little if it is not intimately linked to the everyday, contemporary realities of Indigenous people, particularly those for whom Makataimeshekiakiak's spirit is strong. This is a true move toward postcolonialism.

Unfortunately, existing political thought does not adequately address the specificities of contemporary indigeneity. As Jace Weaver (Tsalagi) argues, "postcolonial discourse says little about indigenous liberation struggles."[11] In postcolonialism's place, however, a radical indigenist thought and action may appropriately attest to ongoing Indigenous struggles. Beginning in 1994, the specter of liberation emerged in the masked faces of Mayan revolutionaries in Chiapas, Mexico. Using the advancement of the North American Free Trade Agreement (NAFTA) as the tipping point, resistance to colonial rule had reached its logical conclusion. Through *zapatismo*, a radical indigenist oppositional political tradition, Indigenous revolutionaries brought their demands onto the national and international stage. Unlike colonized subjects, the Zapatistas refused to be denied the visibility they rightfully deserve. As recently as 2011, Subcomandante Marcos, the non-Native spokesperson for the Zapatistas, maintains, "What we're going to do is shake this country

up from below, pick it up and turn it on its head."[12] Nearly two decades after their initial uprising, in December 2012, 40,000 Zapatistas marched through the streets of Chiapas, reasserting their presence. In February 2013, the Tzetzal leader Major Moisés was announced as the new *subcomandante insurgente*, a significant position in the non-hierarchical organization. Subcomandante Insurgente Moisés is known for, among other things, stating that "Our way is that we practice first and then make theory." Through creative and anticapitalist organization, the Zapatistas have used Indigenous ungovernability to challenge the perceived docility of "Indians."

The model established by the Zapatistas, a multilingual collective of Mayan campesinos, glows bright for Indigenous activists in North America who continually grapple with ongoing colonialism. Taiaiake Alfred (Kanien'kehaka) calls this decolonial process "Wasáse, a ceremony of unity, strength, and commitment to action."[13] Informed by what he calls anarcho-indigenism, Alfred believes that Indigenous liberation is guided by the resistant spirit of the ancestors but founded in entirely new ways of being in the world. For Alfred, Indigenous ontologies are simultaneously ancient and contemporary. Accordingly, "the warrior spirit is the strong medicine we need to cure the European disease. But, drawing on the old spirit, we need to create something new for ourselves and think through the reality of the present to design an appropriate strategy, use fresh tactics, and acquire new skills."[14]

This process of creating "something new" builds on Native traditions existing as cracks and fissures within a settler society that tried but failed to extinguish indigeneity as an ontological threat. Within these minute cracks, we may begin to think beyond the limits of coloniality. As the Maori scholar Linda Tuhiwai Smith notes, these tactics of resistance are intimately intertwined with "our struggles to become self-determining, the need to take back control of our destinies." She continues: "One of the strategies which indigenous peoples have employed effectively to bound people together politically is a strategy which asks that people imagine a future, that they rise above present day situations which are generally depressing, dream a new dream and set a new vision."[15] Given the structural realities of settler colonialism in our lives, this imagining or dream cannot be a fantasy of Indigenous isolation. Glen Coulthard's vision of "a truly postcolonial relationship of peaceful coexistence," based in Indigenous ontologies of "place-based ethics of reciprocity," requires *collective* dreaming between both Natives and settlers. [16]

History provides us with a few examples of what these utopian dreams might look like. In his interview in this volume, the Meskwaki tribal historian Johnathan Buffalo recounts the fundamental difference between Scandinavian immigrant settlers and their Anglo-American peers. He notes that the Swedish and Norwegian immigrants' "instinct wasn't to shoot first, their instinct was, 'Hey, Indians! I'll go talk to them!'"[17] Incompletely assimilated into white society, these northern European immigrants advocated on behalf of the Meskwaki in the Iowa state government, which ultimately allowed the Meskwaki to purchase back a land base. Settler privilege did not always deny Indigenous presence; denial, however, was the dominant form of social interaction.

Like socialist Scandinavian émigrés, other non-Natives in North America, particularly the French, established strong kin networks with Indigenous nations. In fact, francophone Canadiens intermarried with Anishinaabeg (Ojibwe, Ottawa, and Potowatomi), Nēhilawē (Cree), and other Indigenous groups, either integrating into structures of the Native community or establishing new Indigenous societies; such was the case of the Michif (Métis). In the southeast, in particular, black and Indigenous relations also formed a complex racial triangulation that was not easily contained by settler-colonial systems of racial control. Remembering these legacies of settler-Indigenous collaboration can build the foundation for a collective dreaming to challenge colonial structures of inequality and exploitation, while acknowledging the historically unequal structures put into place by these networks.

NORTH: SETTLER COLONIALISM, THE POWER OF DREAMING, AND ART

The radical potential of art shines in the north, alongside the aurora borealis and the North Star. Many indigenous cosmologies are tied to celestial constellations and the stories told about them. Art allows us to dream new celestial possibilities that physical realities may not allow. During the late twentieth and early twenty-first centuries, artistic practice underwent a paradigm shift in which politically engaged artists were no longer content to represent radical politics in their work but instead strived to create works that acted as politics themselves. This shift, described by Victor Burgin as the difference between the "representation of politics" and the "politics of representation," accompanied a move away from modernist aesthetics and an embrace of certain characteristics of earlier politicized avant-gardes: collaborative production, aesthetic deskilling, and a blurring of the boundary between art and life.[18] The art historian Gabriel Peluffo Linari notes that this conceptual shift "made possible a new convergence, for example, of art, anthropology, and politics."[19]

The "politics of representation" is particularly crucial for Indigenous nations, since Native peoples are commonly represented in romantic and mythologized ways that diminish their visibility as political agents in both the past and present, as well as in the future. Moreover, Indigenous aesthetic traditions grant extraordinary power to artistic visions. Just as Indigenous Australian presence is actualized through dreamscapes, and their subsequent materialization through painting, so too do dreams facilitate our imagining of new histories and futures. It is through the intangibility of art, that is, art's ability to transgress easy and quantifiable solutions, that we may individually and collectively dream a radical vision of a better world.

Art does not prescribe mandates; rather it dreams previously unimaginable possibilities. Louis Riel, a Michif revolutionary hanged for treason against Canada in 1885, is credited with saying, "My people will dream for one hundred years; when they awaken it will be the artists who give them back their spirit."[20] With this prophetic statement, Riel acknowledged the immense and transformative power

of art making. From this particularly Indigenous perspective, not only do artists transform the material substance with which they work, they also use their creative labor to construct new and otherwise unthinkable worlds. Dreaming envisions new ways of reclaiming spirit.

As an image-text, *Re-Collecting Black Hawk* carries strikingly dream-like qualities. By juxtaposing problematic settler-colonial appropriations of Makataimeshekiakiak with texts that evoke a radically different and living Indigenous spirit, Brown and Kanouse reimagine his legacy in the landscape and in everyday settler practices. While his likeness remains unquestioned and therefore normalized by most midwestern settlers and their descendants, Brown and Kanouse pose questions that directly challenge ingrained and sustained colonial memories. Although they refuse to give easily identifiable answers, their use of the image-text challenges the very formation of history as science (that is, as quantitative fact). While images have the façade of indexicality, they are significant because of the multiple readings they engender. By amalgamating texts and images, this project stimulates multiple readings of both the text and image, as well as the palimpsests between them. *Re-Collecting Black Hawk* causes discomfort specifically because it forces us to examine who we are as a people and what we know about ourselves—whether Native or settler or having roots in both positions. Even if they do not clearly articulate their ideological position, Brown and Kanouse confront colonial amnesia by coalescing the dialectic between Native presence and absence. It is in this indeterminate space between presence and absence, between being awake and asleep, where the notion of the dream returns. While psychoanalysis might call this the recollection of repressed desires, it might be better to think of these dreams as the space where repressed and marginalized histories are reclaimed. By illuminating and re-collecting these dreams, Brown and Kanouse oppose the centrality of forgetting and the omnipotence of colonial amnesia. These dreams re-collect the power of colonialism and seek to upend it.

Writing in 1931, Bertolt Brecht noted that "photography, in the hands of the bourgeoisie, has become a terrible weapon against the truth. The vast amount of pictured material that is being disgorged daily by the press and that seems to have the character of truth serves in reality only to obscure the facts."[21] This tension between the perceived indexicality of a photograph and its referent, of course, lies at the heart of *Re-Collecting Black Hawk*. Photography, particularly the landscape genre, is a visual tradition that has historically excluded Indigenous individuals from any semblance of subjectivity.[22] But, as Brown and Kanouse visually and conceptually demonstrate, the photograph goes far beyond an indexical relationship between an image and its subject. In fact, from an Indigenous perspective, photography serves an intellectual and philosophical end. The Hopi image maker Victor Masayesva sees in photography "a philosophical sketching that makes it possible to define and then to understand our ignorance. Photography reveals to me how it is that life and death can be so indissolubly one; it reveals the falseness of maintaining these opposites separate. Photography is an affirmation of opposites. The negative contains the positive."[23] It is in this Indigenous dialectic, where

the photograph reveals both positive and negative, truth and fiction, mythology and fact, presence and absence, dreams and reality.

It is here that *Re-Collecting Black Hawk* develops its visual strength. By revealing the "negatives" of history, to borrow from photography's double entendre, Brown and Kanouse illuminate a potential path to the future. This pathway is not prescriptive. Rather it uses photography to illuminate the dark recesses of colonial settlement and Indigenous dispossession in a way that challenges the unfettered continuation of settler colonialism.

Like the world of dreams, art is a cultural space where paradoxes are not rushed to resolution. Dialectical tensions can be experienced, our ignorance can be described, and processes for addressing it can be rehearsed. At the same time, it remains deeply embedded in capitalism and its colonial logics. Critical and avant-garde art practices have long sought to work through these dialectical tensions. In *Empires, Ruins, and Networks*, Scott McQuire and Nikos Papastergiadis argue that "to consider the place of art today is not a matter of imagining alternative places that exist outside capitalism or beyond the reaches of colonialism, for these structures have already claimed a space within us." Instead, they argue that the task of the artist is to develop "a more rigorous strategy [that] would include a practice that not only interrogates from within, seeking to reclaim the past and 'hijack' the present, but also develops collaborative practices that allow a space for ethical relations and the appropriate language that can make sense of specific situations."[24] Since very few live outside the reaches of either colonialism or capitalist, market economics, ongoing coloniality may be challenged by the development of decolonial thought and anticolonial action that transgress the limits of an otherwise violently bounded contemporaneity.

Re-Collecting Black Hawk is built using precisely this collaborative or cooperative model. Initiated in 2007 as a two-person collaborative photo-essay, this book expanded to include the voices of others—specifically the Sauk and Meskwaki who live with the legacy of Makataimeshekiakiak most directly, as well as other Indigenous intellectuals and activists. In sovereign Sauk territory, the image of Makataimeshekiakiak means something quite different than it does among the non-Native inhabitants of the land known today as Iowa, Illinois, and Wisconsin. Sidelining their own authorial voices to, quite literally, listen to the perspectives of Indigenous people, Brown and Kanouse model an important part of the self-decolonization process. In a feminist context, Wendy Hui Kyong Chun develops the notion of a "politics of listening" that also points a way forward for settlers to act in solidarity with Indigenous people.[25] Challenging the centrality granted to speaking as an act of agency, Chun "argues for a politics of listening as a necessary complement to the politics of speaking." She continues: "Although important, the question of how to listen and respond . . . has been largely unaddressed, possibly since the question of listening in general tends to be under-theorized and/or under-valued: more often than not, we assume we know how to listen."[26] In many regards, this is one of the most impressive aspects of *Re-Collecting Black Hawk*. Brown and Kanouse listened before speaking.[27]

In an Indigenist context, Taiaiake Alfred connects this politics of listening directly to another key requirement of decolonization: a transformed relationship to the land. Alfred writes: "If non-indigenous readers are capable of listening, they will learn from these shared words, and they will discover that while we are envisioning a new relationship between Onkwehonwe [original or Indigenous people] and the land, we are at the same time offering a decolonized alternative to the settler society by inviting them to share our vision of respect and peaceful coexistence. The non-indigenous will be shown a new path and offered the chance to join in a renewed relationship between the peoples and places of this land, which we occupy together."[28] For Alfred, Indigenous and non-Native communities have much that they can share with one another, if non-Natives are willing to listen for new paths to be illuminated.

Writing about his experience as a non-Native activist, Richard J. F. Day acknowledges, "I know I am never really of the land, anywhere."[29] This alienation from the land arguably motivates the problematic appropriation of Native imagery documented in the photographs in this book. To legitimate its territorial claim, settler society appropriates the name and image of the people it slaughtered and displaced to possess it. Therefore, they also appropriate the land itself and its very legacy. Unwilling to let this process continue without comment, Brown and Kanouse intimately traverse the land, driving its contours at nearly a walker's pace, learning its spirit, collaborating with its traditional knowledge keepers, and building rapport. In many ways, they incorporate what I have elsewhere called the "Methodology of Visiting." Employing this methodology, practitioners, including Brown and Kanouse, visit community members, listen to their perspectives, and speak with the elders. Indigenous existence on the land is marked by ongoing and reciprocal social relationships, often produced by brief visits at one another's home.

Inverting the process of newcomer assimilation into settler colonial nation-states, Brown and Kanouse integrate Indigenous anticapitalist models of economics and reciprocal kinships into their working process.[30] As anthropologists such as David Graeber have explained, the non- and anticapitalist nature of many Indigenous societies has much to offer the stratified societies of the West. Learning with their Indigenous collaborators, Brown and Kanouse pursue an intimate and profound relationship to the land and its diverse peoples—not by pretending to "go native," but instead by critically examining how those of us living in the rural Midwest or western Great Lakes region relate to our "homeland." While many non-Native people feel constrained or paralyzed by the guilt of settler privilege, Brown and Kanouse actively disavow colonial mythologies and provide alternative ways of engaging with the land and its histories of violence.

A key component of their process of unmaking colonial relationships and economic structures is the decision to make *Re-Collecting Black Hawk* as accessible as possible. In line with contemporary critical artists who circumvent the for-profit gallery system, *Re-Collecting Black Hawk* appears not as a limited-edition set of silver gelatin prints but as a widely distributed print book produced by a nonprofit university press. Selections from this book, including this essay, and supplemental

materials have been posted on a companion website, www.recollectingblackhawk .net. By deliberately *not creating* art objects-turned-commodities, this image-text seeks alternatives to pure market capitalism, in some way nodding to Indigenist economics in its production and distribution.

With these methodological choices—visiting, listening, collaboration, and democratic distribution—Brown and Kanouse demonstrate their commitment to an ethical practice that brings with it the potential eastern movement toward emancipation, both culturally and politically. Through its penchant for dreaming, collaborative or engaged art making can confront issues that quotidian practices would not allow. In her essay "The Collaborative Turn," the curator Maria Lind writes that through cooperation, an artist "emphasizes the notion of working together and mutually benefitting from it."[31] *Re-Collecting Black Hawk*, a cooperative effort by both Indigenous and settler participants, indicates that both constituencies may collectively engage in decolonial projects. By examining colonialism and its racist and capitalist orientations, we in turn participate in the creation of a world, to again echo Taiaiake Alfred, of peaceful coexistence.

SOUTH: DISAVOWING SETTLER PRIVILEGE IN INDIAN COUNTRY

To be Indigenous is to have a kin relationship with the land. Inversely, to be a settler is to control and claim ownership of this same land. Inherently, these two perspectives are at odds with one another. They are based in oppositional and contradictory ontological systems. The logics of settler colonialism, which deny Indigenous ways of being in the world, continue to use violence to appropriate, settle, and extract minerals from lands whose spirits are simultaneously ancient and contemporary. The same logic of capitalism that precipitated initial colonialism in the Americas remains in direct conflict with Native beliefs, priorities, and needs.

Even so, Indigenous people are still very much living with their precolonial governments intact. No matter where one travels, Native peoples will share their intimate and profound bond with and to the land. Looking south to the activism of Latin America's Indigenous nations offers hope in the Global North. From the recent insurrection of teachers in Oaxaca to the struggle for coca in the Andes to, as discussed earlier, the Mayan rebels in Chiapas, our southern cousins have histories and legacies that may inform our own lives and struggles. In traveling to learn from one another, what I would call using a methodology of visiting, it is common protocol for Indigenous people to present themselves, assert their familial clan or family lines, affirm their place of origin, and thank their hosts for kindly welcoming them as guests. Through this process, Native peoples declare who they are while simultaneously constructing kinship with their host and the land on which they walk. They ask permission and engage in reciprocal dialogue. They do not attempt to take the land, as their settler-colonial peers have done and too often continue to do.

L. Frank Manriquez (Tongva/Ajachmem), a self-described "decolonizationist," uses storytelling as a point of entry into the "bad manners" that settler-colonists have

displayed over the past five centuries. While working with youth in the Education Department at California Indian Lifeways, she *stories* youth, an Indigenous pedagogy of employing storytelling in an educational manner. In an interview, she explains that "every Indian knows that there is protocol. You don't go to somebody else's land and do something . . . without asking permission from the other Natives of that land." She continues, "When you go to a place, inside, all you have to do is just acknowledge and say thank you for letting me be in your home. Or I acknowledge your existence, even. And then, there is not so much resentment."[32] The image-texts in this collection demonstrate the long legacy of going against protocol, of not asking permission. Yet in highlighting the results of this practice, Brown and Kanouse depart from it. Not only do Brown and Kanouse "ask permission," but they go even further and work cooperatively with Indigenous intellectuals, artists, and activists.

Of course, Brown and Kanouse are far from alone in the struggle to dismantle settler privilege, white guilt, and colonial amnesia. Others are actively working toward the same goals in more directly activist ways. From current campaigns against the destruction of Migiziiwasin (Eagle Rock), through fights to protect waterways from acid mine drainage, to widespread activism against Tar Sands "development," more and more people are realizing that the only "sustainable" future is a truly postcolonial one in which Natives and non-Natives work in solidarity. Idle No More, a movement named in late 2012 by three Indigenous women (Nina Wilson, Sylvia McAdam, and Jessica Gordon) and their settler ally (Sheelah McLean) from Saskatchewan, exemplifies the tripartite resistance against colonialism, capitalism, and ecological destruction through land dispossession. Richard J. F. Day writes bluntly about his experiences as a settler-Canadian professor teaching settler students to transgress the dominance of coloniality. For Day, the ultimate goal, one that incorporates both settler and Indigenous into its matrix, "is to undermine the global system of states and corporations whenever and wherever [we] can. Every impediment to this system is an impediment to Canadian colonialism and its domination and exploitation of people and the land."[33] Day links nation-states with multinational corporations in describing a global system that exploits both humans and the nonhuman world. Echoing the Zapatistas, who maintain, "we do not struggle to take power, we struggle for democracy, liberty, and justice," Day asserts an additional goal beyond victory or defeat on a particular issue.[34] From his non-Native vantage point, Day seeks to "to renew the spirit . . . with which my people were originally welcomed to this land, and which, sadly, we have shown that we mostly do not comprehend."[35]

Settler society's incomprehension of its status as a visitor to the land has long been a target of the artist Edgar Hock E Aye Vi Heap of Birds (Cheyenne/Arapaho). For the past twenty years, Heap of Birds has used industrial-grade signage to remind various North American and European communities about their *Native Hosts*. Typically, a series of signs informs local settler communities about Native pasts and presence in the land by using reversed English-language texts. In two recent commissions at the University of Illinois and Michigan State University,

several of these signs were vandalized and/or stolen. While the motivations for these acts can never be fully known, continued presence of the signs served as daily reminders of an ongoing colonial apparatus. At Illinois, this reminder was no doubt threatening to those whose resentment about the "retirement" of Chief Illiniwek remains palpable on campus.[36] Heap of Birds's works simply demand their audiences not forget historical events and acknowledge the historicity of our contemporary presence on the land. In an act of violence against the "hosts," those who vandalized the signs chose to deny any and all memory of Indigenous "survivance." They refused, and will forever refuse, to ask permission. Nonetheless, the support of universities for Heap of Birds's interventions and the publication of projects like *Re-Collecting Black Hawk* indicate that countervailing forces are building to confront the colonial matrix in which we are all embedded.

Another component of disavowing colonialism and settler privilege is to look long and unflinchingly at how it operates in one's own life. To truly decolonize, we must look inward. My paternal family were Michif (Métis) voyageurs who traveled the continental expanses of North America disregarding the emerging colonial boundaries that the United States and the Dominion of Canada had established. The Michif are a unique Indigenous people of mixed Nēhilawē (Cree), Anishinaabeg, and European ancestry whose language reflects this etymologically, drawing primarily from Nēhiyawanin (Cree) and French. Historically, borders mattered little for my migratory ancestors as they followed traditional riverways throughout the Great Lakes, west onto the plains and prairies, and north toward the boreal forest and arctic tundra. Although of both Indigenous and settler descent, most Michif saw (and see) themselves (ourselves) as children of the country, intimately connected to their tribal relations and to the land.

Yet my own ancestral place within the history of North America was also secured by the pacification and forced relocation of Indigenous nations in the western Great Lakes and prairies. My mother's family descended from Swedish and Danish immigrants who homesteaded land in Minnesota, eventually establishing successful farms during the late nineteenth century. Like other non-Native settlers, their arrival and economic prosperity could be achieved only through the appropriation of Indigenous lands, primarily those of the Dakota and Anishinaabeg. My own family benefitted by the enactment of the Homestead Act and the execution of thirty-eight Dakota men for their resistance to U.S. colonial expansion. This largest mass execution in U.S. history took place only a few years before they arrived from Scandinavia to "repeople" the land and less than forty miles from my ancestor's eventual homestead.[37]

Implicated in these events, I must personally learn how to disavow the benefits of these structures and events—a very difficult task. As the historian Robin D. G. Kelley notes in a speech on the abolition of whiteness, "The challenge before you/us is how to accomplish this, to dismantle white supremacy. It's not enough to reject your racial designation. After all, your white skin still works for you no matter what you call yourself: it works in terms of how the police treat most of you, where you can live, access to home loans, the way you're treated at work or in

the classroom. The only way to really abolish whiteness is to destroy the structures of racism itself and to commit yourself to anti-racist, anti-sexist struggle."[38] While white privilege is only one component of settler colonialism, its dismantling goes hand in hand with the abolition of settler privilege. By committing to both these struggles—in both what we call our "work" and our "personal" lives—non-Native activists likewise commit to establish a vibrant and sustainable future. Although this essay in no way serves as a prescriptive in offering solutions to overcoming settler colonialism and white privilege, *Re-Collecting Black Hawk* begins to move in this direction, as does the continuing Idle No More movement. This global movement, emerging from Indigenous communities, confronts the logics of settler colonial expropriation of Indigenous lands and its systematic coupling with white privilege.

HOME

After journeying in all directions, we all must return home someday. Settlers and Indigenous, alike, must both develop continued relationships with the land and with each other. In *Re-Collecting Black Hawk*, Brown and Kanouse both document and undermine a legacy of settler appropriation of Indigenous lands and stories. Working with Meskwaki, Sauk, Dakota, and Michif collaborators, they demonstrate that Makataimeshekiakiak is not simply a common patrimony expressing a generic Indian history mutated into an "American" present. As the settler-Australian historian Patrick Wolfe notes, "Indigenous North Americans were not killed, driven away, romanticized, assimilated, fenced in, bred White, and otherwise eliminated as the original owners of the land but *as Indians*."[39] Makataimeshekiakiak's name and image are not empty signifiers that can be filled with inaccurate and deceptive settler narratives of Indians. He is not just another Indian, not even just an adversarial one. In both name and image, Makataimeshekiakiak has irreplaceable history and meaning that, regardless of colonial amnesia's ability to obliterate indigeneity, cannot be stripped away. His story and presence cannot be erased.

Inversely, it goes without saying that colonialism is presently inescapable, while its current presence leaves an indelible stain. Although it does not need to, the history of colonial structures presently informs each and every moment of Indigenous lives in the United States. While there are elders who remember the old ways before the incursion of global capitalism, by and large our daily lives have been fully colonized. From the moment we wake up in the morning until the time we drift off to sleep, our bodies maneuver through a system contained by the limits of colonialism and its twin brother, capitalism. Our bodies and languages are shaped by the historical processes of colonization. It is only during our dreams, both metaphorical and literal, that the limits of capitalist colonialism fade into the background. In these nocturnal moments of liberation, similar to visions while on "the hill," indigeneity and its affiliated national (what many may call tribal) epistemologies allow us to think beyond the limitations of colonialism's reservation formation. Indigenous thought, concurrently ancient and contemporary, is located

in those emancipatory moments when "customary knowledge" filters through the limitations of monetary exchange.[40] Likewise, as stated earlier, the intimate relationship between dreaming and art can be tied to alternative and utopian ways of imagining a truly postcolonial future. Dreaming and art come together at the moment of emancipation.

For some, these unlimited and unconfined thoughts are common. This is the way of the elders whose first languages connect them to the timeless practices of the ancestors. Makataimeshekiakiak, in his resistance to U.S. control, was one of these thinkers. For others, myself included, these autonomous (and precolonized) thoughts are rare, emerging only from the deepest recesses of our being. Only when I dream or make art am I liberated from the omnipresence of colonialism. The work of the others in this book, including George Thurman, Johnathan Buffalo, Sandra Massey, Yolanda Pushetonequa, and Waziyatawin, contributes to the decolonization of their communities and the renewal of Indigenous ways of thinking. They free themselves from colonial epistemological control. Attending to these ways of thinking—listening to these dreams and visions—provides an alternative to the resource-draining ways of capitalism. As Eric Cheyfitz argues, the present moment of neoliberal globalization began with the European invasion of the Americas, and "this Westernized world must begin to think seriously in terms of the philosophies that were providing balanced models of social life when unbalanced Europeans arrived violently more than five hundred years ago."[41]

As the highest stage of colonialism, capitalism operates by reducing our collective history to a short memory.[42] Capitalism functions precisely because we forget its multidirectional and atrocious history. Inversely, Indigenous history, one where intimate relationships are maintained with both animate and inanimate beings, is a history that refuses to forget. Just as Coulthard maintains that intimate and sacred relationships with place are central to Indigenous ontologies, the maintenance of a long memory is at the core of Indigenous modes of knowing. As an act of solidarity and in a process of self-decolonization, non-Native people can assimilate a long memory into their own ways of being. The burden is on all of us who believe in Indigenous sovereignty, both Native and settler alike, as well as those of us who straddle both histories.

This burden, following Brazilian thinker Paulo Freire, emerges at the community level through praxis. That is, it is situated in the dialectic between theory and action. Indigenizing Freire's mandate, Taiaiake Alfred calls this lifelong journey *wasáse*, the ancient Haudenosaunee war ritual. Through this and other ceremonies, the specter of Makataimeshekiakiak's non-acquiescence to settler violence remains today. While Indigenous war rituals and the battles themselves may not be the same today as they were in Makataimeshekiakiak's time, they are nonetheless still ongoing. From the language efforts initiated by the Meskwaki Nation to the intellectual work of Waziyatawin, today's Native warriors have intentionally and tactically shifted their fight against U.S. colonialism. By *re-collecting Black Hawk*, we may collaboratively participate in this ritual of resistance and survivance by listening before speaking.

CODA

Minnesota's Sesquicentennials and Dakota People

Remembering Oppression and Invoking Resistance

WAZIYATAWIN

By noon on May 10, families in wagons and on horseback arrived at Fort Snelling after a long journey from Cannon Falls. They were giddy with excitement about the formation of the State of Minnesota and were eager to make it to the fort where they planned to camp for the night. Their procession was interrupted by throngs of Sioux Indians, beating their drums and yelling to beat the band. Despite this unexpected powwow, the angry Indians could not dampen the enthusiasm of Minnesota's patriots as they celebrated the birth of their beloved state. Law enforcement quelled this small uprising and Minnesota's children cheered while marching to their camp for the night, under the protective shadow of the fort. Tomorrow they intend to finish their journey to the capitol building in St. Paul where Minnesotans will gather for the statehood festivities.

Or:

By noon on May 10, members of the Dakota tribe and their supporters protested a wagon train of Minnesotans celebrating statehood as they made their way to historic Fort Snelling. The wagon train was at the end of a 100-mile trek from Cannon Falls as part of Minnesota's celebration of statehood. In wagons and on horseback, about sixty-five hardy settlers decided to launch their own party. Indians opposed to this Minnesota celebration intercepted the wagon train at the fort and delayed it about an hour before police were able to subdue the protesters, arresting seven. The wagon train then passed through the crowd to the fort where they planned to camp for the night. Tomorrow they will complete their journey to the capitol building in St. Paul where Minnesotans will gather for statehood festivities.[1]

Wait, was this in the year 1858, 2008, or somewhere in between? While the language used to describe interactions between settlers and Indigenous peoples has changed through time, as these accounts demonstrate, the actual relationship seems to have changed little. The above scenario was enacted in 2008, as

white Minnesotans celebrated the sesquicentennial (150 years) of statehood and reenacted a mythical wagon train experience in celebration of pioneer settlement. This example reflects how the colonial relationship must be reinscribed within every generation. It is not sufficient for colonizers to establish their dominance just once. Instead, each successive generation of colonizers must do their part to both subjugate the colonized population and legitimate that subjugation. In the case of settler colonialism, this means celebrating settler invasion and the ongoing occupation of Indigenous territory. Thus, these commemorative practices are directly linked to the settler colonial project. Similar commemorative celebrations persist wherever settler colonialism persists, as these manufactured stories continue to serve as a justification for land theft. Every major milestone in Minnesota history throughout the nineteenth and twentieth centuries was similarly celebrated. Because of the timeliness of Minnesota's sesquicentennial celebrations in the twenty-first century, contemporary Dakota protests and voices offer a case study of resistance to colonial narratives.

One hundred and fifty years after the establishment of Minnesota statehood, Dakota people are experiencing the same attempts by settlers to rationalize their ancestors' (and thus their own) occupation of Dakota homeland through public displays of colonial celebration. White settlers are still celebrating what they gained through genocide, land theft, broken treaties, ethnic cleansing, and colonization, and Dakota people are still trying to exert our humanity in our homeland. White Minnesotans still reflect very little on what the Original People of the land gave up so they could occupy Minisota Makoce (Land Where the Waters Reflect the Skies). Even with a growing awareness of the price paid by Indigenous peoples for white settlement, in 2008 it became crystal clear that many white Minnesotans still believe it was worth it. That is, Dakota people are considered expendable, and settlers deserve whatever benefits they enjoy from the theft of our homeland. Further, law enforcement still works in service to the settler population, regardless of anyone's perceived sense of progress toward racial justice. If we in any way challenge their perceived rights as colonizers, they will use whatever force is necessary to suppress us. This is white supremacy in action. In May 2008, when Dakota people launched protests against Minnesota's sesquicentennial celebrations, there was an unshakeable feeling of déjà vu. This sense of existing within a colonial treadmill, where the colonial drama plays out in recurring fashion, continued through Minnesota's engagement with the 150th commemoration of the U.S.–Dakota War of 1862, another important sesquicentennial in this region's history. In both of these sesquicentennial contexts, settlers sought to re-affirm their role as righteous actors in a Manifest Destiny narrative.

In 2008, Dakota people attempting to resist this narrative did not initially resort to direct action, however. Many of us with a more critical consciousness about this history had participated in the Dakota Commemorative Marches, an event begun in 2002 to retrace the approximate route Dakota families, primarily women and children, were forced to march in November 1862. Because critical education about the march was a major focus, what emerged each year during

seven days of prayerful walking was an acute awareness of both historical and ongoing injustices. Thus, a broader outcome of the march has been an effort to exert Dakota voices regarding our experiences under settler colonialism. We first attempted to bring this process of critical education to the sesquicentennial discussions. In accordance with liberal values and procedures, we sought to effect change by intervening early in the sesquicentennial planning process and by using education and moral persuasion to influence the overall sesquicentennial narrative. Given the fact that Secretary of State Mark Ritchie and the executive director of the Sesquicentennial Commission Jane Leonard first contacted Dakota people about including our perspectives in the planning process, we were cautiously optimistic about the possibility of influencing Minnesota's birthday narrative.[2] Our optimism, however, was misplaced. Throughout the process, it was clear that like other institutional attempts to include a diversity of perspectives, these perspectives are only desirable if they can fit neatly within the master narrative.[3] Rather than allowing Indigenous perspectives to substantively and fundamentally alter the narrative framework, they sought to use Dakota people to legitimate the colonial narrative. When we refused, our conversations stopped and we knew we would have to work in opposition to the state-sponsored agenda.

The 2008 sesquicentennial celebrations in Minnesota forced Dakota people to confront the history of our oppression. For us, it was a time to reflect deeply on what we have lost since we were the primary human inhabitants of the land. It was also a testing ground for gauging settler reactions to Indigenous assertions of humanity in preparation for the sesquicentennial in 2012 of the U.S.–Dakota War of 1862. Settler commemorative events surrounding both the establishment of statehood and the U.S.–Dakota War of 1862 rarely deviated from the Manifest Destiny narrative, though the commemorative events for the latter were typically more somber in tone.[4] Among Dakota people, responses to the two sesquicentennials varied. While there was no support for Minnesota's celebration of the sesquicentennial of statehood in 2008 among Dakota people (though some Dakota individuals did express criticism of our decision to protest sesquicentennial events), Dakota responses to the U.S.–Dakota War of 1862 sesquicentennial were not so united. Instead, responses ranged from full participation in the established colonial narrative of the war to vociferous opposition to that narrative.

Colonizer narratives of the 1862 war have certainly changed within the last century and a half, with a couple of major narrative themes emerging to explain this violent episode in Minnesota history. The first narrative theme predictably entailed mourning the loss of "innocent" white settler lives and emphasized the heroics of white settlers who bravely defended their Minnesota homes. It characterized the more extreme outcomes of the war—such as the mass hanging of thirty-eight Dakota warriors, the forced removal of Dakota people, and the abrogation of Dakota treaties—as unfortunate but inevitable consequences of the war.[5] And it almost exclusively focused on violence perpetrated by Dakota men against white families. This early narrative characterized textbooks as well as public monuments and historical markers during the first century after the war.

In recent decades, another colonizer narrative, albeit a seemingly more enlightened one, has emerged in public discussions surrounding the war. This narrative emphasizes the complexity of the 1862 period and the difficult choices faced by settlers and Dakota people alike. It stresses the pain and loss suffered on all sides of the war, including the opposing factions on the Dakota side, and attempts to include a diversity of perspectives. It purports to be an objective, balanced, and unbiased history, which recognizes some of the root causes of the war. Lastly, it often emphasizes the positive aspects of Indigenous life today, as if to suggest that everyone has overcome this negative episode in Minnesota history.

Most settlers who helped contour the face of the 2012 commemoration used aspects of these two narratives to shape their interpretation. This is true beyond Minnesota, as well. Settlers in a colonial context must continuously seek to justify the actions that resulted in Indigenous dispossession and settler occupation. The stories conveyed in public history venues spearhead this effort. Elements of these narratives are present in the commemorative marker created in 2012 in Mankato, Minnesota, at the site of the hanging of thirty-eight Dakota warriors (the largest simultaneous hanging from one gallows in world history). The memorial contains a poem by the Mankato settler Alice Katherine Hughes titled "Reconcile." The first two stanzas convey how Hughes strips the war of colonial context, thereby denying acts of invasion, land theft, colonization, and genocide:

> Remember the innocent dead,
> Both Dakota and white,
> Victims of events they could not control.

> Remember the guilty dead,
> Both white and Dakota,
> Whom reason abandoned.

She ends the poem with an expression of hope for forgiveness:

> Hope for a future
> When memories remain
> Balanced by forgiveness.

Forgiveness, however, is meaningless in an ongoing colonial context. Yet, this has not stopped settlers and Dakota people alike from pursuing an agenda of forgiveness and reconciliation. The town of Mankato worked with a handful of Dakota people to plan this memorial and ultimately received their approval. Furthermore, horse riders who have made a commemorative journey from South Dakota to Mankato each December in recent years have embraced both the Manifest Destiny narrative and the hope for reconciliation and forgiveness. Adopting the mantra "Forgive everyone everything," they have accepted blame for the actions of Dakota warriors who fought in the war and offered forgiveness to white settlers for all of

their crimes. This sentiment has now been etched in stone benches surrounding the memorial, much to the consternation of Dakota people who oppose reconciliation and forgiveness without justice and decolonization.

The approach toward inclusivity has now become emblematic of the stance taken by the Minnesota Historical Society (MHS) during the sesquicentennial of the 1862 war and at the highly controversial Fort Snelling site. In the past the institution has resisted including the most basic information on crimes perpetrated by white settlers against Dakota people. While this has not changed, they are now promoting a more "inclusive" interpretation through the addition of a broader range of voices. The MHS has consistently been the last holdout for the most offensive and outmoded interpretations regarding Dakota people and the history of white invasion and occupation of Dakota lands. Because of the protests during the sesquicentennial year of Minnesota statehood, as well as the ongoing campaign to "Take Down the Fort," it is clear that the MHS can no longer afford to publicly advocate for the earlier narrative without subjecting themselves to much public criticism and even protest. Similar to challenges of the sesquicentennial's master narrative, the "Take Down the Fort" campaign emerged in response to the MHS's request for millions of dollars from the Minnesota state legislature for renovations to the crumbling Fort Snelling replica that stands at the confluence of the Minnesota and Mississippi Rivers today. This campaign calls for the literal dismantling of the fort (thereby also dismantling its symbolic value) and the return of the land to Dakota people, thereby linking representational and material struggles. It challenges public memory as well as hegemonic representations of settler colonialism and Indigenous peoples. Given the MHS's celebratory interpretation of the fort, one which suppresses the story of the fort's role in imperial expansion and colonial domination, the notion that they would seek to refortify Minnesota's most iconic monument to colonialism was offensive at best. After an embarrassing performance in a debate about Fort Snelling on Fox News, the MHS has had to work to create the appearance that they are genuinely interested in a truthful account of Minnesota history.[6]

Minnesotans at large seem to be at a point where they must at least appear to consider Dakota perspectives and discuss some of the crimes perpetrated by white settlers. Gauging what percentage of the population has reached this conclusion is difficult, and there is no question that some vociferous Minnesotans still believe Dakota people got what they deserved. Online responses to news stories, especially anonymous ones, regarding Dakota people demonstrate the vitriolic and racist rhetoric still espoused by some settlers.

Even public commentators continue to invoke the myth of white innocence and Dakota savagery regularly, thereby revealing the persistence of the older narrative about 1862. For example, in a recent debate with Clyde Bellecourt over Arizona's racist 2010 immigration law, Jeff Passolt of Fox 9 News stated: "I learned a lot about Native American history when I was in school here in Minnesota, including if you wanted to go in the direction you're going, Little Crow and his band of people who went along the Minnesota River Valley and scalped innocent

women and children."[7] In 2012, *This American Life* covered the 1862 war on public radio. Patricia Hammond, a third grade teacher at Monroe Elementary School in Mankato, described how she educated her students about the war: "We just talked about how a conflict is like a disagreement, and we talked about how the Dakota Indians didn't know how to solve their conflicts, and the only way they knew how to solve their disagreements was to fight. Which we know we don't fight when we solve conflict, we use our words, but that was the only way they knew how to solve a conflict, they fought. And the white settlers needed to fight back to protect themselves. And we talked about [how] people were killed."[8] Both Passolt's and Hammond's comments exemplify the failure of the educational system to teach about the way in which white Americans and Europeans worked to wrest the land away from Indigenous peoples. Still, relatively few Minnesotans are willing to expose their racism and hatred for Dakota people, particularly in a public forum. Thus the second major narrative allows for a more palatable compromise, especially since the racism and colonialism is cloaked behind nice sounding ideals like fairness and inclusivity.

This more recent interpretation is viewed as significant progress because it moves beyond the explicitly racist rhetoric prevalent in the historical interpretations characteristic of the first century after 1862, and many people are swayed by an argument of inclusivity and balance. Yet this is just a masquerade that allows settler society to escape addressing the true nature of the 1862 war. If the U.S.–Dakota War of 1862 was a genuinely unique example of an Indigenous population spontaneously rising up to slaughter innocent white settlers, notions of inclusivity and balance might seem downright progressive and enlightened. This limited and skewed scope, however, ignores the larger drama of European and European-American invasion, conquest, and colonization of Indigenous lands and peoples, replicated hundreds of times in the Western Hemisphere from the time of Columbus's landing.

Still, this was the tack taken by the MHS through Minnesota's sesquicentennial commemoration of the 1862 war, as evidenced in their exhibit on the topic. About the war they state: "There are many, often conflicting, interpretations of events relating to the war. 'The U.S.–Dakota War of 1862' exhibit includes multiple viewpoints as well as historical and contemporary voices. Visitors are encouraged to make up their own minds about what happened and why, and to discuss what they are seeing and learning, and to leave comments."[9] After a year of extensive "consultations" with Dakota people, there is no evidence of critical Dakota perspectives in the exhibit they produced.[10] In fact, the lackluster exhibit seems thrown together while completely avoiding discussions of invasion, colonialism, land theft, ethnic cleansing, and genocide. Discussions with Dakota people simply seemed to be a mechanism by which they hoped to avoid criticisms of racism and colonialism.

The U.S.–Dakota War of 1862 occurred in this context of repeated expansion into Indigenous territories, subjugation of Indigenous populations, and exploitation of Indigenous lands and resources. It should come as no surprise that Dakota

people finally went to war to defend our lands and way of life—hundreds of other Indigenous nations had already acted similarly. In this region for example, the Ho-Chunk fought back in 1827 when lead miners were trespassing on their lands, eventually suffering extensive land loss and forced removals. Similarly, the Sauk under Black Hawk attempted to resist invasion and lost. In bitter irony, when Dakota people were deciding whether to go to war against the United States in 1862, the Dakota leader Tamaha (who fought with the United States against Black Hawk), counseled Dakota people to avoid war, stating, "Behold the great Pontiac, whose grave I saw near St. Louis; he was murdered while an exile from his own country! Think of the brave Black Hawk! Methinks his spirit is still wailing through Wisconsin and Illinois for his lost people! I do not say you have no cause to complain, but to resist is self-destruction."[11] Tamaha had participated in the quelling of Indigenous resistance among our eastern neighbors and understood firsthand the ruthlessness with which the United States would crush resistance. In accordance with U.S. policies predicated on the Doctrine of Discovery and supporting notions of the "just" war, acts of Indigenous self-defense were then purposefully construed by the U.S. government as a rationale for full-scale elimination of what they viewed as the "Indian problem." Thus, Dakota violence in self-defense was used as grounds to delegitimize our claim to our Minisota homeland.

Given this history, those who argue for the legitimacy of all perspectives in this drama, or who seek to give equal credence to settler theft of Dakota lands, are no less colonialist or no less racist than their nineteenth-century forebears. In the context of justice, not all accounts of history are equal. The only way for settlers to escape this racist and colonialist past is to acknowledge the larger context in which the 1862 war occurred and to abolish the myth of white innocence. The presence of settlers in Minnesota in 1862 represented the illegal occupation of Dakota lands for which the United States had fraudulently secured treaties that they still failed to honor. In cases like this, in which whites perpetrate genocide and ethnic cleansing to gain unfettered access to Indigenous lands, there can be no balanced perspective. To suggest that settlers' perspectives are as equally valid as those of Dakota people in this context is to condone genocide and ethnic cleansing or to excuse it as legitimate. Invasion, land theft, genocide, and ethnic cleansing must be unequivocally condemned if one is to achieve a nonracist, noncolonialist interpretation of the events of 1862. There is no middle ground.

Furthermore, this unequivocal condemnation of crimes against humanity is the first step toward justice. We cannot begin to address the injustices if we do not first acknowledge them. Most moral-thinking humans would agree that a recognition of genocide should prompt some kind of reparative action. While people may disagree widely about what that action might look like, it is difficult if not impossible to move toward any action without first acknowledging the original crime. For instance, land return as a potential act of reparative justice only makes sense if one recognizes that land theft was a crime in need of rectifying. Thus, the representational struggle surrounding the 1862 war is directly connected to our material struggle for justice.

This struggle is complicated by the troubling unwillingness among some segments of the Dakota population to call for this unequivocal condemnation of crimes against humanity. Colonization has impacted our people to such an extent that we have learned to use the colonizer's lens in reference to 1862. We have learned to blame ourselves for the genocide, ethnic cleansing, and land loss. Perhaps, we have told ourselves, if only we had not gone to war we would still be in possession of our homelands. Perhaps if our men had not picked up weapons, they would not have been hanged and imprisoned. Perhaps if we had helped more whites, our women and children would not have been forced to march and put in concentration camps.

These imaginings fail to account for the larger story of American expansion or the lessons learned from other Indigenous peoples. For example, the Tsalagi (Cherokee) mimicked all aspects of colonizer society, believing that if they were deemed civilized enough, they would keep their homelands. It did not work. They, like hundreds of other Indigenous nations, were ethnically cleansed from their homelands. Or, we may look at the example of our Ho-Chunk relatives who were ethnically cleansed with us, who took no part in the 1862 war yet still faced removal in 1863. After already experiencing forced removal from their ancestral lands in Wisconsin and northern Illinois, Ho-Chunk people were living on a tract of land in Blue Earth, Minnesota, by the time of the 1862 war. White settlers hungry for their land and eager to be freed of all Indigenous populations in the southern part of the state used the war as justification to force them out. They were sent to Crow Creek, South Dakota, with Dakota people, despite their peaceful existence in Minnesota.[12] Similarly, a position of nonresistance and cooperation with the United States did not spare Keokuk and the Sauk and Meskwaki people who followed him. They, too, faced removal to Kansas. For Indigenous peoples across the board, the historical lesson is that regardless of our choices to fight, flee, or capitulate in the face of colonialism we all have suffered remarkably similar experiences. We all experienced land loss and the pain of colonization. We have all seen our homelands desecrated. And most of us experienced some kind of forced removal or exile from our traditional territories. Further, we have all been subject to U.S. policies of ethnocide in which the government systematically sought to eradicate our cultures and ways of life. Given this broad historical lesson, as Dakota people we need to move beyond blaming ourselves and our ancestors for the crimes perpetrated by settler society. We need not apologize for taking up arms in defense of our land and way of life. Millions of Indigenous people around the world have responded similarly. And Americans today would undoubtedly take up arms if an external force invaded these lands again. The problem was not our response; the problems were the acts of invasion, occupation, and colonization.

In previous commemorations and interpretations of Dakota-settler interactions, including the 2008 sesquicentennial celebrations, it is settlers who have determined what narrative is projected. Settlers have controlled public memory because the institutions that promote public memory are run almost entirely by them.[13] They are thus just as deeply invested in maintaining a particular story and image of

themselves as they are in maintaining the material privilege associated with these narratives and interpretations. Further, just as white settlement depended upon the erasure of Indigenous people from the landscape, so too did Minnesota's sesquicentennial rely on our erasure from the official state narrative. Because twenty-first-century sensibilities make it difficult for whites to outwardly celebrate what they gained from land theft and ethnic cleansing, in 2008 white Minnesotans were left with the awkward task of celebrating Minnesota's settlement while suppressing the story of the populations devastated by that settlement. They face what Janna Thompson calls "the apology paradox," the dilemma arising when settlers realize that if their ancestors had not done bad things, they would probably not exist. This makes it difficult for settlers to regret the deeds or practices upon which their existence depends and makes a sincere apology impossible.[14] If the notion of apology places them in an awkward position, even more threatening to them would be the fear of losing their ill-gotten privilege, including their claim to Indigenous land. It is amid this ideological battle that Dakota people are still struggling to become visible and to have our voices heard. We continue to respond to settler molding of public memory while also disrupting that memory whenever possible.

During the sesquicentennial of the U.S.–Dakota War of 1862, settlers could not so easily erase us from the public narrative. They simply could not commemorate 2012 without addressing Dakota people and Dakota history. We are essential to the 1862 story. The struggle within Minnesota's public institutions was not about whether to include Dakota stories about the war or whether to address what happened to Dakota people. Rather, it centered on whether they could continue to shape a public narrative that, to varying degrees, justified the outcomes of the war based on Dakota actions, particularly our violence against white settlers. If the premiere historical institution in the state of Minnesota (the MHS) is used as a measure of the 2012 sesquicentennial interpretations, it is clear that they are a long way from an unequivocal condemnation of settler perpetration of land theft, genocide, and ethnic cleansing. One exhibition text panel attempting to capture the impact of the war reveals their confused and troubling interpretation: "The losses were great and the consequences were severe for all who were touched by the fighting. Dakota people and settlers alike had seen their homes and families torn apart. The trauma didn't end when the fighting stopped—months dragged into years of imprisonment, destitution, disease, starvation, displacement, and death."[15]

In striving for a "balanced" portrayal of the war, they attempt to treat settler loss of newly constructed homes on par with Dakota loss of homeland. Furthermore, while failing to discuss the violence of settler colonialism or the actions of Dakota warriors as righteous acts of self-defense, they provide ample discussion of white suffering at the hands of Dakota violence. Moreover, as the above passage indicates, they do not relay that the years of suffering were experienced entirely on the Dakota side, while settlers benefitted from our extermination and dispossession. Ignoring the last decade of Dakota and Indigenous scholarship on the topic of the war, the institution demonstrated that they are still committed to maintaining the colonial status quo.

The challenge for Dakota people has been quite different. While this is one American story in which we are not expendable—we are front and center and we need not fear or shirk from taking up that space—Dakota people are far from united in our approach to understanding, interpreting, and commemorating this history. Just as our ancestors were divided in 1862 about whether to wage war in defense of our people and homeland, so too are Dakota people divided today about the role of resistance. Certainly one segment of the population is prepared to let bygones be bygones, to accept the status quo and abandon the struggle for justice, but they do not represent all of us.[16] Others of us have committed to exerting our critical voices and our humanity. We are committed to remembering 1862 on our terms and for our own purposes. While the last 150 years was a story of loss for Dakota people, we see a pathway of reclamation for the next 150 years.

For many Dakota people, 1862 remains an iconic number. We don't need to mention the war, the place, or the context, yet whenever it is invoked, we all understand its deep significance. It summons feelings of pain and grief for all that was lost—our people, our lands, our way of life—and it also conjures a righteous sense of anger. We understand all too well that 1862 marked a point of profound change in the destinies of our people. Images come to mind of the mass hanging at Mankato, the concentration camp at Fort Snelling, and the faces of our ancestors. In our minds we can hear the sounds of gunshots, the screams of our grandmothers, and the crying of the children.

But when we contemplate 1862, we can also hear the cries of our Dakota warriors. A sense of pride erupts within us when we invoke the spirit of their resistance. It awakens our desire to defend our homeland and, ultimately, to seek liberation. During the U.S.–Dakota War of 1862, even when our warriors knew they were facing an insurmountable enemy, they chose to fight. They followed the words of the Dakota leader of resistance in 1862, our Chief Taoyateduta, also known as Little Crow, who said, "I tell you we must fight and perish together. A man is a fool and coward who thinks otherwise, and who will desert his nation at such a time. Disgrace not yourselves to those who will hang you up like dogs, but die, if die you must, with arms in your hands like warriors and braves of the Dakota!" This raw courage in the face of overwhelming odds and a ruthless enemy inspires our awe and invokes our fighting spirit. Yet this message has been lost to many of our people through colonization and generations of exile from our homeland.

Today, our struggle of resistance is no less difficult than it was for our ancestors in 1862. In fact, now settler institutions are so deeply entrenched and pervasive that we cannot turn around without bumping into them. But we also live in a time when we are witnessing the failure of those institutions and, consequently, our windows of opportunity for reclamation are also opening wide. With the simultaneous crises of global climate change, the failure of capitalism, and rapid fossil-fuel depletion, the barbarity of industrial civilization is exposed, as is the wisdom of Indigenous ways. While our imaginations have been stymied in generations past, we can now begin to envision a future beyond industrial civilization

and colonial occupation. The year 2012 afforded us an important turning point, a point at which Dakota people began invoking the same call for unity among our people expressed by Taoyateduta nearly 150 years ago and to renew our spirit of resistance. This spirit is best reflected in the words written in the volume *Ohutkan*, a pocket-size booklet distributed by the Dakota collective Anpao Duta to Dakota people at the December 26, 2012, memorials for the Dakota patriots hanged at Mankato:

> Ultimately, our struggle is a struggle for land and our way of life. For us, the resistors, the hostiles, the blanket Indians, those two will always be linked as our ways of life arise from the land.

We will fight with everything we have to defend that.[17]

NOTES

Acknowledgments

1. Davis, "Iowa City to Mark 175 Years with 3-Day Celebration."
2. Rigal, "Watershed Days on the Treaty Line, 1836–1839."
3. King, *The Inconvenient Indian*, 217.

Introduction

1. Makataimeshekiakiak has been loosely translated from Sauk as "Black Hawk," "Black Sparrow Hawk," or "To be a large black hawk." Throughout this introduction, we use "Black Hawk" to refer to the mythic figure and "Makataimeshekiakiak" to refer to the historical person.
2. O'Brien, *Firsting and Lasting*, 107.
3. Peterson, "Black Hawk War," *Utah History Encyclopedia*, http://historytogo.utah.gov /utah_chapters/american_indians/black hawkwar.html.
4. See Berg and Vuolteenaho, *Critical Toponymies*; Berg, "Banal Naming, Neoliberalism, and Landscapes of Dispossession."
5. The Ojibwe activist and writer Winona LaDuke underscores this link in the subtitle to her book, *Recovering the Sacred: The Power of Naming and Claiming*.
6. Dorrian and Rose, *Deterritorialisations . . . Revisioning Landscapes and Politics*, 17.
7. Povinelli, *The Cunning of Recognition*.
8. Heat-Moon, *PrairyErth*; Pearson and Shanks, *Theatre / Archaeology*.
9. Like Jodi Byrd, Kevin Bruyneel's call to resist co-optation by the "modern territorial state" and instead to decolonize our spatial imagination reveals "forms of political space that cannot simply be mapped onto the boundary lines of the international

state system." Bruyneel, *The Third Space of Sovereignty*, 221–22.
10. Byrd, *The Transit of Empire*, xxx.
11. Latour, *Reassembling the Social*.
12. Makataimeshekiakiak and the Black Hawk War and are extensively documented. Nineteenth-century fascination with Makataimeshekiakiak was partly stoked by the 1833 publication of the *Life of Black Hawk*, edited by the journalist J. B. Patterson and based on stories the imprisoned leader told about his life and motivations to the American interpreter Antoine LeClaire. The book represented the first "as-told-to" autobiography of a Native American and has been republished many times, most recently in 2008. Recent accounts of the war include Trask's attempt at a definitive history in *Black Hawk*; an exhaustive military history treatment by Jung in *The Black Hawk War of 1832*; and Bowes's short *Black Hawk and the War of 1832*, which describes the conflict for a popular audience as a key moment in Native American removal in the northern United States. The Wisconsin Historical Society has an extensive collection of digitized primary documents related to the Black Hawk War at http://www.wisconsin history.org/turningpoints/tp-012/, as does Northern Illinois University at http://lin coln.lib.niu.edu/blackhawk/index.html.
13. Gregory, *The Colonial Present*.
14. This refusal disrupts a set of processes characterized by Elizabeth Povinelli as a form of liberal governance—the governance of the prior ("The Governance of the Prior").
15. Aileen Moreton-Robinson emphasizes the corporeality or embodied dimensions (as opposed to legal dimensions) of Indigenous sovereignty in her edited volume, *Sovereign*

Subjects: "Our sovereignty is embodied, it is ontological (our being) and epistemological (our way of knowing), and it is grounded within complex relations derived from the intersubstantiation of ancestral beings, humans and land. In this sense, our sovereignty is carried by the body and differs from Western constructions of sovereignty, which are predicated on the social contract model, the idea of a unified supreme authority, territorial integrity and individual rights" (2). As a result, Moreton-Robinson argues, "The omnipresence of Indigenous sovereignty is part of the ontological condition that shapes patriarchal white sovereignty's investment in itself and its anxiety about dispossession" (9).

16. In the preface to *Manifest Manners*, Gerald Vizenor defines "survivance" as "an active sense of presence, the continuance of native stories, not a mere reaction, or a survivable name. Native survivance stories are renunciations of dominance, tragedy, and victimry" (vii). In a later chapter to his 2008 *Survivance*, "Aesthetics of Survivance," Vizenor contrasts survivance with "absence, deracination, and oblivion." Although theories remain elusive, Vizenor argues, survivance is "invariably true and just in native practice and company" (1).

17. Day, "Who Is This We That Gives the Gift?"

18. Coulthard, "Subjects of Empire," 456.

19. Rifkin, *Manifesting America*, 108.

20. Grande, *Red Pedagogy*, 102.

21. Byrd, *The Transit of Empire*, xxxiv.

22. Reflecting on the function of commemoration in relation to the recent Lewis and Clark bicentennial, Fresonke and Spence argue, "Nothing could be more relevant than strengthening the vitality of the languages that first described the expedition, and no obligation to the future could be more pressing than working to ensure the economic and political autonomy of the people who first described Lewis and Clark" (*Lewis & Clark*, 234).

23. Berger, "Uses of Photography," 293.

24. Raymond Williams famously coined the phrase "structures of feeling" to describe the affective dimension of social meaning that had previously been described in the Marxist tradition by the rather antiseptic terms "hegemony" and "ideology." Williams explains, "We are talking about . . . affective elements of consciousness and relationships: not feeling against thought, but thought as feeling: practical consciousness of a present kind, in a living and interrelating community" (*Marxism and Literature*, 132).

25. Barthes, *Camera Lucida*, 14.

26. Berger, "Uses of Photography," 288.

27. Butler, *Frames of War*, 96.

28. Byrd, *The Transit of Empire*, 37–38.

29. Bertolt Brecht as paraphrased by Benjamin, "A Small History of Photography," 255.

30. David Prochaska, for instance, described Chief Illiniwek, the University of Illinois's infamous mascot, as a floating signifier: "In the heart of the heart of Chief Illiniwek country, there is literally nothing, a historical absence, a nonperson. Chief Illiniwek is a sign without a historical referent, a free-floating signifier in a prairie-flat land wiped clean, erased of Native Americans. This makes the literalness with which pro-Chief supporters invoke and refer to Chief Illiniwek—as if it were a part of them—all the more a conundrum" ("At Home in Illinois," 165).

31. Vizenor, *Manifest Manners*, vii.

32. As demonstrated by the vociferous (yet often sympathetic and generally constructive) Indigenous critique of the rhetoric of the Occupy Wall Street movement, prefiguring more just futures requires substantive reckoning with colonial and racial pasts and presents. See "Representing the Native Presence in the 'Occupy Wall Street' Narrative" on the *Native Appropriations* blog for an example of this critique (http://native appropriations.blogspot.com/2011/10/repre senting-native-resence-in-occupy.html).

33. Coulthard, "Subjects of Empire," 437–60; Simpson, "On the Logic of Discernment."

34. Corntassel, "Toward Sustainable Self-Determination."

35. Citing Vine Deloria's *God Is Red*, Coulthard argues that "land occupies . . . an ontological framework for understanding relationships" ("Place against Empire," 79). It functions, in other words, as an "orienting framework" that guides Indigenous anticolonial

activism. Recognizing the centrality of land to Indigenous "ways of knowing" and "place-based ethics" is necessary, Coulthard insists, to comprehend visions of peaceful coexistence (80). These visions articulate just political and economic relationships based on "principles of reciprocity and mutual obligation."

36. Byrd, *The Transit of Empire*, xxxv.

37. Raymond Williams articulates how the arts and communication are constituted by and constitutive of the concrete organization of society, in all its unevenness and contradictions. He refers to this co-constitution as a "material social process" in which the "form of social relationship and the form of material production are specifically linked." He cautions that this relationship is "not always, however, in some simple identity," but rather that it contains numerous tensions and contradictions (*Marxism and Literature*, 163).

38. Krupar, "Pred's Workshop." See also Pred's own work in this area, as in Pred, *The Past Is Not Dead*.

39. Rancière, *The Politics of Aesthetics*.

40. Martha Rosler laid out a genealogy of critical art in her "Take the Money and Run?," asking whether criticality in art amounts to anything more than a "stringently attractive brand" for some curators and institutions because it flatters the liberal self-image of an educated and privileged global class of intellectuals and art consumers, "provided it does not too baldly implicate the class or subject position of the viewer." Additionally, purely agitational projects find art institutions less friendly environments than the generally "critical." For example, the activist art collective Laboratory for Insurrectionary Imagination was invited to create work or a series of events for the Tate Museum in London. Echoing Hans Haacke's "Shapolsky et al. Real Estate" project at the Museum of Modern Art in the 1970s, the collective was promptly disinvited when the project they pursued involved educating the public about the museum's relationship with the oil company BP as the Deepwater Horizon oil well continued to spew thousands of gallons of crude into the Gulf of Mexico. See the Laboratory of Insurrectionary Imagination's "A User's Guide to ~~Demanding~~ the Impossible," December 2010, http://www.scribd.com/doc/55613891/A-Users-Guide-to-Demanding-the-Impossible.; and Liberate Tate, *License to Spill*, performance, June 28, 2010, http://www.liberatetate.org/licence_to_spill.html.

41. Rosler, "Take the Money and Run?"

42. Eco, *The Open Work*; Barthes, *Image-Music-Text*.

43. Transnational Decolonial Institute, "Decolonial Aesthetics (I)," May 22, 2011, http://transnationaldecolonialinstitute.wordpress.com/decolonial-aesthetics/. The statement is signed by thirteen affiliates of the TDI: Alanna Lockward, Rolando Vásquez, Teresa María Díaz Nerio, Marina Grzinic, Michelle Eistrup, Tanja Ostojic, Dalida María Benfield, Raúl Moarquech Ferrera-Balanquet, Pedro Lasch, Nelson Maldonado Torres, Ovidiu Tichindeleanu, Miguel Rojas Sotelo, and Walter Mignolo.

44. Cobb, "This Is What It Means to Say *Smoke Signals*"; Ohnesorge, "Uneasy Terrain"; Goeman, "(Re)Mapping Indigenous Presence on the Land in Native Women's Literature." See also Huhndorf, *Mapping the Americas*.

45. In November 2013, White Earth voters approved the new constitution 2,780 to 712, and the tribal government is supervising its full implementation. A copy of the ratified White Earth Constitution can be downloaded at http://www.whiteearth.com/data/upfiles/files/The_White_Earth_Constitution.pdf.

46. Robert Adams, *Robert Adams*; Brooks, *Sweet Medicine*; Chan, *Waikiki*.

47. Reflecting on the "praxis of listening" within the context of political theory, anthropology, and Indigenous nationhood, Simpson speculates about how we might achieve a "listening state" or a "state that listens" ("Paths toward a Mohawk Nation," 114). See also Simpson, "On Ethnographic Refusal."

48. Konkle, *Writing Indian Nations*, 2.

49. Povinelli, *The Empire of Love*, 21.

50. Birch, "'The Invisible Fire,'" 114–15.

51. Bruyneel, *The Third Space of Sovereignty*, 224.

52. Moreton-Robinson, "Writing Off Indigenous Sovereignties."

53. Braun, "Nature and Culture," 168.

54. "It is in these complicated relationships to the past, to territory, and to governance," Audra Simpson argues, "that Indigeneity is quite simply a key to critical analysis, not as a model of an alternative theoretical project or method (as valuable as this is) but simply as a case that, when considered robustly, fundamentally interrupts what is received, what is ordered, what is supposed to be settled" ("Settlement's Secret," 209).

55. Whatmore, "Mapping Knowledge Controversies," 1–2.

56. Cadena and Starn, "Introduction," 11.

57. Pratt, "Afterword," 403.

58. Harvey, *Spaces of Global Capitalism*, 146.

59. Cothran, "Exchanging Gifts with the Dead." See also Cothran, *Remembering the Modoc War*.

60. Carter, *The Road to Botany Bay*, xvi.

61. Cothran, "Exchanging Gifts," 37.

62. Povinelli, *The Cunning of Recognition*, 16.

63. Cothran, "Exchanging Gifts with the Dead," 38.

64. See Belenky and Goldberger, *Women's Ways of Knowing*.

65. See especially Chun, "Unbearable Witness"; Cavanagh, "Silence"; Glenn, Ratcliffe, and Ianetta, *Silence and Listening as Rhetorical Arts*; Felman and Laub, *Testimony*; Simpson, "Paths Toward a Mohawk Nation," 114. For an excellent discussion of intersubjective listening in the context of socially engaged art, see Kester, *Conversation Pieces*.

66. Johnson, "Reconciliation, Indigeneity, and Postcolonial Nationhood in Settler States"; Corntassel and Holder, "Who's Sorry Now?"

67. Ultra Red, "Some Theses on Militant Sound Investigation, or, Listening for a Change."

68. Ultra Red, "Some Theses on Militant Sound Investigation, or, Listening for a Change."

69. The strategy of radical ambiguity employed throughout *Re-Collecting Black Hawk* is not intended to diminish the importance or value of clearly articulated demands. For an example of the latter, see Waziyatawin, *What Does Justice Look Like?*.

70. The literary and historical analysis of Native American as-told-to autobiographies is vast, and Makataimeshekiakiak's *Life of Black Hawk* has been closely scrutinized. While earlier readers questioned its authenticity due to the mediation of the translator Antoine LeClair and editor J. B. Patterson, more recent work has viewed it as what Arnold Krupat calls a "bicultural composite composition." The book reflects a process of negotiation among narrator, translator, and editor in which Native storytelling genres and modes of self-presentation are interwoven with Euro-American literary and ethnographic conventions. Black Hawk himself was not passive in this process: he sought out this cross-cultural situation and deliberately addressed a white audience in his story. The book remains a source of pride for the Sauk people; both George Thurman and Sandra Massey describe their admiration for Black Hawk's autobiography in their contributions to this book. See Krupat, *For Those Who Come After*.

71. For more on the need to continually re-perform possession, see Rose, *Property and Persuasion*. For a discussion of the dialectic between property and violence, see Blomley, "Law, Property, and the Geography of Violence."

72. "The task today," Moreton-Robinson argues, "is to name and analyze whiteness in all texts to make it visible in order to disrupt its claims to normativity and universality" ("Whiteness, Epistemology, and Indigenous Representation," 87). Elsewhere, Moreton-Robinson characterizes whiteness as an "ontological and epistemological *a priori*," which "informs the white subject's knowledge production" ("Towards a New Research Agenda?," 78).

73. See Deloria, *Playing Indian*; Boyd and Thrush, *Phantom Past, Indigenous Presence*.

74. For an example of the recentering critique of whiteness studies, see Ahmed, "Declarations of Whiteness."

75. There are actually three recognized Sac and Fox tribes: the Sac and Fox Tribe of Oklahoma (Sakiwaki or Sauk), the Sac and Fox Tribe of the Mississippi in Iowa (Meskwaki), and the Sac and Fox Tribe of Missouri in Kansas (Nemahahaki). However, the Missouri band was recognized

separately in 1815 and removed from Illinois and Iowa long before the Black Hawk conflict of 1832. Although few Meskwaki joined Black Hawk's band (which was itself only a small group of Sauks), the tribes were confederated and seen as a single entity by the government. Thus, both the Sauk and Meskwaki lost their remaining homelands after the conflict. See Johnathan Buffalo's interview in this book for an account of how the Meskwaki returned to Iowa.

76. Rifkin, *Manifesting America*, 4.

77. Writing in an Australian context, Watson reflects on lawfulness and sovereignty in relation to the legal doctrines of discovery and *terra nullius*. Seeking a "safe conversational space where we can have a close encounter without our appropriation" ("Settled and Unsettled Spaces," 18), Watson locates the meditation on discomfort in "places where the settler is made to answer these questions: what brings them to a place of lawfulness? Or how lawful is their sovereign status?" (30).

78. For more on Indigenous refusal, see Simpson, *Mohawk Interruptus*.

79. Vizenor, *Manifest Manners*, 11.

80. Blomley, *Unsettling the City*, 14.

81. Moreton-Robinson, *Sovereign Subjects*, 87.

82. Cheyfitz, "What Is a Just Society?," 292, 298.

83. View the 1491s video poem, "Geronimo E-KIA," accessed January 12, 2015, https://www.youtube.com/watch?v=y7vKu7X4aNA.

84. 1491s, "About," accessed January 15, 2015, http://1491s.com/about.

85. Drew, "Attack on Bin Laden Used Stealthy Helicopter That Had Been a Secret."

Chapter 3. They Don't Even Want Our Bones: An Interview with Johnathan Buffalo

1. Using a different word origin, "Asakiwaki" is also sometimes translated as "People of the Outlet."

Chapter 8. Makataimeshekiakiak, Settler Colonialism, and the Specter of Indigenous Liberation

1. Throughout this essay, I used Black Hawk's Sauk name, Makataimeshekiakiak, in place

of its English-language translation. I make this intellectual move in the spirit of anticolonial solidarity.

2. Coulthard, "Place against Empire," 80.

3. Osterhammel, *Colonialism*, 1, 17.

4. Césaire, *Discourse on Colonialism*, 41.

5. Wolfe, *Settler Colonialism and the Transformation of Anthropology*, 165.

6. *Cherokee Nation v. Georgia*, 30 U.S. 1 (1831), accessed October 1, 2011, http://caselaw.lp.findlaw.com/cgi-bin/getcase.pl?court=us&vol=30&invol=1.

7. Harris, "How Did Colonialism Dispossess?," 173.

8. I intentionally use the U.S. Army's official history as a way to show how this fits within the logics of U.S. military history. The Indian Wars officially "ended" with the 1890–1891 campaign at Pine Ridge, a place that, as of 2010, had the lowest per capita income for the entire country. See U.S. Army Center of Military History, "U.S. Army Campaigns: Indian Wars," accessed March 6, 2013, http://www.history.army.mil/html/reference/army_flag/iw.html.

9. U.S. Army Center of Military History, "U.S. Army Campaigns: Indian Wars."

10. Waziyatawin and Yellow Bird, *For Indigenous Eyes Only*, 2.

11. Weaver, "Indigenousness and Indigeneity," 224.

12. Quoted in Wall, "Why Should Anyone Care about the Lacandon Jungle?"

13. Alfred, *Wasáse*, 19.

14. Alfred, *Wasáse*, 29.

15. Smith, *Decolonizing Methodologies*, 142, 152.

16. Coulthard, "Place against Empire," 80.

17. Johnathan Buffalo interview in this volume.

18. Burgin, *The End of Art Theory*.

19. Linari, Mosquera, and Fischer, *Over Here*, 50.

20. Louis Riel, 1885. This quote is attributed to Riel, although its original provenance and publication date are unclear. See Miner, *Creating Aztlán*, 7.

21. Statement made by Bertolt Brecht in a 1931 issue of *A-I-Z* magazine, cited in Kahn, *John Heartfield*, 64.

22. Rebecca Solnit writes that "American landscape photography is grounded in both

the scenery and ideology of the immigrant's West" ("Unsettling the West," 91).

23. Victor Masayesva in Masayesva and Younger, *Hopi Photographers/Hopi Images*, 90.

24. McQuire and Papastergiadis, "Introduction," 7.

25. Chun, "Unbearable Witness."

26. Chun, "Unbearable Witness," 114.

27. In a video on my youth collaboration *Anishnaabensag Biimskowebshkigewag (Native Kids Ride Bikes)*, as well as in a televised conversation at The Power Plant with Bonnie Devine (Anishinaabekwe), I develop a concept known as the "methodology of visiting" to discuss the Indigenous practice of traveling with, listening to, and speaking with Indigenous elders, peers, and youth.

28. Alfred, *Wasáse*, 35.

29. Day, "Angry Indians, Settler Guilt, and the Challenges of Decolonization and Resurgence," 267.

30. Birch, *Nationalism and Nation Integration*.

31. Lind, "The Collaborative Turn," 17.

32. L. Frank Manriquez, from a clip from a documentary entitled *The L. Frank Project*, July 21, 2008, accessed August 16, 2011, http://www.youtube.com/watch?v=KA32en5G71M.

33. Day, "Angry Indians, Settler Guilt, and the Challenges of Decolonization and Resurgence," 261, 266.

34. Subcomandante Marcos, communiqué issued August 30, 1996, trans. Cecilia Rodriguez, accessed October 5, 2011, http://www.struggle.ws/mexico/ezln/marc_to_cs_se96.html.

35. Day, "Angry Indians, Settler Guilt, and the Challenges of Decolonization and Resurgence," 267.

36. For more on Chief Illiniwek and the history of this controversy, see King and Springwood, *Team Spirits*. In March 2013, a student-led initiative at the University of Illinois placed the return of Chief Illiniwek on the university ballot. Media accounts call the ballot results "non-binding."

37. The Mankato Massacre is the subject of Waziyatawin's essay in this book.

38. Kelley, "The Abolition of Whiteness and the Black Freedom Movement."

39. Wolfe, "Settler Colonialism and the Elimination of the Native," 388.

40. "Customary knowledge" is the term that Maori scholars use to refer to Indigenous ontologies.

41. Cheyfitz, "What Is a Just Society?," 300.

42. Paraphrased from Lenin, *Imperialism, the Highest Stage of Capitalism*.

Coda. Minnesota's Sesquicentennials and Dakota People: Remembering Oppression and Invoking Resistance

1. The tone of this paragraph was taken from Maria Elena Baca, "Right out of History," *Star Tribune* (Minneapolis, MN), May 5, 2008, 1B.

2. Ramona Kitto Stately, Neil McKay, and I delivered a presentation on Dakota history and culture before the Sesquicentennial Commission in 2007.

3. For example, I consulted with the Minnesota Historical Society (MHS) for their exhibit on the sesquicentennial of Minnesota Territory in 1999. Though they sought and included Dakota perspectives, they were still framed within a celebratory narrative.

4. This is one element that has changed in the last several decades. For example, the town of New Ulm held celebratory parades as late as 1962 in commemoration of the war. To my knowledge, no such celebrations were held publicly in 2012 to commemorate the war during the sesquicentennial, though commemorations were still firmly rooted in Manifest Destiny ideology.

5. Dakota people often use terms such as "mass-lynching," "ethnic cleansing," and "genocide" today.

6. For further information on the Take Down the Fort campaign, see Waziyatawin, *What Does Justice Look Like?*, 97–118.

7. See Jeff Passolt's debate with Clyde Bellecourt, Fox 9 News, August 15, 2010, http://www.myfoxtwincities.com/dpp/news/protesters-want-mlb-to-boycott-arizona.

8. See *This American Life*, "479: Little War on the Prairie," http://www.thisamericanlife.org/radio-archives/episode/479/little-war-on-the-prairie?act=1#play.

9. See the Minnesota Historical Society, "The U.S.–Dakota War of 1862," http://minnesotahistorycenter.org/exhibits/us-dakota-war-of-1862.

10. "Consultations" is in scare quotes because the institution had no mechanism for ensuring that Dakota perspectives would actually influence the exhibit or the MHS collections. For example, the MHS holds the noose that killed Caske, one of the thirty-eight hanged in Mankato. While they agreed not to display the noose (as the staff had clear reservations about displaying it), when Dakota people consistently argued that the noose should be burned, they failed to comply.

11. Eastman, *Indian Heroes and Great Chieftains*, 66–67.

12. For further discussion of Ho-Chunk removal in 1863, see Lonetree, "Transforming Lives by Reclaiming Memory."

13. I should note here that in the case of the Minnesota Sesquicentennial Commission, Dallas Ross, a Dakota from Upper Sioux, was the lone Dakota on the commission, appointed by Governor Tim Pawlenty. Rather than taking the opportunity to effect change while serving on the commission, Dallas Ross simply did not participate in the sesquicentennial meetings. He never publicly stated whether he supported the sesquicentennial celebratory activities or, conversely, whether he supported the Dakota protests of those activities. In not taking a position, he effectively supported the status quo.

14. Thompson, "The Apology Paradox," 470–72.

15. Exhibit Text Panel, "The U.S.–Dakota War of 1862" exhibit at the Minnesota Historical Society, 2012.

16. For a critique of the rhetoric of reconciliation and forgiveness associated with the 38 + 2 memorial horse ride, see: http://indiancountrytodaymedianetwork.com/opinion/co-opting-memory-dakota-382-146660.

17. Anpao Duta, *Ohutkan*. For further information, see http://oyatenipikte.org/anpao-duta.

BIBLIOGRAPHY

Ackley, Arlyn. "State of the Tribes Address from Sokaogon Chippewa Chairman Arlyn Ackley." Wisconsin State Legislature. February 24, 2009. http://www.wis politics.com/index.iml?Article=150181. Accessed June 30, 2013.

Adams, Robert. *Robert Adams: Turning Back*. New York: Distributed Art Publishers, 2005.

Ahmed, Sara. "Declarations of Whiteness: The Non-Performativity of Anti-Racism." *Borderlands e-journal* 3, no. 2 (2004). http://www.borderlands.net.au /v013n02_2004/ahmed_declarations .htm. Accessed January 7, 2015.

Alfred, Taiaiake. *Peace, Power, Righteousness: An Indigenous Manifesto*. Oxford: Oxford University Press, 1999.

Alfred, Taiaiake. *Wasáse: Indigenous Pathways of Action and Freedom*. Peterborough, ON: Broadview Press, 2005.

Allen, Nikki, and Rachael Nowicki. "Black(Hawk)ed Out Barcrawl." User-generated Facebook page for public event taking place April 19, 2011. https://www.facebook.com /events/201994573163915. Accessed June 29, 2013.

Allmendinger, Blake. "Toga! Toga!" In *Over the Edge: Remapping the American West*, edited by Valerie Matsumoto and Blake Allmendinger, 32–49. Berkeley: University of California Press, 1999.

Anpao Duta. *Ohutkan*. Minisota Makoce: Anpao Duta, 2012.

Archuleta, Elizabeth. "Gym Shoes, Maps, and Passports, Oh My! Creating Community or Creating Chaos at the National Museum of the American Indian?" In *The National Museum of the American Indian: Critical Conversations*, edited by Amy Lonetree and Amanda J. Cobb, 181–207. Lincoln: University of Nebraska Press, 2008.

Argetsinger, Timothy Aqukkasuk. "VAWA's Loudest Advocates Further Silence Native Women." *Indian Country Today Media Network*, March 24, 2013. http:// indiancountrytodaymedianetwork.com /opinion/vawas-loudest-advocates-fur ther-silence-native-women-148312. Accessed April 24, 2013.

Arndt, Grant P. "The Nation in the City." In *Native Chicago*, 1st ed., edited by Terry Straus and Grant P. Arndt, 201–5. Chicago: Albatross Press, 1998.

Barthes, Roland. *Camera Lucida: Reflections on Photography*. Translated by Richard Howard. New York: Hill and Wang, 1981.

Barthes, Roland. *Image-Music-Text*. Translated by Stephen Heath. New York: Hill and Wang, 1978.

Belenky, Mary Field, and Nancy Rule Goldberger. *Women's Ways of Knowing: The Development of Self, Voice, and Mind*. New York: Basic Books, 1997.

Benjamin, Walter. "A Small History of Photography." In *One Way Street and Other Writings*, translated by E. Jephcott and K. Shorter, 240–57. London: Verso, 1985. Originally published 1931.

Berg, Lawrence D. "Banal Naming, Neoliberalism, and Landscapes of Dispossession." *ACME: An International E-Journal for Critical Geographies* 10, no. 1 (2011): 13–22.

Berg, Lawrence D., and Jani Vuolteenaho, eds. *Critical Toponymies: The Contested Politics of Place Naming*. Burlington, VT: Ashgate Publishing, 2009.

Berger, John. "Uses of Photography." In *About Looking*, 48–63. New York: Pantheon, 1980. Essay originally published in 1978.

Berry, Jason. *The Spirit of Black Hawk: A Mystery of Africans and Indians.* Jackson, MS: University Press of Mississippi, 1995.

Birch, Anthony H. *Nationalism and Nation Integration.* New York: Routledge, 1989.

Birch, Tony. "'The Invisible Fire': Indigenous Sovereignty, History, and Responsibility." In *Sovereign Subjects: Indigenous Sovereignty Matters*, edited by Aileen Moreton-Robinson, 105–17. Crows Nest, NSW: Allen and Unwin, 2007.

Biskakone. "Editors Favorite Recipe: Maple Sugared Deer and Leek Stew Recipe." *Lac du Flambeau News* 14, no. 6 (Strawberry Picking Moon/June 2007): 8.

Black Hawk. *Life of Black Hawk: Ma-ka-tai-me-she-kia-kiak.* Edited by J. B. Patterson. Chicago: R. R. Donnelley and Sons Company, 1916.

"Black Hawk Descendant to Speak at Apple River Fort." *Galena Gazette*, July 28, 2009. http://www.galenagazette.com/print.asp?ArticleID=14038&SectionID=142&SubSectionID=344. Accessed January 13, 2015.

Blackhawk, Ned. "Recasting the Narrative of America: The Rewards and Challenges of Teaching American Indian History." *Journal of American History* 93, no. 4 (March 2007): 1165–70.

Blomley, Nicholas. "Law, Property, and the Geography of Violence: The Frontier, the Survey, and the Grid." *Annals of the Association of American Geographers* 93, no. 1 (2003): 121–41.

Blomley, Nicholas. *Unsettling the City: Urban Land and the Politics of Property.* New York: Routledge, 2004.

Bowes, John P. *Black Hawk and the War of 1832.* New York: Chelsea House, 2007.

Boyd, Colleen E., and Coll Thrush. *Phantom Past, Indigenous Presence: Native Ghosts in North American Culture and History.* Lincoln: University of Nebraska Press, 2011.

Braun, Bruce. "Nature and Culture: On the Career of a False Problem." In *A Companion to Cultural Geography*, edited by James S. Duncan, Nuala C. Johnson, and Richard H. Shein, 151–79. Malden, MA: Blackwell Publishing, 2004.

Brooks, Drex. *Sweet Medicine.* Albuquerque: University of New Mexico Press, 1995.

Bruyneel, Kevin. *The Third Space of Sovereignty: The Postcolonial Politics of U.S.-Indigenous Relations.* Minneapolis: University of Minnesota Press, 2007.

Buffalo, Johnathan. "Convention Center Meeting Room Names at the Casino." *Meskwaki Nation Times* 4, no. 7 (April 6, 2007): 5.

Burgin, Victor. *The End of Art Theory.* New York: Palgrave MacMillan, 1986.

Butler, Judith. *Frames of War: When Is Life Grievable?* New York: Verso, 2009.

Byrd, Jodi A. *The Transit of Empire: Indigenous Critiques of Colonialism.* Minneapolis: University of Minnesota Press, 2011.

Cadena, Marisol de la, and Orin Starn. "Introduction." In *Indigenous Experience Today*, edited by Marisol de la Cadena and Orin Starn, 1–30. Oxford: Berg, 2007.

Canton, John Dean. *The Last of the Illinois and a Sketch of the Pottawatomies.* Chicago: Rand McNally, 1870.

Carlson, James A. "Indians' Reaction Varies over Property Takeover." *Nashua Telegraph* (New Hampshire), August 30, 1974, 6.

Carter, Paul. *The Road to Botany Bay: An Exploration of Landscape and History.* New York: Alfred A. Knopf, 1988.

Cavanagh, Matt. "Silence: A Politics." *Contemporary Political Theory* 2 (March 2003): 49–65.

Césaire, Aimé. *Discourse on Colonialism.* Translated by Robin D. G. Kelley. New York: Monthly Review Press, 2000. Originally published in 1955.

Chan, Gaye. *Waikiki: A History of Forgetting and Remembering.* Honolulu: University of Hawai'i Press, 2006.

Cheyfitz, Eric. "What Is a Just Society? Native American Philosophies and the Limits of Capitalism's Imagination: A Brief Manifesto." *South Atlantic Quarterly* 110, no. 2 (spring 2011): 291–307.

"Chief Black Hawk Statue." *Lakeview-ia.com.* http://www.lakeview-ia.com/tourism/#1. Accessed September 25, 2011.

Chun, Wendy Hui Kyong. "Unbearable Witness: Toward a Politics of Listening." *Differences: A Journal of Feminist Cultural Studies* 11, no. 1 (1999): 112–49.

Claiborne, William. "Tribal Land Claim Meets Resistance in Illinois: Miamis' Suit Viewed as Tactic for Casino Accord." *Washington Post.* February 13, 2001, A3.

Clark, David Anthony Tyeeme. "Wa a o, wa ba ski na me ska ta! "Indian" Mascots and the Pathology of Anti-Indigenous Racism." In *In the Game: Race, Identity, and Sports in the Twentieth Century,* edited by Amy Bass, 137–66. New York: Palgrave Macmillan, 2005.

Cobb, Amanda. "This Is What It Means to Say *Smoke Signals*: Native American Cultural Sovereignty." In *Hollywood's Indian: The Portrayal of the Native American in Film,* edited by Peter C. Rollins and John E. O'Connor, 206–28. Lexington: University Press of Kentucky, 2003.

Corntassel, Jeff. "Toward Sustainable Self-Determination: Rethinking the Contemporary Indigenous-Rights Discourse." *Alternatives: Global, Local, Political* 33, no. 1 (2008): 105–32.

Corntassel, Jeff, and Cindy Holder. "Who's Sorry Now? Government Apologies, Truth Commissions, and Indigenous Self-Determination in Australia, Canada, Guatemala, and Peru." *Human Rights Review* 9, no. 4 (2008): 465–89.

Cothran, Boyd. "Exchanging Gifts with the Dead: Lava Beds National Monument and Narratives of the Modoc War." *International Journal of Critical Indigenous Studies* 4, no. 1 (2011): 30–40.

Cothran, Boyd. *Remembering the Modoc War: Redemptive Violence and the Making of American Innocence.* Chapel Hill: University of North Carolina Press, 2014.

Coulthard, Glen S. "Place against Empire: Understanding Indigenous Anti-Colonialism." *Affinities: A Journal of Radical Theory, Culture, and Action* 4, no. 2 (fall 2010): 79–83.

Coulthard, Glen S. "Subjects of Empire: Indigenous Peoples and the 'Politics of Recognition' in Canada." *Contemporary Political Theory* 6, no. 4 (2007): 437–60.

Coulthard, Glen S. "Subjects of Empire? Indigenous Peoples and the 'Politics of Recognition' in Canada." Doctoral dissertation, University of Victoria, British Columbia, 2009.

Daubenmier, Judith M. *The Meskwaki and Anthropologists: Action Anthropology Reconsidered.* Lincoln: University of Nebraska Press, 2008.

Davis, Andy. "Iowa City to Mark 175 Years with 3-Day Celebration." *Press-Citizen,* December 3, 2014. http://www.press-citizen.com/story/news/local/2014/12/03/iowa-city-celebrates-birthday/19862151.

Day, Richard. "Who Is This We That Gives the Gift? Native American Political Theory and the Western Tradition." *Critical Horizons* 2, no. 2 (2001): 173–201.

Dean, Thomas. 2012. "UR Here: Open Spaces." *Little Village,* October 11, 2012. http://littlevillagemag.com/ur-here-open-spaces. Accessed May 11, 2013.

Death Penalty Information Center. "Native Americans and the Death Penalty." *Deathpenaltyinfo.org.* http://www.deathpenaltyinfo.org/native-americans-and-death-penalty. Accessed June 30, 2013.

Deer, Ada E. "Confirmation Statement of Ada E. Deer before the Senate Committee on Indian Affairs, July 15, 1993." In "So That You Will Hear Us: A Native American Leaders' Forum," edited by Sandra Lee Nowack, special issue, *American Indian Law Review* 18, no. 2 (1993): 551–75.

Deloria, Philip. *Playing Indian.* New Haven: Yale University Press, 1998.

DeMeyer, Trace A. "Thorpe Honor Restored: The Jim Thorpe Family Gathers for Medals Ceremony." *News from Indian Country* 11, no. 6 (1997): 4A.

Dodsworth, Robert O. *The Battle of Wisconsin Heights and the Black Hawk War of 1832.* Madison, WI: Wisconsin Department of Natural Resources, 1996.

Dorrian, Mark, and Gillian Rose. *Deterritorialisations . . . Revisioning*

Landscapes and Politics. London: Black Dog Publishing, 2003.

Downes, Dennis. "Great Lakes Trail Marker Tree Society: Our Society." *Greatlakestrailtreesociety.org.* http://www .greatlakestrailtreesociety.org/trail_tree _about.html. Accessed April 24, 2013.

Doyle, Jim. "Executive Order #39: Relating to an Affirmation of the Government-to-Government Relationship Between the State of Wisconsin and Indian Tribal Governments Located Within the State of Wisconsin." February 27, 2004. http:// witribes.wi.gov/docview.asp?docid =23379&locid=57. Accessed June 29, 2013.

Drew, Christopher. "Attack on Bin Laden Used Stealthy Helicopter That Had Been a Secret." *New York Times*, May 5, 2011, http://www.nytimes.com/2011/05/06 /world/asia/06helicopter.html. Accessed October 24, 2011.

Eastman, Charles Alexander. *Indian Heroes and Great Chieftains.* Lincoln: Nebraska, 1991. Originally published 1918.

Eby, Cecil. *"That Disgraceful Affair," the Black Hawk War.* New York: W. W. Norton and Company, 1973.

Eco, Umberto. *The Open Work.* Cambridge, MA: Harvard University Press, 1989.

Editorial. "Black Hawk, The Great Sac Nation Leader, Faces Yet Another Indignity." *Quad-City Times*, November 29, 2008. http://qctimes.com/news/opinion /editorial/black-hawk-the-great-sac-nation-leader-faces-yet-another/arti cle_673e7fd5-1dd7-50fa-98ad-a802dbc 8ca32.html. Accessed June 29, 2013.

Elliot, Michael A. *Custerology: The Enduring Legacy of the Indian Wars and George Armstrong Custer.* Chicago: University of Chicago Press, 2008.

Emmett, Bill, and Doris Emmett. "How Our Journey Began." *Grandvillage.org.* http:// www.grandvillage.org/journey.html. Accessed July 2, 2011.

Enbridge. "Enbridge (ENB) and Enbridge Energy Partners L.P. (EEP), Project Expansions, May 2012." http://www .enbridge.com/EEP-and-ENB-project-expansions-May-2012.aspx. Accessed April 24, 2013.

Erdman, Joyce M. *Handbook on Wisconsin Indians.* Published with the cooperation of the University of Wisconsin Extension. Madison, WI: Governor's Commission on Human Rights, 1996.

"Fall Native Language Summits." *Cultural Survival,* November 24, 2010. http:// www.culturalsurvival.org/news/unit ed-states/fall-native-language-summits. Accessed June 29, 2013.

Farrell, Clare. "Coming Home: The Return of the Ancestors." In *Native Chicago*, 1st ed., edited by Terry Straus and Grant P. Arndt, 209–10. Chicago: University of Chicago Master of Arts Program in Social Science, 1998.

Felman, Shoshana, and Dori Laub. *Testimony: Crises of Witnessing in Literature, Psychoanalysis, and History.* New York: Routledge, 1992.

Fliege, Stu. "A Trail of Tears across Southern Illinois." *Tales and Trails of Illinois*, 69–72. Urbana and Chicago: University of Illinois Press, 2002.

Foley, Douglas. *"The Heartland Chronicles* Revisited." *Qualitative Inquiry* 11, no. 2 (2005): 296–320.

Fresonke, Kris, and Mark Spence, eds. *Lewis and Clark: Legacies, Memories, and New Perspectives.* Berkeley: University of California Press, 2004.

Fretland, Katie. "Indian Tribe Worries Pipeline Will Disturb Graves." Associated Press/ *Yahoo! Finance*, March 26, 2012. http://finance.yahoo.com/news/ indian-tribe-worries-pipeline-dis turb-223445068.html. Accessed April 24, 2013.

Gaul, Alma. "Few Artifacts, Letters Remain from Dark Part of Quad-City History." *Quad-City Times*, March 31, 2013. http:// qctimes.com/news/local/few-artifacts-letters-remain-from-dark-part-of-quad-city/article_6258ed6c-99bd-11e2-9b84-0019bb2963f4.html. Accessed May 29, 2013.

Gedicks, Al. "Activist Sociology: Personal Reflections." *Sociological Imagination* 33, no. 1 (1996): 55–72. http://comm-org .wisc.edu/si/gedicks.htm. Accessed June 30, 2013.

Geyer, Thomas, and Ann McGlynn. "Tribes
　　Ask Black Hawk to Drop Indian Names."
　　Quad-City Times, January 20, 2006.
　　http://qctimes.com/news/local/arti
　　cle_99bfa9f1-58c3-51f5-9b77-2ac3155a136f
　　.html. Accessed June 29, 2013.

Glenn, Cheryl, Krista Ratcliffe, and Melissa
　　Joan Ianetta. *Silence and Listening as
　　Rhetorical Arts*. Carbondale, IL: SIU
　　Press, 2011.

Goeman, Mishuana. "(Re)Mapping Indigenous
　　Presence on the Land in Native Women's
　　Literature." *American Quarterly* 60, no. 2
　　(June 2008): 295–302.

Grande, Sandy. *Red Pedagogy: Native American
　　Social and Political Thought*. Lanham,
　　MA: Rowman and Littlefield Publishers,
　　2004.

Gregory, Derek. *The Colonial Present*. Malden,
　　MA: Blackwell Publishing, 2004.

Grossman, Zoltan, and Debra McNutt. "From
　　Enemies to Allies." *ColorLines* (spring
　　2001): 22–25.

Harris, Cole. "How Did Colonialism Dispossess?
　　Comments from an Edge of Empire."
　　*Annals of the Association of American
　　Geographers* 94. no. 1 (2004): 165–82.

Harvey, David. *Spaces of Global Capitalism:
　　A Theory of Uneven Geographical
　　Development*. London: Verso, 2006.

Hauberg, John. "Hobby Hitching Post."
　　Rotarian, March 1950, 60.

Heat-Moon, William Least. *PrairyErth*. Boston:
　　Houghton Mifflin, 1991.

Helton, Tena L. "What the White 'Squaws' Want
　　from Black Hawk: Gendering the Fan-
　　Celebrity Relationship." *American Indian
　　Quarterly* 34, no. 4 (2010): 498–520.

Hodge, William H. "The Indians of Wisconsin."
　　In *The State of Wisconsin 1975 Blue
　　Book*, edited by H. Rupert Theobald and
　　Patricia V. Robbins, 95–196. Madison:
　　Wisconsin Legislative Reference Bureau,
　　1975. Available online at http://digicoll
　　.library.wisc.edu/cgi-bin/WI/WI-
　　idx?type=header&id=WI.WIBlueBk1975.
　　Accessed April 26, 2013.

Huhndorf, Shari M. *Mapping the Americas: The
　　Transnational Politics of Contemporary
　　Native Culture*. Ithaca: Cornell
　　University Press, 2009.

Illinois Historic Preservation Agency. "Was
　　Black Hawk an Early Illinois Terrorist,
　　and What Was Homeland Security Like
　　in 1832?" Press Release, April 29, 2007.
　　http://www.illinois.gov/PressReleases
　　/ShowPressRelease.cfm?SubjectID
　　=27&RecNum=5890. Accessed June 29,
　　2013.

Johnson, Miranda. "Reconciliation, Indigeneity,
　　and Postcolonial Nationhood in Settler
　　States." *Postcolonial Studies* 14, no. 2
　　(2011): 187–201.

Jones, Jennifer. "Hawks' Logo May Be No-Go."
　　Chicago Sun-Times. March 6, 2000, 96.

Jung, Patrick J. *The Black Hawk War of 1832*.
　　Norman: University of Oklahoma Press,
　　2008.

Kahn, Douglas. *John Heartfield: Art and Mass
　　Media*. New York: Tanam, 1985.

Kelley, Robin D. G. "The Abolition of Whiteness
　　and the Black Freedom Movement."
　　Speech delivered in New York City
　　organized by the editors of *Racetraitor:
　　Journal of New Abolitionism*, May 2–3,
　　1997.

Kester, Grant H. *Conversation Pieces:
　　Community and Communication in
　　Modern Art*. Berkeley and Los Angeles:
　　University of California Press, 2004.

King, Richard C., and Charles Fruehling
　　Springwood, eds. *Team Spirits: The
　　Native American Mascots Controversy*.
　　Lincoln: University of Nebraska Press,
　　2001.

King, Thomas. *The Inconvenient Indian: A
　　Curious Account of Native People in
　　North America*. Minneapolis: University
　　of Minnesota Press, 2013.

Klein, Naomi. "Dancing the World into Being:
　　A Conversation with Idle No More's
　　Leanne Simpson." *YES! Magazine*, March
　　5, 2013. http://www.yesmagazine.org
　　/peace-justice/dancing-the-world-in
　　to-being-a-conversation-with-idle-no-
　　more-leanne-simpson. Accessed April
　　24, 2013.

Konkle, Maureen. *Writing Indian Nations:
　　Native Intellectuals and the Politics of
　　Historiography, 1827–1863*. Chapel Hill:
　　University of North Carolina Press,
　　2004.

Krouse, Susan Applegate. "A Warrior Celebration: The Photographs of Tom Jones." *Visual Anthropology* 19 (2006): 295–314.

Krupar, Shiloh. "Pred's Workshop." *Progress in Human Geography* 31, no. 6 (December 2007): 817–19.

Krupat, Arnold. *For Those Who Come After: A Study of Native American Autobiography.* Berkeley and Los Angeles: University of California Press, 1989.

Kuc, Chris. "Chicago Blackhawks Developing Ties to Native American Community." *Chicago Tribune*, November 12, 2011. http://articles.chicagotribune.com/2011 -11-12/sports/ct-spt-1113-blackhawks- chicago--20111113_1_iconic-indian-head- logo-statue-black-hawks. Accessed April 24, 2013.

LaDuke, Winona. *All Our Relations: Native Struggles for Land and Life.* Cambridge, MA: South End Press, 1999.

LaDuke, Winona. *Recovering the Sacred: The Power of Naming and Claiming.* Cambridge, MA: South End Press, 2005.

LaGrand, James B. "Indian Work and Indian Neighborhoods: Adjusting to Life in Chicago during the 1950s." In *Enduring Nations: Native Americans in the Midwest*, edited by R. David Edmunds, 195–313. Urbana, IL: University of Illinois Press, 2008.

Lake View Carnival Committee. 57th Annual Black Hawk Lake Summer Water Carnival Program, 2010.

Latour, Bruno. *Reassembling the Social: An Introduction to Actor-Network-Theory.* New York: Oxford University Press, 2005.

Lenin, V. I. *Imperialism, the Highest Stage of Capitalism.* London: Pluto Press, 1996. Originally published in 1917.

Light, Steven, and Kathryn Rand. *Indian Gaming and Tribal Sovereignty: The Casino Compromise.* Lawrence, KS: University Press of Kansas, 2005.

Limerick, Patricia Nelson. *The Legacy of Conquest: The Unbroken Past of the American West.* New York: W.W. Norton, 1987.

Linari, Gabriel Peluffo, Gerardo Mosquera, and Jean Fischer, eds. *Over Here: International Perspectives on Art and Culture.* Cambridge, MA: MIT Press, 2004.

Lind, Maria. "The Collaborative Turn." In *Taking the Matter into Common Hands: On Contemporary Art and Collaborative Practices*, edited by Johanna Billing, Maria Lind, and Lars Nilsson, 15–31. London: Black Dog Publishing, 2007.

Loew, Patty. *Indian Nations of Wisconsin: Histories of Endurance and Renewal.* Madison, WI: Wisconsin Historical Society Press, 2001.

Lonetree, Amy. "Transforming Lives by Reclaiming Memory: The Dakota Commemorative March of 2004." In *In the Footsteps of Our Ancestors: The Dakota Commemorative Marches of the Twenty-First Century*, edited by Waziyatawin, 246–56. St. Paul: Living Justice Press, 2006.

Love, Orlan. "New School for Meskwaki: School Will Teach Tribal Language, Culture." *Gazette* (Cedar Rapids, Iowa), August 22, 2009, A1.

Macivor, Ivor. "So We Commemorate a Good and Dead Indian." *Saturday Evening Post*, March 13, 1954, 96.

Masayesva, Victor, and Erin Younger, eds. *Hopi Photographers/Hopi Images.* Tucson, AZ: University of Arizona Press, 1983.

May, Caroline. "The Costs of Political Correctness Mount for Wisconsin Schools." *Daily Caller*, September 29, 2011. http://dailycaller.com/2011/09/29 /the-costs-of-political-correct ness-mounting-for-wisconsin-schools. Accessed April 24, 2013.

McLaughlin, Benjamin. *In Black Hawk's Footsteps.* Santa Fe, NM: B. McLaughlin Publishing, 2005.

McQuire, Scott, and Nikos Papastergiadis. "Introduction." In *Empires, Ruins, and Networks: The Transcultural Agenda in Art*, edited by Scott McQuire and Nikos Papastergiadis, 2–10. London and Chicago: Rivers Oram Press, 2005.

Melmer, David. "Water Finally Flows through Sac and Fox Reservation." *Indian Country Today*, January 13, 1997, A1.

Menominee Tribal Enterprises. *The Forest Keepers: The Menominee Forest-Based Sustainable Development Tradition.* Keshena, WI: Menominee Tribal Enterprises (Maeqtekuahkihkiw Kew Kanahwihtahquaq), 1997. http://www.epa.gov/ecopage/upland/menominee/forestkeepers.pdf. Accessed January 13, 2015.

Merli, Melissa. "Artist Questions Value Placed on Stolen Signs." *News-Gazette*, June 27, 2009, B1.

Meskwaki Settlement School. "Prom—Bright Lights. Big City." *Meskwaki Settlement School Newsletter*, May 2013, 1. http://www.msswarriors.org/newsletter.pdf. Accessed May 11, 2013.

Midwest SOARRING. "That a Healing Begins." *Wings: The Newsletter of Midwest Save Our Ancestors Remains & Resources Indigenous Network Group* (summer 1997). http://musicchat.reocities.com/RainForest/canopy/6630/wings5.htm. Accessed June 29, 2013.

Mikdashi, Maya. "What Is Settler Colonialism?" *American Indian Culture and Research Journal* 37, no. 2 (2013): 23–34.

Miner, Dylan A.T. *Creating Aztlán: Chicano Art, Indigenous Sovereignty, and Lowriding Across Turtle Island.* Tucson: University of Arizona Press, 2014.

Moreton-Robinson, Aileen, ed. *Sovereign Subjects: Indigenous Sovereignty Matters.* Crows Nest, NSW: Allen and Unwin, 2007.

Moreton-Robinson, Aileen. "Towards a New Research Agenda? Foucault, Whiteness, and Indigenous Sovereignty." *Journal of Sociology* 42, no. 4 (2006): 383–95.

Moreton-Robinson, Aileen. "Whiteness, Epistemology, and Indigenous Representation." In *Whitening Race: Essays in Social and Cultural Criticism*, edited by Aileen Moreton-Robinson, 75–88. Canberra ACT: Aboriginal Studies Press, 2004.

Moreton-Robinson, Aileen. "Writing Off Indigenous Sovereignties." Paper presented at Conditions of Settler Colonialism symposium, University of Chicago, April 25–26, 2008.

Morgensen, Scott Lauria. *Spaces Between Us: Queer Settler Colonialism and Indigenous Decolonization.* Minneapolis: University of Minnesota Press, 2011.

Mosher, Frederick. "Visitor's Guide: The Black Hawk Trail." *Chicago Reader*, June 30, 1994. http://www.chicagoreader.com/chicago/black-hawk-trail/Content?oid=884848. Accessed June 29, 2013.

Musil, Robert. "Monuments." *Posthumous Papers of a Living Author.* Translated by Peter Wortsman. Brooklyn, NY: Archipelago Books, 2006. Originally published in 1927.

Nason, Dory. "We Hold Our Hands Up: On Indigenous Women's Love and Resistance." *Decolonization: Indigeneity, Education & Society*, February 12, 2013. http://decolonization.wordpress.com/2013/02/12/we-hold-our-hands-up-on-indigenous-womens-love-and-resistance. Accessed April 24, 2013.

Nelson, Josh. "Meskwaki School Kicks Off First Football Season." *Waterloo-Cedar Falls Courier*, September 9, 2009. http://wcfcourier.com/news/local/article_9165c5c0-0c72-50e6-a0ac-de59a6f72c68.html. Accessed June 29, 2013.

Nichols, Roger L. "The Black Hawk War in Retrospect." *Wisconsin Magazine of History* 65, no. 4 (1982): 239–46.

O'Brien, Jean M. *Firsting and Lasting: Writing Indians Out of Existence in New England.* Minneapolis: University of Minnesota Press, 2010.

Ohiyesa (Charles Eastman). "Comments at the Unveiling of Lorado Taft's Sculpture, 'Black Hawk.'" In *Lorado Taft's Indian Statue "Black Hawk": An Account of the Unveiling Ceremonies at Eagles' Nest Bluff, Oregon, Illinois, July the First Nineteen Hundred and Eleven, Frank O. Lowden Presiding*, edited by Wallace Heckman, 55–70. Chicago: University of Chicago Press, 1912.

Ohnesorge, Karen. "Uneasy Terrain: Image, Text, Landscape, and Contemporary Indigenous Artists in the United States." *American Indian Quarterly* 32, no. 1 (winter 2008): 43–69.

Osterhammel, Jürgen. *Colonialism: A Theoretical Overview*. Princeton, NJ: Markus Wiener, 1997.

Pearson, Mike, and Michael Shanks. *Theatre / Archaeology*. London: Routledge, 2001.

Pember, Mary Annette. "Speak Your Piece: Fixing Ourselves." *Daily Yonder*, May 6, 2011. http://www.dailyyonder .com/speak-your-piece-fixing-our selves/2011/05/03/3307. Accessed June 29, 2013.

Peterson, John A. "Black Hawk War." *Utah History Encyclopedia*. http://historytogo .utah.gov/utah_chapters/american_in dians/blackhawkwar.html. Accessed October 24, 2011.

Pope, Alexander. "An Essay on Man." *An Essay on Man: Moral Essays and Satires*. Edited by Henry Morley. London: Cassell and Company, 1891. Originally published 1734. http://www.gutenberg.org /files/2428/2428-h/2428-h.htm. Accessed June 3, 2013.

Potter, Andrew. 2012. "Meskwaki Tell Their Own Story with Museum." *Times-Republican* (Marshalltown, IA), November 3, 2012. http://www.times republican.com/page/content.detail /id/554194/Meskwaki-tell-their-own-story-with-museum.html. Accessed April 24, 2013.

Povinelli, Elizabeth A. *The Cunning of Recognition: Indigenous Alterities and the Making of Australian Multiculturalism*. Durham: Duke University Press, 2002.

Povinelli, Elizabeth A. *The Empire of Love: Toward a Theory of Intimacy, Genealogy, and Carnality*. Durham: Duke University Press, 2006.

Povinelli, Elizabeth A. "The Governance of the Prior." *Interventions* 13, no. 1 (2011): 13–30.

Pratt, Mary Louise. "Afterword: Indigeneity Today." In *Indigenous Experience Today*, edited by Marisol de la Cadena and Orin Starn, 397–404. Oxford: Berg, 2007.

Pred, Allan. *The Past Is Not Dead: Facts, Fictions, and Enduring Racial Stereotypes*, 1st ed. Minneapolis: University of Minnesota Press, 2004.

Prochaska, David. "At Home in Illinois: Presence of Chief Illiniwek, Absence of Native Americans." In *Team Spirits: The Native American Mascots Controversy*, edited by C. Richard King and Charles F. Springwood, 157–85. Lincoln: University of Nebraska Press, 2001.

Protect the Earth. "About Walt." *Protecttheearth .org*. http://www.protecttheearth.org /Walter/aboutwalt.htm. Accessed December 23, 2014.

Ramirez, Renya K. *Native Hubs: Culture, Community, and Belonging in Silicon Valley and Beyond*. Durham: Duke University Press, 2007.

Rancière, Jacques. *The Politics of Aesthetics: The Distribution of the Sensible*. Translated by Gabriel Rockhill. New York: Continuum International Publishing Group, 2006.

Rand, Jacki Thompson. "Reviewed Work: *A Tribute to Survival* by James Kelly." *American Anthropologist* 96, no. 2 (1994): 490–92.

Rez Dog Clothing Company. "The Girls of Rez Dog Clothing Company 2006." *American Indian Beauties*, 2006. http:// www.rezdog.com/2006_calendar.htm. Accessed July 10, 2007.

Richter, Daniel K. *Facing East from Indian Country*. Cambridge, MA: Harvard University Press, 2001.

Rickert, Levi. "Ojibwe George Martin Carries in Eagle Staff before Sold Out Stanley Cup Playoff Crowd." *Native News Network*, June 1, 2013. http://www.nativenewsnet work.com/ojibwe-george-martin-car ries-in-eagle-staff-before-sold-out-stan ley-cup-playoff-crowd.html. Accessed June 4, 2013.

Rifkin, Mark. *Manifesting America: The Imperial Construction of U.S. National Space*. New York: Oxford University Press, 2009.

Rigal, Laura. "Watershed Days on the Treaty Line, 1836–1839." *Iowa Review* 39, no. 2 (2009): 202–23.

Roediger, David R. *How Race Survived U.S. History*. London: Verso, 2008.

Rosaldo, Renato. *Culture and Truth: The Remaking of Social Analysis*. Boston: Beacon Press, 1980.

Rose, Carol M. *Property and Persuasion: Essays on the History, Theory, and Rhetoric of Ownership*. Boulder: Westview Press, 1994.

Rosler, Martha. "Take the Money and Run? Can Political and Socio-critical Art 'Survive'?" *e-flux* #12 (January 2010). http://www.e-flux.com/journal/view/107. Accessed January 13, 2015.

"Sac and Fox Tribe of the Mississippi in Iowa." *Indian Country Today,* June 28, 2000. http://indiancountrytodaymedianet work.com/2000/06/28/mesk waki-sac-and-fox-tribe-of-the-mississip pi-iowa-86129. Accessed June 29, 2013.

Schroeter, Elaine. "Sac and Fox to Develop Computerized Language Program." *News from Indian Country* (Hayward, WI) 19, no. 9 (1995): 10A.

Sherfy, Michael. "Narrating Black Hawk: Indian Wars, Memory, and Midwestern Identity." Doctoral dissertation, University of Illinois, Urbana-Champaign, 2005.

Simonson, Mike. "Valedictorian Calls High School Out on Native American Discrimination." *Wisconsin Public Radio*, June 6, 2013. http://news.wpr.org/post/valedictorian-calls-high-school-out-na tive-american-discrimination. Accessed June 30, 2013.

Simpson, Audra. "Mohawk Interruptus." Lecture for Indigenous Speakers Series, Program in Indigenous Governance, University of Victoria, November 7, 2012. Transcribed by Nicholas Brown and Sarah Kanouse. Video available online, http://www.youtube.com/watch?v=FW zXHqGfH3U. Accessed May 30, 2013.

Simpson, Audra. *Mohawk Interruptus*. Durham: Duke University Press, 2014.

Simpson, Audra. "On Ethnographic Refusal: Indigeneity, 'Voice,' and Colonial Citizenship." *Junctures: The Journal for Thematic Dialogue* 9 (2007): 67–80.

Simpson, Audra. "On the Logic of Discernment." *American Quarterly* 59, no. 2 (2007): 479–91.

Simpson, Audra. "Paths toward a Mohawk Nation: Narratives of Citizenship and Nationhood in Kahnawake." In *Political Theory and the Rights of Indigenous Peoples*, edited by Duncan Ivison, Paul Patton, and Will Sanders, 113–36. Cambridge: Cambridge University Press, 2000.

Simpson, Audra. "Settlement's Secret." *Cultural Anthropology* 26, no. 2 (2011): 205–17.

Smith, Andrea. *Conquest: Sexual Violence and American Indian Genocide*. Cambridge, MA: South End Press, 2005.

Smith, Linda Tuhiwai. *Decolonizing Methodologies: Research and Indigenous Peoples*. London: Zed Books, 1999.

Smith, Paul Chaat. *Everything You Know about Indians Is Wrong*. Minneapolis: University of Minnesota Press, 2009.

Solnit, Rebecca. *Savage Dreams*. Berkeley: University of California Press, 2000.

Solnit, Rebecca. "Unsettling the West: Contemporary American Landscape Photography." *As Eve Said to the Serpent: On Landscape, Gender, and Art*, 90–99. Athens: University of Georgia Press, 2001.

Sotomayor, Sonia. Dissenting opinion. *Adoptive Couple v. Baby Girl, 570 U.S. ____*, 2013. http://apps.washingtonpost.com/g/page/politics/supreme-court-says-native-american-child-isnt-required-to-be-giv en-to-father/266. Accessed June 30, 2013.

Spence, Mark. "Let's Play Lewis and Clark!" In *Lewis and Clark: Legacies, Memories, and New Perspectives*, edited by Kris Fresonke and Mark Spence, 219–38. Berkeley: University of California Press, 2004.

Spindel, Carol. *Dancing at Halftime: Sports and the Controversy over American Indian Mascots*. New York: New York University Press, 2002.

Stark, William F., and Don Davenport. *Along the Black Hawk Trail*. Sheboygan, WI: Zimmermann Press, 1984.

Steinberg, Theodore. *Slide Mountain, or the Folly of Owning Nature*. Berkeley: University of California Press, 1995.

Tar Sands Blockade. "Red Lake Chippewa Discover Enbridge Tar Sands Pipelines Through Nation-Owned Land Have

No Easement Contracts." *Tar Sands Blockade*, March 16, 2013. http://www.tarsandsblockade.org/redlakeblockade. Accessed April 24, 2013.

Taylor, Diana. *The Archive and the Repertoire: Performing Cultural History in the Americas*. Durham, NC: Duke University Press, 2003.

Thomas-Muller, Clayton. "The Rise of the Native Rights-Based Strategic Framework." *Canadian Dimension*, May 23, 2013. http://canadiandimension.com/articles/5314. Accessed June 29, 2013.

Thompson, Abbey. "Memories of Survival: LdF Boarding School Restoration Project." *Lac du Flambeau News* 14, no. 3 (Crusty Snow Moon/March 2007): 18.

Thompson, Janna. "The Apology Paradox." *Philosophical Quarterly* 50, no. 201 (October 2000): 470–72.

Thorpe, Dagmar. *People of the Seventh Fire: Returning Lifeways of Native America*. Ithaca, NY: Akwekon Press, 1996.

Thorpe, Grace. "Radioactive Racism? Native Americans and the Nuclear Waste Legacy." *Indian Country Today* 14, no. 38 (March 16, 1995): A-5.

Till, Karen E. *The New Berlin: Memory, Politics, Place*. Minneapolis: University of Minnesota Press, 2005.

Trask, Kerry A. *Black Hawk: The Battle for the Heart of America*. New York: Henry Holt and Company, 2007.

Tyranena Brewing Co. "Chief BlackHawk Porter." Product Label. Tyranena Brewing Co., Lake Mills, Wisconsin. http://www.tyranena.com/wordpress2/wp-content/uploads/2013/02/ChiefBlackHawkPorter.png. Accessed January 15, 2015.

Ultra Red. "Some Theses on Militant Sound Investigation, or, Listening for a Change." In *In the Middle of a Whirlwind: 2008 Convention Protests, Movement and Movements*, edited by Team Colors Collective. Los Angeles: Journal of Aesthetics and Protest, 2008. http://www.scribd.com/doc/3108693/Whirlwinds-Ultrared#archive. Accessed January 13, 2015.

Vander Puy, Nick. "'Kill the Indian, Save the Man,' a Boarding School Story." *Lac du Flambeau News* 14, no. 5 (Flower Moon/May 2007): 28.

Vizenor, Gerald. "Aesthetics of Survivance: Literary Theory and Practice." In *Survivance: Narratives of Native Presence*, edited by Gerald Vizenor, 1–23. Lincoln: University of Nebraska Press, 2008.

Vizenor, Gerald. *Manifest Manners: Narratives on Postindian Survivance*. Lincoln: University of Nebraska Press, 1999.

Wall, Joseph. "Why Should Anyone Care about the Lacandon Jungle?" *Harvard Political Review*, May 22, 2011. http://hpronline.org/world/why-should-anyone-care-about-the-lacandon-jungle/. Accessed August 15, 2011.

Wallace, Anthony F. C. "Prelude to Disaster: The Course of Indian-White Relations Which Led to the Black Hawk War of 1832." *Wisconsin Magazine of History* 65, no. 4 (1982): 247–88.

Watson, Irene. "Settled and Unsettled Spaces: Are We Free to Roam?" In *Sovereign Subjects: Indigenous Sovereignty Matters*, edited by Aileen Moreton-Robinson, 15–32. Crows Nest, NSW: Allen and Unwin, 2007.

Watt, Anthony. "Saukenuk Lives Again: 'Welcome Home' Powwow to Celebrate New Exhibit." *Radish* 4, no. 6 (April 2010): 6.

Waziyatawin. *What Does Justice Look Like?* St. Paul, MN: Living Justice Press, 2008.

Waziyatawin, Angela Wilson, and Michael Yellow Bird, eds. *For Indigenous Eyes Only: A Decolonization Handbook*. Santa Fe, NM: School of American Research, 2005.

Weaver, Jace. "Indigenousness and Indigeneity." In *A Companion to Postcolonial Studies*, edited by Henry Schwartz and Sangeeta Ray, 221–35. Malden, MA: Blackwell, 2008.

Wesner, Chelsea. "Traditional Foods." *Wellness in Native America*, July 16, 2012. http://americanindianinstitute.wordpress.com/2012/07/16/traditional-foods-part-1. Accessed April 24, 2013.

Whaley, Rick. "The Black Hawk Vigil: The Importance of Allies." *Ojibwe Akiing* 8, no. 9 (2004): 6.

Whatmore, Sarah. "Mapping Knowledge Controversies: Science, Democracy, and the Redistribution of Expertise." *Progress in Human Geography* 33, no. 5 (October 2009): 587–98.

Williams, Raymond. *Marxism and Literature.* Oxford: Oxford University Press, 1977.

Wilson, Natalia. "The Chicago Indian Village, 1970." In *Native Chicago*, 1st ed., edited by Terry Straus and Grant P. Arndt, 155–162. Chicago: Albatross Press, 2002.

Wisconsin Department of Administration. *Tribes of Wisconsin.* Madison, WI: Division of Intergovernmental Relations, 2011.

Wisconsin Department of Health Services. "Department of Health Services and WI Indian Tribes Consultation and Implementation Plan, 2009." http://www.dhs.wisconsin.gov/tribalaffairs/Plan/2009ImplementationPlan.pdf. Accessed June 30, 2013.

Wolfe, Patrick. "Settler Colonialism and the Elimination of the Native." *Journal of Genocide Research* 8, no. 4 (December 2006): 387–409.

Wolfe, Patrick. *Settler Colonialism and the Transformation of Anthropology: The Politics and Poetics of an Ethnographic Event.* London: Continuum, 1999.

Wortman, Deanne. "Paint the Town." *Little Village* (Iowa City, IA), November 15, 2010. http://littlevillagemag.com/paint-the-town. Accessed January 7, 2015.

Wurth, Julie. "Chief Is Gone, but Is Anybody Moving On?" *News-Gazette* (Champaign, IL), March 3, 2013. http://www.ais.illinois.edu/mascot/news/gone13.html. Accessed April 24, 2013.

Young Bear, Ray A. "The Rock Island Hiking Club." *Virginia Quarterly Review* 64, no. 4 (1988): 624–25.

Nicholas A. Brown is a scholar and artist based in Iowa City. He teaches in the American Indian and Native Studies Program and the Department of Geographical and Sustainability Sciences at the University of Iowa. His research focuses on land, justice, settler colonialism, and the politics of indigeneity in the Great Lakes and Alberta–Montana borderlands.

Johnathan Buffalo has spent thirty years researching tribal history and recovering Meskwaki artifacts. As the tribe's historic preservation director, he preserves Meskwaki cultural heritage and conducts educational programs, as well as enforcing the Native American Graves Protection and Repatriation Act and section 106 of the National Historic Preservation Act. He holds a degree in history from the University of Iowa.

Sarah E. Kanouse is an interdisciplinary artist examining landscape, public space, and cultural memory. Her research-based creative work takes many forms, including web platforms and multimedia, print materials, group events, and audio-visual projects. Her critical essays have been published in the *Journal of Aesthetics and Protest*, *Leonardo*, *Acme*, and *Art Journal*, and she is a core collaborator with Compass. An assistant professor of art at the University of Iowa, she teaches courses in video and time-based media and art and ecology.

Sandra Massey is the historic preservation officer for the Sac and Fox Nation of Oklahoma.

Dylan A. T. Miner (Métis) is a border-crossing artist, activist, historian, and curator. In 2010, he was awarded an Artist Leadership Fellowship from the National Museum of the American Indian (Smithsonian). As a member of Justseeds, he was awarded the Grand Prix at the Twenty-Eigth Biennial of Graphic Arts in Slovenia, and installed a solo Justseeds exhibition at the Twenty-Ninth Biennial. Miner holds a PhD in the history of art from the University of New Mexico. He has published and lectured extensively, with two forthcoming books on art and indigeneity from the University of Arizona Press and IB Tauris. To date, he has published more than forty journal articles, book chapters, review essays, and encyclopedia entries. Currently, Miner is an associate professor at Michigan State University, where he teaches in the Residential College in the Arts and Humanities, coordinates the Michigan Native Arts Initiative, and curates at the MSU Museum. His artwork can be viewed at www.dylanminer.com or www.justseeds.org.

Yolanda Pushetonequa is the former Meskwaki Language Department director for the Sac and Fox Tribe of the Mississippi in Iowa, and is currently a graduate student at University of Minnesota Twin Cities Institute of Linguistics. Raised on the Meskwaki Settlement, she holds a BA in finance from the University of Northern Iowa.

George Thurman was elected to serve as the principal chief of the Sac and Fox Nation in August 2007. Prior to this position, he served as tribal secretary from 2000–2007, being elected to two terms in 2001 and 2005. He currently serves as the vice chairman/secretary of the Self-Governance Communication and Education Tribal Consortium Board, Bellingham, Washington; a member of National Congress of American Indian and National Indian Education Association; a

Central Tribes Shawnee Area Board Member; the secretary of the Inter-Tribal Monitoring Association Board; a Southern Plains alternate to the Self-Governance Advisory Committee, Department of Interior; and as a liaison to Sac and Fox Nation Historic Preservation Office, the Education Department, the Environmental Department, the Self-Governance Department, the Law Enforcement / Juvenile Center, and the Rodeo Committee.

Thurman received his bachelor of science degree in organizational leadership from Southern Nazarene University. He is a member of Shawnee First Indian Baptist Church and resides in Shawnee, Oklahoma. He is a member of the Thunder Clan and a direct descendant of Black Hawk.

Waziyatawin is a Wahpetunwan Dakota from the Pezihutazizi Otunwe (Yellow Medicine Village) in southwestern Minnesota. Waziyatawin received her PhD in American history from Cornell University in 2000 and earned tenure and an associate professorship in the history department at Arizona State University, where she taught for seven years. Her work centers on Indigenous decolonization strategies such as truth telling and reparative justice, Indigenous women and resistance, the recovery of Indigenous knowledge, and the development of liberation ideology in Indigenous communities. She is the author or editor of five volumes, including *Remember This! Dakota Decolonization and the Eli Taylor Narratives*; *Indigenizing the Academy: Transforming Scholarship and Empowering Communities*; *For Indigenous Eyes Only: A Decolonization Handbook*; *In the Footsteps of Our Ancestors: The Dakota Commemorative Marches of the 21st Century*; and, her most recent volume, *What Does Justice Look Like? The Struggle for Liberation in Dakota Homeland*.

IMAGE CREDITS

INDEX

healing/empowerment of, 48; lifeways of, 48; pacification of, 7; pastness of, 7; protocols for working with, 74–75; as second-class citizens, 179

Native Hosts (Heap of Birds), 179, 231

Navajo (tribe), removal of, 52

Nēhilawē (tribe), 226, 232

Nēhiyawanin (tribe), 232

Nepermann, Mark, 179

"Next Dance, The" (UI), 194

Nichols, Roger L., 26

nicknames, 160, 192–93

Nizhawendaamin Inaakiminaan (We Love Our Land), 157

North American Free Trade Agreement (NAFTA), 224

nuclear waste, legacy of, 78–79

Obama, Barack, 31

O'Brien, Jean M., 2, 87

"Of the Nature and State of Man, with Respect to the Universe" (Pope), text of, 82

Ohiyesa (Charles Eastman), 178

Ojibwe (tribe), 16, 58, 91, 111, 128, 226; as former spelling "Chippewa," 16, 91

Omaha (tribe), 16, 57

Oneida (tribe), 108, 115

Oneida Community Integrated Food System (OCIFS), 115

Original People, 229, 237

Osage (tribe), 59, 224

Osterhammel, Jürgen, 220

Ottawa (tribe), 226

pacification, 15, 16, 232

Papakee, Jon, 56

Papastergiadis, Nikos, 228

Peluffo Linari, Gabriel, 226

photography, 7–8, 9; as affirmation of opposites, 227–28; as documentary form, 7;

phrenology, 83

political correctness, 3, 8, 76

political imagination, 4, 9

politics, 9, 10, 15, 16, 108; Native American, 120, 137, 167; organization of, 13; radical, 226; representation of, 226; revisioning, 126

Pontiac's War, 65

Pope, Alexander: verse by, 82

postindians, 8, 40

Potawatomi (tribe), 159, 226

Povinelli, Elizabeth, 4

power, 227; political, 120, 167; racialized, 175; self-creative, 84

"Prairies, The" (Bryant), text of, 203

Pratt, Mary Louise: on indigeneity, 11

Pred, Allan, 8

Prochaska, David, 154

Proclamation Day, 43, 68

Protect the Earth, 81

Pushetonequa, Yolanda, 14, 214, 234; language/culture and, 209; language preservation and, 211–12, 213

Quad-Cities Native American League, 204

Quashquame, 222

race, 232; capitalism/free labor and, 197; legacy of, 135

racism, 15, 241; Native Americans and, 78–79, 175

Ramirez, Renya K., 167

Rancière, Jacques, 9

Rand, Jacki Thompson, 130

Rand, Kathryn, 118

"Reconcile" (Hughes), text of, 239

reconciliation, 12, 206–7, 239

Red Cliff Ojibwe (tribe), 77, 111

Red Cloud, Mitchell, Jr., 116

Red Earth (reservation), 58

Red Lake Chippewa, Enbridge tar sands pipelines and, 157

Renard, 58, 59, 68

resource rights, deprivation of, 49, 220

Rez Dog Clothing Company, 61

Richter, Daniel K., 63

Rickert, Levi, 161

Riel, Louis, 226–27

Rifkin, Mark, 5, 32–33

Ritchie, Mark, 238

Rock Island, 68, 71, 164, 170, 182, *194–200*, 201, *204–7*; Black Hawk War and, 200

"Rock Island Hiking Club, The" (Young Bear), text of, 45

Rock River, 38, 164, 165, 176, 183, 200, 204

Roediger, David R., 197

Rosaldo, Renato, 106

Rose, Gillian, 3–4, 126

Rosler, Martha, 8, 9

Ruscha, Ed, 8

Sac and Fox Tribe, 13, 14, 21, 37, 43, 51, 58, 62, 68, 69, 145, 170, 171, 183, 192–93, 201, 215,